CONTACTS

CONTACTS
Communicating Interpersonally

TERI KWAL GAMBLE
MICHAEL GAMBLE

RANDOM HOUSE NEW YORK

FOR MATTHEW JON

First Edition
98765432
Copyright © 1982 by Random House, Inc.

Library of Congress Cataloging in Publication Data
Gamble, Teri Kwal.
Contacts, communicating interpersonally.
Includes index.
1. Interpersonal communication.
I. Gamble, Michael. II. Title.
HM132.G35 302.2′2 81-17912
ISBN 0-394-32558-3 AACR2

Manufactured in the United States of America

Cover photo: © Erich Hartmann/Magnum

Book designed by Karin Gerdes-Kincheloe

PERMISSIONS-ACKNOWLEDGMENTS

CHAPTER 1

2, photo © Randy Matusow; 6, drawing by S. Gross, © 1974 The New Yorker Magazine, Inc.; 7, drawing by Opie, © 1976 The New Yorker Magazine, Inc.; 16, © 1976 by Sidney Harris/American Scientist Magazine; 17, communications model, from *Speech Communication: A Behavioral Approach* by Gerald Miller, © Bobbs-Merrill Educational Publishing; 18, "How Communication Works," in *The Process And Effects Of Mass Communication* by Wilbur Schramm © 1954 The University of Illinois Press; 19, from, Frank E. X. Dance "Toward a Theory of Human Communication," in *Human Communication Theory: Original Essays.* Ed. F. E. X. Dance. Holt, Rinehart and Winston, 1967. Copyright: F. E. X. Dance.

CHAPTER 2

32, photo © Bruce Davidson/Magnum; 37, Reprinted by permission of Faber and Faber Ltd. from *The Collected Poems of Louis Macneice*; 39, © Muscular Dystrophy Association 1980; 40, © 1980 United Features Syndicate; 42–43, "Cat's In The Cradle," by Sandy Chapin and Harry Chapin. Copyright 1974, Story Songs Ltd.; 52, From *The People, Yes* by Carl Sandburg, copyright 1936 by Harcourt Brace Jovanovich, Inc.; copyright 1964 by Carl Sandburg. Reprinted by permission of

Preface

Our goal in writing this book was two-fold. First, we wanted to familiarize you with the theory of interpersonal communication. Second, and just as important, we strove to help you make the book's key communications principles part of your day to day behavior. We believe that after reading the text, completing the exercises (called "skill builders"), and applying what you learn to your life, you will have a clearer understanding of interpersonal communication *and* you will handle yourself better in interpersonal situations.

Every attempt was made to ensure that *Contacts* will hold your interest and motivate you to improve your skills—that you will enjoy reading it. To this end, we aimed for clear, readable writing, interesting and relevant content, and a design that is visually exciting. Because we believe that active involvement heightens learning, we have created a plethora of skill builders that will enable you to put into practice the theoretical principles presented in the text immediately after you encounter them.

It is this series of skill builders—learning experiences that guide you in exploring, assessing, and improving your interpersonal communications skills—that distinguishes *Contacts* from every other interpersonal communications textbook. Each one focuses attention on a specific aspect of the interpersonal communications process. It is our expectation that the skill builders will make your study of interpersonal communications active and experiential.

Rather than placing skill builders at ends of chapters, we have placed them throughout the chapters. In this way, they will help you *experience*, not just intellectualize about, the concepts of interpersonal communications.

We do not expect that all of the skill builders will be used in the course of a single semester. Instead, your instructor may pick and choose from them to fit the needs of your individual class.

In addition, *Contacts* contains other tools that will help you increase your grasp of communications theory and sharpen your communications skills. Each chapter is introduced by a behavioral objectives preview that clarifies exactly what you will have learned after completing the chapter. Each concludes with a summary that will give a broad overview of the territory it covered.

An outstanding feature of *Contacts* that will enhance both your enjoyment and your comprehension is its lavish visual program of photographs, cartoons, and original illustrations. Much more than decoration, this program highlights the text's key concepts and reinforces important principles. It also emphasizes the real human impact of interpersonal communications, as well as its lighter side.

Complementing the pictorial program is an exciting literary program of stories, songs, poems, articles, and essays. Like the visuals, they highlight important communciations principles. They also present a wide variety of perspectives on human interaction.

Through theory and activity, through the verbal and the visual, *Contacts* encourages you to learn by doing, observing, and experimenting; by thinking, experiencing, and taking chances. By the time you have finished this book, the study of what happens when people communicate interpersonally—when they make contact—will be more meaningful than ever before.

We would like to thank the following reviewers for their thoughtful reading and helpful suggestions: James Byrns, Diablo Valley College; Steve Collins, Modesto Junior College; Cynthia Cone, San Antonio College; Robert T. Dixon, Jr., St. Louis Community College; Keith Erickson, Texas Tech University; Marsha A. Gephart, San Antonio College; Lee Granell, California State University; Tim Hegstrom, West Valley College; Cathy Konsky, Illinois State University; E. Joseph Lamp, Anne Arundel Community College; Sally R. McCracken, Eastern Michigan University; Charles E. Muench, Millersville State College; Candy Rose, Mission College; Stephen Sasala, Cuyahoga Community College; Robert Simons, Queensborough College; John C. Strom, Thomas Nelson Community College; Barbara Walker, Florida State University; Maxine Watson, Mount Hood Community College; and William A. Yaremchuk, Monmouth College.

We also wish to express our appreciation to Roth Wilkofsky, Kathleen Domenig, Dorchen Leidholdt, and Richard Garretson, our editors at Random House. The assistance, guidance, and encouragement they offered during the book's development was invaluable. We are also grateful to designer Karin Gerdes-Kincheloe, photo editor Lynn Goldberg, and illustrator Carol Grobe. Credit for the book's striking design and visual program goes to them.

September 1981

Teri Kwal Gamble
Michael Gamble

Contents

PREFACE VI

CHAPTER 1

WHAT IS INTERPERSONAL COMMUNICATION? 3

Who Is the Interpersonal Communicator? How Good an Interpersonal Communicator
Are You? 5
Components of Interpersonal Communication: What Do You Need to Get Going? 9
A Look at Some Communication Models: Picture This 16
Characteristics of Interpersonal Communication: A Closer Look 21
The Interpersonal Contact: Encountering Five Axioms 24
How to Improve Your Effectiveness as an Interpersonal Communicator 29

CHAPTER 2

WHO ARE YOU AND HOW DO YOU KNOW? 33

Meet Your Self-Concept: A Definition 35
Role-Taking and Self-Exploration: Categorizing the Self 46
Popular Culture and You: Through the Electronic Looking Glass 48
The Self-Fulfilling Prophecy: Meeting Positive and Negative Pygmalions 52
The Self-Concept Is Not the Self: Developing Self-Awareness 54
Joining Together: The Johari Window and Self-Disclosure 56
How to Make Your Self-Image Work for You 60

CHAPTER 3

PERCEPTION: I AM MORE THAN A CAMERA 65

What Is Perception? The "I" and the "Eyes" 66

The "I" of the Beholder: Through a Glass Darkly 72

Perceiving Others: What Are You, Please? 81

Other Barriers to Perception: Don't Fence Me In 89

How to Increase the Accuracy of Your Perceptions 98

CHAPTER 4

LISTENING: AN ACTIVE PROCESS **103**

Why Listen? 104

Hearing vs. Listening 111

Listening Levels 112

Feedback: A Prerequisite for Effective Listening 114

How to Increase Your Ear Power: A Listening Improvement Program 125

CHAPTER 5

NONVERBAL COMMUNICATION: SILENT LANGUAGE SPEAKS **143**

Can You Hear What I'm Not Saying? 144

Characteristics of Nonverbal Communication: Cues and Contexts 148

If You Could Read My . . . 150

How to Assess Your Communication Effectiveness: Nonverbally Speaking 191

CHAPTER 6

TRUST: STICKING YOUR HEAD IN THE LION'S MOUTH 197

Trust and Risk Taking: The Road to Self-Actualization 200

The Influence of the Social Environment 204

The Prisoner's Dilemma: Can I Trust You? 212

Ethical Considerations: "What? Me Lie?" 220

How to Develop Trust in Your Relationships 226

CHAPTER 7

LANGUAGE AND MEANING: HELPING MINDS MEET **231**

Language: What's That? 233

The Triangle of Meaning: Words, Things, and Thoughts 234

Measuring Denotative and Connotative Meaning 235

Bypassing and Bypassing the Bypass 242

Word–Thing Confusions: Label Madness 243
Improving Oral Language Abilities: A Call for Common Sense and Clarity 246
How to Make Words Work for You: A Guide to Further Skill Development 252

CHAPTER 8

BELIEFS, VALUES, AND ATTITUDES: PERSUADE ME IF YOU CAN 259

Your Attitudes Are Showing 261
Your Beliefs Are Showing 270
Your Values Are Showing 273
Promoting Attitude and Behavioral Change: Balance and Imbalance 283
How to Become More Effective at Interpersonal Persuasion 288

CHAPTER 9

ENTER CONFLICT: DISAGREEING WITHOUT BEING DISAGREEABLE 297

How Do You View Conflict? 298
How Conflict Arises: The Tug of War 304
Combating the Win–Lose Syndrome: Constructive Versus Destructive Conflict 312
How to Manage Conflict Successfully: Skills and Strategies 322

CHAPTER 10

THE CAT AND THE MOUSE: ASSERTION, NONASSERTION, AND AGGRESSION 331

Behaving Assertively: Watching Out for Yourself 332
Relationships and Struggles 359
How to Make Assertiveness Work for You 364

CHAPTER 11

WHERE DO YOU GO FROM HERE? A LIFELONG PERSPECTIVE 371

How to Keep Improving Your Interpersonal Communication Effectiveness 372
A Look at the Major Arenas of Your Life—Family, Friends, Education, and Work 376
Checkbacks: Exercises You Can Use Again and Again 380

INDEX 386

CONTACTS

CHAPTER

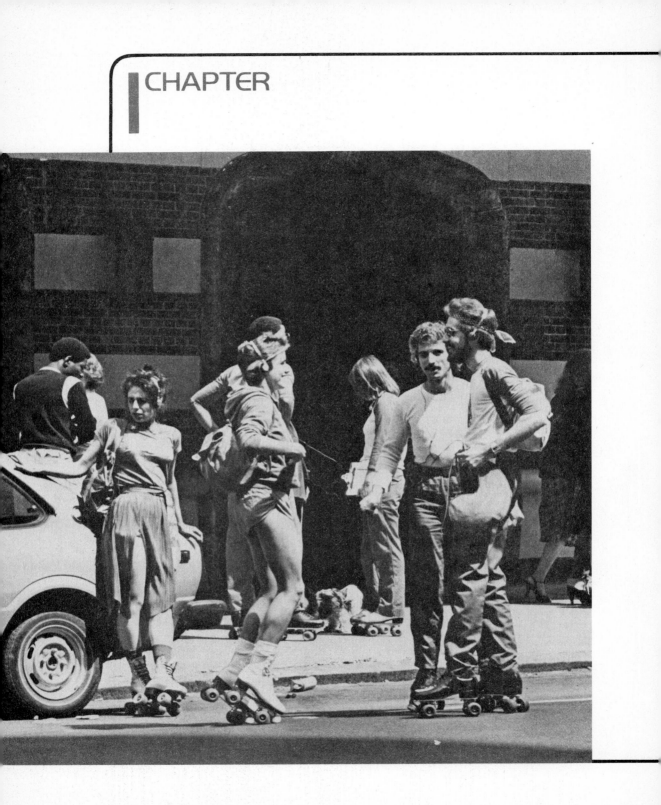

What Is Interpersonal Communication?

CHAPTER PREVIEW

After experiencing this chapter, you should be able to:

Explain what is meant by the term "interpersonal communicator"

Define "interpersonal communication"

Use a variety of tools to assess your effectiveness as an interpersonal communicator

Identify the characteristics of a healthy interpersonal relationship

Enumerate and explain the essential ingredients of interpersonal communication

Provide examples of representative communication models

Create and explain an original model of communication

Demonstrate an understanding of the characteristic attributes of interpersonal communication

Identify and provide examples of Watzlawick's communication axioms

Explain how you can improve your effectiveness as an interpersonal communicator

> Human contact is a challenge. It is also
> a joy, a means of self-expression and
> self-discovery.
>
> Leonard Zunin, M.D.

This book is about you—the interpersonal communicator. The topics covered will help you as you go about your usual business of making friends, maintaining work ties, strengthening ongoing relationships, falling in love, and making relationships work. We all depend on other people to help us meet our needs, attain personal happiness, and find personal fulfillment. Thus, each of us will benefit from discovering more effective ways of relating to others. This is where interpersonal communication fits in. We cannot overemphasize the role that interpersonal communication plays in each of our lives. Whether you have just graduated from high school or cannot remember where you went to high school, whether you are a teen-ager, in your twenties, in your thirties, middle-aged, or an octogenarian, it is never too late to learn skills you can use to enrich and

SKILL BUILDER

CONTACTS!

1. Make a list of each interpersonal contact you experience (each person with whom you communicate) during the next twenty-four hours (note: the contact need not be initiated by you). Also indicate the nature of your communication (the subject or message), the context or environment in which it occurred (classroom, office), the outcome (what happened as a result), and whether you communicated as effectively as you would have liked to during the encounter.

2. Use the following format for your notes:

Contact 1	Person with Whom I Communicated	Subject or Message	Context or Environment	Outcome

Self Evaluation: During this contact, I would rate my effectiveness as 1, 2, 3, 4, or 5, with 1 representing extremely ineffective and 5 representing extremely effective.

Rationale: I have given myself this rating because:

improve the quality of your life. Developing interpersonal communication skills is a lifelong process, and this book will provide you with a program for lifelong learning. Effective interpersonal skills are not inborn; rather, you have to work at developing them. Whether you would like to improve your ability to relate to people who are part of your personal life, your job life, or your student life, the time to begin is now.

WHO IS THE INTERPERSONAL COMMUNICATOR? HOW GOOD AN INTERPERSONAL COMMUNICATOR ARE YOU?

The interpersonal communicator is a person who enters into relationships with other people. The interpersonal communicator is involved in initiating, developing, and sustaining effective personal contacts. We are all interpersonal communicators: Every time we knowingly or unknowingly send a verbal or nonverbal message to a friend, a lover, a relative, a stranger, an acquaintance, a supervisor, an employee, or a coworker, interpersonal communication takes place. Every facet of our lives, from birth to death, is dependent on and affected by interpersonal communication skills.

Contact 2	Person with Whom I Communicated	Subject or Message	Context or Environment	Outcome

Self Evaluation: 1, 2, 3, 4, 5
Rationale:

Contact 3	Person with Whom I Communicated	Subject or Message	Context or Environment	Outcome

Self Evaluation: 1, 2, 3, 4, 5
Rationale:

3. You may wish to share some of your observations with other class members.

> I . . . have never been the same
> person alone that I am with people.
>
> *Philip Roth*

After completing the chart, it should be clear that interpersonal communication is a very significant part of your life. However, simply communicating frequently, simply having many, many interpersonal contacts each day, does not mean that you are as effective an interpersonal communicator as you could be.

Although we frequently neglect to consider the problems that plague interpersonal relationships, these issues are at the heart of contemporary literature and art.

> "Why didn't you talk to me the first time I approached you?"
> "I didn't know what to say."
> "You have trouble talking to people?"
> "I got out of practice."
>
> *from Bernard Slade's* Tribute

> "I'd like to see you become the greatest success in the world. But you'd better be on your guard. Because I'll do my damndest to make you fail. Can't help it. I hate myself. Got to take revenge on everyone else. Especially you."
>
> *from Eugene O'Neill's* Long Day's Journey into Night

> "What's Humanitis?"
> "It's when the human condition is suddenly too much for you."
>
> *from Saul Bellow's* The Last Analysis

> "Suicide kills two people, Maggie, that's what it's for."
>
> *from Arthur Miller's* After the Fall

"I don't talk to many people—except to say like: give me a beer, or where's the john, or what time does the feature go on, or keep your hands to yourself, buddy. You know—things like that. . . . But every once in a while I like to talk to somebody, really talk; like to get to know somebody, know all about him."

from Edward Albee's The Zoo Story

I am a rock
I am an island
And a rock feels no pain
And an island never cries.

Paul Simon

The preceding examples illustrate basic communication problems. When we lack interpersonal sensitivity and fail to consider the feelings of others, our relationships suffer. We can all improve our interpersonal skills; we can never be *too* effective at establishing and maintaining contacts with others. You have just evaluated how proficient you think you are during a variety of interpersonal contacts. Let us now formalize that evaluation.

"*I do have the exact change, but I prefer the human contact.*"

The New Yorker

HOW DO YOU MEASURE UP?

1. Use the accompanying scale to rate your overall effectiveness as a communicator when compared to your best friend, an older relative, a fellow student, a boss or instructor, or a boyfriend, girl friend, or spouse. Use a red marker to indicate your evaluation of yourself, a blue marker to indicate your evaluation of your best friend, an orange marker for a fellow student, a black marker for a boss or teacher, a purple one for an older relative, and a yellow one for a boyfriend, girl friend, or spouse.

Totally 0__10__20__30__40__50__60__70__80__90__100 Totally
Ineffective Effective

2. According to your evaluation, whose communication skills do you see as "better" than your own? Why?
3. Whose communication skills do you see as "equal to" your own? Why?
4. Whose communication skills do you see as "inferior" to your own? Why?
5. Set a goal for yourself. Using a green marker (for go), indicate the extent to which you would like this course to improve your interpersonal effectiveness rating.

To realize this improvement, there are a number of skills you must work to maintain, a number of skills you must work to master, and a number of ineffective behaviors you must work to eliminate. To create, nourish, and maintain healthy relationships, certain abilities and understandings must be present. Among these are:

1. An ability to understand and communicate with yourself
2. An ability to know how and why you and those with whom you relate see things the way you do
3. A capacity to listen to and process information you receive
4. A sensitivity to the silent messages you and others send
5. A willingness to trust others and a demonstrated ability to be trusted
6. A knowledge of the ways in which words affect you and those with whom you interact
7. An understanding of how beliefs, values, and attitudes affect the development of your relationships
8. An ability to handle conflict by learning how to disagree without being disagreeable
9. An understanding of assertiveness and your basic rights as an individual
10. A desire to apply these skills to each of your interpersonal experiences

By now, you may have realized that we have just provided you with a brief description of each chapter in this book. As we continue our work together, we will explore and investigate what it means to experience effective person-to-person communication.

COMPONENTS OF INTERPERSONAL COMMUNICATION: WHAT DO YOU NEED TO GET GOING?

All interpersonal encounters have certain common components that, together, help define the communication process. The better we understand them, the easier it will be for us to develop our own communication abilities. Let us begin by examining what we believe to be "the essentials" of interpersonal communication, the components we believe to be present during every interpersonal contact.

People

Who are the people that make interpersonal contact? Interpersonal encounters take place between all types of sources and receivers. Sources and receivers are simply persons who send and receive messages. Although it is easy to picture an interpersonal contact as beginning with a sender and ending with a receiver, it is important to understand that during interpersonal communication the sending and receiving processes are constantly being reversed. Thus, when we communicate interpersonally, we both send and receive. The sending role does not "belong" to one person and the receiving role to another. We all function simultaneously as sources and receivers.

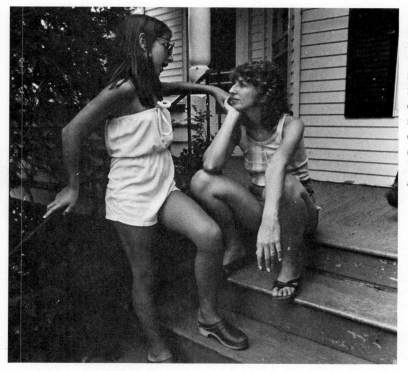

In interpersonal communication, both verbal and nonverbal messages are exchanged by sender and receiver. (© *Michael Weisbrot & Family*)

Were we just senders, we would simply emit signals, never stopping to consider whom, if anyone, we were affecting. Were we just receivers, we would simply accept signals like a receptacle, never having an opportunity to let others know how we were being affected. But this is not how effective interpersonal communication works. The verbal and nonverbal messages we send to others are, in part, determined by the verbal and nonverbal messages we receive from them.

Messages

What kinds of messages do you send and receive during your interpersonal contacts?

B. A conversation between two strangers waiting for a bus during a storm
C. A teacher–student controversy about a grade
D. A discussion between friends about the rising cost of tuition

3. After enacting your scene, explain how what one person did and said influenced what the other person did and said.

Each of you sent and received verbal and nonverbal messages to and from each other. What you talked about, the words you used to express your thoughts and feelings, the sounds you made, the way you sat and gestured, your facial expressions, perhaps even your touch or your smell communicated information. We can say that everything a source or receiver does or says is a potential message. Thus, as long as someone is there to interpret your behavior, you cannot not send a message. Whether you smile, frown, shout, whisper, or turn away, you are communicating and your communication is having some effect.

Channels

As we see, we send and receive messages with and through our senses; thus, messages may be sent and received through verbal and nonverbal modes. In effect, we are multichanneled communicators.

SKILL BUILDER

TUNE YOUR CHANNEL

Use the chart below to inventory each message you receive during the next two minutes.

Message Received	Channel(s) Messages Came Through
Ex: Joan is hungry.	Sound: She asked me for a cookie. Sound: Her stomach growled.

Your chart might reveal that you received sound messages (heard noises from the street), sight messages (saw how someone looked), taste messages (felt the dryness of your mouth), smell messages (smelled the cologne of your friend), touch messages (felt the roughness of your hands). Which channel were you most attuned to? Why? To what extent did you rely on one or more channels while excluding or disregarding others? Effective communicators are adept channel switchers. They recognize that interpersonal communication is a multichanneled experience.

Noise

From an interpersonal communication perspective, noise is anything that interferes with or distorts your ability to send or receive messages. Thus, although we are used to thinking that "noise" must contain sound, the interpersonal communicator knows that "noise" can also be created by physical discomfort, psychological make-up, intellectual ability, or the environment.

SKILL BUILDER

THE NOISE NOOSE

In what ways could each of the following elements function as noise and interfere with effective interpersonal communication?

1. A black eye
2. Chewing gum
3. A cold, damp room
4. A personal bias
5. An inappropriate word choice
6. A stomachache
7. Sunglasses
8. Shyness
9. The television
10. The habit of not smiling

Context

Interpersonal transactions always take place in some context or setting. Sometimes, the context is so natural that we hardly notice it. At other times, however, the context makes an impression on us and exerts considerable control over our behavior. Consider the extent to which the environment you find yourself in influences the way you act with others. Consider the extent to which certain environments cause you to alter or modify your posture, manner of speaking, or attire. Sometimes environmental conditions of place and time affect our interpersonal encounters without our consciously realizing it.

Our environment has a powerful influence on the way we communicate. In a crowded subway car, for example, we may be inhibited by the close presence of strangers and by noise.
(© Donald C. Deitz/Stock, Boston)

SKILL BUILDER

CONTACT IN CONTEXT

Compare and contrast the type of interpersonal contacts that would be most apt to occur in each of the following contexts. Include a description of the nature of each interaction, the probable attire of each interactant, and his or her demeanor.

1. The first few minutes of a party
2. A business meeting
3. Your home at mealtime
4. A funeral home
5. A college classroom
6. A park
7. A football stadium

Feedback

Whenever we communicate interpersonally, we get back information. The verbal and nonverbal cues we perceive function as feedback. Feedback tells us how we are coming across. A smile, a frown, a chuckle, a sarcastic remark, a muttered thought, or silence can cause us to change, modify, continue, or end a transaction. Feedback that encourages us to continue behaving as we are is called positive feedback, and it enhances behavior in progress. In contrast, negative feedback serves to extinguish a behavior; it serves a corrective rather than a reinforcing function. Thus, negative feedback can help to eliminate

SKILL BUILDER

HOW ARE YOU DOING?

1. Compile a list of feedback messages you receive during the next eight hours. Categorize each message as follows:

Ten Positive Messages I Sent to Myself

Ten Positive Messages I Received from Others

unwanted, ineffective behaviors. Note that the terms "positive" and "negative" should not be interpreted as meaning "good" or "bad." The terms simply reflect the way responses affect behavior.

Both positive and negative feedback can emanate from internal or external sources. Internal feedback is feedback you give yourself as you monitor your own behavior or performance during an interpersonal transaction. External feedback is feedback from others who are involved in the encounter. To be an effective communicator, you must be sensitive to both types of feedback: You must pay attention to your own reactions and the reactions of others.

Ten Negative Messages I Sent to Myself

Ten Negative Messages I Received from Others

2. In general, how alert were you to feedback? What types of messages were you most responsive to? Why?

Effect

An interpersonal communication contact always has some effect on you and on the person with whom you are interacting. Its effect can be physical, cognitive, or emotional. For instance, an interpersonal contact can elicit feelings of joy, anger, or sadness; it can cause you to fight, argue, become apathetic, or evade an issue; it can lead to new insights, increased knowledge, the formulation or reconsideration of opinions, silence, or confusion. The effects are not always visible or immediately observable. There is more to an interpersonal communication effect than meets the eye or the ear! Now that we have examined the basic components of interpersonal communication, let us see how they can be joined together to give us a picture, or model, of the interpersonal communication process.

"ALTHOUGH HUMANS MAKE SOUNDS WITH THEIR MOUTHS AND OCCASIONALLY LOOK AT EACH OTHER, THERE IS NO SOLID EVIDENCE THAT THEY ACTUALLY COMMUNICATE WITH EACH OTHER."

A LOOK AT SOME COMMUNICATION MODELS: PICTURE THIS

Through interpersonal communication we share meaning with others, sometimes by sending or receiving intentional messages and sometimes by sending or receiving unintentional messages. In other words, interpersonal communication includes all the things that could affect two or more individuals as they knowingly or unknowingly relate to each other. It occurs whenever one person assigns significance or meaning to the behavior of another person.

At this point you can ask "So what? Will knowing this enable me to understand or establish more meaningful relationships with my friends, my spouse, my employer, my parents?" The answer is "Yes!" If you understand the processes that permit people to contact and influence each other, if you understand the forces that can impede or foster the development of effective interpersonal contacts, then you stand a better chance of experiencing such relationships yourself. The following models can help us picture the process by which people initiate and maintain their interpersonal contacts. Use them as tools to discover how communication operates and to examine your own interpersonal encounters.

Start with this model adapted from the work of Gerald R. Miller:

Context

The model indicates that a source-encoder (a person) sends a message about some referent (object, act, situation, experience, idea). The message is made up of at least three factors: verbal stimuli (words), physical stimuli (such as gestures, facial expressions, movements), and vocal stimuli (such as rate, loudness, pitch, emphasis). The message is consciously or unconsciously sent by the source-encoder to a receiver-decoder (another person) who responds in some way to it (feedback). Both the source's message and the receiver's response are affected by the context and by each person's communication skills, attitudes, and past experiences. Thus, the extent to which message sent differs from message received could be said to be due to the presence of noise, even though noise is not overtly present in this particular model.

For illustration, let us analyze the following husband-wife dialogue with reference to this model.

SHE: What's the matter with you? You're late again. We'll never get to the Adams's on time.

HE: I tried my best.

SHE: (Sarcastically) Sure, you tried your best. You always try your best, don't you? (Shaking her finger) I'm not going to put up with this much longer.

HE: (Raising his voice) You don't say! I happen to have been tied up at the office.

SHE: My job is every bit as demanding as yours, you know.

HE: (Lowering his voice) Okay. Okay. I know you work hard too. I don't question that. Listen, I really did get stuck in a conference. (Puts his hand on her shoulder) Let's not blow this up. Come on. I'll tell you about it on the way to Bill and Ellen's.

What message was the wife (the initial source-encoder) sending to her husband (the receiver-decoder)? She was letting him know with her words, her voice, and her physical actions that she was upset and angry. Her husband responded in kind. He too used words, vocal cues, and gestures in an effort to explain his behavior. Both individuals were affected by the nature of the situation (they were late for an appointment), their attitudes (how they felt about what was occurring), and their past experiences.

Next, look at this model by Wilbur Schramm:

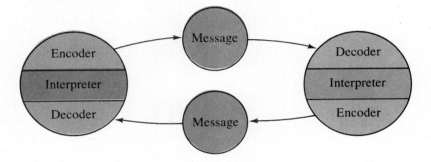

Schramm's model shows us even more explicitly that interpersonal communication is a circle, not a one-way event. In Schramm's model, each party to the communication process is perceived as both an encoder and a decoder. In addition, each party interprets the messages he or she receives in a somewhat different way. We are each affected by a field of experience or psychological frame of reference (a form of noise) that we carry with us wherever we go.

Consider this brief dialogue:

WIFE: Hey kids, don't bother Dad now. He's really tired. I'll play with you.

HUSBAND: Don't isolate me from my own children! You always need to have all their attention.

WIFE: I'm not trying to do that. I just know what it's like to have a really trying day and feel that I have to close my eyes to get back to myself.

HUSBAND: I sure must be wound up.

WIFE: I understand.

Here we see how one's psychological frame of mind can influence the meaning given to messages received. In addition, we come to realize that neither party to the communicative encounter functions solely as a sender or a receiver of messages. Rather, each sends and receives messages simultaneously. The wife received the message that her husband was exhausted and sent a message that the kids should let him rest. The husband received a message that his wife was trying to alienate him from the children and sent a message expressing his concern. By listening to how her husband felt, the wife was able to determine how he had interpreted her message. She was thus able to avoid a serious misunderstanding.

The next model combines the strengths of these first two models.

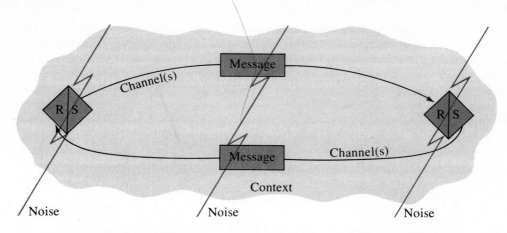

Here we see that interpersonal communication is a circle, that sending and receiving responsibilities are shared, that a message or messages may be sent through one or more channels, that the interaction occurs in and is affected by a context, and that noise can enter at any point in the process. Noise can affect the sending or the receiving abilities of the interactants. It can be caused by the context, it can be present in the channel, or it can pop up in the message itself.

Frank Dance created a more abstract model, a helical spiral to depict the dynamic nature of the communication process.

The spiral represents the way communication evolves or progresses in one individual from birth to the present moment. The spiral also emphasizes the fact that every individual's behavior in the present is affected by his or her past experience. Likewise, present behavior will have an impact on his or her future actions. Thus, Dance's helix indicates

that communication is additive and accumulative; it has no clear observable beginning, and no clear observable end. When two different helixes meet, anything might happen. We can picture two communication spirals meeting in a number of different ways.

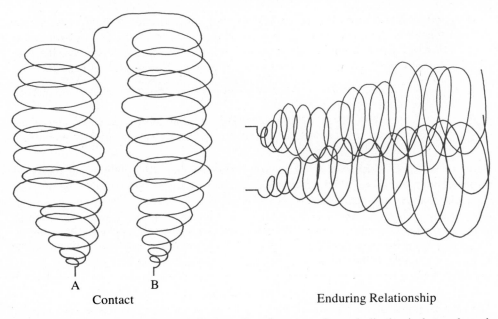

A B
Contact Enduring Relationship

The point where the spirals touch is the point of contact. Some helical spirals touch each other but once during a lifetime; others crisscross each other or intertwine in a pattern that indicates an enduring relationship. Each time a contact is made, messages are sent and received by the interactants. Sometimes we develop in similar ways, sometimes we develop in different ways. Sometimes we grow together, and sometimes we grow apart.

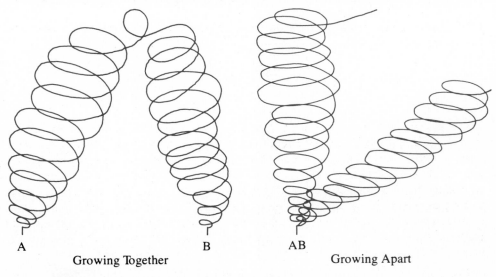

A B AB
Growing Together Growing Apart

1. Draw or build something that represents your understanding of interpersonal communication. You can focus on any or all components of the processes we have examined thus far. Your models can be literal or abstract representations. Be ready to present your model (representation) to the class. Specifically, be sure to offer:

 A. An explanation of what your model says about the interpersonal communication process
 B. A description of what your model suggests are the essential ingredients of the interpersonal communication process (whether overtly pictured or inferred)
 C. A slogan that sums up your perception of the state of interpersonal communication

2. As a class, discuss:

 A. The insights into interpersonal communication provided by the models
 B. The ways in which the creations can help improve the development of our own relationships

We have examined a number of interpersonal communication models. Let us now explore basic characteristics of interpersonal communication.

CHARACTERISTICS OF INTERPERSONAL COMMUNICATION: A CLOSER LOOK

Besides having ingredients in common, every interpersonal communication contact also has certain characteristics in common.

Interpersonal Communication Is a Dynamic Process

When we call interpersonal communication a dynamic process, we mean that all the ingredients that are a part of it constantly interact and affect each other. Everyone is interconnected. What happens to one person, in part, determines what happens to the others. Like the people who compose them, interpersonal relationships change and evolve with time. Nothing is static. Everything is accumulative. We continue to communicate as long as we are alive. Communication is ever-changing and it is continuous. Thus, every interpersonal contact is a part of a series of happenings—something always went before it and something more will happen after it. In other words, all of our present contacts may be thought of as points of departure for future encounters.

When we communicate we send verbal symbols and nonverbal cues.

Interpersonal Communication Is Unrepeatable and Irreversible

Every interpersonal contact you experience is unique. It has never happened before, and it never will happen in just that way again. Just as a person cannot step in the same river twice (the experience affects and changes the river and the person), so a person cannot exactly repeat or duplicate an encounter (the encounter affects those who are party to it). Thus, although we are influenced by our past, we can never reclaim it. Communication is unrepeatable.

Likewise, we cannot take back something we have said or erase the effects of something

that we did. Interpersonal communication is irreversible. What we communicate remains, although we may attempt to qualify it.

> Even the emperor
> cannot buy back
> one single day.
> *Old Chinese Proverb*

SKILL BUILDER

CAN I TAKE THAT BACK, PLEASE?

Describe a situation in which the irreversible nature of communication caused difficulties for you. Be sure to note who was involved, what was communicated, what effect the communication had, and what you wish you could have changed.

Functions of Interpersonal Communication: What Can It Do for You?

Every interpersonal communication contact serves one or more functions. For example, an interpersonal communication experience can help us discover who we are, aid us in establishing a meaningful relationship, or prompt us to examine and try to change either our own attitude and behavior or the attitude and behavior of another.

Self–Other Understanding. A main function served by interpersonal communication is self–other understanding. When you get to know another person, you also get to know yourself. When you get to know yourself, you learn how others affect you. In fact, we depend on communication to develop self-awareness. Communication theorist Thomas Hora put it this way: "To understand himself man needs to be understood by another. To be understood by another he needs to understand the other."

We need feedback from others and we need to give feedback to others. Interpersonal communication offers us numerous opportunities for self–other discovery. It lets us know when and why we are trusting or untrusting, whether we can make our thoughts and feelings clear, under what conditions we have the power to influence others, and if we have the ability to resolve conflicts or problems that confront us.

Establish Meaningful Relationships. In order to build a relationship, we cannot be overly concerned for ourselves; we must consider the needs and wants of others. It is through effective interpersonal contacts that basic social needs are met. Interpersonal communication offers each of us the chance to satisfy what William Schutz calls our needs for inclusion, control, and affection. The need for inclusion involves our need to be with others, our need for social contact. We like to feel that others accept and value us, and we want to feel like a full partner in a relationship. The need to control involves

Effective interpersonal communication enables us to meet our needs
for social contact and for participation in relationships with others.
(© Stephen Shames 1980/Woodfin Camp & Assoc.)

our need to feel that we are capable and responsible, that we are able to deal with and
manage our environment. We like to feel we can influence others. The need for affection
involves our need to express and receive love. In a meaningful relationship, each of these
needs are met. Thus, if we are able to communicate meaningfully with others, we are
less likely to feel unwanted, unloved, or incapable.

Examine and Change Attitudes and Behaviors. During interpersonal contacts, indi-
viduals have ample opportunities to influence each other subtly or overtly. We spend
much time trying to persuade one another to think as ''we'' think, do what ''we'' do,
like what ''we'' like. Sometimes our efforts meet with success, and sometimes they do
not. In any case, our persuasion experiences afford each of us the chance to influence
another so that we may try to realize our personal goals.

THE INTERPERSONAL CONTACT: ENCOUNTERING FIVE AXIOMS

We have looked at the components, characteristics, and functions of interpersonal com-
munication. Let us now turn our attention to a number of communication principles or
axioms. The following communication properties are described by Paul Watzlawick,

Janet Beavin, and Don Jackson in *Pragmatics of Human Communication: A Study of Interaction Patterns, Pathologies and Paradoxes*. Each has fundamental interpersonal implications and is essential to our understanding of the interpersonal communication process.

Axiom One: You Cannot Not Communicate

It is not uncommon for individuals to believe that we communicate because we want to communicate, that communication is purposeful, intentional, or consciously motivated. Sometimes this is true. However, we also communicate even though we do not wish to, do not think we are, and have not consciously attempted to send a message.

SKILL BUILDER

CAN YOU SEND AN UNMESSAGE?

1. Describe a situation where you tried to avoid communicating with someone. During the course of your description, identify the person you did not want to communicate with, give your reason, and describe your strategies to try to avoid communicating and the results of your efforts.

2. Describe a situation when someone tried to avoid communicating with you. Again, identify the person involved and describe your perception of his or her reasons for not wanting to relate to you, the strategies he or she used to try to avoid communicating, and the results.

Your analyses almost certainly showed you that whenever you are involved in an interactional situation, you must respond in some way. In other words, you cannot voluntarily stop behaving because behavior has no opposite. Even if you do not choose to respond verbally, even if you choose to maintain absolute silence, even if you attempt to not move a muscle, your lack of response is itself a response and in and of itself has message value, influences others, and communicates.

Watzlawick, Beavin, and Jackson have identified four basic strategies we readily employ when trying not to communicate—when we want to avoid making interpersonal contact. First, we try to *reject* communication by making it clear to the other person that we are not interested in conversing. By doing this, however, we have not avoided communicating. Instead, we have probably created a strained, embarrassing, and socially uncomfortable condition, and in addition, a relationship does exist between us. Second, we decide to *accept* communication. We operate according to the law of least effort, giving in reluctantly and agreeing to make conversation, in the hope that the person will go away quickly. Third, we attempt to *disqualify* our communication. We communicate in a way that invalidates our own messages or the messages sent by the other person. We

contradict ourselves, switch subjects, utter incomplete sentences or nonsequiturs in the hope that the other person will give up. Fourth, we simply *pretend* we would like to talk, but because we are tired, nervous, sick, drunk, mourning, deaf, or otherwise incapacitated, we simply cannot communicate at the moment. In other words, we use the symptom as a form of communication. To summarize, no matter how hard we try, we cannot not communicate. All behavior is communication; all behavior has message value.

Axiom Two: Every Interpersonal Contact Has a Content and a Relationship Dimension

The content level of a communication is the information or data level, and describes the behavior expected as a result of the response. In contrast, the relationship level of a communication indicates how the exchange is to be taken, and it signals what one individual thinks of the other. For example, the sentence "Close the door" is a directive that asks the receiver to perform an action. However, the same statement can be delivered in many ways—as a command, a plea, a request, a come-on, or a turnoff. Each manner of delivery says something about the nature of the relationship existing between source and receiver. We constantly give others clues about how we see ourselves in relationship to them.

Watzlawick, Beavin, and Jackson have identified three types of responses we use to indicate our reactions to each other. First, we can *confirm* the other person's self-definition or self-concept and treat that person as he or she believes he or she ought to be treated. For example, if your friend believes herself to be competent and smart and if those around her reward her by asking for advice or seeking her help, her self-concept is being confirmed.

Second, we can *reject* the other person's self-definition by simply refusing to accept the other person's beliefs about himself or herself. If your friend imagines himself to be

SKILL BUILDER

CONFIRM, REJECT, DISCONFIRM

1. Working with a partner, improvise three scenes: one in which a person confirms another person's self-image; one in which a person rejects the other person's self-image; and one in which a person disconfirms the other person's self-image—that is, communicates as if the person did not even exist. Note the verbal and nonverbal behaviors that aid in confirming, rejecting, or disconfirming the person.

2. Describe an interpersonal contact during which you were (a) confirmed, (b) rejected, and (c) disconfirmed. How did you respond?

3. Describe an interpersonal contact during which you (a) confirmed, (b) rejected, and (c) disconfirmed another person. How did he or she respond?

a leader, but no one else treats him as if he had leadership potential, your friend may have to revise his picture of himself.

Third, we can *disconfirm* another person's self-definition. While confirmation says, "I accept you as you see yourself; your self-assessment is right," and rejection says, "I do not accept you as you see youself; your self-assessment is wrong," disconfirmation says simply, "You do not exist." The other person is a nonentity. We do not care enough to let the other person know how we feel, and we always treat the person the same way no matter what he or she does. In other words, we do not offer these people the clues they need to let them know whether we believe they are performing well. In effect, we ignore them. Thus, through disconfirmation we do not let others know how we really see them because we pay no real attention to them. Consistent disconfirmation is perhaps the cruelest psychological punishment a human being ever experiences. As psychologist William James stated: "No more fiendish punishment could be devised . . . than that we should be turned loose in society and remain absolutely unnoticed."

Axiom Three: Every Interpersonal Contact Is Defined by the Way the Interactants Punctuate Communication Events

Even though we know that communication is continuous, we often act as if there were an identifiable starting point or a traceable cause for an elicited response. What is stimulus and what is response is not easy to determine, however. It is quite as feasible for a father to think he reads or daydreams all the time to escape his child's screaming as it is for the child to believe she screams because her father is reading or daydreaming and won't play with her. One sees behavior progressing from screaming to retreating, and the other sees it progressing from retreating to screaming. What is stimulus for one is response for the other. What needs to be acknowledged is that we divide up or punctuate experience differently because we see it differently.

SKILL BUILDER

SEE IT AND SEE IT AGAIN

1. Think of an argument you recently had that you believed was caused by the other person's behavior. Describe the situation, and identify the person's stimulus behavior (the starting point).

2. Now, put yourself in the other person's place. How might he or she have answered the same question? Whenever you suggest that communication began because of a particular stimulus, you are forgetting that communication has no clearly distinguishable starting point and no clearly distinguishable finish line. Try to remember that communication is a circle, a continuous, on-going series of events.

Axiom Four: Interpersonal Contacts Are Digital and Analogic

When we talk to another person we send two kinds of messages: discrete, digital, verbal symbols (words); and continuous, analogic nonverbal cues.

CONTACTS = WORDS + ACTIONS

According to Watzlawick, Beavin, and Jackson, the content of a message is more likely to be communicated through the digital system, and the relationship message is more likely to be carried through the analogical system. Although words are under our control and for the most part uttered intentionally, many of the nonverbal cues we send are not. Thus, Watzlawick, Beavin, and Jackson write, "... it is easy to profess something verbally, but difficult to carry a lie into the realm of the analogic." Thus, while you may attempt to lie with words, the nonverbal signals you emit will almost certainly give you away.

Axiom Five: Interpersonal Exchanges Are Either Symmetrical or Complementary

The terms *symmetrical* and *complementary* do not refer to good (normal) or bad (abnormal) interpersonal communication exchanges. The two terms simply represent the two basic categories into which all interactions are divided. Both serve important functions, and both will be present if a relationship is healthy.

If the behavior of one person is mirrored by the behavior of the other person during an interpersonal contact, Watzlawick, Beavin, and Jackson would say that a symmetrical interaction has occurred. However, if the behavior of one person precipitates a different behavior in the other person, they would say that complementary interaction has occurred. Thus, if you act in a dominating fashion and the person you are relating to also acts in a dominating fashion, or if you act happy and the other person acts happy, or if you express anger and the other person expresses anger, for the moment you share a symmetrical relationship. You are making an attempt to minimize your differences.

In contrast, in a complementary relationship you and your partner engage in different behaviors, with your behavior serving to elicit his or her behavior or vice versa. Thus, if you behaved in an outgoing manner, your partner might adopt a more quiet mood; if you were aggressive, he or she might become submissive; if you were the leader, your partner would be the follower. Under these circumstances, you and your partner are maximizing your differences.

Neither the symmetrical nor complementary relationship can exist trouble-free. Parties to a symmetrical relationship are apt to experience what is termed *symmetrical escalation*. Since both people believe they are "equal," both also believe they have an equal right to assert control. When this happens, they may feel compelled to engage in a battle to show how equal they really are. Remember Orwell's *Animal Farm:* "All animals were equal. Some animals, however, had to prove they were more equal." It is not uncommon for individuals who share a symmetrical relationship to find themselves in a status struggle

with each other. Thus, the main danger of a symmetrical relationship is an escalating, runaway sense of competitiveness.

In contrast, the problem that surfaces in many complementary relationships is termed *rigid complementarity*. When one party to the relationship begins to feel that control is automatically his or hers, the relationship can become rigid or fixed. Control no longer alternates between interactants; it is no longer a function of skill or mood. When this happens, both persons lose a certain degree of freedom; neither is free to choose how he or she will behave. Thus, the teacher who never pictures herself as a learner, the father who cannot see that his child has reached adulthood, and the leader who can never permit herself to act as a follower have become locked in self-perpetuating, unrealistic, unchanging, unhealthy patterns of behavior.

SKILL BUILDER

MIRROR, MIRROR ON THE WALL

1. Describe interpersonal contacts you have experienced that illustrate:

 A. A symmetrical relationship
 B. A symmetrical escalation
 C. A complementary relationship
 D. Rigid complementarity

2. Working with a partner, improvise a scene that illustrates symmetrical escalation and one that illustrates rigid complementarity. Play the scene again, and this time show how the relationship struggle could have been avoided.

These five axioms provided us with the additional knowledge we need to understand interpersonal communication and increase the effectiveness of our interpersonal contacts. Now let us narrow our focus on these concerns.

HOW TO IMPROVE YOUR EFFECTIVENESS AS AN INTERPERSONAL COMMUNICATOR: ARE YOU READY?

The major purpose of this book is to help you gain an understanding of interpersonal communication while you are developing your interpersonal communication skills. Attaining this dual goal should improve the quality of your interpersonal contacts and relationships. Thus, we want you to consider this book as a tool that, if used properly, will enhance your ability to communicate interpersonally. To do this, you need to accomplish the following tasks.

Understand How Each of the Topics Covered
Influences Your Own Interpersonal Effectiveness

Each of the chapters in the book contains information that clarifies and illuminates the interpersonal communication experience: Chapter 2 explores self-concepts and the ways in which coming to know yourself can improve your ability to relate to others. Chapter 3 focuses on perception and the myriad ways our interpretations of our interpersonal contacts are influenced by what we would like to see or expect to see. In Chapter 4 you come "ear-to-ear" with listening, and you have an opportunity to develop your ear power and use your listening skills during interpersonal contacts. In Chapter 5 you examine the silent side, or nonverbal dimension, of interpersonal communication. You have an opportunity to analyze how effectively you send and receive nonverbal cues.

During your study of Chapter 6 you explore trust and its relationship to the development of meaningful relationships. In Chapter 7 you focus on words and how they affect the nature of your interpersonal contacts. Beliefs, values, and attitudes are considered in Chapter 8. Exactly how are they reflected in our attempts at interpersonal persuasion? Conflict is the subject of Chapter 9. What is it? How do you handle it? In Chapter 10 we examine the relationship between assertion, nonassertion, aggression, and interpersonal effectiveness. Finally, in the last chapter, we put it all together; what we have is a learning package to use and carry with us all our lives.

Each chapter preview contains targets (behavioral objectives) that specify what you should be able to do after completing your study of chapter materials. Use them to clarify your own communication objectives as you make your way through the book.

Become Actively Involved in the Study of
Interpersonal Communication

The materials contained in this resource will benefit you only if you make a commitment to try out, or experience, the principles discussed. A plethora of exercises (Skill Builders) are included for just that purpose. The Skill Builders are designed to help you become aware of what you must do to become a more effective interpersonal communicator. They give you an opportunity to apply the knowledge you are gaining to actual interpersonal experiences. If you use them as directed, you will increase your opportunities to grow because you will be actively directing your own learning and diagnosing your own needs for self-improvement. Realize that growth takes time—lasting change does not just happen. Mistakes should be viewed as occasions for learning, and new learnings must be continually practiced. Only in this way are ineffective patterns of behavior unfrozen and new, effective patterns substituted and made a part of your interpersonal behavior repertoire.

Believe in Yourself

You must believe that you are worth the time and effort it will take to develop your interpersonal communication skills. You must believe that developing these skills will make a difference in your life. We think you are worth it. Do you?

SUMMARY

We explored who the interpersonal communicator is, what interpersonal communication is, and why it is important to be able to develop effective interpersonal contacts. We also examined the components we believe to be present during interpersonal contacts, some representative communication models we can use to help us understand how the components interrelate, and the key characteristics that interpersonal contacts share with each other. In addition, we discussed the interpersonal implications of Watzlawick's five communication axioms.

We stressed that developing interpersonal skills is a lifelong process, and we suggested strategies you can use to assess your interpersonal abilities, improve the effectiveness of your interpersonal relationships, and, in so doing, enhance the quality of your life.

SUGGESTIONS FOR FURTHER READING

Gallwey, Timothy W. *Inner Tennis*. New York: Random House, 1976. This book goes far beyond tennis; a self-mastery guide.

Holtzman, Paul D., and Donald Ecroyd. *Communication Concepts and Models*. Skokie, Ill.: National Textbook Company, 1976. This work offers an understandable and thorough treatment of communication models.

Knapp, Mark L. *Social Intercourse: From Greeting to Goodbye*. Boston: Allyn & Bacon, 1978. This book surveys interpersonal communication and offers a theoretical overview of its dimensions.

Lakein, Alan. *How to Get Control of Your Time and Your Life*. New York: New American Library, 1973. The author presents a practical discussion of how setting goals and establishing priorities can help you accomplish more and stay "on target."

Miller, Gerald, and Mark Steinberg. *Between People*. Chicago, Ill.: Science Research Associates, 1975. This book examines the forces that affect person-to-person communication.

Watzlawick, Paul H., Janet Beavin, and Don D. Jackson. *Pragmatics of Human Communication: A Study of Interactional Patterns, Pathologies and Paradoxes*. New York: Norton, 1967. This comprehensive work offers an analysis of the systemic nature of communication and the pathologies that can hamper healthy relationships.

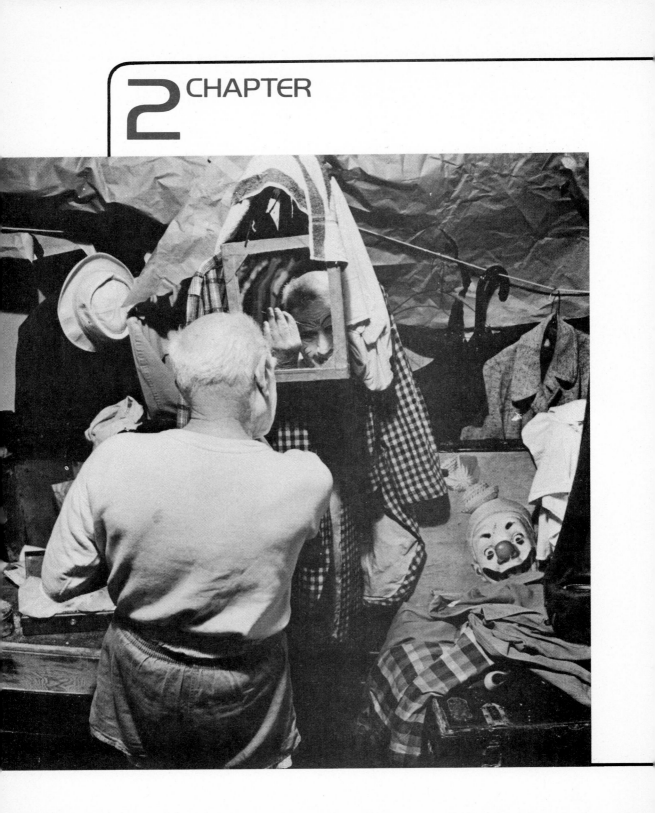

Who Are You and How Do You Know?

CHAPTER PREVIEW

After experiencing this chapter, you should be able to:

Define ''self-concept''

> Describe the part role-taking plays in the development of self-concept

> Identify dimensions of yourself that you had not recognized before

Identify how popular culture helps shape your self-concept

Define the ''self-fulfilling prophecy''

> Explain how the self-fulfilling prophecy can influence behavior

Identify factors that contribute to the development of an unrealistic self-concept

Compare and contrast your own assets and liabilities

Identify the purposes and functions of the Johari Window and self-disclosure

> Provide examples of the types of information contained in the open, blind, hidden, and unknown areas of the self

Describe how you see yourself and how you think others see you

Even the simplest clown manages by gesture and
incident to explore the mythology of the self. . . .
In him, in his ludicrous contradictions of dignity
and embarrassment, of pomp and rags,
of assurance and collapse, of sentiment and sadness,
of innocence and guile, we learn to see ourselves.

Samuel Howard Miller

The lights in a circus arena suddenly are dimmed. Accompanied by a drumroll and fanfare, an incredibly small clown car is driven into the center ring. A spotlight highlights the red, blue, green, yellow, and orange colors which decorate the tiny automobile. Cymbals crash as one car door opens and a small clown with a bright happy face tumbles out into the arena. As the elf-like figure picks himself up only to stumble again and again, the door reopens and a larger clown jumps out of the car. This clown wears a mask of anger and fury and begins to chase the vulnerable little clown around the center ring. Suddenly, a third clown timidly and nervously crawls out of the car. Following this clown is a large, rotund, smiling clown who rolls about the ring like a Slinky. The clowns continue their antics in this manner until approximately fifteen to twenty different clowns have emerged from the single car. Each clown has a distinctive face or mask, which depicts his or her particular attitude or emotion: one looks perpetually happy; another looks perpetually sad; one looks chronically silly; another looks chronically angry; one looks very jealous; another appears to be in love; one has eyes that dance; another has a nose that walks on the floor. Finally, the empty clown car backfires a few times and begins to chase the clowns out of the arena as the crowd cheers and roars with laughter.

THE CLOWN

Teri Kwal Gamble

The rubber man in the spotlight
Propels himself
Beyond the reach
Of reality.
Midway between today and tomorrow
He pauses
Suspended in his reverie by the crowd.

The rubber man in the spotlight
Warmed by laughter
Finds a face
To play to.
Dancing upon an ever-turning spindle
He plays to another
And another and another.

The rubber man in the spotlight
Sweeps up the dreams
That remind him
Of yesterday.
Then tumbling out of the ring
His face frozen in a rainbow smile
He wonders who he is.

MEET YOUR SELF-CONCEPT: A DEFINITION

Each spectator in the arena sees what he or she would call a clown, but how many clowns does the spectator see? In other words, how many faces or masks are associated with the word *clown*? One? Two? Ten? An infinite number? Student clowns at the Ringling Brothers Clown College in Florida pride themselves on their ability to create original clown masks. The number of clown faces that can be designed is infinite. Just as each person who creates a face is different, so each clown mask created is different. Thus, the question we must consider is, which face really represents the concept of "clown"? The answer must be that *all* of the faces are representations of the word *clown,* for each expresses a different facet or view of what a clown is.

Let us consider one other aspect of the clown before we move on. Who are these people who live behind clown masks or faces? What type of people are they? Do they usually appear with white face, a huge red mouth, and red frizzy hair? Do they always wear clown clothes? Are they ever clowns for twenty-four hours a day? The men and women who act as clowns assume their parts for a certain amount of time each day while the circus gives a performance. Rarely if ever do these people pile fifteen to twenty deep in a tiny car to journey down the street to shop for groceries or attend the movies! A person who performs as a clown takes on that role and behaves in a specified, planned, and rehearsed manner only while the circus performance is in progress. Those of us in the audience recognize that a *role* is being played by each clown-person—that this is not the real person.

Do you ever wear a special face or mask in your own life? We are sure that you do not normally walk around wearing a clown face any more than the circus performers do; yet, you may find that you wear a variety of faces or masks throughout the course of a single day. For example, does your face look the same when you are happy as when you are sad? How do you know? How does your face look when you are really furious? Let's see. Try this now.

FACIAL MASKS

Put on the biggest smile you can muster. Really attempt to smile from ear-to-ear. Next, find a partner and exchange smiles with that person. Then, put on a very *sad* face. Again, share it with your partner or others around you. To what extent did your faces change as your mood changed? Repeat the process by donning an angry face, a sympathetic face, a pouting face, a jealous face, and a proud face.

Actually, we wear many different masks throughout our lives. We wear happy and sad masks, glad and mad masks, bored and excited masks, sorry and thrilled masks. Besides wearing masks that display our innumerable feelings, we also wear masks that are associated with the roles we play—student, brother, spouse, sister, boss, whatever. We wear so many faces that the question ultimately becomes, "Who are we really?" No matter your age or position, it is important that you spend some time considering who you are and what you are going to do with the rest of your life. Louis MacNeice did this in "Prayer Before Birth."

We all wear a variety of masks.

Analyze what you have gained from participating in this experience by responding to the following questions: How do you feel as you change expressions? Do you use some of these same masks or expressions in a less exaggerated form in your daily life? When? Why? What if you were not free to change faces? What if your face were stuck portraying a single mood or emotion? How do you think that would affect your ability to communicate or relate to others at work? In class? At a party? Would others view you as a clown? Why?

PRAYER BEFORE BIRTH

Louis MacNeice

I am not yet born: O hear me.
 Let not the bloodsucking bat or the rat or the stoat
 or the club-footed ghoul come near me.

I am not yet born, console me.
I fear that the human race may with tall walls wall me,
 with strong drugs dope me, with wise lies lure me,
 on black racks rack me, in blood-baths roll me.

I am not yet born; provide me
With water to dandle me, grass to grow for me, trees
 to talk to me, sky to sing to me, birds and a white
 light in the back of my mind to guide me.

I am not yet born; forgive me
For the sins that in me the world shall commit, my
 words when they speak me, my thoughts when
 they think me, my treason engendered by traitors
 beyond me, my life when they murder by
 means of my hands, my death when they
 live me.

I am not yet born; rehearse me
In the parts I must play and the cues I must take when
 old men lecture me, bureaucrats hector me,
 mountains frown at me, lovers laugh at me,
 the white waves call me to folly and the
 desert calls me to doom and the
 beggar refuses my gift and my
 children curse me.

I am not yet born; O hear me,
Let not the man who is beast or who thinks he is God
 come near me.

I am not yet born; O fill me
With strength against those who would freeze my
 humanity, would dragoon me into a lethal
 automaton, would make me a cog in a machine,
 a thing with one face, a thing, and against
 all those who would dissipate my entirety,
 would blow me like thistledown hither
 and thither or hither and thither
 like water held in the
 hands would spill me.

Let them not make me a stone and let them not
spill me. Otherwise kill me.

It is important that you use each available opportunity to find out about yourself. In this chapter you will be given the chance to explore some aspects of who you are. How you will answer this question is extremely significant since who you think you are determines to a large extent what you choose to do, how you choose to act, who you choose to

Circumstances affect our concept of who we are. A wheelchair may come to feel like an extension of our bodies.
(© Michael Weisbrot & Family)

communicate with, even whether you choose to communicate at all. One might say that you are the center of your communication system. But who are you, anyway? Jolene Tennis, a muscular dystrophy victim, described her unique sense of self.

My wheelchair is my life. My wheelchair is my legs, and it gets me wherever I want to go. I have climbed Mt. Ranier, and I have gone across swinging foot bridges, and I have crossed streams. My wheelchair to me is me. It is part of me. I can tell when somebody touches it with two fingers because it is part of my skin. I know I live in an able-bodied world, but I don't think of myself as disabled. I've never been any other way than the way I am now. I've always been in a wheelchair, and that's normal. When David and I decided to get married, I'm not even sure David realized people in wheelchairs got married. I showed David that there were a lot of things to do other than physical things, and that you could have fun. Freedom is being able to do what you have to do when you have to do it. I moved away from home when I was two months short of eighteen. I couldn't live at home any more. I wasn't being allowed to change there, I guess. Being alive is changing. Being able to change. That's what being alive is to me.

I love the sound of water. I can move freely when I am in the water. I can move my body from one place to another and I don't have anything doing it for me. Not anybody or any wheelchair. I don't think about the passage of time any more. I'm happy now.

From a videotaped speech by Jolene Tennis, aired on the 1980 Muscular Dystrophy Telethon.

If someone were to ask you the question "Who are you?" ten separate times, and each time you had to supply a different answer, what types of responses do you think you would offer? The next skill builder lets you find out.

SKILL BUILDER

THE "I AM" GAME

Find a partner. Ask that person the question and only the question: "Who are you?" As he or she answers, jot down his or her response on a sheet of paper. Repeat this process ten times, noting your partner's answers as you go. After you receive ten *different* answers, switch roles and have your partner ask you the same question, "Who are you?" ten times. What answers did you and your partner give? How did your responses compare with the responses of others in your class?

Your instructor may wish to place some of your responses on the chalkboard. What do you discover from them? What do your answers tell you about your self-concept? To what extent can your responses be grouped into categories? For example, did you see yourself in reference to your feelings (happy, upset)? Your attitudes (optimistic, insecure)? Your physical attributes (tall, short)? Your intellectual attributes (capable, slow)? Your occupation (student, salesperson)? Or your role relationships with others (brother, father, sister, mother, son, boss, employee)? Chances are your responses fall into these groupings. Your self-concept consists of everything you think and feel about yourself. It is the entire collection of attitudes and beliefs you hold about yourself. In effect, it is your own theory about what you are like. This theory or picture you have of yourself is fairly stable and difficult to change. For example, have you ever tried to alter your parents' or your friends' opinions about themselves? Did you have much luck? Our opinions about ourselves grow more and more resistant to change as we grow older and "wiser."

Where did your self-concept come from? To a large extent it is shaped by your environment and those around you, including your parents, your relatives, your teachers, your supervisors, your friends, and your coworkers. If people who are important to you have sent you messages that have made you feel accepted, valued, worthwhile, lovable, and significant you have probably developed a positive self-concept. On the other hand, if people who are important to you have sent you messages that have made you feel left-out, small, worthless, unlovable, or insignificant, you have probably developed a negative self-concept. It is not difficult to see how people we value influence the picture we have of ourselves and help determine the way we behave. The nineteenth-century poet Walt Whitman and the contemporary songwriters Harry and Sandy Chapin both recognized this.

THERE WAS A CHILD WENT FORTH

Walt Whitman

There was a child went forth every day,
And the first object he look'd upon, that object he became,
And that object became part of him for the day or a certain part of the
 day,
Or for many years or stretching cycles of years.

. . . .

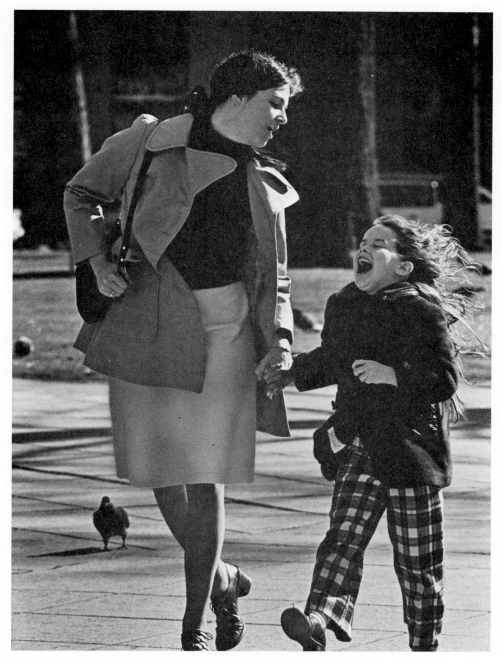

We develop a self-concept by interacting with those around us. If others send us the message that we are valuable, we come to value ourselves.
(© Sylvia Johnson/Woodfin Camp & Assoc.)

His own parents, he that had father'd him and she that had conceiv'd him in
her womb and birth'd him,
They gave this child more of themselves than that,
They gave him afterward every day, they became part of him.

The mother at home quietly placing the dishes on the suppertable,
The mother with mild words, clean her cap and gown, a wholesome odor
falling off her person and clothes as she walks by,
The father, strong, self-sufficient, manly, mean, anger'd, unjust,
The blow, the quick loud word, the tight bargain, the crafty lure,
The family usages, the language, the company, the furniture, the yearning
and swelling heart,
Affection that will not be gainsay'd, the sense of what is read, the thought if
after all it should prove unreal,
The doubts of day-time and the doubts of night-time, the curious whether
and how,
Whether that which appears so is so, or is it all flashes and specks?
Men and women crowding fast in the streets, if they are not flashes and
specks what are they?

The streets themselves and the facades of houses, and goods in the
windows,
Vehicles, teams, the heavy-plank'd wharves, the huge crossing at the ferries,
The village on the highland seen from afar at sunset, the river between,
Shadows, aureola and mist, the light falling on roofs and gables of white or
brown two miles off,
The schooner near by sleepily dropping down the tide, the little boat slack-
tow'd astern,
The hurrying tumbling waves, quick-broken crests, slapping,
The strata of color'd clouds, the long bar or maroon-tint away solitary by
itself, the spread of purity it lies motionless in,
The horizon's edge, the flying sea-crow, the fragrance of salt marsh and
shore mud,
These became part of that child who went forth every day, and who now
goes, and will always go forth every day.

CAT'S IN THE CRADLE

Harry Chapin and Sandy Chapin

My child arrived just the other day.
He came to the world in the usual way.
But there were planes to catch, and bills to pay;
He learned to walk while I was away.
And he was talkin' 'fore I knew it, and as he grew, he'd say,
I'm gonna be like you, Dad. You know I'm gonna be like you.

And the cat's in the cradle and the silver spoon.
Little boy blue and the man in the moon.
When you comin' home, Dad? I don't know when,
But we'll get together then;
You know we'll have a good time then.

My son turned ten just the other day.
He said, "Thanks for the ball, Dad.
Come on, let's play.
Can you teach me to throw?"
I said, "Not today. I got a lot to do."
He said, "That's ok," and he walked away,
But his smile never dimmed and said,
"I'm gonna be like him, yeah,
You know I'm gonna be like him."

Well, he came from college just the other day,
So much like a man, I just had to say,
"Son, I'm proud of you. Can you sit for a while?"
He shook his head, and he said with a smile,
"What I'd really like Dad is to borrow the car keys.
See you later. Can I have them, please?"

I've long since retired. My son's moved away.
I called him up just the other day.
I said, "I'd like to see you if you don't mind."
He said, "I'd love to Dad, if I can find the time.
You see my new job's a hassle, and the kids have the flu,
But it's sure nice talking to you, Dad.
It's sure nice talking to you."
And as I hung up the phone, it occurred to me,
He'd grown up just like me.
My son was just like me.

Self-concept is the mental picture you have of yourself. This mental image is easily translated into the faces you wear, the roles you play, and the ways you behave. In order to solidify your understanding of this, examine the pictures on page 44. The pictures demonstrate the ways in which one man changes as either the roles he is expected to perform change or the roles he perceives himself performing change.

The top panel of the picture presents us with an image of a cockroach; our man developed this image of himself because he felt that he was performing a dull job in an impersonal work environment. However, when invited to attend a conference, he alters this perception, changes his demeanor, and adopts an executive appearance. In the middle panel, we see how our man viewed his colleagues who attended the conference: One is seen as close-mouthed like a clam, another ill-tempered like a ram, another loyal like a

Adapted from *Psychology Today,* August 1972, p. 5

dog, another dangerous as a wolf, another unforgetful like an elephant, another whining like a horse, and another proud like a peacock.

Finally, in the bottom panel, we see what happens to our man once the meeting is over: He retreats into "roachhood." However, he does reemerge at lunch to play the knight in shining armor for his secretary. When lunch is finished, he goes back to what he perceives as mindless busywork. To put it politely, he views himself as a donkey. Yet, our man has not completely submerged his "better" self. When he is called on to make a decision, he once again changes his self-image and this time pictures himself as a captain of industry.

We can conclude that the nature of the self at any given moment is a composite of

all the factors that interact with each other in a particular environment. How you look at yourself is affected by how you look at people, how people look at you, and how you imagine or perceive that people look at you. In effect, you might say that self-concept is derived from experience and projected into future behavior. Further your understanding of your self-concept by participating in this next experience:

SKILL BUILDER

A DAY IN THE LIFE OF

(Your Name)

1. On a sheet of paper list the names of all the people with whom you interacted on a particular day this week. For each, identify the environment in which you communicated.

2. Next, choose an animal, object, or color to represent your image of you during each interaction; also select an animal, object, or color to represent your image of the individual with whom you spoke.

3. Finally, graph your perceptions on the chart below by entering each of your responses in an appropriate box.

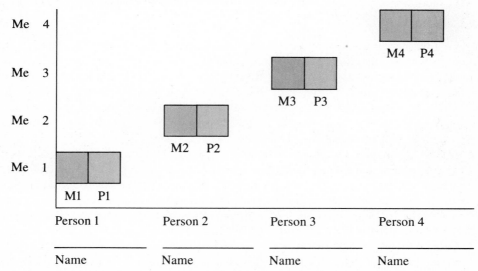

4. Demonstrate your understanding by responding to these questions: What does your chart tell you about the nature of your self-image? To what extent does your view of yourself change as you move from person to person? What factors can you point to in yourself, the individual with whom you were interacting, or the environment that can help account for the changes?

THE ROLES WE PLAY

William James

A man has as many social selves as there are individuals who recognize him and carry an image of him in their mind. . . . But as the individuals who carry the images form naturally into classes, we may practically say that he has as many different social selves as there are distinct *groups* of persons about whose opinions he cares. He generally shows a different side of himself to each of these different groups. Many a youth who is demure enough before his parents and teachers swears and swaggers like a pirate among his "tough" young friends. We do not show ourselves to our children as to our club companions, to our masters and employers as to our intimate friends. From this there results what practically is a division of the man into several selves; and this may be a discordant splitting, as where one is afraid to let one set of his acquaintances know him as he is elsewhere; or it may be a perfectly harmonious division of labor, as where one tender to his children is stern to the soldiers or prisoners under his command.

The Principles of Psychology, 1890

ROLE-TAKING AND SELF-EXPLORATION: CATEGORIZING THE SELF

We vary the masks we wear or the roles we perform a number of times each day. The language we use, the attitudes we display, and the appearance we present constantly change. For example, would you play basketball in the same clothes that you wear to attend a wedding? Do you sleep in the same clothes that you wear to school? Probably not! We alter our dress and appearance according to the role we are playing at a particular moment. Many schools have dress codes for students. In those schools, dress is viewed as an integral part of the role associated with being a student. Likewise, a certain style of dress is often required if one wants to work in a particular business or profession. Just as hamburger chains have employees don carefully designed "costumes" or uniforms, many business executives are expected to wear traditional clothes to work daily; this constitutes their uniform. We might even note that you must adhere to certain dress codes if you choose to frequent certain fancy restaurants. Thus, we dress according to the specifications of the role we are playing. "What am I going to wear?" is a familiar cry in households around the world!

We are different selves as we move from one set of conditions to another. The more we attempt to be ourselves, the more selves we find there are to be. We should recognize that conditions and circumstances affect the nature of the self. In every situation, how we see ourselves and how we think about ourselves in relation to others directs and modifies our behavior. Our self-concept and demeanor are affected by our perceptions of other people and how we think they will respond to us. In part, the roles we choose

SKILL BUILDER

DO CLOTHES MAKE THE PERSON?

Bring two or three old worn hats to class. Toss the hats into a box with those of your classmates. Randomly draw a hat from the box and try it on. If possible, compare how you look and feel in a number of different hats. Ask yourself what kind of person would wear the hat. How would he or she stand or walk? What would be his or her occupation? Name? After considering these questions carefully, introduce your "hat character" to the class. For example, you might say, "Hi! I'm Juniper! I work at the local Chicken and Burger Joint." After your classmates have completed their introductions, draw another hat and repeat the process. How does your second role differ from the first?

Most people find that wearing a different hat causes them to feel or act differently. So do wearing different clothes, visiting different places, and mingling with different people. When you put on a certain outfit, arrange your hair in a certain way, or don a certain piece of jewelry, you are telling others something about who you are, who you would like to be, and how you would like to be treated.

If desired, you can further your understanding of how clothes affect your perception of others by trying this as a class: While wearing hats from the preceding experience, form two lines that face each other. Your instructor will assign each of you in line A a number and each in line B a letter. In turn he or she will call out a letter and a number. The selected individuals, behaving in keeping with the personality suggested by their hats, will move from their place in line to the center of the room, where they will meet and talk to each other. After a brief encounter they will return to their respective places in character. To what extent did you treat people wearing different hats differently? What prompted this? Continue until everyone who wishes to perform has had the opportunity.

to play are a result of the values held by members of our society. To see how this works, try the exercise above.

Were there any hats that you would be unwilling to wear on the street? Why? Were there any hats that you felt your fellow class members should not wear? Why?

The exercise in which you have just participated should increase your self-understanding. Clues to self-understanding come to you continually as you interact with others and your environment. If you are to understand yourself well, you need to be open to information that other people give you about yourself. Just as we tend to categorize ourselves, so others also tend to categorize us. For good or bad, the categorization process is a basic part of interpersonal communication. We all do it and have it done to us. We classify people according to their roles, their status, their personality traits, their physical and vocal qualities, and their skills and accomplishments. Which of these categories is

Dress signifies role: in some schools, students are expected to look the part.
(© *Thomas Hopker 1980/Woodfin Camp & Assoc.*)

most important to you? Which do you think is most important to others who are significant in your life? How do others help shape your image of yourself? How do they serve to enhance or belittle your own sense of self?

POPULAR CULTURE AND YOU: THROUGH THE ELECTRONIC LOOKING GLASS

Thus far we have established that your self-image is composed of information and feelings drawn from experience and from your interactions with others. There are at least two

other sources that affect your opinion of who you are—television and film. We are influenced by television and film characters and television and film life styles to a greater extent than we probably realize. Subtly but effectively, television and film shape our views of ourselves and our relationship to our world. Let us consider how these media affect the picture you have of yourself.

SKILL BUILDER

MEDIA CONCEPTS

If you could trade places with any television or film star or character, who would it be and why? Frequently, we respond to media images that fill a need for us. What does the television or film character or star you selected do for you? To begin to find out, fill out the questionnaires on page 50. Each questionnaire asks you to enter a self-description or an "other" description in an appropriate space. You are then asked to rate how much you like perceived aspects of yourself as compared to how much you like perceived aspects of your selected character. Finally, you are asked to indicate how you would like to change each listed aspect of yourself and each listed aspect of your chosen character if you could.

Do you have a more positive image of yourself or of your chosen character? Why? Do you find that you would like to be more like the television or film image or that you would like the television or film image to be more like you?

CHARTING MYSELF (EXAMPLE)

Self-aspect	Description of self-aspect	Indicate on a scale of 1 to 5 how much you like each aspect	Indicate any desired changes in this aspect
Chin	pointed, jutting	1 2 3 ④ 5	I would like to make it rounder
Skin	freckled	① 2 3 4 5	I wouldn't change the freckles for anything

Instructions for Completing Scale

1	2	3	4	5
Love it	Like it	Neutral	Dislike it	Hate it

SKILL BUILDER CONTINUED ON THE FOLLOWING PAGE

CHARTING MYSELF

NAME: _____

Self-aspect	Description of self-aspect	Indicate on a scale of 1 to 5 how much you like each aspect	Indicate any desired change in this aspect
Mouth		1 2 3 4 5	
Chin		1 2 3 4 5	
Mode of dress		1 2 3 4 5	
Physique/figure		1 2 3 4 5	
Height		1 2 3 4 5	
Posture		1 2 3 4 5	
Walk		1 2 3 4 5	
Attitude toward sex		1 2 3 4 5	
Attitude toward money		1 2 3 4 5	
Attitude toward work		1 2 3 4 5	

CHARTING MY STAR/CHARACTER

CHARACTER'S NAME: _____

Self-aspect	Description of self-aspect	Indicate on a scale of 1 to 5 how much you like each aspect	Indicate any desired change in this aspect
Mouth		1 2 3 4 5	
Chin		1 2 3 4 5	
Mode of dress		1 2 3 4 5	
Physique/figure		1 2 3 4 5	
Height		1 2 3 4 5	
Posture		1 2 3 4 5	
Walk		1 2 3 4 5	
Attitude toward sex		1 2 3 4 5	
Attitude toward money		1 2 3 4 5	
Attitude toward work		1 2 3 4 5	

The images we meet on television or on film can affect the image we have of ourselves. Through the media we come face-to-face with standards of living few of us can emulate or expect to achieve. Thus, our evaluations of ourselves as providers—or even whether we view ourselves as successful—can be seriously colored by what we see in the media. For example, how does television affect the ways in which parents and children perceive themselves and each other? After all, both parents and children are exposed to a steady diet of media counterparts who are either so perfect that even their mistakes become the raw material of a closer relationship or so absurd that they can be the subject only of comedy. When we were younger, it was easy and fun to try on television and film images. For example, we could put on a cape or mask and become Batman, Wonderwoman, Spiderman, Flash Gordon, Superman, or the Bionic Woman. As we mature, however,

Television and film influence both our self-image and our view of the world. From childhood on, we may seek to be like our video heroes. (© *Stephen Shames 1980/Woodfin Camp & Assoc.*)

the emulation process becomes a bit more subtle. Today, we attempt to become like popular idols or heroes by imitating the fashion trends they set, by adopting phrases they speak, and by copying their ways of moving. Thus, we communicate part of the picture we have of ourselves through the ways we dress, move, speak, and arrange ourselves. When you put on a certain outfit, comb your hair in a new style, walk or speak in a particular way, or choose to wear a certain artifact, you are telling other people something about who you think you are, who you would like to resemble, and how you would like to be treated.

Programs and films offered by the media can also support us or deflate us. They can cause us to feel good, adequate, or even inferior.

THE SELF-FULFILLING PROPHECY: MEETING POSITIVE AND NEGATIVE PYGMALIONS

Take some time to consider the following excerpt from *The People Yes* by Carl Sandburg.

> Drove up a newcomer in a covered wagon. "What kind of folks live around here?" "Well, stranger, what kind of folks was there in the country you come from?" "Well, they was mostly a lowdown, lying, gossiping, backbiting lot of people." "Well, I guess, stranger, that's about the kind of folks you'll find around here." And the dusty grey stranger had just about blended into the dusty grey cottonwoods in a clump on the horizon when another newcomer drove up. "What kind of folks live around here?" "Well, stranger, what kind of folks was there in the country you come from?" "Well, they was mostly a decent, hardworking, law abiding, friendly lot of people." "Well, I guess stranger, that's about the kind of people you'll find around here." And the second wagon moved off and blended with the dusty grey . . .

The speaker in the preceding passage understands the significance of a concept called the self-fulfilling prophecy. The self-concept is such a powerful force that it not only affects how you view yourself today, but it also affects how you will view yourself tomorrow. A self-fulfilling prophecy occurs when your expectations of an event help create the conditions that will permit the event to happen. In other words, your predictions can cause you or others to behave in ways that make your conceptions—true or false—come true. Your thinking and your believing act to increase the likelihood of an unlikely occurrence. For example, have you ever had to take a class that other students told you would be dull and uninteresting? Was it? Why? You probably acted in a way that caused their predictions to come true.

Perhaps the most widely known example of the self-fulfilling prophecy is the Pygmalion effect. The term comes to us from a Greek myth in which Pygmalion, a sculptor, falls in love with a beautiful ivory statue of his own creation. The goddess Aphrodite, moved by Pygmalion's belief in and worship of the statue, comes to his rescue and brings it to

life. George Bernard Shaw adapted the story to a more modern setting. Shaw's rendition, in turn, served as the basis for the stage and film musical we know as *My Fair Lady*. In this version, Henry Higgins (Pygmalion) transforms a flower girl, Liza Doolittle, into a duchess. The play illustrates the principle that we live up to labels. We and Liza act like the sort of person others perceive us to be. Liza Doolittle understood this when she noted:

> . . . you see, really and truly, apart from the things anyone can pick up (the dressing and the proper way of speaking, and so on), the difference between a lady and a flower girl is not how she behaves, but how she's treated. I shall always be a flower girl to Professor Higgins because he always treats me as a flower girl, and always will; but I know I can be a lady to you, because you always treat me as a lady, and always will.

Robert Rosenthal also emphasized this precept in his book *Pygmalion in the Classroom*. In this resource, Rosenthal describes a rather fascinating and intriguing educational study. He tells us that a number of teachers were notified that certain of their students were expected to "bloom," or do exceptionally well, during the course of the school year. There was no real basis for this determination, however; the experimenters had simply selected the names of the "late bloomers" at random. Do you believe the selected students bloomed? Why? If you said yes, you are quite right. Those students whose names were given to teachers did perform at a higher level than would otherwise have been expected and did improve their IQ scores. The expectations of the instructors apparently influenced the way they treated the late bloomers. Instructors gave these students extra positive verbal and nonverbal reinforcement, waited patiently for them to respond if they hesitated, and did not react negatively when they offered a faulty answer. It seems that the way the instructors treated the students had a marked impact on the way the students perceived themselves and their own abilities. Late bloomers were simply responding to the prophecy that had been made about them—they fulfilled it.

It should be recognized that the self-fulfilling prophecy has many important implications for one's education as well as one's personal life. Have you ever joined a group of people that you were convinced would not like you? What happened? Undoubtedly, you were probably proven right. What you probably did was to act in a way that encouraged them to dislike you. Far too frequently, we make assumptions about how others will behave and then act as if they had already behaved that way. For example, if you view yourself as a failure in school or in a particular subject, it is likely you will begin to act the part. Poor study habits, lack of participation in class, and poor grades will help you reinforce your feelings. This growing negative image can mushroom into a vicious, all-consuming spiral. What happens, simply, is that you or others predict something will occur, and then you or they create the behavior that precipitates it. Thus, a self-fulfilling prophecy can result because your own expectations influence your behavior or because another person's expectations affect another's behavior.

Here again, the media may affect the self-fulfilling prophecies we create. For instance, it has been noted that women are underrepresented in television programming. In fact, some researchers assert that television offers us pictures of two men for every woman. As Gaye Tuckman notes in *Hearth and Home,* television seems to be telling us that

women do not count for much in our society. This message is underlined by the ways in which women who do appear are shown. If a show mentions that a character has a job, that character is probably a male. On the other hand, if a woman is permitted to have an occupation, she is frequently depicted as beneath her male counterparts. Characteristic of this mentality was the fact that on "The Mary Tyler Moore Show," Mary Richards was the only worker to refer to her boss as "Mr. Grant"; her male colleagues simply called him "Lou." A researcher by the name of Ann Beuf reports an even more revealing observation: When asked what he would want to be when he grew up if he were a girl, a young boy said, "Oh, if I were a girl, I'd have to grow up to be nothing." Do you think it is possible that by portraying men and women fulfilling particular types of roles, television will influence the choice of roles that men and women will seek to fulfill?

Now we better understand why the way we and others answer the question "Who are you?" has significance for how we behave.

THE SELF-CONCEPT IS NOT THE SELF: DEVELOPING SELF-AWARENESS

The self-concept represents who you think you are, not necessarily who you really are. You are not usually very objective about your self-concept. Sometimes your image of yourself is more favorable than the image others have of you. You might view yourself as an extremely talented writer, but others might view you as a "hack." There are many reasons why we are able to maintain a picture of ourselves that others regard as unrealistic or ridiculous. For instance, we might be so worried about our presentation of self that we fail to pay attention to feedback from others about how they see us. Or, others might send us distorted information in an attempt not to hurt our feelings. Or, we might be basing our view of ourselves on outdated, obsolete information that allows us to cling to the memories of the past rather than face the realities of the present.

Just as there are times when we view ourselves more favorably than we should, so there are times when we view ourselves more harshly than we should. For example, a person might be convinced of her "ugliness" despite the insistence of others that she is attractive. Again, this woman might be acting on the basis of obsolete data: Perhaps as a young child she was gawky or fat; even though she is now graceful and slender, events of the past might still pursue her.

Distorted feedback can also help to nourish such a negative self-image. The individual who is strongly influenced by an overly critical parent, friend, or adult can be led to develop a view of himself or herself that is far harsher than the view others hold. Another reason people often cheat themselves of a favorable self-concept is related to the social customs of our society. It is far more acceptable for individuals to downplay, underrate, and criticize themselves than it is for them to praise and boast about or openly display their self-appreciation. To put it simply, far too many people are taught that SPS—self-praise stinks.

Walt Whitman in his poem "Song of Myself" writes, "I celebrate myself and sing myself." To what extent are you able to celebrate yourself? In other words, do you

The image we have of ourselves is only an image. It may be
extremely unrealistic, as when we are overly concerned with our
appearance; we are seldom as unattractive to others as we are to our
critical selves.
(© Menschenfreund)

possess a predominantly positive or negative self-concept? The practice of honestly reviewing your own strong and weak points can help to shape your image of yourself. Take some time now to inventory what you perceive to be your own assets and liabilities.

JOINING TOGETHER: THE JOHARI WINDOW AND SELF-DISCLOSURE

We need to realize that self-understanding is the basis for our self-concept. To understand ourselves, we must understand our own way of looking at the world. To understand others, we must understand how they look at the world. Consider this:

LOCKED IN

Ingemar Gustafson

All my life I lived in a cocoanut.
It was cramped and dark.
Especially in the morning when I had to shave.
But what pained me most was that I had no way
to get into touch with the outside world.
If no one out there happened to find the cocoanut,
if no one cracked it, then I was doomed
to live all my life in the nut, and maybe even die there.
I died in the cocoanut.
A couple of years later they found the cocoanut,
cracked it, and found me shrunk and crumbled inside.
"What an accident!"
"If only we had found it earlier . . ."
"Then maybe we could have saved him."
"Maybe there are more of them locked in like that . . ."
"Whom we might be able to save,"
they said, and started knocking to pieces every cocoanut
within reach.
No use! Meaningless! A waste of time!
A person who chooses to live in a cocoanut!
Such a nut is one in a million!
But I have a brother-in-law who
lives in an
acorn.

The following experience can help you improve your ability to understand your self and to understand others.

SKILL BUILDER

YESTERDAY, TODAY, AND TOMORROW

1. Your instructor will divide you into dyads or small groups.

2. Each group can use the following incomplete sentences as conversation starters. During the first round you should use the sentence starter to reveal how you would have responded to the probes as a very young child (between five and eight years old). During the second round you should indicate how you would have responded to the conversation starters during your older childhood and adolescent years. Finally, during the third round, you should disclose how you would respond to the statements today.

 a. Other people want me to . . .
 b. The best way to measure personal success is . . .
 c. When I do what I really want to do, I . . .
 d. I get frustrated when . . .
 e. I want to be a . . .
 f. I have fun when . . .
 g. Marriage for me is . . .
 h. People who are ''in charge'' should be . . .
 i. I miss . . .
 j. What I really like about myself is . . .
 k. When I am with people who do a lot of talking, I . . .
 l. Sometimes I feel like . . .
 m. A decade from now, I . . .

3. Attempt to demonstrate your ability to process the experience by answering the following questions: What do the responses tell you about yourself and your peers during these three life stages? Were there discernible consistencies? Were there changes? Why?

Psychiatrist Eric Berne's concept of the ''unconscious life plan'' may have been reflected in a number of your answers. Sometimes we pattern our transactions in such a way that we repeatedly reenact a similar script with a different set of players. In other words, it is not uncommon for us to attempt to ''stage'' a drama with casts of characters who come from different points in our life cycle. This repetition urge could become a problem for you if it is leading you to fail rather than to succeed. Take some time and ask yourself the extent to which your response-groups demonstrated flexibility rather than rigidity. Attempt to determine the degree to which you have been successful at eliminating or extinguishing behaviors you did not like. In addition, try to resolve what each of your responses says about your past, present, and future needs.

At one time or another we all wish we knew ourselves or others better. The concept of self-awareness, so basic to all functions and forms of communication, may also be explored through the Johari Window. Joseph Luft and Harrington Ingham used an illustration of a paned window as a device to help us examine both how we view ourselves and how others view us. Before proceeding further take a few moments to examine the Johari Window, which is shown below.

THE JOHARI WINDOW

	Known to Self	Not Known to Self
Known to Other	I Open Area	II Blind Area
Not Known to Other	III Hidden Area	IV Unknown Area

Quadrant I represents information about yourself that is known to you and another. At times, your name, age, religious affiliation, and food preferences might be found in this pane. The size and contents of the area vary, however, from relationship to relationship. For example, do you allow some people to know more about you than others? Why? The size of the open area is affected by and related to the degree of closeness you share with another individual.

Quadrant II, the blind area, contains information about yourself that you are not aware of but that others are. Some people have a very large blind area and are oblivious to either the faults or virtues they possess. At times, an individual may feel compelled to seek outside help or therapy to reduce the size of his or her blind pane. Do you know something about a friend that he or she does not know? Do you feel free to reveal this information to him or her? Why? What effect do you think your revelation would have on your friend's self-image?

Quadrant III represents your hidden area. It contains information you know about yourself but do not wish others to find out for fear they will reject you. John Powell, author of *Why Am I Afraid to Tell You Who I Am?* puts it this way: "If I tell you who I am, you may not like who I am, and it is all that I have." Can you identify some of the things you are hesitant to let others know about yourself? Why are these aspects of you easier to hold back than express? Or are they? Sometimes it takes a great deal of effort to avoid becoming known.

DON'T CRY OUT LOUD

Peter Allen and Carole Bayer Sager

Baby cried the day the circus came to town,
'Cause she didn't like parades just passin' by her.
So she painted on a smile and took up with some clown,
And she danced without a net upon the wire.
I know a lot about her 'cause you see,
Baby is an awful lot like me.

We don't cry out loud, we keep it inside,
Learn how to hide our feelings.
Fly high and proud, and if you should fall,
Remember you almost had it all.

Baby saw them when they pulled the big top down,
They left behind her dreams among the litter.
And the different kind of love she thought she'd found,
Was nothing more than saw-dust and some glitter.
But baby can't be broken 'cause you see,
She has the finest teacher, me.

An' I taught her don't cry out loud,
Just keep it inside,
Learn how to hide your feelings.
Fly high and proud, and if you should fall,
Remember you almost had it all.

At one time or another we each probably feel a need to cry out loud and rid ourselves of some or all of the masks we wear. We feel a need to have individuals important to us know us well and accept us for what we are. When we move information from Quadrant III to Quadrant I we engage in this self-disclosure process. Thus, self-disclosure occurs when we purposefully reveal to another personal information that the person would not otherwise know. By self-disclosure, we show others that we trust them and we care enough about them to reveal to them personal and intimate information we would not willingly share with everyone. Often, our attempts at self-disclosure will be reciprocated. This sharing of hidden parts is essential if meaningful and lasting relationships are to develop between persons.

This is not to suggest that the hidden area should not exist. It is up to you to decide when it is appropriate for you to share your innermost thoughts, feelings, and intentions with others. It is up to you to decide when complete openness is in your best interest.

Quadrant IV is the unknown area. It contains information about which neither you nor others are aware. Eventually, education and life experience may help to bring some of the mysteries contained in this pane to the surface. Only then will its secrets be available

for examination. Has anything you have done ever surprised both you and others? Did you and a friend ever exclaim together, "Wow! I didn't know I/you could do that!"?

In any meaningful relationship, the goal is to increase the size of the open area at the same time that you decrease the size of the hidden, blind, and unknown areas. The open area becomes larger whenever information is moved from any of the remaining quadrants into it. This could happen if you disclose any of your hidden perceptions to others or if they reveal any of their hidden perceptions they have about you. We know that as human beings we are constantly thinking about others and what they think about us. The question is whether or not we are able and willing to share what we are thinking. Let's try another exercise in self–other disclosure now.

SKILL BUILDER

OBJECT TO OBJECT

This exercise calls on you to bring four objects to class. The first object should reveal something about the way you see yourself, something you believe everyone recognizes about you. In other words, it should represent an aspect of your open area. The second object should reveal something about you that up until this point you believe resided in your hidden area. The object you select could symbolize an attitude, feeling, desire, or fear that you hoped to keep from others but are now willing to move into the open quadrant. The third object you bring to class should represent how you believe another person sees you. For example, do you believe a particular friend or relative sees you in the same way you see yourself? How do you think your perceptions are similar? How are they different? Finally, after selecting these three objects, *ask* another person to choose an object that he or she believes represents his or her perception of you. Bring this object to class. Be prepared to discuss how your perceptions of yourself, your perceptions of the other person's perception of you, conflict or coincide. To what extent has each phase of the experience altered the appearance of your Johari Window?

HOW TO MAKE YOUR SELF-IMAGE WORK FOR YOU: IMPROVING AWARENESS OF SELF AND OTHERS

Throughout this chapter we have stressed that we all carry figurative "pictures" of ourselves and others with us wherever we go. Together these pictures form a mental collage. Contained within the collage are past, present, and future images of us alone or interacting with people. If you closely examine your images, you probably will be able to discern that how you look in each is related to the "time" the picture was taken, the environment that you were in, and the people you were communicating with. In spite of

the fact that each of the pictures reveals a somewhat different you, in spite of the fact that you change and grow from moment to moment, situation to situation, and year to year, you may tend to forget that your self-image also can change. Keeping "self-pictures" updated and current is, indeed, a challenge. Redefining a fuzzy image, refocusing an old image, and developing a new image are processes that can help to keep you from clinging to outmoded, worn, or inaccurate self–other perceptions. The following guidelines can be used to further improve the self–other "picture-taking" skills you have gained while working your way through this chapter.

Continue Taking Pictures

You can further your self-awareness by continuing to take the time to examine your self-image and your relationship to others. Developing a clear sense of who you are is one of the most worthwhile goals you can set for yourself. Be willing to watch yourself in action. Periodically examine your own self-perceptions and self-misconceptions. Consider how you feel about yourself, how you think you look, to what extent you approve of your values and behaviors. Study the composite picture that emerges as a result of your self-reflections. How close are you to becoming the person you would like to be? In what ways would you like to alter your various self-portraits? We hope you will take the time you need and have the courage and openmindedness required to engage in productive and worthwhile self-examinations.

Encourage Others to Take Pictures of You

As we have seen, the way others perceive you may be very different from the way you perceive yourself. Obtaining information from others can help you assess how realistic your self-concept is. Others who come to know you may observe strengths you overlook, traits you undervalue, or weaknesses you choose to ignore. Your looking at the pictures other individuals take of you does not mean you must accept all of them. No one can prevent you from adhering to your original belief and rejecting the opinions of others. Looking does mean, however, that you are at least opening yourself to the possibility of change by attempting to see yourself as others see you. Receiving messages from others can help you acquire insight into who others think you are and how they think you are coming across.

Refocus, Refocus, Refocus

Carl Sandburg wrote, "Life is like an onion; you peel off one layer at a time." Your "self" is in transition. You are in a process of moving from yesterday through today and into tomorrow. Try not to let your view of your self today prevent you from adapting to meet the demands of changing circumstances and conditions. By continually formulating new answers to the question "Who am I?" you will discover the vibrant, flexible, dynamic qualities of your self. Self-discovery is never-ending and ongoing. It is a way of reacting to life.

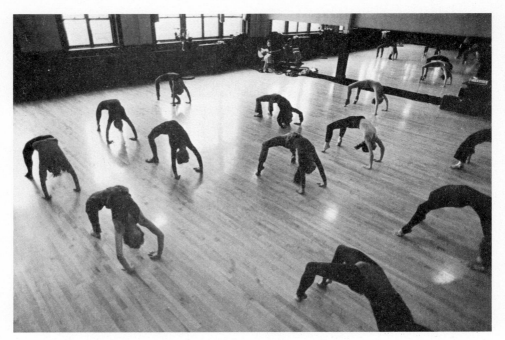

Your self is in transition, but your self-image may not change as
rapidly as you do.
(© *Jim Harrison/Stock, Boston*)

SUMMARY

In this chapter we have explored the self-image and the ways it is expressed through
behavior. We have discussed how the self-concept is formed, and we have examined the
parts that role-taking and the self-fulfilling prophecy play in its development. By partic-
ipating in a number of "self-searches" we have begun to identify those factors that can
contribute to the growth of a realistic or an unrealistic self-image. We have seen that self-
concept can change, and we have experienced ways of developing greater self-awareness
and self-understanding. Finally, we participated in a variety of self-disclosure experiences,
and we offered guidelines to facilitate the personal self-discovery process.

SUGGESTIONS FOR FURTHER READING

Branden, Nathaniel. *The Psychology of
Self-Esteem*. New York: Bantam, 1969. The
author examines our need for self-esteem and
discusses the conditions necessary for mental
well-being.

Jourard, Sidney M. *The Transparent Self*.
New York: D. Van Nostrand, 1971. An
interesting, in-depth look at the self and the
nature of the self-disclosure process.

Luft, Joseph. *Group Processes: An
Introduction to Group Dynamics*, 2nd ed. Palo
Alto, Calif.: Mayfield Publishing Company,

1970. Provides a clear, well-written explication of the Johari Window and how it can be used to analyze our relationships.

Powell, John. *Why Am I Afraid to Tell You Who I Am?* Chicago: Argus Communications, 1969. A basic introduction to the defenses people construct in an effort to avoid becoming known.

Rosenthal, Robert, and Lenore Jacobson. *Pygmalion in the Classroom.* New York: Holt, Rinehart & Winston, 1968. Reports on the role self-fulfilling prophecies play in education, research, and everyday life.

Tuchman, Gaye, Arlene Kaplan Daniels, and James Benet. *Hearth and Home: Images of Women in the Mass Media.* New York: Oxford University Press, 1978. This work contains articles that explore and describe the ways women are portrayed in the media.

Villard, Kenneth L., and Leland J. Whipple. *Beginnings in Relational Communication.* New York: Wiley, 1976. Explores the dynamic nature of human interaction.

3 CHAPTER

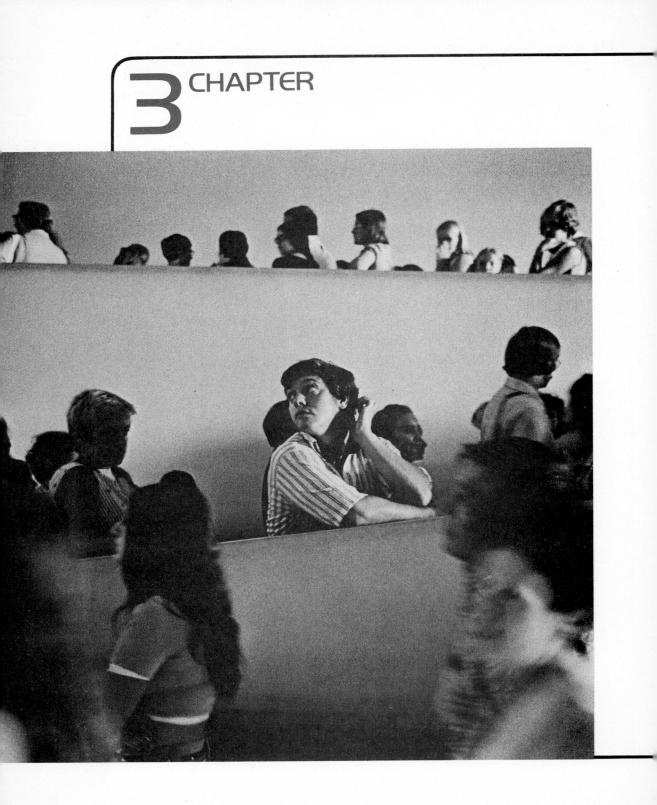

Perception: I Am More Than a Camera

CHAPTER PREVIEW

After experiencing this chapter, you should be able to:

Explain why a person is "more than a camera"

 Demonstrate how an individual's angle of vision, or perspective, affects perception

 Identify how we limit what we perceive

 Demonstrate how an individual's sensory capabilities affect perception

Define "perception"

Explain the figure–ground principle

Describe the ways in which past experience can influence perception

Distinguish between an open orientation and a closed orientation

Compare and contrast "selective exposure" and "selective perception"

Define "closure"

Explain how first impressions affect perception

Define "stereotyping"

 Explain how the media help perpetuate stereotypes

 Identify common stereotypes you and others hold

Define and provide examples of "allness"

Explain what is meant by "blindering"

Distinguish between "facts" and "inferences"

Identify ways to increase the accuracy of your perceptions

So much
There is
To perceive.

Anonymous

If, to people, crickets appear
to hear with their legs, it is
possible that to crickets, people
appear to walk on their ears.

Anonymous

Picture this. The setting: a football stadium. The time: the last moments of a nationally televised football game. The score: tied. The situation: one team has possession of the ball and is only five yards from the opposing team's goal line. The play: the quarterback hands the ball to a member of the backfield who races around the right end. He is tackled just as he reaches the goal line. Did he score? The official rules that the ball carrier was stopped short of the goal line. The team's fans are furious. From the stands it looked as if their player had scored. The national television audience is confused. The play, as televised, showed the player crossing the goal line successfully. However, an "instant replay" that shows the play from another angle proves the player was stopped short of the goal line. The official ruling was correct. The television camera reveals that the player had indeed failed to score.

Why is it that when we look at the same event, we do not all see the same thing? Why was the instant replay camera able to "perceive" the correct outcome while millions of people erred in their original judgment? Do we see things as they are? Do we see things as we want them to be? Or, do we see things as we are? How do our sensory capabilities affect perception? How do our experiences affect perception? In this chapter, we will attempt to answer these questions as we explore how we perceive the world around us and why we are, in effect, "more than a camera."

WHAT IS PERCEPTION? THE "I" AND THE "EYES"

In many ways, we each live in or inhabit different worlds. We each view reality from a different angle, perspective, or vantage point. Our physical location, our interests, our personal desires, our attitudes, our values, our personal experiences, our bodily conditions, and our psychological states interact to influence our judgments or perceptions. Let's examine how.

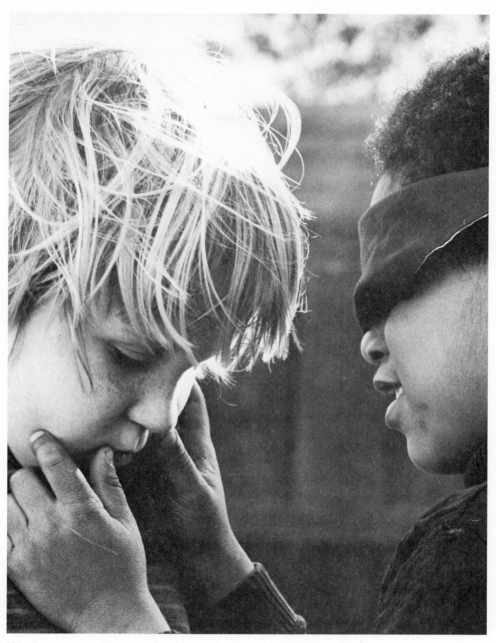

We do not see with our eyes alone: what we ''see'' is influenced by
who we are and what the world around us is like.
(© *Hella Hammid/Rapho/Photo Researchers*)

SKILL BUILDER

ARE YOU OUT IN THE WORLD, OR ARE YOU OUT IN YOUR WORLD?

1. Divide into small groups of four or five individuals. Each group will select a location that group members will visit together. For example, your group may decide to visit a cafeteria, a street corner, a book store, an office, a bus depot, or a supermarket.
2. Once at the selected location, all group members are to compile a list of personal observations—that is, each is to record descriptions of persons at the site, behaviors, happenings, or interactions. You are not to converse or share your observations with other group members during this three- to five-minute phase of the experience.
3. When you return to class, you and the other members are, in turn, to report on your observations. Compare and contrast the extent to which each of you perceived different or similar stimuli.
4. Repeat the experience. Only this time, when in a selected location, each member of your group is to view the scene from a different physical perspective. For instance, one might sit on the floor, another might stand on a chair, a third might sit on a chair. Seek to determine how these changes affect each individual's observations.
5. Repeat the experience with the group, but this time each of you pretend to have different physical capabilities. For instance, one person might imagine that he is extremely near-sighted, another that she is extremely far-sighted, one very short, another very tall. How do these imagined changes affect the members' observations?
6. Repeat the exercise one last time, this time attempting to change your emotional perspective. For example, while making observations, one group member could think of herself as a snob, another could see himself as a busybody, a third as angry, a fourth as lazy. Again, seek to assess how these alterations affect individual perceptions.

During the preceding exercise series, you adopted differing perspectives. Each perspective helped to determine how you organized and perceived the world around you. Each time you altered your angle of vision or frame of reference, you changed your perceptions.

Now, how do you absorb information from the world around you? Do you look and listen? Do you touch, taste, and smell your environment and those who interact in it? Certainly! Your senses function as perceptual antennae and gather information for you all the time. However, it is impossible for you to internalize or process all the stimuli or data available to you. Without realizing it, you take steps to limit what you perceive. Try this.

As you can see, you simply cannot effectively handle or process all the sensory experiences that compete for your attention. You are forced to identify or select those stimuli you will attend to or experience. By doing so you are able to create a more coherent and meaningful picture of your world.

What this means is that perceptual processes are personally based. For this reason, different people will experience the same cues in very different ways. In the book *Communication and Organizational Behavior,* William Haney emphasizes this when he notes that we never really come into direct contact with reality. Instead, everything we experience is manufactured by our nervous system. The "kind of sense" we make out

It is the "I" behind the eye that controls perception.

of the people and situations in our world depends on the kind of perceivers we are. In other words, what is seen, heard, tasted, felt, or smelled depends on *who* is doing the experiencing. It is the "I" behind the eye that is in control. What you see, hear, taste, feel, or smell when you experience something depends on what you are able to experience, want to experience, or need to experience. Your perceptions of a stimulus are shaped by your loves and hatreds, your past experiences, your desires, and your physical capabilities. Thus, only in part are they determined by the world outside. In large measure your perceptions are determined by your senses, the organizational processes you employ, and how you interpret and evaluate your experiences. We could say that your perception of a stimulus and the stimulus itself are not even one and the same thing. The stimulus is "out there," whereas your perception of it is unique, personal, and inside you.

Let's continue our discussion by exploring the ways in which your senses affect how you assign meaning to experiences. What would happen to your view of the world if your sensory abilities were decreased or dulled? How would such changes affect perception?

Before beginning the next Skill Builder, consider this:

> I have often thought it would be a blessing if each human being were stricken blind and deaf for a few days at sometime during his early adult life. Darkness would make him more appreciative of sight; silence would teach him the joys of sound.
>
> *Helen Keller*

What we smell (or see, hear, taste, or feel) depends on who we are. Helen Keller, who was blind and deaf, was probably more sensitive to smell and touch than are most "normal" people. (*Culver Pictures*)

SKILL BUILDER

DULLING YOUR SENSES

1. Make a commitment to wear a pair of gloves for an entire day. Wear them in class, at work, during your lunch hour, while out for an evening—wherever you go. Be prepared to report to the class how your "gloved state" changed the nature of the world you experienced.

2. On another day, make a commitment to wear dark glasses for the entire day. Wear them outside and inside, while eating, while traveling, while in class, while conversing with friends. To what extent did dark glasses affect your perception of the day and the people you met? How did they make you feel? How did others react to you?

3. On still another day, either place cotton in your ears, wear ear plugs, or put on earphones. How did this physical alteration affect your behavior and the behavior of others toward you? To what extent did you find yourself speaking less? To what extent did you feel "out of touch"?

Note: Use discretion while participating in these exercises. For example, if you work with machinery you may have to remove the gloves or the dark glasses. Do nothing that will jeopardize your safety or the safety of others.

To reiterate an important point, even when we do perceive the same stimulus, we each react to it differently. We simply are not endowed with identical sensory equipment. You can demonstrate this by obtaining thin strips of coated PTC paper from a chemistry lab in your school. (PTC —phenylthiocarbamide—is a harmless, tasteless chemical.) Place one slip of PTC paper on your tongue. How does it taste? Obtain taste reactions from other students in your class. Some people find that the PTC slip tastes bitter; others find that it tastes sweet, salty, or slightly sour. Since the senses predominate in perceptual experience, the first step in the process of perception is picking up sensory data. If we cannot agree on the taste of a piece of paper, is it any wonder that all of us do not perceive more complex stimuli in the same way?

In many respects, human beings are like television sets. We simply are limited in the "shows" we can present. For instance, information theorists tell us that the eye can process about 5 million pieces of data, or "bits," per second; they also tell us that the brain can utilize only some five hundred pieces, or "bits," per second. Thus, selection is an inevitable part of our perceptual processes.

But what is perception? Certainly, as we now realize, perception includes more than just the eye alone, more than just the ear alone, more than just the nose alone, more than just the skin alone, and more than just the tongue alone. Perception is the "I." Keeping this in mind, we can define perception as the process of selecting, organizing, and interpreting sensory data in such a way that we are able to make sense of our world. The remaining sections of this chapter will elaborate on this definition.

THE "I" OF THE BEHOLDER: THROUGH A GLASS DARKLY

We have seen that perception provides each of us with a unique view of the world—a view sometimes related to but not necessarily identical with that held by others. Since we never come into direct contact with the world "out there," we are forced to use our senses to help create a personal picture of the people and objects that surround us. How do we make sense out of our world? How do we process the stimuli that compete for our attention? To be sure, during the perception process we are active, not passive participants. We do not simply relax and absorb stimuli available to us as a sponge absorbs liquid. Rather, we are actively involved. We select, we organize, and we evaluate. We have learned to cope with the multitude of stimuli that bombard us by focusing on but a few of them. By doing this, we give coherence and meaning to our world.

SKILL BUILDER

CATCH!

1. Select a partner. Gather together four or five tennis-sized rubber balls. You and your partner are to stand fifteen to twenty feet apart and face each other.
2. Round One. Person A, the pitcher, simultaneously tosses all the balls to person B, the catcher, making an effort to ensure that the balls pass to either the right or the left side of the catcher—in other words, the balls should not be tossed directly at the person. The catcher's task is to try to catch all the balls.

 After several quick tosses, it should be evident that if the catcher attempts to catch *all* of the balls at once, he or she will almost certainly fail.

3. Round Two. Have the pitcher toss the balls to the catcher once again. This time the catcher is to focus on *one* ball only and make an effort to catch that one. Most people find that they are able to succeed when they concentrate on and try to catch only one ball.
4. Pitcher and catcher should switch roles and repeat the preceding sequence.

This exercise illustrates the perceptual principle of figure–ground. Once you focused your attention on catching a particular ball, the remaining spheres blended into the background. In a manner of speaking, what you focused on became the "figure" and the rest of what you saw became the "ground." As was demonstrated, you can focus on only one part of your total environment at any given moment. To further clarify the figure–ground concept, look at the picture on the top of page 73.

What do you see? At first glance, some of you probably see a vase, and others see two people facing each other. When stimuli compete for your attention, you can focus

on only one of them. It is simply impossible to perceive something in two ways at once. Although you may be able to switch your focus rapidly, you will still perceive only one stimulus at any given point in time.

The "Catch!" exercise also helps illustrate the nature of perceptual selectivity by showing that we sometimes need to eliminate or reduce the number of stimuli that impinge on our awareness. We cannot "catch" or process each idea or each sensory stimulus in our world or environment. We must select.

What other variables affect us during the selection process? In other words, what additional forces interact to guide us in making our perceptual selections?

Are Your Past Experiences Following You?

The selection phase of perception is affected by past experiences. For example, assume that you are pushing a shopping cart down a supermarket aisle during a weekly trip to the market. You arrive at the breakfast cereal section. You know you are going to purchase a box of cereal, but how do you decide what kind to buy? At least thirty different cereals compete for your attention. Of course, packaging could influence you, but suppose that all cereal came in the same size box with simple black lettering indicating the product's name. Would you be able to pick out the cereal you wanted to buy? The one you wanted to avoid? The one that tastes like dried cardboard? Certainly! You would let your past experience guide you in making the selection. After all, your experience with the cereal you choose probably dates back many years. Even a four-year-old child will happily let you know if he or she does not approve of a shopping choice. "I don't like it! I don't

want you to buy that cereal!'' is a familiar supermarket cry. Past experience is an important factor in the selection process.

We can further examine the way past experience affects perception by posing this problem: If you took a third-grade child to one of your college classes, do you think he would perceive the class experience in the same way you do? If you asked him to take notes for you, would the notes he took be identical to yours? Of course not. How would they differ? Would you mind if the notes were taken in crayon? Would you mind if your script were replaced with a large scribble and supplemented with doodles? Although doodling is not unknown among college note takers, the child's notes would probably be far inferior to the notes you yourself would take. First, you have learned to take notes. Second, you have some familiarity with the material being presented. Third, your intellectual capabilities are probably superior to the child's.

SKILL BUILDER

YOUR NOTES AND YOU

Exchange notes from the same class with someone in your section. How do your notes differ? Can you read the other person's notes? Would you be able to study from them? What has this student included that you omitted? What did you include that he or she did not? Why?

As we can see, age alone does not determine the part played by past experience. Even among peers of the same age, past experiences differ and affect the way stimuli are perceived.

Your past experiences provide you with expectations or ''perceptual sets'' that affect the way you process your world. In order to better understand the concept of *perceptual set*, quickly read the statements written in each of these triangles:

Now examine the words more carefully. During your first reading, did you miss anything that you now perceive? Many fail to see the second *the* or *a* in the statements the first time they read them. Did you? Why? We are so accustomed to seeing words in groups or clusters that we simply fail to perceive a number of single words when we see them in familiar phrases. Faster, more accomplished readers make this mistake more readily

than do slower, less skillful readers. In their attempt to perceive the overall meaning, fast readers simply skip what they perceive as unessential words. Based on this, how do you imagine first- and second-graders would respond to the triangle experience? Your authors showed these triangles to a group of such students and found that for the most part, since they still read individual words rather than word groups, many noticed the repetition immediately. They were not "set" to perceive the phrases.

Thus, the educational experiences we have had are a part of our past experiences. They, too, affect the way we process and perceive information. To what extent do you view the world differently now than you did in the seventh grade? Do you believe that your college education will alter your perception again? We hope it will. For instance, you may find that your views of television and the media have also changed since you were younger, and they will change again as you acquire additional education. Young children, for example, view television commercials as a kind of truth. A certain amount of maturity—possibly aided by education—is required to realize that a commercial's prime purpose is to sell something. Of course, if we are not careful, our education can occasionally serve as a barrier to rather than a facilitator of common sense. This danger is seen in the following humorous essay by columnist Russell Baker.

OPINION: AN ANALYSIS OF MISS MUFFET

Russell Baker

Little Miss Muffet, as everyone knows, sat on a tuffet eating her curds and whey when along came a spider who sat down beside her and frightened Miss Muffet away. While everyone knows it, the significance of the event had never been analyzed until a conference of thinkers recently brought their special insights to bear upon it. Following are excerpts from the transcript of their discussion:

SOCIOLOGIST: Miss Muffet is nutritionally underprivileged, as evidenced by the subminimal diet of curds and whey upon which she is forced to subsist, while the spider's cultural disadvantage is evidenced by such phenomena as legs exceeding standard norms, odd mating habits and so forth.

In this instance, spider expectations lead the culturally disadvantaged to assert demands to share the tuffet with the nutritionally underprivileged. Due to a communications failure, Miss Muffet assumes without evidence that the spider will not be satisfied to share her tuffet, but will also insist on eating her curds and whey. . . .

MILITARIST: Second-strike capability, sir! That's what was lacking. If Miss Muffet had developed a second-strike capability instead of squandering her resources on curds and whey, no spider on earth would have dared launch a first strike capable of carrying him right to the heart of her tuffet. I am confident that Miss Muffet had adequate notice from experts that she could not afford both curds and whey and at the same time support an early-spider-warning system. . . .

BOOK REVIEWER: Written on several levels, this searing, sensitive exploration of the arachnid heart illuminates

the agony and splendor of Jewish family life with a candor that is at once breath-taking in its simplicity and soul-shattering in its implied ambiguity. Some will doubtless be shocked to see such subjects as tuffets and whey discussed without flinching, but hereafter writers too timid to call a tuffet a tuffet will no longer. . . .

EDITORIALIST: Why has the Government not seen fit to tell the public all it knows about the so-called curds-and-whey affair? It is not enough to suggest that this was merely a random incident involving a lonely spider and a young diner. . . .

PSYCHIATRIST: Little Miss Muffet is, of course, neither little, nor a miss. These are obviously the self she has created in her own fantasies to escape the reality that she is a . . .

divorcee whose superego makes it impossible for her to sustain a normal relationship with any man, symbolized by the spider. . . .

FLOWER CHILD: This beautiful kid is on a bad trip. Like. . . .

STUDENT: Little Miss Muffet, tuffets, curds, whey and spiders are what's wrong with education today. They're all irrelevant. Tuffets are irrelevant. Curds are irrelevant. Whey is irrelevant.

CHILD: This is about a little girl who gets scared by a spider.

(The child was sent home when the conference broke for lunch. It was agreed that the child was too immature to add anything to the sum of human understanding and should not return until he had grown up.)

The New York Times, April 14, 1969

Hearing what we want to hear and seeing what we want to see is one of the great obstacles to effective communication.

As is apparent, perceptual sets are a result of unique experiences. The lessons life has taught you necessarily differ from the lessons life has taught others. As a result, we will each perceive the same stimulus differently. This helps explain why a boss and an employee, a teacher and a student, a parent and a child, or two friends can have widely differing opinions about a job, a company, an institution, or a situation. While the boss or the person with more power may be situated at the top looking down, the employee or person with less power may be situated at or near the bottom, looking up. One's position in an organization affects the way he or she perceives the organization. For example, while attending the Army's Officer Candidate School (OCS), one of your authors was struck by the way an individual's behavior correlated with role changes. When performing one role (order giver), a person was set to respond in one way, and when performing another role (order taker), that same person was set to respond in an entirely different way. The OCS system of training necessitated this. In OCS, a person who was a corporal on Friday could become the student company commander on Saturday. When "looking up" the OCS organization, the corporals often perceived the rules and orders to be "worthless." However, when they suddenly reached the "top," these corporals changed their perceptual set, for from this new vantage point, they were able to perceive that the company had a mission, and they expected others to perform

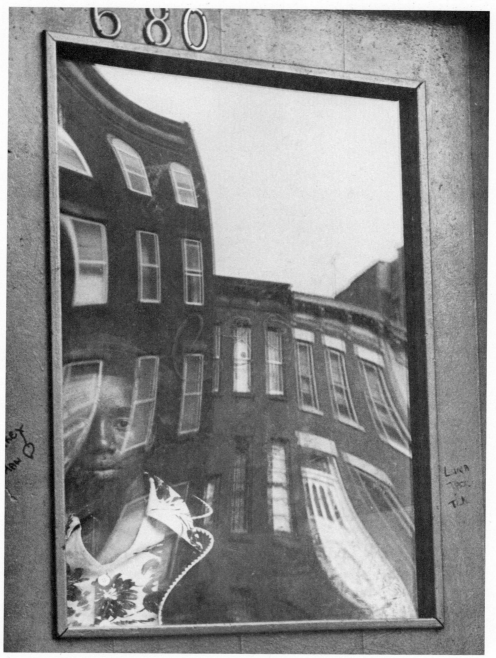

Perceptual sets are the result of our unique experiences: how we perceive objects and events depends on our personal history. (© *Hazel Hankin 1981*)

enthusiastically. When they rejoined the ranks a few days later, however, they would usually return to their previous set—that is, they again viewed the tasks they were expected to perform as meaningless or silly. We can see that the role we play or the position we hold helps us internalize perceptual sets that, in turn, cause us to react in particular ways.

Are You Open or Closed?

As we see, a key factor in how we view our world is the extent to which we are able to open ourselves to experience. Despite the numerous sensory stimuli that compete for our attention, we tend to select only those experiences that reaffirm existing attitudes, beliefs, and values. Likewise, we tend to ignore or diminish the significance of those experiences that are incongruent or dissonant with existing attitudes, beliefs, and values. Just as children can place their hands over their ears to avoid hearing what a parent is saying, so we can select what we will perceive by deciding whether to expose ourselves to a variety of types and sources of information.

When driving through poverty-stricken areas, for example, people will often roll up automobile windows. They tell themselves they are doing this for "self-protection," but it also is a means of self-deception—it helps them avoid contact with some of the depressing sights and sounds of their society. Can you cite instances when you deliberately chose not to expose yourself to a particular stimulus or idea? Are there not some subjects you would just as soon not know about or deal with? Are there not some people whom you would just as soon avoid contacting interpersonally? Because we tend to answer these questions affirmatively, social scientists assert that selective exposure helps determine how we perceive our world.

A 1959 study gave support to this premise. Through research, Wilbur Schramm and Richard Carter determined that after a massive television campaign by a Republican senatorial candidate, Republicans were twice as likely to have seen a portion of the campaign as were Democrats. Likewise, during the 1972 presidential campaign, researcher Dorothy Bartlett discovered that twice as many people who expected to vote Republican failed to open a letter with the return address "Voters for McGovern" as did Democrats. Similar results were obtained among Democrats who received a letter with the return address "Voters for Nixon." In each instance, voters chose to expose themselves only to that information with which they already agreed. Is it difficult for you to expose yourself to certain ideas, places, or experiences? Why?

Are You a Distorter?

A concept related to selective exposure is selective perception. We see what we want to see and hear what we want to hear. Through the process of selective discrimination, the same message or stimulus may be interpreted in different ways by different people. But why do we distort stimuli until they conform to what we want or expect? What causes us to act this way? To find out, try this.

SKILL BUILDER

STORIES

1. Select a partner and together design an itinerary to follow. For instance, you might decide to visit the cafeteria or take a walk around the block.

2. Travel the route you map out together. After fifteen minutes have elapsed, return to the classroom and compile a list of the stimuli you both remember seeing. Then, working separately, describe each stimulus. When writing, use the pronoun ''I'' and as many descriptive words as you feel are needed to provide an accurate picture of what you saw. For example, ''I crossed the street and saw a poor, wet, bedraggled, pepper-colored puppy.''

3. Enter the stimuli and your descriptions on the chart below.

Observer _____

LOCATION	STIMULUS	DESCRIPTION

4. Compare and contrast your descriptions with those of your partner. To what extent were your descriptions of the stimuli you experienced similar? Different?

5. To what extent do you think your perceptions were affected by what you needed to perceive? Wanted to perceive? Explain.

Since at any given moment of the experience, each participant may have focused on a different part of each stimulus, no two individuals will have had exactly the same perceptions. Each individual's perception of an event is influenced by his or her existing attitudes. Thus, out of the swirling mass of information available to us, we interpret and digest the information that confirms our own beliefs, expectations, or convictions, and we reject the information that contradicts our beliefs and convictions. Try viewing the same news broadcast with someone whose political views differ sharply from your own. How similar do you imagine your interpretations of the delivered information would be?

Why? Our selective processes cause us to add information, delete information, or change information so that we do not have to deal with what we do not wish to deal with.

Time and time again past experiences, expectations, and needs and wants join forces and help determine our present perceptions. They are aided in this effort by our desire for *closure*—that is, by our desire to perceive a completed world. Examine the illustrations provided below. Identify what you see by entering a word or words in the spaces indicated.

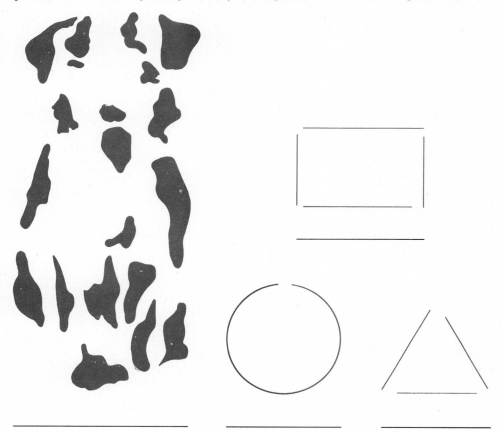

Your labels probably indicate that you see a dog rather than a collection of inkblots, a rectangle, triangle, and circle rather than lines and an arc. We tend to complete familiar figures in our mind. We fill in the forms based on our previous experiences and our needs. We complete stimuli until they make sense to us; we fill in gaps.

What significance does this tendency to fill in missing information have for your everyday perception and interpersonal communication? How often do you feel a need to fill in "people gaps"? How often do you make sense out of the actions of people by completing them as you would like to see them completed? It is important to realize that your perceptions of another individual are a key determinant of the type of interpersonal relationship you will share with that individual.

PERCEIVING OTHERS: WHAT ARE YOU, PLEASE?

On what basis do you form first impressions or make initial judgments about the people you meet? What makes you decide if you like or dislike someone? Is it their economic status? Is it the job they hold? Perceiving others and the roles they play is an essential part of the interpersonal communication process. Can you imagine walking into a bank and not being able to determine to whom you should give your money? A number of people might be willing to take it—not just the tellers! In this section we will explore how we form first impressions of others and why we sometimes stereotype others. We will attempt to determine why we often feel it necessary to *freeze* people and *squeeze* people until they ''fit into'' or conform to our expectations for them.

RICHARD CORY

Edwin Arlington Robinson

Whenever Richard Cory went down town,
We people on the pavement looked at him:
He was a gentleman from sole to crown,
Clean favored, and imperially slim.

And he was always quietly arrayed,
And he was always human when he talked;
But still he fluttered pulses when he said,
"Good-morning," and he glittered when he walked.

And he was rich—yes, richer than a king—
And admirably schooled in every grace:
In fine, we thought that he was everything
To make us wish that we were in his place.

So on we worked, and waited for the light,
And went without the meat, and cursed the bread;
And Richard Cory, one calm summer night,
Went home and put a bullet through his head.

First Impressions: Making Them or Breaking Them

''You must make a good first impression'' is advice frequently given to people as they start a new job, embark on an interview, or prepare to participate in other interpersonal communication encounters. But how important is the first impression? Let's find out by adapting an experiment conducted by Solomon Asch.

SKILL BUILDER

WHAT'S ON FIRST?

1. Read the following list of character traits in order. Do not reexamine the list.

 ### CHARACTER TRAITS OF PERSON A

 A. Intelligent D. Critical
 B. Industrious E. Stubborn
 C. Impulsive F. Envious

 Choose one word to represent your impression of the person just described:

2. Now, read this list of words and repeat the exercise as indicated in phase one.

 ### CHARACTER TRAITS OF PERSON B

 A. Envious D. Impulsive
 B. Stubborn E. Industrious
 C. Critical F. Intelligent

 Choose one word to represent your impression of the person just described:

3. To what extent was the word you chose to represent your impression of person A similar to or different from the word you chose to represent your impression of person B?

4. Read the preceding two lists aloud to a number of your friends. Ask them to perform the same tasks you did. To what extent were their initial impressions of the individuals comparable to yours?

People usually attribute positive qualities to person A, selecting a descriptive word with very positive connotations. In contrast, person B is often perceived as possessing negative qualities; for this reason, the word chosen as representative also has negative connotations. Why is this? The first list began with positive traits and the second list began with negative traits. Otherwise, each list was precisely the same. As we see, first impressions can dramatically affect perception. In addition, the first impression, or the *primacy effect* as it is sometimes termed, can even alter the end result of communication efforts. Trial lawyers, for example, depend to some degree upon the primacy effect (the first impression individuals create) when selecting persons to serve on a jury. The first impression potential jurors make on the lawyer will determine whether the attorney accepts them or uses a preemptory challenge. In the long run, this decision could have an important impact on the outcome of the case and the future of the defendant.

The first impression we present during an interview is also of critical importance. What kind of first impression do you create during an interview situation? To find out, try this:

SKILL BUILDER

INTERVIEW

1. Select a partner. One of you will function as the job interviewer and the other as the job interviewee. The interviewer should begin by inviting the interviewee to enter the office. The interviewee and the interviewer should then shake hands, take seats, and begin their discussion. The interviewer should ask such questions as ''Tell me about yourself'' and ''Why are you qualified for this job?''

 The interviewee should attempt to do everything wrong. For example, if you are the interviewee you might charge into the office, slouch in a chair, put your feet on a table, and chew gum, in an effort to give the interviewer a bad first impression.

2. Replay the scene a second time. This time, as the interviewee, you should attempt to do everything right—that is, you should exhibit those behaviors you believe will cause the interviewer to develop a positive first impression.

3. Repeat the entire sequence, reversing roles with your partner.

4. What behaviors did you exhibit when you wanted to create a bad impression? How did you change those behaviors to create a good impression? What can you do to further improve your ability to create favorable first impressions?

The first impression we create during an interview tends to last, and thus it is of crucial importance.
(© *Peeter Vilms 1978/Jeroboam*)

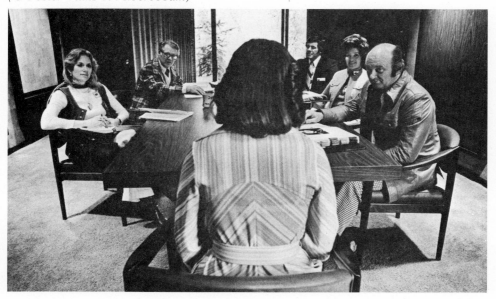

It should be noted that the receiver's psychological state of mind can also affect his or her first impressions. Sometimes the receiver uses cues provided by the sender, mixes them with his or her own preconceptions, and creates a perception based partly on myth or fiction. One factor that affects the way we perceive others is our tendency to divide people into groups, place them in niches, and stereotype them. Let's explore this concept next.

Stereotyping: Have I Got a Niche for You!

A stereotype is a generalization about people, places, or events that is held by many members of a society. For example, when we go into a physician's waiting room for the first time, we carry with us a general idea, or stereotype, about seeing a doctor. Our stereotype helps us decide how to behave in that particular environment. In other words, we have developed an ability to identify and generalize about the behavior we feel it is proper to exhibit in a physician's office. To be sure, we would not expect to find flashing colored lights or people dancing to loud music while waiting to be examined. Our stereotype does not allow for this.

It would be difficult for us to function without stereotypes. If, for example, you had formed no picture of how a salesperson, mechanic, waiter, or politician functions in our society, you would find it more difficult to get along. Knowing what categories people and things fit into helps us decide how to deal with them. Somehow, knowing whether a stranger is a corporate president, a lawyer, or a teacher helps us decide how to behave in his or her presence. We simply judge people on the basis of what we know about the category to which we feel they belong. We assume they possess characteristics similar to those we attribute to others in that class, and we simplify our task by overlooking whatever differences may exist. By implication, when we stereotype, we say, "Those who belong in the same niche have the same traits; those who belong in the same niche are alike."

The media help us create and maintain stereotypes. Television news programs, for one, help us identify people, places, ideas, and things by providing us with stereotyped images of them. In his book *News from Nowhere*, Edward Jay Epstein explains that news-show camera operators and correspondents are told to pepper their stories with pictures that have universal meaning. "Hence, stories tend to fit into a limited repertory of images, which explains why so often shabbily dressed children symbolically stand for poverty [and] . . . fire symbolically stands for destruction." If you look closely, you will also notice that news-show producers try to select images that illustrate the human experience. Inflation is portrayed as the housewife shopping in a supermarket; jobless statistics are depicted by an unshaven man walking into the unemployment office. In television news as well as in newspapers and magazines, emotionally charged stereotypical images are often chosen to supplement and illustrate factual data that would otherwise seem uninteresting. Increase your understanding of stereotypes by participating in this exercise:

SKILL BUILDER

TELEVISED STEREOTYPES

1. Tonight, with pencil and paper in hand, watch a thirty-minute nationally televised news program. If possible, all members of your class should view the same broadcast. (If time and equipment are available, some instructors may be able to show a videotape of the program during class.)

2. Make a list of the stereotypical images or pictures used in the telecast. Also note the functions of each image—that is, your impression of its purpose. Use this chart to record your reactions.

TELEVISED IMAGE	FUNCTION OF THE IMAGE
1.	1.
2.	2.
3.	3.
4.	4.
5.	5.
6.	6.
7.	7.
8.	8.
9.	9.
10.	10.
11.	11.
12.	12.

3. To what extent, if any, do the images "enrich" your understanding of the story? Which images do you find most effective? Least effective?

4. Since newspapers and magazines also use stereotypical images, assemble a group of such images for class examination.

5. Those who create these stereotypic images expect to provide a mass audience with easily recognizable pictures that trigger predictable reactions. Supposedly, the media employ the images to help prevent confusion among viewers. Do you think they succeed?

PEANUTS® by Charles M. Schulz

Unfortunately, stereotyping is rarely a positive force in interpersonal relations or in the various institutions that make up this society. Ralph Ellison, a Black man and author of *The Invisible Man,* noted this when he wrote:

SKILL BUILDER

WHAT SLOT DO YOU FIT IN?

1. Identify the common stereotypes individuals have for these groups:

GROUP	DESCRIPTION OF STEREOTYPE
Police officers	
Airline flight attendants	
Rock singers	
College teachers	
Plumbers	
Californians	
New Yorkers	
Southerners	
High school drop-outs	
Criminals	
Prostitutes	
Artists	
Dancers	
People of Irish descent	

I am an invisible man. No, I am not a spook like those who haunted Edgar Allan Poe. . . . I am a man of substance, of flesh and bone, fiber and liquid . . . and I might be said to possess a mind. I am invisible, understand, simply because people refuse to see me. Like the bodiless heads you see sometimes in circus side shows, it is as though I have been surrounded by mirrors of hard, distorting glass. When they approach me they see only my surroundings, or figments of their imagination— indeed, everything and anything except me.

If we are not careful, the practice of stereotyping can be quite harmful. When we stereotype during interpersonal contacts, we take our attitudes toward a group of people and project them onto a particular member of the group. Some of us have formed fixed impressions of a racial group, an ethnic group, a religious group, people who hold a particular job, or people who occupy a certain economic level of society. What are some of the more common stereotypic impressions held by people you know?

GROUP	DESCRIPTION OF STEREOTYPE
People of Polish descent	
WASPs	
Jews	
Baptists	
Blacks	
Puerto Ricans	
Mexicans	
Athletes	
Feminists	
College graduates	
Cadillac owners	
Van owners	
Motorcycle riders	

2. To which of these groups, if any, do you, your best friend, and a person whom you dislike belong? Do you fit the typical stereotype in every way? In any way? Does your friend? Does the person you dislike?

What should be emphasized is that we are all individuals. Whenever we interact with another person, we must realize that we are communicating with an individual, not with a stereotype. Furthermore, we need to understand that our stereotype of any group is necessarily based on incomplete information. Becoming aware of our stereotypes is one thing; interacting with people in such a way that our stereotype does not interfere with communication between us is quite another.

Seeing someone transcend a common stereotype (that women are fragile, helpless, and unable to do heavy work, for example) may help us abandon such preconceived ideas and evaluate people more realistically.
(© Robert Azzi 1980/Woodfin Camp & Assoc.)

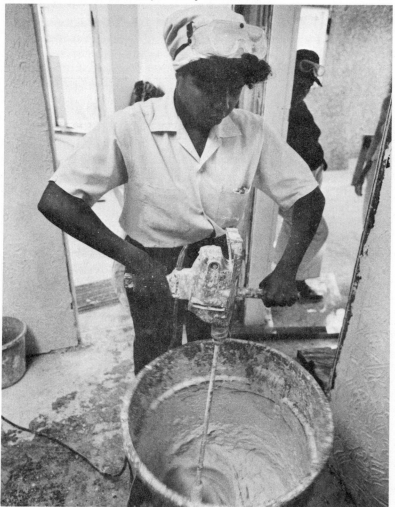

STEREOTYPE BREAKTHROUGH

1. Divide into groups of five individuals.

2. Compile a list of groups that the members of your group could be seen as belonging to. Compile a list of common stereotypes attributed to each group.

3. Then have each individual generate examples that illustrate how he or she does or does not live up to each of the common stereotypes. For instance, a man who is perceived to be a dumb athlete might discuss what he considers to be his academic strengths.

After completing this exercise, most people find that, although they might live up to some aspects of some stereotypes, they certainly do not live up to all of them. Stereotypes may be partly true; they are never always true. Clearly, when we stereotype, categorize, or pigeonhole others, we are really stereotyping, categorizing, or pigeonholing aspects of ourselves! Only when we break through our stereotypes do we look beyond ourselves and interact with another person instead of with our perception or preconception of the person.

Thus, we can see that although stereotyping simplifies and gives a sense of order and stability to our lives, it can also have very limiting and debilitating effects. Far too frequently, we fail to recognize the variations and differences in apparently similar individuals. We overlook differences and emphasize similarities. We enjoy classifying and categorizing, finding differentiating too difficult. Yet, if we are to improve our perceptual capabilities, we should make an effort to see the differences as well as the similarities. To paraphrase communicologist Irving J. Lee, the more we are able to discriminate among individuals, the less we will actively discriminate against individuals. It is time to recognize the uniqueness of each individual; it is time to tear down those neat, prearranged boxes that restrict rather than encourage accurate perception.

OTHER BARRIERS TO PERCEPTION: DON'T FENCE ME IN

We have seen that a number of barriers limit and impede our perceptual accuracy. Many of these barriers are a result of our past experiences. However, theorists have identified at least three additional factors that can function as perceptual blocks; theses are allness, blindering, and fact/inference confusions. Let us consider each of these forces now.

Allness: Is That All There Is?

Have you ever noticed how some radio and television commentators speak with great finality? Several have based their careers at least partially around a parent-like image—

that is, they seem to have all the answers about what is happening in the world. Is it possible for a commentator—or any of us for that matter—to know, much less tell about, all there is to know concerning a topic? Of course not. Knowledge of everything about anything is certainly an impossibility. In his book *Science and Sanity*, Alfred Korzybski coined the term ''allness'' to refer to the erroneous belief that any one person could possibly know ''all'' there was to know about anything. Even if we are wise and do not assume that the newscaster (or even our friend) is telling us all there is to know, we often make the false assumption that he or she is telling us all that is *important* about what there is to know. This, too, may not necessarily be true, but we often believe it is.

Did you ever have someone fill you in on the content of a class you missed? Did you assume that the person was delivering all the important information to you? Did a later exam ever prove you wrong? The allness fallacy is aptly illustrated in the following poem by John Godfrey Saxe:

THE PARABLE OF THE BLIND MEN AND THE ELEPHANT

It was six men of Indostan
 To learning much inclined
Who went to see the Elephant
 (Though all of them were blind),
That each by observation
 Might satisfy his mind.

The First approached the Elephant,
 And happening to fall
Against his broad and sturdy side,
 At once began to bawl:
"God bless me! but the Elephant
 Is very like a wall."

The Second, feeling of the tusk
Cried, "Ho! what have we here
So very round and smooth and sharp?
 To me 'tis very clear
This wonder of an Elephant
 Is very like a spear."

The Third approached the animal
 And, happening to take
The squirming trunk within his hands
 Thus boldly up he spake:
"I see," quoth he, "the elephant
 Is very like a snake!"

The Fourth reached out an eager hand,
 And felt about the knee:
"What most this wondrous beast is like
 Is very plain," quoth he;
" 'Tis clear enough the Elephant
 Is very like a tree!"

The Fifth, who chanced to touch the ear,
 Said: "E'en the blindest man
Can tell what this resembles most;
 Deny the fact who can
This marvel of an Elephant
 Is very like a fan!"

The Sixth no sooner had begun
 About the beast to grope
Than seizing on the swinging tail
 That fell within his scope:
"I see," quoth he, "the Elephant
 Is very like a rope!"

And so these men of Indostan
 Disputed loud and long,
Each in his own opinion
 Exceeding stiff and strong.
Though each was partly in the right,
 They all were in the wrong!

Each person in the poem assumed that he knew all there was to know about the elephant. Because we sometimes succumb to the allness misevaluation, our perceptions of others and the world around us can be as limited as those of the blind men depicted in the poem. Far too frequently we believe that there is no more to be said, or at least no more to be said that is worth perceiving.

We fall victim to allness when we close ourselves to new or different information. In other words, we think we "know it all." However, remaining open to new ideas and experiences is important for lifelong learning. We should refrain from thinking of ourselves as the center of the world. Have you ever considered why, on our maps of the earth, the United States is nearly always placed in the center? Is there any sensible geographical rationale for this? Could this be an example of allness on the part of map makers and those who use the maps?

How can we avoid allness? We can begin by recognizing that because we focus on only a portion of a stimulus or an event, we necessarily neglect other aspects of the stimulus or event. Thus, we certainly should not feel free to say that "we know it all!"

SKILL BUILDER

THE KNOW-IT-ALL

1. Use the following chart to keep a record of "allness" statements uttered by you or others you talk to during the next week.

SPEAKER	SITUATION	STATEMENT	REACTION

2. In each case how did others react to the "know-it-all"? How did he or she respond?

The allness attitude can impede the development of effective interpersonal relationships. To counter this possibility, try this:

SKILL BUILDER

A PERSON NAMED

(You Fill in the Name)

1. Select a person you know well.
2. On a sheet of paper compile a list containing as many details about the person as you can.

Because you could never mention everything there was to mention about your chosen person, you would be wise to end your list with the word "et cetera." In this way, you remind others, or at least yourself, that you could not possibly cover everything. You do not pretend to know it all.

Blindering: A Person Is Not a Horse

The concept of *blindering* as a factor in perception can best be illustrated by the following exercise. Attempt to draw four straight lines that connect each of the dots provided in the diagram below; do this without lifting your pencil or pen from the page or retracing over a line.

```
•        •        •

•        •        •

•        •        •
```

Did you find it difficult or impossible to accomplish? Most people do. Why? There was only one restriction imposed by the problem—that you connect the dots with four straight lines without lifting your pen from the page or backtracking over a line. Most of us, however, add another restriction. After examining the dots, we insist that the figure to be formed is a square; in actuality, no such form or restriction exists. Once you realize this, the solution to the problem becomes clear. (The answer appears on page 385.) In effect, the word or image of a square blindered you in your attempts to solve the problem. Just as we put blinders on a horse to cut down on the number of visual stimuli it receives, so we also foolishly put blinders on ourselves. However, while blinders aid the horse, they may hinder us.

Blindering forces us to see only certain things or to see things only in certain ways. For example, how much time was wasted and how many lives were lost because the word "malaria" was contracted from the Italian words "mala" and "aria," meaning bad air. As communication specialist William Haney notes, this could have perpetuated the faulty assumption that the dread disease was carried by the bad air around swamps instead of by the mosquito. Thus, blindering can lead to undesirable solutions or actions. It can also impede or slow down needed actions or decisions. Each day we would benefit from uncovering and removing our blinders.

Observation or Inference: Which Is Which?

Another factor that affects our perception and evaluation of people and events in our world is our inability to distinguish what we have inferred from what we have observed. For example, if you plan to leave your home to drive to a friend's house, which is about a mile away, you probably make some inferences: that when you put the key into the ignition, your automobile will start, that you do not have a flat tire, and that no construction will block your approach to the person's home. When you take out a pen to use during an exam, you often infer that the pen has sufficient ink in it to permit you to complete the test. Likewise, when a light turns green, you usually infer that it is safe to cross the

street. Your authors found it difficult to walk across many streets in London because the custom there is for the pedestrian to enter the crosswalk and infer that all traffic will stop! Can you safely infer that traffic will stop for you at a lightless intersection in your home town?

It is important to distinguish factual statements (observations) from inferences. A fact is something you have experienced personally. Everything else is an inference. You see a man walking down the street with a frown on his face. Is the statement "That man is unhappy" a fact or an inference? It is an inference. All you can state with any degree of certainty is that the man has a frown on his face. In the old television crime series

"*Well, gee, frankly, Mr. Danforth, you being my boss, and asking me to lunch and all, I thought you would pick up the tab.*"

The New Yorker

"Dragnet," Jack Webb would often tell witnesses, "All I want is the facts. Just the facts." But facts are not always easy to come by. In fact, sometimes we falsely believe we are dealing with facts when we are actually dealing with inferences. Failing to recognize that we have made an inference can be embarrassing or dangerous.

During the summer that the film *Jaws II* was released, a local television station broadcast photographs of a boat being drawn out to the sea by an unseen force. Many people assumed that the "force" they "observed" was a shark. Was that a fact or an inference? What would have had to appear in the film for it to have been considered a fact? Right! A shark. Sharpen your understanding of facts/inferences by reading this newspaper story.

NORWICH, N.Y., (AP) They had arrested him for drunken driving, but he insisted he was sober.

Police said his eyes were glassy, his speech thick and his walk unsure.

Roswell Woods was given the usual tests. He was asked to pick up a coin from the floor. He couldn't quite make it. He was asked to blow up a balloon as a test. He couldn't do it.

He was taken to court. He pleaded not guilty and asked for an attorney.

Before a jury, the 47-year-old veteran heard himself accused. His attorney, Glen F. Carter, asked Woods to stand. He did.

"It has been testified that your eyes were glassy," the attorney said gently.

The accused pointed to his glass eye, placed there after he had lost an eye in battle.

"It has been testified that your speech was thick," the lawyer continued.

The defendant, speaking with difficulty, said he had partial paralysis of the throat. He said it resulted from one of the 27 injuries received in the line of duty in the South Pacific.

"It is also testified," Carter went on, "that you failed to pick up a coin from off the floor."

He brought out that Woods had been injured in both legs and had undergone an operation in which part of a bone in one leg was used to replace the shattered bone in the other. Woods was unable to stoop, he said.

"And now, the blowing-up of the balloon," the attorney said. "You couldn't blow it up, could you?"

The defendant replied: "I lost one of my lungs in the war. I can't exhale very well."

The jury returned its verdict quickly: "Not guilty."

Acting as if an assumption were a certainty can be risky.

When we confuse facts and inferences, we can run into trouble. We jump to conclusions; we act on our inferences as if they were facts. They are not. Now, test your own ability to distinguish facts from inferences:

SKILL BUILDER

THE DETECTIVE

1. Read the following story (italicized below). Assume that the information contained in it is true and accurate.

2. Answer the questions that follow the story in order. Do not go back to change any of your answers. After you read a statement simply indicate whether you think the statement is definitely true by circling *T*, definitely false by circling *F*, or questionable by circling the question mark. (Note: The question mark indicates that the statement could be true or false, but on the basis of information contained in the story, you cannot be certain.)

A tired executive had just turned off the lights in the store when an individual approached and demanded money. The owner opened the safe. The contents of the safe were emptied and the person ran away. The alarm was triggered notifying the police of the occurrence.

1. An individual appeared after the owner had turned off the store's lights. T F ?
2. The robber was a man. T F ?
3. The person who appeared did not demand money. T F ?
4. The man who opened the safe was the owner. T F ?
5. The owner emptied the safe and ran away. T F ?
6. Someone opened the safe. T F ?
7. After the individual who demanded the money emptied the safe, he sped away. T F ?
8. Although the safe contained money, the story does not reveal how much. T F ?
9. The robber opened the safe. T F ?
10. The robber did not take the money. T F ?
11. In this story, only three persons are referred to. T F ?

How did you do? (Check your answers against those in the answer key on p. 385.) This test is not designed to discourage you from making inferences. We have to make inferences. For the most part, we live our lives on an inferential level. The test is designed, however, to discourage you from making inferences without being aware that you are doing so. It is designed to help you stop acting as if your inferences are facts. If we are to improve our communication, we must know the difference between facts and inferences. Only in this way will we become conscious of our inference-making behaviors.

The following list summarizes some of the essential differences between facts and inferences.

FACTS	INFERENCES
1. May be made only after observation or experience.	1. May be made at any time.
2. Are limited to what has been observed.	2. Extend beyond observation.
3. Can be offered by the observer only.	3. Can be offered by anyone.
4. May refer to the past or the present.	4. May refer to any time—past, present, or future.
5. Approach certainty.	5. Represent varying degrees of probability.

Are you aware of the inferences you make? Try this:

SKILL BUILDER

I INFER

During the next twenty-four hours, make a list of every inference you make. In the space provided, indicate whether later developments confirmed or denied the validity of each of your inferences.

INFERENCES OUTCOMES

As S.I. Hayakawa notes, the real question is not whether we make inferences, but whether we are cognizant of the inferences we make. One of the key characteristics of a mature relationship is that neither party to it jumps to conclusions or acts on inferences as if they were facts.

HOW TO INCREASE THE ACCURACY OF YOUR PERCEPTIONS

Although our effectiveness as an interpersonal communicator is determined in part by our perceptual ability, we rarely if ever consider what steps we could take to increase our perceptual accuracy. Let us now examine some suggestions for improving perceptual skills.

Realize That Your Perceptual Processes Are Personally Based

As we have mentioned, your perception of a person, thing, or event is different from the person, thing, or event. The person, thing, or event is "out there," but your perception is not "out there." Instead, your perception is a composite, or mixture, of what exists out there and what exists in you. You are the major actor in the perception process; you are its star. Thus, what you perceive is determined by the physical limitations of your senses and by the psychological limitations of your past experiences, needs, fears, desires, and interests. By becoming aware of your role in perception, by realizing you have biases, by acknowledging that you do not have a corner on the "truth market," you can increase the probability that your perceptions will provide you with accurate information about the world around you and the people who are a part of it.

Take Your Time

Effective communicators are not in a rush; rather, they take the time they need to process information fairly and objectively. When we act too quickly, we often make careless decisions that display poor judgment. In our haste, we overlook important clues, make inappropriate or unjustified inferences, and jump to conclusions. To combat this, we need to take our time; we need to be sure we have assessed a situation correctly. Delaying a response instead of acting impulsively gives us an opportunity to check or verify our perceptions. The following story by A. Averchenko illustrates what can happen if we fail to pause, delay, or analyze carefully.

"Men are comic!" she said, smiling dreamily. Not knowing whether this indicated praise or blame, I answered noncommittally: "Quite true."

"Really, my husband's a regular Othello. Sometimes I'm sorry I married him."

I looked helplessly at her. "Unless you explain—" I began.

"Oh, I forgot that you haven't heard. About three weeks ago I was walking home with my husband through the square. I had a large

black hat on, which suits me awfully well, and my cheeks were quite pink from walking. As we passed under a street light, a pale, dark-haired fellow standing near by glanced at me and suddenly took my husband by his sleeve.

" 'Would you oblige me with a light?' he says. Alexander pulled his arm away, stooped down, and quicker than lightning banged him on the head with a brick. He fell like a log. It was awful "

"Why, what on earth made your husband get jealous all of a sudden?"

She shrugged her shoulders. "I told you men are very comic."

Bidding her farewell, I went out, and at the corner came across her husband.

"Hello, old chap," I said. "They tell me you've been breaking people's heads."

He burst out laughing: "So you've been talking to my wife. It was jolly lucky that brick came so pat into my hand. Otherwise, just think: I had about fifteen hundred dollars in my pocket, and my wife was wearing her diamond earrings."

"Do you think he wanted to rob you?"

"A man accosts you in a deserted spot, asks for a light and gets hold of your arm. What more do you want?"

Perplexed, I left him and walked on.

"There's no catching you today," I heard a voice say from behind.

I looked around and saw a friend I hadn't set eyes upon for three weeks.

"Lord!" I exclaimed. "What on earth has happened to you?"

He smiled faintly and asked in turn: "Do you know whether any lunatics have been at large lately? I was attacked by one three weeks ago. I left the hospital only today."

With sudden interest, I asked: "Three weeks ago! Were you sitting in the square?"

"Yes, I was. The most absurd thing. I was sitting in the square dying for a smoke. No matches! After ten minutes or so, a gentleman passes with some old bag. He was smoking. I go up to him, touch him on the sleeve and ask in my most polite manner: 'Can you oblige me with a light?' And what d'you think? The madman stoops down, picks something up, and the next moment I was lying on the ground with a broken head, unconscious. You probably read about it in the newspaper."

I looked at him, and asked earnestly: "Do you really believe you met up with a lunatic?"

"I am sure of it."

An hour afterwards I was eagerly digging in old back numbers of the local paper. At last I found what I was looking for: a note in the accident column:

UNDER THE INFLUENCE OF DRINK

Yesterday morning, the keepers of the square found on a bench a young man whose papers show him to be of good family. He had evidently fallen to the ground while in a state of extreme intoxication, and had broken his head on a nearby brick. The distress of this prodigal's parents is indescribable.

This Week Magazine, August 16, 1947

Remember, quick, impulsive reactions contribute to faulty perceptions and make us act on inferences as if they were fact. Accurate interpretation of our perceptions takes time; it does not occur instantaneously.

Try to Be More Open

Far too frequently, we act like robots that have been programmed to look at the world in a set way. But a person is not a robot, a person is not a computer. We can take steps to become more observant and to broaden our expectations. But we need to become willing to expect the unexpected and to expand the size of our perceptual window. This will happen if we recognize that our "reality" is subjective, incomplete, and unique. Thus, if we want to cultivate a fuller, more valid perception of our world, we must be willing to review, revise, and update our view of the world. As we work to internalize the premise of change, we should recognize that if we remove our self-imposed blinders we will also remove some of the self-imposed restrictions that limit our ability to perceive accurately the individuals with whom we relate, the situations in which we become involved, and the problems we would like to solve. If we want our perceptions to be valid, we must make a commitment to search out alternatives in an effort to acquire as much information as possible. We cannot expect our perceptions to be accurate or useful if we are unwilling to change them by adding to them, discarding them, or readjusting them as needed. Remember, the more valid your perceptions, the better your chances to communicate effectively with others. Being willing to look at things differently can help make your world a better place to live.

SUMMARY

In this chapter we discovered why a human being is "more than a camera." We examined the personal basis for our perceptions, and we saw how perspective and sensory capabilities could affect perception. Along with this, we realized that perception provides each of us with a unique view of our world and that, consequently, no two people ever evaluate the same stimulus in precisely the same way.

We examined the ways in which our past experience, our degree of open-mindedness or closed-mindedness, and our tendency to distort information could affect our perception. Finally, we analyzed factors that could influence our perception of others, discussed a number of additional perceptual barriers, and suggested steps we could take to improve the accuracy of our perceptions.

SUGGESTIONS FOR FURTHER READING

Bartlett, Dorothy L., Pamela B. Drew, Eleanor Fable, and William A. Watts, "Selective Exposure to a Presidential Campaign Appeal," *Public Opinion Quarterly*, Vol. 38 (1974), pp. 264–270. Discusses the factors that influence the type of information individuals will expose themselves to during a campaign.

Berman, Sanford I. *Why Do We Jump to Conclusions?* San Francisco: International Society for General Semantics, 1969. A simple, yet effective analysis of how we can avoid jumping to conclusions.

Cook, Mark. *Interpersonal Perception.* Baltimore: Penguin, 1971. Discusses the variables that affect perceptual capabilities.

Crouse, Timothy. *The Boys on the Bus.* New York: Ballantine Books, 1973. A definitive look at the prism through which reporters view events.

Epstein, Edward J. *News from Nowhere.* New York: Vintage Books, 1974. A detailed examination of the evening news programs of major networks. Epstein attempts to determine whether television mirrors or creates reality.

Haney, William V. *Communication and Organizational Behavior.* Homewood, Ill.: Irwin, 1973. A comprehensive look at the misevaluations we are prone to make and how we can avoid them.

Hastrof, Albert, David Schneider, and Judith Polefka. *Person Perception.* Reading, Mass.: Addison-Wesley, 1970. A thorough survey of research in the field.

Hastrof, Albert, and Hadley Cantril. "They Saw a Game: A Case Study," *Journal of Abnormal and Social Psychology,* Vol. 49 (1954), 129–134. Describes how football fans perceive their home team and the opposition.

Milgrim, Stanley. "Confessions of a News Addict," *The New York Times,* August 7, 1977. A readable detailing of one person's news views.

Schramm, Wilbur, and Richard F. Carter. "Effectiveness of a Political Telethon," *Public Opinion Quarterly,* Vol. 23 (1959), 121–126. An analysis and discussion of voter exposure preferences.

Tagiuri, Renato. "Person Perception," in *The Handbook of Social Psychology,* 2nd ed., edited by G. Lindzey and E. Aronson. Reading, Mass.: Addison-Wesley, 1969. A classic article, scholarly and thorough.

Wilmot, William. *Dyadic Communication.* Reading, Mass.: Addison-Wesley, 1975. Clear discussion of the perceptual process.

Listening:
An Active Process

CHAPTER PREVIEW

After experiencing this chapter, you should be able to:

Define "listening"

Explain the nature of serial communication

Identify the amount of time you spend listening

Compare and contrast the effects of helpful and harmful listening habits

Distinguish between the hearing and listening process

Explain the *Listening Level Energy Involvement Scale*

Define "feedback"

Describe the ways in which feedback affects interpersonal communication

Demonstrate an ability to use the different types of evaluative and nonevaluative feedback discussed

Focus your attention while listening

Set appropriate listening goals

Listen to understand ideas

Listen to retain information

Listen to evaluate and analyze content

Listen emphatically

Knowing how to listen takes more
than two good ears.

Sperry Corporation

"What's the point of talking,
You don't listen to me, anyway."

A number of prominent American corporations have recently launched
advertising campaigns designed to promote an awareness of the importance of listening.
Running through the companies' advertisements are slogans such as:

"Did you hear that?"

"Listening is more than just good philosophy. It's vital to our future."

"How can we expect them to learn when we haven't taught them how
to listen?"

Do you believe you listen well? Far too frequently, listening is something we take for
granted. However, listening is a difficult, intricate skill, and like other skills, it requires
training and practice.

WHY LISTEN?

All of us engage in the following activities: we interact face-to-face with friends and
acquaintances, we use the telephone, we attend meetings, we participate in interviews,
we take part in arguments, we give or receive instructions, we make decisions based on
information received orally, and we generate or receive feedback. We do all this without
paying much attention to the role that listening plays in each of our experiences. If any

of the following statements sound familiar to you, you could stand to improve your ear-power—that is, you could stand to improve your listening effectiveness.

Think back over the years you have spent as a student. Did you receive training in writing? reading? speaking? The answer to each of these questions is probably yes. In fact, many children now learn to read and write before they start school; even more important, reading and writing skills are taught and emphasized throughout our educational careers. In addition, courses in writing and speed reading have recently become popular, if expensive, offerings in adult-oriented programs. We often take public speaking courses as a part of our educational sequences, and oral presentations are required in many of our classes. But what about listening? How much training have you actually received in listening? Of the four communication skills—reading, writing, speaking, and listening—listening has received the least attention from educators. Studies, however, show that on the average we spend 42 percent of our communicative time listening, 32 percent speaking, 15 percent reading and only 11 percent writing. Do we not receive listening training because we are innately good listeners? Are we born knowing how to listen? The answer to each of these questions is no. How efficient are your personal listening skills? In the

Although it is crucial to education, listening is one skill that is rarely taught in classrooms.
(© Erich Hartmann/Magnum)

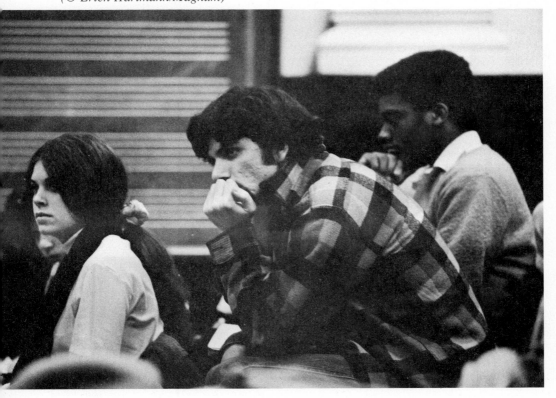

space provided, estimate the percentage of listened-to information that you believe you retain:

Personal Listening
Efficiency Estimate: _____%

Your response gives you an indication of how good a listener you *think* you are, but how good a listener are you really? Let's find out.

It's Time to Stamp Out Unlistening Problems

Experience has shown that most people estimate that they listen with 70 to 80 percent accuracy. This means that a majority feel they can relate interpersonally with others and accurately retain 70 to 80 percent of what is said. In contrast, Ralph Nichols, a noted listening researcher, tells us that most of the people he has studied actually listen at only 25 percent efficiency—that is, instead of retaining 75 percent of what is said, they lose 75 percent of what they hear. How effective do you think your writing would be if 75 percent of your work contained writing errors? What grade would you receive if you misspelled 75 percent of the words you used in an essay or if you incorrectly punctuated 75 percent of your paper? And yet, we seem content to listen at 25 percent efficiency. In *Are You Listening?* (1957), Nichols and his coauthor Leonard Stevens point out how poor our listening habits are by referring to a very famous example.

At 8 P.M. on October 30, 1938, about six million people across the United States heard the following announcement on their radios:

"The Columbia Broadcasting System and its affiliated stations present Orson Welles and the Mercury Theatre of the Air in *The War of the Worlds,* by H.G. Wells."

The announcement was followed by a weather report and dance music. Suddenly, the dance music was interrupted with a "flash" news story. "A series of gas explosions has just been noted on the planet Mars," said the announcement. The broadcast went on to report that a meteor had landed near Princeton, New Jersey, killing fifteen hundred persons. Before many minutes, however, the announcer explained that it wasn't a meteor, but a metal cylinder from which poured Martian creatures with death rays to attack the earth.

The program lasted one hour. At the half hour, two announcements were made indicating that what people were hearing was only a fictitious story. The same sort of an announcement was made at the program's conclusion. And at least 60% of all stations carrying the program interrupted the play to say it was fiction.

But at their radios that night, there were about a million people who missed these announcements. Only the word "invasion" caught their ears, and it gripped them with fear.

Twenty families on a single block in Newark, New Jersey, rushed from their homes to escape what they thought was a gas raid. Their faces were covered with wet towels and handkerchiefs.

A San Francisco man phoned authorities: "My God, where can I vol-

unteer my services?" he said. "We've got to stop this awful thing."

In Mount Vernon, New York, a man who was considered a hopeless invalid heard the broadcast. With the news of "invasion" he rushed from his home, climbed into an automobile, and disappeared.

Unfortunately, despite years of supposed "listening practice," errors in listening are common. According to communication theorist William Haney, we frequently run into problems when we use serial communication or chain-of-command transmissions to relay messages. What happens in serial communication is that person one sends a message to person two; person two then communicates his or her perception of person one's message (not person one's message) to person three, who continues the process. The following example from "Permutation Personified" in *Boles Letter* (1962) by Edmond D. Boles will further clarify the serial communication concept.

PERMUTATION PERSONIFIED

Despite telemetering advances, improvements in mechanical transmission of data and collating total knowledge, there are occasional breakdowns in communication. We're indebted to a traveler recently returned from Miami for this example.

Operation: Halley's Comet

A Colonel issued the following directive to his executive officer:
"Tomorrow evening at approximately 2000 hours Halley's Comet will be visible in this area, an event which occurs only once every 75 years. Have the men fall out in the battalion area in fatigues, and I will explain this rare phenomenon to them. In case of rain, we will not be able to see anything, so assemble the men in the theatre and I will show them films of it."
Executive Officer to Company Commander:
"By order of the colonel, tomorrow at 2000 hours, Halley's Comet will appear above the battalion area. If it rains, fall the men out in fatigues. Then march to the theatre, where the rare phenomenon will take place, something which occurs only once every 75 years."
Company Commander to Lieutenant:
"By order of the colonel in fatigues at 2000 hours tomorrow evening, the phenomenal Halley's Comet will appear in the theatre. In case of rain in the battalion area, the colonel will give another order, something which occurs once every 75 years."
Lieutenant to Sergeant:
"Tomorrow at 2000 hours, the colonel will appear in the theatre with Halley's Comet, something which happens every 75 years. If it rains, the colonel will order the comet into the battalion area."
Sergeant to Squad:
"When it rains tomorrow at 2000 hours, the phenomenal 75-year-old General Halley, accompanied by the Colonel, will drive his Comet through the battalion area theatre in fatigues."

Although the example is fictional, let us use it to examine what happened and why. As is noted by John R. Freund and Arnold Nelson in "Distortion in Communication," whenever one individual speaks or delivers a message to a second individual, the message occurs in at least four different forms:

1. The message as it exists in the mind of the speaker (his or her thoughts)
2. The message as it is spoken (actually encoded by the speaker)
3. The message as it is interpreted (decoded by the listener)
4. The message as it is ultimately remembered by the listener (affected by the listener's personal selectivities and rejection preferences)

Thus, ideas get distorted by as much as 80 percent as they travel through the unwieldy "chain of command." A number of factors cause this. First, we like to simplify messages. Passing along complex, confusing information poses many problems for us. To avoid dealing with these problems, we unconsciously delete information from the messages we

SKILL BUILDER

LISTENING LOG

1. Use the following chart to determine your reasons for listening and the percentage of each waking day you spend listening to others. At the end of each hour, simply estimate the number of minutes you spent listening, and note the type of listening activity in which you were engaged.

LOG

Time	Number of Minutes Spent Listening	Types of Listening Activities—That Is, My Reasons for Listening
8:00–9:00		
9:00–10:00		
10:00–11:00		
11:00–12:00		
12:00–1:00		
1:00–2:00		

receive before we pass the information along to others. Second, we like to think the messages we pass along to others make sense. We feel we will look foolish if we convey a message we do not seem to understand or if we deliver a message that appears to be illogical. Thus, we try to "make sense out of it" before we communicate it to someone else. We do this by adding to or altering what we have heard. Unfortunately, once we "make sense out of the message," it may no longer correspond to the message that was originally sent to us. Such errors occur even though we have had years to practice listening. In fact, communicologist Gerald Goldhaber estimates that a twenty-year-old person has practiced listening for at least ten-thousand hours, a thirty-year-old has practiced at least fifteen-thousand hours, and a typical forty-year-old has had twenty-thousand hours or more of listening practice. The figures are mind boggling, but have we really been practicing "unlistening" instead of listening?

How much time do you actually spend listening? Why do you listen? Complete the exercise below to find out.

LOG

Time	Number of Minutes Spent Listening	Types of Listening Activities—That Is, My Reasons for Listening
2:00–3:00		
3:00–4:00		
4:00–5:00		
5:00–6:00		
6:00–7:00		
7:00–8:00		
8:00–9:00		
9:00–10:00		
10:00–11:00		

2. At the end of the day, divide the total minutes you spent listening by the total number of minutes you were awake. The resulting figure represents the percentage of your time that was spent listening.

Was your day typical? Did you spend more or less time listening than you had imagined? What types of situations demanded that you listen? Your list probably demonstrated that you listened for a variety of reasons. At times you may listen to be courteous; other times you may listen for profit. At times you may listen out of fear; other times you may listen to be entertained. At times you may listen to share meaning; other times you may listen to gather information that you hope to use to impress others. In any case, your chart should demonstrate why it is so important for you, the interpersonal communicator, to develop skillful listening habits. Your chart should reveal that listening takes up a very important and very significant portion of your waking day. In effect, it should show you that you need to listen as if your life depended on it. You need to work to stamp out "unlistening habits." Let's start now!

SKILL BUILDER

PROBLEMS AND BENEFITS

1. Make a list of five or more problems that could result (or have resulted) from unlistening—that is, from deficient listening skills.

 A.
 B.
 C.
 D.
 E.

2. Make a list of five or more benefits that could result from improving your listening skills.

 A.
 B.
 C.
 D.
 E.

People who listen effectively demonstrate a sense of caring and concern for those with whom they interact. In contrast, people who do not listen effectively tend to drive people away from them. Thus, by listening accurately, you help avoid interpersonal difficulties and breakdowns. An old proverb reads: "Nature gave us two ears and one mouth so we can listen twice as much as we speak." In many ways this statement should serve as a guide for the interpersonal communicator, because the effective communicator is not afraid to be two parts listener and one part speaker. Who has primary responsibility for effective communication—the speaker or the listener? Since we all function as senders and receivers, we believe that both must share the responsibility. We believe each should

take 51 percent of the responsibility. That adds up to 102 percent. While that may not be mathematically sound, it would increase the effectiveness of our communicative efforts.

HEARING VS. LISTENING

Hearing and listening are not one and the same thing. Unlike hearing, listening is a skill we acquire. Thus, whereas most people are born with an ability to hear or not hear, all of us who hear need to learn to listen. Hearing and listening both involve aural stimuli. That is, during both the hearing and the listening process, sound waves enter the ear. It is apparent that we hear and listen to a wide variety of sounds, including words, music, and noise. Let us now briefly examine the hearing process so that we may differentiate it from listening.

During a basic hearing experience, sound waves are simply transformed by the ear into electrochemical energy. It happens much like this: Let's say you strike a note on a piano. The hammer of the key contacts a string, which vibrates back and forth very rapidly causing a disturbance in the air.

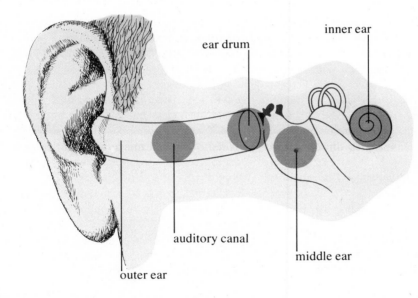

inner ear

ear drum

auditory canal

middle ear

outer ear

This disturbance travels through the air at 1,100 feet per second. The sound waves then hit your ear drum, a membrane stretched across your auditory canal much as a skin is stretched across a bass drum. The vibration is transformed into electrochemical energy by the mechanisms within your ear. Finally, the energy is carried by your nervous system to your brain. Thus, hearing occurs automatically. It requires no conscious effort on your part. If the physiological elements within your ear are functioning properly, the brain will process the received electrochemical impulses, and you will hear. However, what you do with the impulses you receive belongs in the realm of listening. It is listening that

gives you the option of ignoring the sounds you automatically hear. Far too many sounds bombard you each day for you to be able to attend to each.

SKILL BUILDER

LISTEN TO THE SOUNDS

Increase your awareness of the number of sounds you hear versus those you actually listen to by participating in this exercise. Begin by closing your eyes and listening. Attempt to listen to every sound around you, making a mental list of the sounds you notice. After sixty seconds have elapsed, open your eyes and commit your mental list of sounds to paper. Then compare and contrast lists with those around you.

To what extent did more sounds than you expected bombard you? Why? Did some people around you perceive sounds that you did not? Why? To what extent did the place where you were sitting affect what you heard?

Most likely, you now realize that you noticed many more sounds during the experience than you would have been aware of under normal circumstances. Ordinarily, you would not have listened to each sound or noise in your environment. Many of the sounds you hear are simply not relevant to you, your activities, or your interests.

Thus far, we have established that hearing is a physical process over which we have little control. But what is listening? As we will see, listening is a complex set of skills. It is an active process through which we seek to understand and retain aural stimuli. Thus, while hearing simply happens to us and we cannot manipulate it, listening requires us to make an active, conscious effort to comprehend and remember what we hear. Of course, who we are affects what we listen to. Several people can listen to the same stimulus and understand or retain very different parts of it.

When we listen, we actively process the external sounds of our environment. This is not to say, however, that listening is just an external process. Listening is also an internal process. We listen to the sounds we hear, and we listen to what others say, but we also listen to what we say aloud and what we say to ourselves in response. Thus, listening is a complex process that goes beyond hearing; listening involves conscious thought. Do you ever talk to yourself? Are you your own best listener? Most of us are!

LISTENING LEVELS

We have seen that hearing is a natural process. When we hear, we employ little if any conscious effort. Listening, on the other hand, is an active process. But, how active is it? How much effort must we expend to listen effectively? For example, do you work harder when you are listening to a professor's lecture that you believe covers important material or when you are listening to a disc jockey routinely announcing an upcoming recording that you like but is of little consequence to you? In many ways, listening is similar to reading. Some material we read very carefully and very closely, and other

material we scan quickly to abstract only relevant facts. For still other material, we need only check the title and author to know we do not care to read it. We approach the information we receive aurally in much the same way. Some information we pass over lightly, and other information we attend to with more care. In other words, if the information is important to us, we work harder to retain it.

To help you begin to develop more effective listening skills, we have identified four levels of receiving. An understanding of these levels should serve you as personal guideposts and help you assess your interpersonal listening effectiveness. Begin by examining the *Listening Level Energy Involvement Scale:*

LISTENING LEVEL ENERGY INVOLVEMENT SCALE

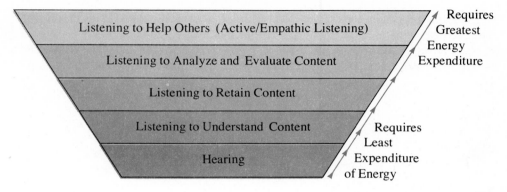

Listening to Help Others (Active/Empathic Listening)

Listening to Analyze and Evaluate Content

Listening to Retain Content

Listening to Understand Content

Hearing

Requires Greatest Energy Expenditure

Requires Least Expenditure of Energy

As our model indicates, hearing requires little if any energy expenditure or involvement on your part. In contrast, listening to understand requires a somewhat greater expenditure of energy. You now need to insure that you comprehend what is being said. Remembering or retaining a message requires even more effort on your part, and working to analyze and evaluate what is said is still more difficult and consumes more energy. When we listen to help others (engage in active or empathic listening), we are required to exhibit an even greater degree of involvement—as we shall see—and consequently we expend even more energy.

A problem shared by many poor listeners is the inability to determine the listening or involvement level appropriate to a given situation. For example, in a course with large lecture sections, it is not uncommon to find some students "tuning out"—simply hearing when they should be listening to understand, retain, analyze, and evaluate content so as to improve their performance on examinations. All too frequently, these same individuals are quite adamant in asserting that certain points were never covered in class: "I was sitting right here, and I never heard you say that!" is an all too familiar refrain. Let's examine an example of what can happen when people fail to listen effectively at the appropriate level.

Kevin Daly, founder of Communispond, a company that helps train executives to communicate their ideas more effectively, reports that the president of a steel company in Pittsburgh had aides prepare a news

release for him to read at a press conference. The release, as written by his speech writers, was eleven pages. The president did not have time to review the manuscript before arriving at the conference and taking his place at the podium. Nonetheless, he began to read the announcement confidently. As he continued reading the lengthy statement, he realized that page eight had been printed twice. Indeed, he was now reading page eight aloud for the second time. Somewhat flustered, he gazed out at the audience, only to observe that there was "no quiver of recognition" among his listeners. He finished reading the release certain that no one had picked up his error. He was right. The mistake was never reported.

Why didn't the audience—all of them educated individuals—listen critically to what they were being told? How could they fail to perceive so blatant an error? How could they effectively evaluate what was said to them if they were obviously unaware of the content? Are you a more effective listener than the persons referred to in the story? Are you sure?

A major portion of this chapter will be devoted to helping you develop the skills that will enable you to function effectively at each of these four listening levels. Before beginning this work, however, we would like to consider the related concept of feedback. Feedback consists of the messages we send that help individuals who are trying to communicate with us determine if we understand and accept their messages. Feedback cues permit our cocommunicators to adjust their messages as needed. Knowing how to give and receive feedback is a prerequisite to improving our interpersonal listening skill. With this in mind, let us examine the feedback process.

FEEDBACK: A PREREQUISITE FOR EFFECTIVE LISTENING

The feedback process is intimately connected with the listening process. Developing an understanding and appreciation of the way feedback works is essential if you are to build a secure foundation for improving your listening skills.

What Is Feedback?

The word "feedback" seems to imply that we are feeding someone by giving something back to the person. Indeed, this is true. Feedback refers to all of the verbal and nonverbal messages that a receiver consciously or unconsciously sends in response to another sender's communication. As students, you continually provide your instructors with feedback. Many of you, however, are probably not completely honest when you communicate feedback. At times when you are confused or bored, you may put on an "I'm interested" face, smile, and nod your head, indicating that you understand and agree with everything your professor has said. We are certain that, on one day or another, though you were completely baffled by a class you attended, you nevertheless nodded in an affirmative manner when the instructor glanced your way. Unfortunately, such

behavior tends to encourage your instructor to continue sending the messages, when it would be more appropriate for him or her to backtrack and explain. If class members admitted confusion, the instructor would be more likely to go back over the fuzzy material, find alternative ways to state or present the concepts, and formulate new, more interesting examples. In many ways, the quality of teaching is a reflection of the quality of feedback you provide. Feedback affects communication. The following experiences will demonstrate how.

SKILL BUILDER

SMILES AND FROWNS

1. For tomorrow, make a conscious effort to smile at each person you meet or communicate with. Do this for individuals you see and talk to during class, in between class, at lunch, at work, and at home. You may carry on a normal conversation with each person, just be certain to smile. In other words, do not let the topic you are discussing or your feelings influence your demeanor. When others ask why you are smiling, simply reply that you are in a good mood. Do not reveal that you are participating in a class exercise. As the hours pass, keep notes on the reactions of those who interact directly or indirectly with you.

2. Repeat the above exercise the next day; however, this time put on a solemn or sad face whenever you interact with someone. Again record the reaction of the individuals who communicate directly or indirectly with you.

3. How did your friends, instructors, or relatives react to your happy and sad faces? To what extent were a person's responses to you influenced by your demeanor? What were each individual's specific reactions or comments? To what degree did the feedback you provided affect the tone and the content of the communication experience? Use the accompanying chart to help evaluate your experience:

Name of Person	Condition (Smile/Frown)	Topic	Responses to Me
1.			
2.			
3.			
4.			
5.			
(etc.)			

You probably found that the kind of feedback you provided affected the type and amount of verbal and nonverbal communication you received. Some individuals respond

more actively and talk at greater length when a listener is smiling at them than when a listener appears to be sad or bored. We must recognize that the nature of the feedback we give people will affect the communicative interactions we share with them.

SISTER, CAN YOU SPARE A SMILE?

By Dove Bradshaw

The good Sisters who sit collecting in the subway corridors under Grand Central Terminal generally look pretty glum. One day I saw one smiling, and the activity at her basket seemed unusually brisk. Cause or effect? As a performance artist, I saw the makings of an experiment. What *is* the value of a smile, anyway? I'd pose as a nun on two successive days—deadpan the first, smiling the next.

Armed with permission from the Transit Authority, a rented habit, and a folding chair, I set out one Tuesday morning. I arrived at eight, after a truly first-class subway trip—seats had been offered, hats doffed, doors held.

I planted the chair in an empty corner and, with a wicker basket balanced on my knees, gazed vacantly before me. Coins began falling into the basket.

People of all kinds came up. A white-haired executive softly asked me to pray for him as he dropped a $5 bill into the basket. At a moment when the passage was empty, three rough-looking boys approached, their hands in their pockets. I thought they meant to rob me—until two of them gave me money.

I looked up at one point to see a smartly dressed woman standing before me. "Does God forgive an abomination?" she asked.

This I was not prepared for. I recalled something from a conversation with a Catholic friend. "With a firm purpose of amendment, it is possible."

The woman looked relieved. She made no offering, but thanked me.

In late morning, when traffic was light, a shopping-bag lady sidled up and stood at my elbow. She did not look at me. At last I held the full basket out to her. She carefully picked out two quarters, then moved quickly away without a word.

The first day's collection with a straight face amounted to $143 and change; "service with a smile" on the second day reaped a 30 percent improvement—a $186 total.

My plan at the outset had been to honor the intention of those who gave by sending their offerings to a Catholic institution. I learned that the nuns in Grand Central are out-of-towners from White Plains. I called the mother superior; would she accept what I had collected with my good wishes? She would not. She didn't sound displeased, just unreceptive. She suggested that *I* choose a charity. I'd always heard good things about CARE. They're the people who got the check.

New York magazine,
February 25, 1980, p. 7

Let us now examine more closely the types of feedback we can give and the types we can receive.

Types of Feedback

We constantly provide others with feedback, whether we intend to do so or not. Imagine a man who writes fifty love letters to the woman of his dreams but receives no answer. Did the man receive feedback? Certainly! In this case, no response is also a response. Thus, everything we do or fail to do in a relationship we share with others can be considered feedback. Sometimes feedback is given consciously and is intended to evoke a particular response from the person communicating with us. For example, if you laugh or chuckle at a friend's joke or story, you may be doing so because you want your friend to feel that you enjoyed the story and you hope that she will tell more jokes. In contrast, some of the feedback messages we send to others are sent unconsciously and evoke unintentional or unexpected responses. For example, have your words or behaviors ever prompted another individual to exhibit a reaction you never intended to precipitate? Such situations are often followed by useless phrases such as, "That's not what I meant!" or, "I didn't mean it that way. What I meant was . . ."

SKILL BUILDER

THE EXPECTED VS. THE UNEXPECTED

1. Describe a situation where a feedback message you sent was interpreted as intended. What effect did your feedback have on the nature of the relationship?
2. Describe a situation when a feedback message you sent was misinterpreted. What effect did your feedback have on the nature of that relationship?

As we can see, what we intend to convey by the feedback messages we send may not be what others perceive. Sometimes others intentionally choose not to perceive our messages. At other times, confusion comes about because feedback that we mean to be nonevaluative in tone is interpreted by our cocommunicator as evaluative in tone. Let us next examine the differences between these two feedback categories. Distinguishing them will help us use both types effectively and appropriately during interpersonal encounters.

Evaluative Feedback. When we provide another person with an evaluative response, we state our opinion about a matter being discussed. Thus the question, "How do you like my new dress?" will almost always evoke a response that will be perceived as evaluative in tone. For example, a slight hesitation before the words, "I love it," might be perceived as connoting a negative response. When we give evaluative feedback we make judgments—either good or bad—based on our own system of values. In many situations, such judgments need to be made. For instance, we should evaluate the relative worth of ideas, the importance of projects, and the classifications of abilities.

By its very nature, the effect of evaluative feedback is either positive and rewarding or negative and punishing. *Positive evaluative feedback* tends to keep the communication and resulting behaviors moving in the direction in which they are already heading. If a company places an advertisement and receives a tremendous growth in sales, the company will tend to place the same or a very similar ad in the same or very similar media in the future. If a person begins wearing a new hair style and is showered with compliments, he will tend to keep that hair style. If you are speaking to your instructor and she appears receptive to your ideas and suggestions, you will tend to continue offering those ideas and suggestions. Thus, positive evaluative feedback serves to make us continue behaving as we are already behaving. It enhances or reinforces existing conditions or actions.

On the other hand, *negative evaluative feedback* tends to serve a corrective function in that it helps to extinguish undesirable communicator behaviors. Thus, when we or others perceive feedback as negative in tone, we tend to change or modify our performance accordingly. For example, suppose you told a number of "off-color" stories that your listeners judged to be in bad taste. Your listeners would send negative responses to you: They might turn away from you, attempt to change the subject, or simply maintain a cold, lengthy silence. Each cue they sent would tell you that your message had overstepped the bounds of propriety.

As human beings, we learn to make evaluations in many contexts: we
make judgments not only about people, but about objects and
situations as well.
(© Paul Fusco/Magnum)

Whenever you send evaluative feedback messages, whether positive or negative, it is
advisable to preface your statements in such a way that your cocommunicator realizes
that what you are offering is your opinion only. Such phrases as "It seems to me . . . ,"
"In my opinion . . . ," or "I think . . ." are usually helpful. They let the target of
your remarks know that you realize that other opinions and options are available. When
possible, avoid using phrases of the "you must" or "that's stupid" type. Such comments
almost always elicit a certain amount of defensiveness in people. In contrast, couching
positive and negative feedback in less than adamant terms tends to make your comments
more acceptable and creates a climate that helps rather than stifles the relationship.

A special kind of negative evaluative feedback is called *formative feedback*. Don Tosti,
an industrial psychologist, utilized timed negative evaluative feedback with some inter-
esting results. Tosti discovered that in a learning situation it is best to provide positive
feedback to an individual immediately after the individual has displayed a desired behavior.
Thus, comments such as "You did a good job" or "Keep up the good work" would be
offered immediately after the desired behavior was exhibited. Such responses give people
a sense of pride; they become pleased with themselves and their work. Tosti, however,
suggests that negative feedback—or what he calls "formative feedback"—should only

be given just before the same (or a similar) activity is to be performed again. Withholding negative feedback until the individual really needs it, in Tosti's eyes, makes the negative, or formative, feedback seem like coaching rather than criticism. Comments such as "Okay team, let's eliminate the errors we made last time. When you go out there today, try to . . . ," or "The last time you trimmed the hedge, it was a little too short. This time . . . ," or "I wasn't really satisfied with the restaurant we ate at last week. Could we go someplace else this week?" help to alleviate the extent to which negative feedback is perceived to be a harmful rather than helpful force. Thus, saving formative or negative feedback until just before an activity is to be repeated can help eliminate the feelings of rejection that sometimes accompany negative judgments. In contrast, it should be emphasized that the immediate dispensing of positive feedback can do wonders for your cocommunicator's self-image and morale.

The implications of Tosti's findings for interpersonal communication are many. For example, what if you handed in a paper to your instructor, and after reading it, he handed you a list containing only his positive observations. Not until the instructor made the next assignment would he offer you formative, or negative, feedback in a list containing errors to avoid. With formative feedback, it is the timing that counts. Test the theory behind formative feedback by using formative feedback in your own interpersonal communications.

Unlike traditional negative evaluative feedback, formative feedback does not tend to discourage an individual from attempting to perform an activity again. It does not tend to demoralize that person.

Nonevaluative Feedback. In contrast to evaluative feedback, nonevaluative feedback makes no overt attempt to direct the actions of a communicator. Thus, we use nonevaluative feedback when we want to learn more about a person's feelings or when we want to aid another person in formulating thoughts about a particular subject. When we offer nonevaluative feedback, we make no reference to our personal opinions or judgments. Instead, we simply describe, question, or indicate an interest in what the other person is saying to us.

Despite its nonjudgmental nature, nonevaluative (or nondirective) feedback is often construed as positive in tone. That is, our cocommunicator's behavior is reinforced as we probe, interpret his or her message, and offer support as he or she attempts to work through a problem. Nonevaluative feedback actually reaches beyond the realm of positive feedback, however, because nonevaluative feedback provides others with an opportunity to examine their own problems and solve them in their own way. For this reason, carefully phrased nonevaluative feedback can be an enormous aid to people and sustain them as they go through difficult periods.

We will consider four kinds of nonevaluative feedback, three identified by David Johnson—probing, understanding, and supporting—and a fourth—"I" messages—identified by Thomas Gordon.

Probing is a nonevaluative technique in which we ask an individual for additional information. Our goal is to draw out the other person and let him or her know that we

are willing to listen to the problem. For example, if a student was concerned with her grades in a particular course and said to you, "I'm really upset. All of my friends are doing better in geology than I am," how would you respond? If you chose to utilize the nonevaluative technique of probing, you might ask, "Why does the situation you described bother you?" or, "What is there about not getting good grades that concerns you?" or, "What do you suppose caused this to happen?" Responding in this fashion gives the other person the chance to think through the overall nature of her problem while providing her with needed opportunities for emotional release. In contrast, comments like "So what. Who cares about that dumb class?" or "Grades don't matter. What are you worrying about?" or "You really were dumb when you stopped studying," would tend to stop the student from thinking through and discussing her problem; instead they would cause her to experience feelings of defensiveness.

A second kind of nonevaluative response is what Johnson terms *understanding*. When we offer understanding we seek to comprehend what the other person is saying to us, and we check ourselves by paraphrasing (restating) what we believe we have heard. Our paraphrasing of what has been said shows that we care about the other person and the problem he or she is facing. Examine the following paraphrases in order to develop a feel for the nature of the understanding response:

PERSON 1: I don't think I have the skill to be picked for the team.

PERSON 2: You believe you're not good enough to make the team this year?

PERSON 1: I envy those guys so much.

PERSON 2: You mean you're jealous of the people in that group?

If we use understanding responses early in a relationship, in effect we communicate to our partner that we care about the interaction enough to want to be certain we comprehend what he or she is saying to us. Such responses encourage the relationship to develop because they encourage the other person to elaborate by describing and detailing personal feelings. By delivering understanding responses verbally and nonverbally, we also support the other person by showing that we are sensitive to his or her feelings and are willing to really listen.

A third kind of nonevaluative feedback is what Johnson refers to as *supportive* feedback. By giving supportive feedback, we indicate that a problem an individual deems important and significant is also viewed by us as important and significant. For example, suppose a friend comes to you with a problem that he feels is extremely serious. Perhaps he has worked himself into a state of extreme agitation and implies that you cannot possibly understand his situation. What would you do? You would want to calm your friend down by assuring him that the world has not ended and that you do understand his problem. Offering others supportive feedback is difficult. We need to reduce their intensity of feeling while letting them know that we believe their problems to be real. Such comments as "It's stupid to worry about that," or "Is that all that's worrying you? That's nothing!" are certainly not supportive. A better approach might be to say, "I can see you are upset. Let's talk about it. I'm sure you can find a viable way to solve the problem." A friend who is upset because she just failed an exam needs supportive feedback: "I can see you

are worried. I don't blame you for being upset.'' This is certainly not the time to suggest that she has no valid reason to be upset or that her feelings are inappropriate. It would be foolish to say, ''Next time you'll know better. I told you not studying wouldn't get you anywhere, you idiot.'' When we use supportive feedback, we judge the problem to be important, but we do not attempt to solve other people's problems for them. Instead, we simply offer evaluations about the importance of the problem and encourage the individual to discover his or her own solutions.

The final kind of nonevaluative feedback messages we will refer to are called *''I'' messages*. This term was coined by Thomas Gordon, author of *Leader Effectiveness Training*. When we deliver ''I'' messages, we do not pass judgment on the actions of others, but rather, we convey our feelings about the nature of the communicative situation to them. According to Gordon, when people interact with us, they are often unaware of how their actions affect us. We have an option to provide these persons with either evaluative or nonevaluative feedback. Neither type is inherently good or bad. However, far too often, the way we formulate our evaluative feedback adversely affects the nature of our interactions and the growth of our relationship. For example, do any of these statements sound familiar? ''You made me angry!'' ''You are a bad boy!'' ''You are in my way!'' ''You are a slob.'' What do each of these statements have in common? As you have probably noticed, they each contain the word *you*. Thus, each statement places the blame on another person. As relationships experience difficulties, the involved parties tend to resort more and more to name calling and placing blame as ways to deal with their situation. Such feedback messages serve to create schisms between people that are difficult and sometimes even impossible to bridge. To avoid this, Gordon suggests that we replace ''you'' messages with ''I'' messages. If, for example, a parent tells a child, ''You are pestering me,'' the child's interpretation will probably be, ''I am bad,'' precipitating a certain amount of defensiveness or hostility toward the parent on the part of the child: ''I am not bad!'' On the other hand, if the parent tells the child, ''I'm really very tired and I do not feel like playing right now,'' the child's reaction is more likely to be, ''Mom is tired.'' Such an approach is more apt to elicit the type of behavior the parent wants than the name-calling, blame-placing ''You are a pest'' statement would.

The point is that if the respondent communicates his or her feelings about a situation, the other person is more likely to take those feelings into consideration as the relationship progresses. Keeping this in mind, which of the following messages do you believe would be more likely to evoke a favorable response?

SITUATION: A supervisor is speaking to his workers.
SUPERVISOR: You lazy bums. We'll never meet the deadline if you don't work faster!
or
I'm afraid that if we don't work faster, we'll miss the deadline, and the company will lose a lot of money.

Right! The second statement would not produce the feelings of defensiveness that would be engendered by the first. Check your understanding of ''I'' messages by participating in the next exercise.

There is one other quality you should realize about "I" messages and their use. It is quite common for any of us to say, "I am angry" to another person. Anger, however, is a secondary emotion. We are angry because of something else, because of another stimulus. In actuality, we "develop" anger. For example, should your child or a child you are watching run into the street, your first response would probably be fear. Only after the child was safe would you develop anger, and then you would probably share your anger with the child. When formulating angry "I" messages during your communicative encounters, be certain to look beyond or below your anger. Ask yourself why you are angry. Attempt to determine the forces that precipitated your anger—these are feelings that should be expressed. Thus, if someone says something that hurts you, try to find ways to express your hurt rather than simply venting the resulting anger. Using "I" messages as feedback will not always evoke the behavior you want from the other party, but they will help to prevent defensive, self-serving behaviors that "you" messages frequently elicit.

At this point, ask yourself which type of feedback you think is best. Which do you feel is most important? The categories and types of feedback we have discussed are neither good nor bad. Each may be put to good use. Thus, whether you choose to offer evaluative or nonevaluative responses depends on the individual with whom you are interacting and the nature of the interpersonal situation in which you find yourself.

Effects of Feedback

How do you think feedback affects interpersonal communication? Suppose, for example, someone was telling you a very funny story. What would happen if you consciously decide to treat this man politely, but you also decided that you would neither smile nor

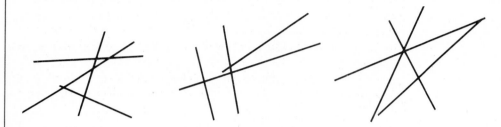
laugh at what he said? We have found that such polite but somber reactions can cause the best of storytellers to stop communicating. Sometimes in the middle of a story, the teller will notice that the listener is not amused. At this point, in an attempt to determine if the listener heard what was said, the teller will repeat or rephrase key phrases of the story: "Don't you understand? What happened was . . ." or "You see, what this means is . . ." It is clear that the feedback given to the storyteller, or to a participant in any interpersonal encounter for that matter, strongly influences the direction and outcome of that interaction. You might want to try this "no laugh" procedure the next time someone begins to relate a humorous incident or tale to you. If you do, be sure to note how your not laughing affected the sender and his or her abilities to formulate a message.

We can study the way feedback affects the development of our interpersonal relationships by adapting the experiment above performed by Harold Leavitt and Ronald Mueller and reported in a 1968 article entitled, "Some Effects of Feedback on Communication."

Usually, feedback increases the accuracy with which information is passed from person to person. However, it also increases the amount of time required to transmit information. Under zero-feedback conditions (phase one of the exercise), the speaker requires less time to transmit the information to the receiver than under either the limited feedback (second phase of the exercise) or free feedback conditions (third phase of the exercise). Still, most communicators feel that the added time is more than compensated for by the increased accuracy of the replications. In other words, under free feedback conditions, time is not wasted.

partner and neither watch nor comment on his or her efforts. Also, your partner is not allowed to speak or look at you during this phase of the experience. This approximates a zero-feedback (no feedback) condition.

B. When you describe the second design, you may turn around and watch your partner work. You may comment on what he or she is drawing, but your partner may not speak to or look at you. This approximates a limited feedback condition.

C. Finally, when you communicate a description of your third design to your partner, you may interact openly with each other. You may observe and comment on your partner's efforts, and your partner may interact with you by facing you and asking you questions that permit him or her to check on the accuracy of the drawing. This approximates a free feedback condition.

If time permits, partners should reverse roles and repeat the above three steps.

3. Which condition produced the quickest replication? Why? Which condition produced the most accurate replication? Why? During which phase of the experience were you most confident? Least confident? Why? How did functioning as sender or receiver alter your feelings during each phase of the experience?

HOW TO INCREASE YOUR EAR POWER: A LISTENING IMPROVEMENT PROGRAM

The first step in developing effective listening habits is to develop an awareness of the importance and effects of listening. The second step is to develop an awareness of the importance and effects of feedback. This much we have accomplished. The next step is to develop your listening skills by participating in a series of exercises and experiences. It should be pointed out that if you really are to improve your listening, these exercises should not merely be done once and put aside. Your listening skill will improve only if you return to try these and similar experiences repeatedly. The suggestions presented here will help you learn to focus your attention so that you will be better able to listen to understand, retain, analyze and evaluate content, and help others. Our listening improvement program will also provide you with the tools you need to give adequate and appropriate feedback to those with whom you interact. Mastering or accomplishing each of these goals will increase the effectiveness of your interpersonal communication encounters.

Focus Your Attention While Listening

Let's begin our listening improvement program by first considering our need to be able to focus our attention. It is apparent that if we are to listen effectively, we must be able

to pay attention to what is being communicated. However, numerous internal and external stimuli bombard us and compete for our attention.

The difficulties we experience when attempting to focus attention are confirmed by the number of times we are admonished to "pay attention." When was the last time someone uttered words to you like the following: "He told us that in class. Weren't you paying attention?" All too frequently the response is, "Well, I thought I was." We will explore several ways in which you can work to improve your ability to consciously attend to information. Before beginning, we should emphasize that learning to focus your attention will be a lifelong battle. In fact, in the book *Human Listening*, Carl Weaver points out that the type of attention we are able to give to a stimulus continually increases and decreases in intensity. Weaver notes that at times our attentiveness level fades to such a degree that we actually lapse into moments of "microsleep." Unfortunately, when this happens, no matter how hard we try to attend to the stimuli, we will miss some of it because we are, in effect, asleep.

To master a skill, we must learn how to focus our attention so that we are not distracted by the competing stimuli that constantly bombard us. (© J. Berndt/Stock, Boston)

Of course, by learning to actively focus your attention, you can reduce your moments of microsleep activity to a minimum. Accomplishing this will help insure that you will not let microsleep periods cause you to miss important information. If you are to conquer the microsleep phenomenon and improve your listening skills, one of your main needs is to learn to handle your emotions. Feelings of hate, fear, anger, happiness, and sadness can all act as attention distractors and cause us to decrease our listening efficiency. As we become emotionally involved in a conversation, we simply are less able or less willing to focus our attention accurately. Ralph Nichols in the book *Are You Listening?* notes that single words will often cause us to react emotionally and thus reduce the extent to which we are able to pay attention. He terms these "red-flag words." According to Nichols, they trigger an emotional deafness that drops our listening efficiency to zero. Among the words that are known to function as red flags for certain listeners are: communist, punk, mother-in-law, spastic, and income tax. When particular individuals hear these words they abandon efforts to understand and perceive. Instead, they take side trips, dwelling on endemic feelings and connections. In effect, the emotional eruption they experience causes a listening disruption. It should be noted that, like words, phrases or topics can also tend to make us react emotionally and lessen our ability to concentrate. For these reasons, it is important that you identify the words, phrases, and topics that tend to distract you emotionally.

SKILL BUILDER

ATTENTION DISTRACTORS

1. Compile a list of words that tend to distract your attention. Note the reasons for your choices.

WORD DISTRACTOR REASON

2. Next, compile a list of topics that elicit emotional reactions from you. Again, these should be topics that cause you to withdraw attention from the issue at hand. As before, note reasons for your selections.

TOPIC DISTRACTOR REASON

The lists you have developed are personal and unique to you. However, as you change, so do they. An issue that precipitated emotional deafness for you in the past may not even momentarily distract you in the future. For this reason, we believe it is a good practice for you to keep a record of all your attention distractors. If possible, list them on cards, and reexamine them every three or four months. By constantly updating your red-flag list, you will be better able to recognize and handle distractions when they manifest themselves during interpersonal encounters.

We should point out that physical factors can also act as attention distractors. For example, the room you are in can be too hot or cold for your comfort, seating arrangements can be inadequate, or the space may be too small or too large. Have you ever tried to listen politely and efficiently to someone as the springs in your chair were about to poke through the upholstery and pierce you? In addition to environmental factors, people can also provide distractions. The individual you are relating to may speak too loudly or too softly. He or she may have an accent you find difficult to comprehend or an appearance that interests or even alarms you. Have you ever been engaged in conversation with someone wearing such an unusual outfit that you found it difficult to focus your attention on what the person was saying?

One additional attention determinant should be noted. Simply put, we think faster than we speak. When engaged in interpersonal communication, we usually speak at a rate of 125 to 150 words per minute. Researchers have found, however, that we can attend to much higher rates of speech—perhaps even five hundred words per minute. There are several speech compression devices on the market today that use up our excess thinking time by speeding up the rate of ordinary speech without producing distortions in the speaker's voice quality. This keeps us from becoming impatient with a speaker's slow progress.

What does this mean for you, the listener? It means that when someone speaks at a normal rate, you have free time left over and tend to take mental excursions and daydream. When you return your attention to the speaker, however, you may find that he or she is far ahead of you. Your side trip took more time than you realized. Thus, not only are we physically tied to the microsleep concept discussed earlier, but we complicate the problem by permitting ourselves to use our thinking time unwisely. To combat this, we must make conscious efforts to use the speech/thought differential effectively. We can do this by internally summarizing and paraphrasing what is being said and by asking ourselves questions that help focus our attention instead of distracting it from the subject at hand.

Finally, it is important to realize that maintaining or focusing your attention is an act you must constantly perform. It is the smart communicator who periodically checks his or her attention to see if it has wandered. Try the Skill Builder at the top of the next page to see how often your attention wanders.

We realize that while the attention check could itself function as an attention distractor, its benefit outweighs the potential deficit. It helps you become aware of reduced attention spans. Make the attention check an integral part of your listening improvement regimen. Only after becoming aware that you are not listening can you begin to make the necessary corrections.

Set Appropriate Listening Goals

Have you ever said to yourself, "Why am I sitting here listening to this?" Far too often, we find ourselves listening without adequately understanding what we are listening for. Thus, we become bored and irritated. One way to combat the "listening blahs" is to set specific listening goals. Research indicates that listening effectiveness increases after goals are identified. Let us examine how we can make this fact work for us.

Listening goals may be defined as statements identifying what you personally would like to gain during and after attending to a particular message. When you establish goals, you answer the question: Why am I listening to this? This does not mean that you should set rigid listening goals; indeed, they should be flexible so that you can modify them as the nature of the experience changes. Listening goals are closely related to the levels of listening we discussed earlier in this chapter. In general, we listen to understand, to retain, to analyze and evaluate content, and to develop an empathic relationship with others. Thus, one way to set your listening goals is to identify which level of listening is most appropriate to a particular situation. For example, if you were an employee who was expected to internalize a series of directions for handling highly explosive materials, you would listen to understand and retain instructions. If you were listening to a series of lectures on "Types of Computer Operations," and your objective was to select a computer for your company, you would again listen to understand and retain, but in addition you would listen to analyze and evaluate. In contrast, suppose your friend has lost a parent. In this situation, your goal would not be to retain or evaluate information, but rather to listen in an active, empathic manner. Only in this way would you help your friend come to grips with her loss.

Just as trains frequently switch tracks, so you should be able to switch listening goals.

The goals you set are not meant to imprison you; rather, you need to be flexible and able to adapt to the demands of each situation.

Another way to view goal setting is to picture a clock composed of our listening levels.

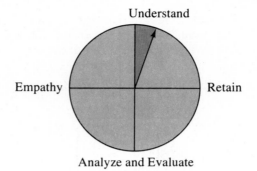

The dial may be set at any one level, then as conditions and needs change, the dial may be moved accordingly. Listening is a cyclical process that is ever-changing.

Listen to Understand Ideas

After listening to information from another person, have you ever made a statement like, "I'm sure I understand the main point," or "The central idea is crystal clear"? When we listen to understand, we listen for the main ideas or central concepts of messages. Let's examine how this works.

Listening to understand may be compared to a simple tooth extraction. When we visit the dentist to have a tooth pulled, we assume the dentist will not simply reach into our mouth and begin pulling our teeth out at random. Instead, we operate under the belief that the dentist will locate the tooth that needs to be extracted, take hold of only that tooth, and remove it. When we listen to understand—a process that underlies all higher levels of listening—we, too, must locate the central concepts contained in the speaker's message and remove them—this time for further examination. Since it is almost impossible for us to remember every word said to us, we should work to recall only those concepts that are most important—in other words, those ideas that comprise the main points of the person's message. Thus, when you listen to understand you seek to identify words and phrases that will help you accurately summarize the concepts being discussed. For practice, try to identify the main ideas contained in this speaker's message.

> I am really upset about all of the emphasis that is being placed on running or jogging. Sure, it is important and useful for some people to develop an exercise regimen. But far too frequently, overzealous, inexperienced, and ill-advised individuals overdo it. Running and jogging injuries for these people range from pulled muscles to heart attacks. In addition, the amount of time one needs to devote to preparing to run and recovering

from the run is excessive, especially when you count the "suiting up" time and final shower time. Finally, I think running is too costly. A pair of running shoes, sweat socks, and a warm-up suit can cost you well over one hundred dollars.

This speaker is obviously voicing her displeasure with the current jogging fad. In fact, we might summarize her statement by noting that the speaker opposed jogging. What data does the speaker offer to support her beliefs? The speaker points to health hazards, excessive time consumption, and high cost as reasons supporting her stance.

Learning how to extract main ideas can aid you in improving the effectiveness of your interpersonal relationships. For example, if a manager or instructor tells you how to do something, you will want to listen to understand his or her remarks, leading this person to perceive you as being intelligent and concerned. Likewise, if a friend voices a complaint or explains a personal opinion to you, and you understand the basis for his feelings, that individual will also judge you to be an astute, caring, and alert receiver.

SKILL BUILDER

EXTRACT THOSE CONCEPTS!

The longer radio and television news programs that are now being broadcast provide you with an inexpensive way to practice and improve your ability to listen with understanding. Begin this experience by reminding yourself that your primary goal is to listen to understand. Your instructor will bring a tape recording of a major news story to class. Mentally record or actually list each main idea or concept you hear as the recording is played. You will receive five points for every main idea or concept you accurately extract. Continue to practice extracting main ideas or concepts each time you listen to or watch a news broadcast. After each segment, list all of the main points you can remember. The game can easily be played with others at any time.

Remember, unless the ideas we extract from the messages we receive are accurate representations of what was said, we are only hearing; we are not listening.

Listening to Retain Information

Robert Montgomery, a trainer who has developed a wealth of material on memory for the American Management Association, says, "The art of retention is the art of attention." If you are to retain what you hear, you must learn, first, how to focus your attention and, second, how to make certain you understand what you have heard. Once you are able to focus your attention on what another person is saying, and once you are able to understand what the person has said, you are ready to move your listening selector up to the next level—listening to retain.

After receiving travel directions, did you ever find yourself saying, "Do I turn right or left here? What was I told?" After having a discussion with a friend and assuming that you understood his point of view, did you ever find yourself wondering what that point of view was? Even worse, after being introduced to someone, do you ever find yourself asking, "What was that person's name?" Let us now explore several techniques that you can use to help you retain what you hear. Such aids are commonly referred to as mnemonic devices. Use those devices that work best for you.

Repeat and Paraphrase. Your basic tool to help retain information you hear is repetition. The more we repeat a concept or idea, the more we are likely to be able to recall it later. Repetition has two faces: We use repetition when we repeat a statement verbatim (exactly reproduce what was said), and we use repetition when we paraphrase (restate what was said using other words).

One good way to remember what others say is to reproduce their words in writing. For example, the more proficient you are at note taking, the more information you are likely to be able to retain. Of course, in interpersonal situations, it is neither advisable nor practical to take notes. It is, however, a good idea to keep a couple of index cards or a small note pad handy. You can use such devices to record important names, numbers, appointments, and information.

You can also use repetition to help you remember the names of people you meet, thus avoiding interpersonal dilemmas posed by "forgotten names." Consider this dialogue:

"Hi! I'm Sammy Smith."

"Hello, I'm Kathy Jamison."

"Kathy Jamison—nice to meet you. How do you spell your name?"

"J-a-m-i-s-o-n."

"Where are you from, Kathy?"

"I live in Montreal."

"Kathy, you sure are a long way from home!"

Notice that the speaker repeated Kathy's name as many times as he could. He asked her to spell her last name, and he made a real effort to use her first name in every sentence he generated. Far too often, we never actually listen to the names of the individuals we meet. We are much too concerned with how we are coming across to them. However, checking to see if you understand and have accurately deciphered someone's name can improve future interpersonal encounters you share. Remembering an individual's name enables you to call the person by name when you meet again. Remembering names helps cement interpersonal relationships.

The paraphrase can also be used to improve your personal retentiveness level. By stating what a person has said to you in your own words, you not only check on your understanding, but you also help yourself recall what the other person has said. We will consider the art of paraphrasing in more detail when we consider active/empathic listening. For now it will suffice if you realize that paraphrasing can help alleviate some of the problems created by the speech/thought differential we spoke of earlier. If you use some

of your extra thinking time to replicate for yourself what has just been said, you give your mind fewer opportunities to wander. To reinforce your understanding of this, participate in the next experience.

SKILL BUILDER

REPEAT—REPEAT—REPEAT

This exercise should help you in establishing interpersonal relationships by making it easier to remember the names of people you meet.

1. All of the students in your class are to choose new names for themselves.
2. When your instructor gives you the signal to begin, stand up and begin to mingle with fellow classmates. Introduce yourself to another student, using your imaginary name. Both you and your partner should seek to repeat each other's name several times during a casual conversation.
3. When your instructor gives another signal, move on to another person and repeat the process. After the eighth encounter, be seated.
4. At this point, write down the imaginary names of each person you "met."
5. Double-check yourself by comparing your remembered names with each partner's imaginary name.
6. Attempt to determine the extent to which passage of time affects retention by trying to introduce the individuals you met during this experience to the entire class during a subsequent session.

In all probability, you discovered that you recalled fewer of the imaginary names over time. Although a number of devices exist to help alleviate this problem, we have chosen to focus on a method based on visualization.

Visualization. Frequently, we are more easily able to recall information if we picture something about the information. For example, many people are able to associate names, places, and numbers with particular visual images. Often, the more outrageous and creative the picture, the more effective the image is in helping them recall a name. For instance, you might picture an individual with the name of John Sanderson standing atop a large sand pile or sand dune. A woman named Susan Grant might be pictured standing inside of Grant's tomb. You can create similar internal visuals to help you recall a list containing tasks you need to accomplish. Mental pictures can be easily stacked atop each other to produce what we term a mental memory sculpture. For example, suppose you were asked to go to the laundry, the newsstand, the hairdresser, and the supermarket before returning home; the visual sculpture you create might look like this:

SKILL BUILDER

VISUAL SCULPTURES

1. Turn to a page in a telephone directory. Work with a partner to develop creative, exaggerated visualizations that will serve to help you recall fifteen to twenty of the listed names on the page. Share your associations with the class.

2. Once again, watch or listen to a news broadcast. This time, however, instead of just listening to understand the information you hear, also listen to retain it. Do this by mentally compiling a list of the major ideas being presented. Next, develop creative, exaggerated associations for each idea; that is, devise mental sculptures to aid you in recalling the information. Finally, when the news story is concluded, compile a written list that corresponds to your mental visualizations.

3. You may wish to make a habit of compiling mental visual sculptures each time you listen to or watch newscasts. Such a device will aid you in retaining information in all of your interpersonal encounters.

Listen to Analyze and Evaluate Content

Being able to analyze and evaluate what you listen to calls for even greater skill than retention. When you learn to analyze and evaluate content effectively, you become adept at spotting fallacies in the arguments and statements you hear during interpersonal discourse. Let us examine a number of these fallacies now.

Too often, we let our prior convictions prevent us from processing and fairly evaluating what we hear. For instance, consider the following conversation:

ALICE: Did you hear? Sandy was arrested by the police for selling drugs.

JIM: Sandy? I don't believe it. The police made a mistake. She isn't that type.

Jim was jumping to a conclusion. Instead of analyzing the information he was given, he has reacted on the basis of his prior knowledge. How should Jim have reacted? Should he have agreed that the police were right to arrest Sandy? Certainly not. Listeners should never let their emotional convictions run away with them. Rather, good listeners reserve judgment until the facts are in. They withhold evaluation until their comprehension of the situation is complete.

Interpersonal attempts at persuasion often find one individual attempting to make another individual believe something because "everyone else believes it." If we accept such drivel, we find ourselves swept away on the bandwagon. Effective listeners, however, realize that they have a choice. They may join the bandwagon, or they may let it pass them by. Effective listeners are not mere weathervanes; they do not feel compelled to follow the crowd.

If you become proficient at evaluating and analyzing the information you listen to, you will discover that frequently people argue or talk in circles. For example:

ELLEN: Divorce is wrong.

JOSÉ: Why?

ELLEN: Because my minister told me it is wrong.

JOSÉ: Why did he tell you that?

ELLEN: Because it is wrong!

We have a tendency to talk in circles when we argue without evidence. This is apt to happen if we feel an emotional tie to the topic being discussed or if we believe our stance is closely connected to our value system. When this occurs, we simply insist we are right: "That's all there is to it." We tell ourselves that we do not need reasons. Effective listeners perceive the fallacy inherent in such behavior. They weigh the speaker's evidence by mentally questioning it. Effective listeners listen between the lines.

SKILL BUILDER

THE CIRCLE GAME

1. For the next week, keep a record of all "circular conversations" you hear.
2. Point out the fallacy contained in each example.

Listen Empathically, Listen Actively

When questioning witnesses, attorneys listen for contradictions or irrelevancies in testimony: They listen to analyze. In contrast, social workers usually listen to help a person work through a personal problem; this, too, is an important level of listening. It is referred to as *empathic*, or *active*, listening and is the last type of listening we will consider in our Listening Improvement Program.

The term *empathic listening* was popularized by Carl Rogers, who believed that listening could be used to help individuals understand their own situations and problems. When you listen actively, or empathically, you do more than passively absorb the words that are spoken to you. Active listeners also try to internalize the other person's feelings and see life through his or her eyes. The following poem by David Ignatow depicts the nonempathic listener in operation. Are you at all like this person?

The empathic listener tries to see life through another's eyes: how does the world seem to her?
(© Sepp Seitz 1980/Woodfin Camp & Assoc.)

TWO FRIENDS

David Ignatow

I have something to tell you.
I'm listening.
I'm dying.
I'm sorry to hear.
I'm getting old.
It's terrible.
It is, I thought you should know.
Of course, and I'm sorry. Keep in touch.
I will. And you too.
And let me know what's new.
Certainly, though it can't be much.
And stay well.
And you too.
And go slow.
And you too.

How often do you put on your "listening mask," nod agreement, utter the appropriate "ohs" and "I sees," while in reality you are miles away and self-concerned? We need to be willing to acknowledge the seriousness of another person's problem. We need to take the time required to draw the other person out so that he or she is able to discuss the problem and come to terms with it. We need to show the other person that we understand the problem. We can do this by paraphrasing the person's statements and by reinforcing those statements with genuine nonverbal cues—eye contact, physical contact (touching), and facial expressions. A similar situation is revealed in this dialogue between two men taken from David Berlo's "Interaction: The Goal of Interpersonal Communication."

JOHN: Harry, let me tell you about what happened last night at home. . . .

HARRY: Fine, John. You know, things aren't going well on that experimental assembly job on the line. . . .

JOHN: I came in last night, and everything hit me. The wife said that the kids had ruined some of the plants in the yard . . .

HARRY: If we don't get into full production pretty soon on that job, I don't see how . . .

JOHN: the plumbing stopped up in the basement . . .

HARRY: we can fulfill the contract we're working on.

JOHN: and the dog tried to bite the little boy down the street.

HARRY: Things are sure rough.

JOHN: They sure are.

John and Harry were not communicating with each other. They were simply talking. Unfortunately, we sometimes think we are too busy to listen empathically to another. Our failings in active or empathic listening have given rise to the need for "a man who is all ears." This need was reflected in a recent Associated Press news article.

LISTEN HERE: POSSIBLE MOTTO FOR A MAN WHO IS ALL EARS

M. Kirk Martin listens, in person and by appointment only. "I will talk, if a person asks me to, or if he looks like he wants me to," Mr. Martin explains. "I can talk eyeball to eyeball to anyone who comes through my front door." Mr. Martin, 48, a professional truck and taxicab driver who sells one-family homes and farms on the side, began his listening enterprise with a newspaper ad: "I will listen to you talk 30 minutes without comment for $5," the ad said. "I get about 10–20 calls a day now, but only a few of those make appointments." He says his clients are from all walks of life. "Many of them are troubled people who need someone to hear them out, just once. . . ."

Active/empathic listeners put themselves in the speaker's shoes in an effort to understand the speaker's feelings. Active/empathic listeners make it clear that they appreciate both the meaning and the feeling behind what another person is saying. In effect, active/empathic listeners convey to the speaker that they are seeing things from the speaker's point of view.

Active/empathic listeners rely heavily on the paraphrase.

PERSON 1: I am so mad at my mother.

PERSON 2: Your mother is giving you trouble.

PERSON 1: My boss is really trying to fire me.

PERSON 2: You believe your boss is out to replace you.

By paraphrasing the sender's thoughts, active/empathic listeners accomplish at least two purposes: First, they let the other person know they are listening, that they care enough

to listen, and second, if the speaker's message is not accurately received, they offer the other person the opportunity to adjust, change, or modify the message so that they can understand it as intended:

PERSON 1: I'm quitting my job soon.

PERSON 2: You're leaving your job tomorrow?

PERSON 1: Well, not that soon! But within a few weeks.

In summary, when you listen actively, you listen for total meaning, and you listen to respond to feelings. When you listen empathically, the following statements will *not* appear in your conversation:

You must do . . .

You should do . . .

You are wrong!

Let me tell you what to do.

You sure have a funny way of looking at things.

You're making a big mistake.

The best answer is . . .

Don't worry about it.

You think you've got problems. Ha!

That reminds me of the time I . . .

Active/empathic listeners do not judge; they reflect. In effect, active listeners only have to restate in their own words their impressions of the expression of the sender. Active listeners are checkers who seek to determine if their impressions are acceptable to the sender. What kind of a checker are you?

SKILL BUILDER

WHAT'S THAT YOU SAID?

1. Choose a partner and select one of the following topics to discuss.

Abortion	Premarital sex
Capital punishment	Socialized medicine
An embarrassing situation	Lying

2. One person begins the discussion. Before the partner can add ideas, he or she must paraphrase the first speaker's statement. If the paraphrase is accurate, the person may continue by offering his or her own thought. However, if the paraphrase is inaccurate, the individual must correct his or her misperceptions. Only when the other person agrees that the paraphrase is accurate may the individual continue.

At this point, you should realize why it takes more than two good ears to listen. Paul Simon recognized this when he wrote "The Dangling Conversation."

THE DANGLING CONVERSATION

Paul Simon

It's a still life water color
On a now late afternoon
And the sun shines through the curtain lace
And the shadows wash the room
And we sit and drink our coffee
Couched in our indifference
Like shells upon the shore
You can hear the ocean roar
In the dangling conversation
And the superficial sighs
In the borders of our lives

And you read your Emily Dickinson
And I my Robert Frost
And we note our place with bookmarkers
That measure what we've lost
Like a poem poorly written
We are verses out of rhythm
Couplets out of rhyme
In syncopated time
And the dangling conversation
And the superficial sighs
Are recorders of our lives

Yes we speak of things that matter
With words that must be said
Can analysis be worthwhile?
Is the theater really dead?
And how the room has softly faded
I can only kiss your shadow
I cannot feel your hand
You're a stranger now unto me
Lost in the dangling conversation
And the superficial sighs
In the borders of our lives.

Recognize that you can eliminate the dangling conversations in your own life by improving your Ear-Q—that is, by developing your active listening skills.

SUMMARY

In this chapter we have explored the nature and the importance of listening. We have compared and contrasted hearing and listening, and we have distinguished between different listening levels. In addition, we have examined feedback—a prerequisite for effective listening. We discovered that it is feedback that lets us confirm or correct the impressions that are formed by those with whom we interact. Frequent and continuous feedback plus effective and efficient listening are keys to improved communication.

Like other behavior, good listening behavior is contagious. Thus, to promote healthy interpersonal relationships, each of us needs to assume the responsibility for bettering our listening abilities. Developing the self as listener is a basic step in developing the self as an interpersonal communicator.

SUGGESTIONS FOR FURTHER READING

Barker, Larry L. *Listening Behavior.* Englewood Cliffs, N.J.: Prentice-Hall, 1971. This book offers a comprehensive, well-documented analysis of listening and feedback.

Duker, Sam, ed. *Listening: Readings.* New York: Scarecrow Press, 1966. Contains a series of articles relating to listening theory and practice.

Gordon, Thomas. *Leader Effectiveness Training.* New York: Wyden Books, 1977. A popular book that contains material relevant to the study of listening.

Johnson, David W. *Reaching Out: Interpersonal Effectiveness and Self-Actualization.* Englewood Cliffs, N.J.: Prentice-Hall, 1972. Especially helpful for individuals interested in empathic listening.

Kelly, Charles M. "Empathic Listening," in *Small Group Communication: A Reader.* Boston: William C. Brown, 1974. Discusses what listening is and is not; presents suggestions for improving listening abilities.

Nichols, Ralph G. "Do We Know How To Listen?" *The Speech Teacher,* Vol. 10 (1961), pp. 118–124. Provides a useful overview of the listening process.

Nichols, Ralph G., and Leonard A. Stevens. *Are You Listening?* New York: McGraw-Hill, 1957. A classic book about listening; helped popularize interest in the field.

Rogers, Carl R. *On Becoming a Person.* Boston: Houghton Mifflin, 1961. Rogers builds his theory of helping others on sound listening skills.

Weaver, Carl H. *Human Listening: Processes and Behavior.* Indianapolis, Ind.: Bobbs-Merrill, 1972. Contains exercises useful to individuals who want to improve their listening abilities.

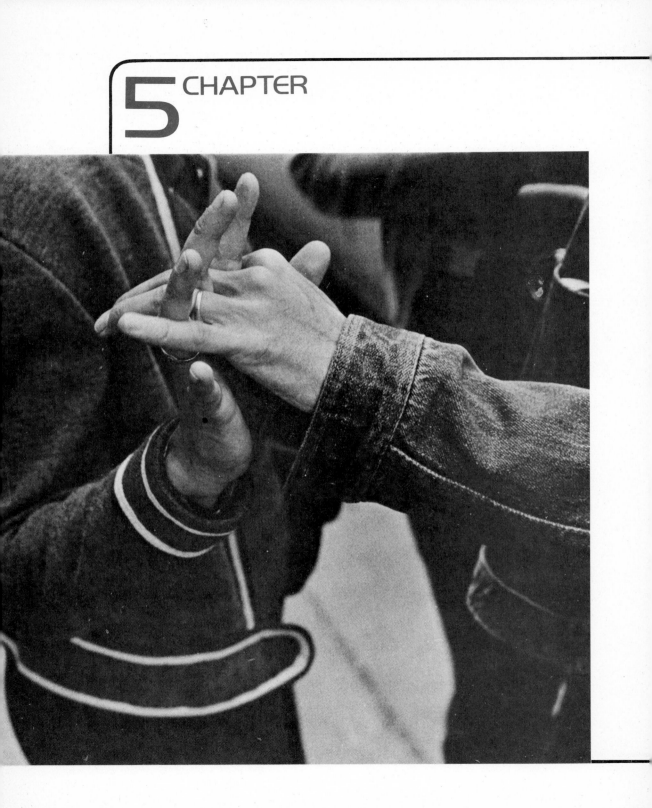

Nonverbal Communication: Silent Language Speaks

CHAPTER PREVIEW

After experiencing this chapter, you should be able to:

Define ''nonverbal communication''

Explain why nonverbal cues can be ambiguous

Define ''kinesics''

Explain why the face is an important source of information

 Demonstrate how the face is used to send emotionally charged messages

 Explain the meaning of ''microfacial expression''

Provide examples of the kinds of messages communicated by postural cues

Provide examples of the kinds of messages communicated by gestures

Distinguish between mesomorphic, endomorphic, and ectomorphic body types

Explain how dress style can affect communication

Define ''paralanguage''

 Explain how pitch, volume, rate, and pause affect interpersonal communication

Define ''proxemics''

 Distinguish between intimate distance, personal distance, social distance, and public distance

 Explain why territoriality is an important variable in interpersonal communication

Describe how color can be used to communicate

Explain the types of messages communicated by touch

What you are speaks so loudly that I cannot hear what you say.

Ralph Waldo Emerson

Arthur Conan Doyle had his most famous character, the famed detective Sherlock Holmes, tell his cohort Dr. Watson: "You see, but you do not *observe*." What do you think Holmes meant by that statement? Holmes was able to solve the most perplexing crimes because he noticed those minute details that eluded his colleagues. Modern television detectives have also inherited Holmes' eye for detail; they, too, unravel seemingly unsolvable puzzles—just prior to the final commercial, of course! Thus, Sherlock Holmes knew what he was saying when he advised:

> By a man's finger nails, by his coat-sleeve, by his boots, by his trouser-knees, by the callosites on his forefinger and thumb, by his shirt-cuffs—by each of these things a man's calling is plainly revealed. That all united should fail to enlighten the competent inquirer in any case is almost inconceivable.

Sherlock Holmes was a fictional creation. His words, however, may be applied to real-life situations.

CAN YOU HEAR WHAT I'M NOT SAYING?

The founder of psychoanalysis, Sigmund Freud, once wrote: "He that has eyes to see and ears to hear may convince himself that no mortal can keep a secret. If his lips are silent, he chatters with his finger tips; betrayal oozes out of him at every pore." Many a time our creative problem-solving abilities are challenged as we seek to make sense out of human communication situations. Here is one such mystery that challenged the thinking capabilities of many human minds:

In turn-of-the-century Berlin, Herr Von Osten purchased a horse, which he named Hans. Von Osten desired to train Hans, only he did not want to train him to jump, stand on his hind legs, or even dance. Instead, Von Osten wanted to train Hans to count by tapping his front hoof. To Von Osten's astonishment, the horse learned to count very quickly; in fact, in a short time he also learned to add, multiply, divide, and subtract. Von Osten decided to exhibit his horse at fairs and carnivals. The crowds loved it when Hans would correctly count the number of people in the audience, identify the number of persons wearing eyeglasses, or count the number of individuals wearing hats. In addition, Hans thrilled the observers when he displayed his ability to tell time and "announce" the date. Of course, Hans did all this by tapping his hoof. Von Osten soon decided to teach his horse the alphabet, which he had coded into hoofbeats. An *A* was given one hoof tap, a *B* two taps, and so on. Once he learned this, Hans was able to reply to oral and written questions, too. The horse seemed to actually comprehend the German language and to be more intelligent than many of the individuals who applauded him.

Hans' proficiency earned him the title "Clever Hans." Word of his abilities spread throughout the world.

Naturally, some who heard about the feats of "Clever Hans" were skeptical and reasoned that no horse could do these things and so there must be some trickery involved. A committee was charged with the task of deciding whether there was any deceit involved in Hans' performances. On the committee were professors of psychology and physiology, the head of the Berlin Zoo, a circus director, veterinarians, and cavalry officers. Von Osten was not permitted to be present when the committee tested Hans. Despite the absence of his trainer, however, Hans was still able to supply correct answers for the questions put to him. A committee member would ask, "Hans, how much is three plus four?" Hans would respond by tapping his front hoof seven times. The committee decided there was no trickery involved.

Some skeptics were still not satisfied, however, so a second investigation was conducted by a new committee. This time procedures were changed. Herr Von Osten was asked to whisper a number into Hans' left ear, then another experimenter, named Pfungst, whispered a number in Hans' right ear. Then Hans was instructed to add the two numbers—an answer none of the observers, Von Osten, or Pfungst knew. Hans couldn't do it. It seems that Hans could only answer a question if someone in his visual field knew the answer.

Why do you think this was so? Apparently, when Hans was asked a question that all the observers had heard, the observers assumed an expectant posture and increased their body tension. When Hans tapped the correct number of hoofbeats, the observers would relax and slightly move their heads—cues that Hans used to know when to stop tapping. Somehow, Hans had the ability to respond to the almost imperceptible movements of people around him. Much as you are able to sense when someone wants you to stop talking or when it is time to leave a party, Hans was able to sense when to stop tapping. The goal of this chapter is to help you increase your awareness of nonverbal stimuli and expand your ability to use the cues you perceive. Doing so will help make you a more effective interpersonal communicator.

To fully understand the interpersonal communication process, we must examine its nonverbal dimension. Theorists Albert Mehrabian, Mark Knapp, and Ray Birdwhistell agree that in a normal two-person conversation, the verbal channel carries less than 35 percent of the message's social meaning; more than 65 percent of the meaning is communicated nonverbally. The nonverbal level can help us define the nature of each relationship we share. By analyzing nonverbal messages, we can enhance our understanding of what is really going on when people talk. Remember, whether we are aware of it or not, we all communicate nonverbally. With some practice, we can also learn to use the nonverbal mode to provide us with "a way of knowing" that would not otherwise be available to us.

In this chapter, we will present an overview of the nonverbal arena, explore different types of nonverbal messages, and suggest techniques to help improve your abilities to send and interpret nonverbal cues. You need to realize that a lack of awareness of the nonverbal dimension often works against effective communication, and a working knowledge of the nonverbal mode can increase effective communication.

How much information can we really gain by paying attention to nonverbal messages from people and the environment? Participate in the following exercise to find out.

SKILL BUILDER

NONVERBAL OBSERVATION LOG

1. Proceed to a location that is typically crowded—a bus station, an airport, the campus lounge, the cafeteria, or any other place where large numbers of people usually gather. Once in the location, compile a list of six to twelve behavioral observations.

LOG 1

THE CROWDED ENVIRONMENT

Location:

Date:

Time:

Weather:

Describe the location in detail (furniture arrangements, wall colors, lighting, etc.)

Brief Description of Persons Observed	Brief Description of Their Actions
1.	
2.	
3.	
4.	
5.	
6.	
7.	
8.	
9.	
10.	
11.	
12.	

2. Next, proceed to a more protected and quiet environment—perhaps a doctor's waiting room, a dean's office, or the library. While there or immediately afterward, enter as many observations as you can in a second log.

LOG 2
THE QUIET ENVIRONMENT

Location:

Date:

Time:

Weather:

Describe the location in detail (colors, furniture, books, etc.)

Brief Description of Persons Observed	Brief Description of Their Actions
1.	
2.	
3.	
4.	
5.	
6.	
7.	
8.	
9.	
10.	
11.	
12.	

3. Be prepared to report your findings to your class. You should be able to describe the most interesting or the most surprising of your nonverbal observations. In addition, you will want to answer these questions: What messages do you believe people send through their actions? Their facial expressions? Their voice tone? What was communicated by the space itself? How did the dress of individuals affect your interpretation? What cues did you perceive that under ordinary circumstances you might have missed or ignored? To what extent are the meanings you associate with your observations clear? To what extent are they ambiguous?

It should be apparent that we can indeed "hear" what others are not saying. We can do this by observing what their nonverbal messages say. We can become nonverbal detectives, noticing the nonverbal clues that are constantly given away.

CHARACTERISTICS OF NONVERBAL COMMUNICATION: CUES AND CONTEXTS

What is nonverbal communication? How do you recognize it? The term "nonverbal communication" designates all aspects of human responses not contained in words. This includes a wide range of behaviors. Bernard Gunther in his book *Sense Relaxation Below Your Mind* (1968) has identified some of the factors we should be concerned with when analyzing human communication—your own messages and those of others.

Shaking hands
Your posture
Facial expressions
Your appearance
Voice tone
Hair style
Your clothes
The expression in your eyes
Your smile
How close you stand to others
How you listen
Your confidence
Your breathing . . .
The way you move
The way you stand
How you touch other people

These aspects of you
affect your relationship
with other people, often
without you and them
realizing it. . . .

The body talks, its message
is how you really are,
not how you think you are. . . .
. . . Many in our culture
reach forward from the neck
because they are anxious
to get a-head. Others
hold their necks tight;
afraid to lose their head.
Body language is literal.

Nonverbal content is even more extensive than Gunther indicates. Gunther is right when he observes that we communicate with our body and appearance. But we also communicate by sending messages through the environment. If, for example, someone entered and walked through your house or apartment at this very moment, what kinds of assumptions would they be able to make about you and your family? The spaces we inhabit broadcast information about us to others, even when we are not in them. For instance, are you sloppy or tidy? Do you like roominess, or do you crave the security of cozy spaces? How you dress your environment and how you dress yourself provide clues about your role, status, age, and goals. Your voice also carries information about you to others. As Paul Watzlawick, author of *Pragmatics of Human Communication,* pointed out, ". . . no matter how hard one may try, one cannot not communicate." You cannot stop sending nonverbal messages; you cannot stop behaving. The following exercise explores this premise.

SKILL BUILDER

LET'S NOT COMMUNICATE

1. Select a partner. Sit facing that person.
2. For the next two minutes try not to communicate anything to him or her.
3. What happened? Did you look at each other? Look away? Giggle? Smile? Shift positions? Pick your fingers? What specific behaviors did your partner display?

As long as one person is observing the actions of another, it is impossible not to communicate. Even if one partner got up and left the room, he or she would be communicating his or her attitudes. If you stuck your head in a paper bag or sat in class while completely encased in a sack, you would still be communicating to those around you. In fact, you are communicating nonverbally right now. If at this very moment someone were to photograph you, what could others surmise by examining the photograph? How are you sitting? Where are you sitting? How are you dressed? What would your facial expression reveal about your reaction to this chapter? Would different people interpret the photograph in the same way? Why?

You may have already realized that nonverbal information is easily misinterpreted. Nonverbal communication is ambiguous. Like words, nonverbal messages may not mean what we think they do. Thus, we have to be careful about misinterpreting them. Do not be surprised if you find that the real reason a person glanced at a clock, left a meeting early, or arrived late is quite different from what you assumed. It is simply not possible to develop a list of nonverbal behaviors and attach a single meaning to each. All nonverbal communication must be evaluated or interpreted within the context in which it occurs. You cannot "read a person like a book"—nor can others always "read" you. Still, you should realize that those you interact with will attribute meaning to your behavior and make important judgments and decisions based on their observations. Then too, verbal and nonverbal messages can—and often do—contradict each other. Sometimes we say

one thing but do another thing: We send a "mixed" or incongruent message. To gain a better understanding of how verbal and nonverbal messages can work at cross-purposes, try this.

SKILL BUILDER

CONTRADICTORY MESSAGES

1. Say the following verbal statement aloud while working alone, before the class, or with a partner:

 I am glad to be here.

 As you utter the words, try to do everything you can to indicate to those watching and listening that you are not glad to be here.

2. Substitute the following statements and repeat the experience:

 I would love to go out with you.
 I'll see you soon.
 This is a wonderful meal.
 I cannot stand to be near him.
 I hate going to work each day.

3. What devices did you and others use to communicate your contradictory messages? Voice tone? Posture? Facial expressions? You may want to make a videotape of this exercise so that the sender can also analyze his or her nonverbal cues.

As you become more aware of the nonverbal cues you and others send, you will begin to recognize contradictory messages that impede communication effectiveness. Wherever you detect an incongruity between verbal (word level) and nonverbal (behavior level) messages, you would probably benefit by paying greater attention to the nonverbal messages. It is believed that nonverbal cues are harder to fake than verbal cues, hence the importance of examining the nonverbal dimension. If we are going to rely on it, we should understand it.

IF YOU COULD READ MY . . .

In order to arrive at a deeper understanding of interpersonal communication and develop skills that will permit us to both send and receive cues more accurately, we will examine the following areas of nonverbal communication:

Body language (kinesics)

Physical characteristics and dress style

Voice (paralanguage)

Space, distance, color, and time (proxemic and environmental factors)

Touch

The types of messages listed here do not occur in isolation from each other. Rather, they interact and sometimes support each other. Then too, sometimes they contradict each other. We will first examine them separately, then, during the skills section of this chapter, we will bring them together so that you can reassemble the nonverbal puzzle and increase your overall communication effectiveness.

Body Language

The concept that bodily movement reflects emotions has been acknowledged since at least the nineteenth century. In his book *The Expression of Emotions in Man and Animals,* Charles Darwin addressed the importance of body action in expressing emotion. Likewise, Delsarte conducted extensive studies of people's physical reactions to emotional situations. He developed a manual for gestures and body positions that was long used as an actor's bible. The study of body communication has received much attention since those early days, and it is now referred to as the study of kinesics. Kinesics—body motion, or body language as it is popularly called—typically includes gestures, body movements, facial expressions, eye behavior, and posture. Thus, talking with your hands, a surprised stare, drooping shoulders, a knowing smile, and a tilt of the head are all part of kinesics.

Facial Expression. Examine this photograph of Joan Miller from the Joan Miller Dance Company. How would you interpret her facial expression? Is it an expression you

Courtesy Joan Miller Dance Company

would expect to see on someone walking casually down the street? Do you believe someone would wear this expression in a typical interpersonal conversation? Probably not. However, it does dramatize the extent to which we send messages with our facial muscles. Let us examine this aspect of kinesics more closely.

Entire industries exist to make people's faces more attractive or pleasing in appearance. Women purchase innumerable bottles and cartons of paints, powders, and creams for their faces, and men typically lather, shave, and condition theirs. Why is the face so important? First, the face is our main channel for communicating our own emotions and for analyzing the feelings and sentiments of others. This is one reason why motion picture and television directors employ so many close-ups. In fact, television is often referred to as the medium of talking heads. It is the face that is relied on to reinforce or contradict what is being communicated through dialogue. Likewise, in your personal relations, your face and the faces of those around you broadcast inner feelings and emotions. How well do you read faces? Research has shown that many of us are able to decipher facial cues with great accuracy, but others of us do not display such proficiency. To check your "face-reading" abilities, try this:

SKILL BUILDER

FACIAL BROADCAST

1. Choose a partner. Each of you in turn will select an emotion at random from the following list:

happiness	anger
sadness	surprise

2. Turn away from your partner and put on a facial expression that you believe portrays the selected emotion. Turn back and face your partner, who is to guess the emotion you are portraying. Reverse roles and repeat the exercise. What is it about your partner's face that causes you to select one feeling rather than another? What did your partner's eyes tell you? The mouth? The nose? Repeat this step a number of times, alternating roles. Your goal during each round is to analyze how various facial features and their positions help "broadcast" emotions.

3. Now challenge yourselves by adding the following emotions to the list:

shame	love
despair	sorrow
humiliation	rage
disgust	astonishment
coyness	nervousness

 To what extent did the newly added emotions make things more difficult for the "performer"? For the "observer"? How accurate were your observations?

Of all nonverbal channels, the face is the single most important broadcaster of emotions. You may be able to hide your hands, and you may choose to keep silent, but you cannot hide your face without making people feel you are attempting to deceive them. Since we cannot "put the face away," we take great pains to control the expressions we reveal to others. Yet, even this is a formidable task. Let's examine why.

We may at any time, without our realizing it, be communicating multiple emotions rather than one single emotion. Researchers Paul Ekman and Wallace Friesen call these facial movements "affect blends." The presence or absence of affect blends may help explain why we feel comfortable around some people and uncomfortable around others. It seems that some expressions appear on a person's face for only fractions of a second. Thus, what began as a smile may become ever so briefly a grimace and then may be retransformed into a smile. The change in emotion may last no more than one-fifth to one-eighth of a second. Researchers called the fleeting emotional displays "microfacial, or micromomentary, expressions." They discovered their presence by employing slow-motion film techniques. What escaped the naked eye at normal speed (twenty-four frames per second) became visible when the film was slowed to four frames per second. Micromomentary expressions are believed to reveal actual emotional states. They usually occur when an individual is consciously or unconsciously attempting to conceal or disguise an emotion or feeling. Although such microexpressions may be little more than a twitch of the mouth or an eyebrow, they indicate to an observer that the message the person is trying to transmit is not the message he or she is thinking. If you have not done so

Of all the nonverbal channels, the face is the single most important broadcaster of our emotions.
(© Ken Robert Buck/The Picture Cube)

already, you should begin to realize the importance of observing the facial expressions of others. But what should you watch for? Here are some general suggestions.

For purposes of analysis, a person's face can be divided into three general areas: (1) the eyebrows and forehead, (2) the eyes, and (3) the mouth. Let us focus on each separately. If you raise your eyebrows, what emotion do you show? Surprise is probably the most common response. Fear, however, may also elicit raised eyebrows, and when we experience fear, the duration of the movement will probably be more sustained. The brows help express other emotions as well. Right now, move your brows into as many different configurations as you can. With each movement, analyze your internal emotional response. What do these brows communicate?

The brows of former President Richard Nixon provided him with a
sinister look caricaturists relished.
(© J. P. Laffont/Sygma)

The forehead also helps communicate your physical and emotional state. A furrowed brow accompanied by a wrinkled forehead suggests tension, worry, or deep thought. A sweating forehead suggests nervousness or great effort.

The last of the three areas is the eye area. Ralph Waldo Emerson displayed his wisdom when he said: "The eyes of men converse at least as much as their tongues." Consider this.

Anthropologist Edward T. Hall says PLO leader Yasir Arafat wears dark glasses to take advantage of the pupil response—to keep others from reading his reactions by watching the pupils of his eyes dilate.

Hall is an authority on face-to-face contact between persons of different cultures. In an interview on understanding Arab culture, he says a University of Chicago psychologist discovered the role pupils play as sensitive indicators. Hall says Eckhard Hess found pupils dilate when you are interested in something but tend to contract if something is said that you dislike.

". . . The Arabs have known about the pupil response for hundreds if not thousands of years," Hall says. "Since people can't control the response of their eyes, which is a dead giveaway, many Arabs, like Arafat, wear dark glasses, even indoors."

United Press International, September 18, 1979

"Are you looking at me funny?"

The New Yorker

NONVERBAL CLUES HELP LAWYERS LEARN THE TRUTH

Want to know if a prospective juror is apt to rule for your client? If your client is telling the truth? If a witness is lying?

There are nonverbal clues that can help answer those questions, according to Julius Fast of New York, author of *Body Language*; V. Hale Starr of Des Moines, who aids lawyers in choosing juries; and Roger Bennett, a professor at Ohio University.

Fast said a lawyer choosing a jury should look for someone "who maintains eye contact, smiles, and has an open posture. You don't want someone who sits with his arms tightly locked, folded across his chest. That is a sign of resistance."

He cautioned that body language must be put into context and must be related to the culture if it is to be read correctly.

Starr agreed that a juror should be loose. "His spine should not be rigid and his neck, shoulder and head muscles should be relaxed," she said. She suggests looking at the face, but "don't let obvious signs deceive you." For example, a person may be smiling and have a wide-open expression because that is the way he wants to be perceived. "But there are leakage clues that give away our true emotions. Watch for facial tics, which are the beginnings of expressions that are not completed. If you see several of these, then you realize the prospective juror is controlling his expressions. Even if a person is able to control his facial expressions, his hands and feet can betray his true emotions. The face

may be smiling but the hands might be in a claw formation and the calves and feet may be tense," Starr said.

Bennett agreed it is important to watch a person's face to determine if he is telling the truth. When a person lies, split-second facial expressions—"micromomentaries"—occur, he explained. Some of these expressions may last only 1/100th of a second, but a person can be trained to see them. The micromomentaries include flaring of the nostrils, rapid eye blinking, and rapid up-and-down movement of the eyebrows.

He believes the micromomentaries are more dependable indicators of whether a person is telling the truth than broader clues, such as averting the eyes and hand movement. "When a person is lying, the hand is generally brought up to the mouth area," Bennett said. Persons can be trained in a few hours to see micromomentaries, he said, "The primary thing is to pay close attention to the person being interviewed, and not let your attention waiver. The tendency is to look away. You almost have to stare."

A prospective juror may lie because he knows only 12 will be chosen and he may feel challenged to gain one of those seats, Starr said. "There is no juror that is perfect for every trial. Generally, though, you want someone who tends to be liberal, has a high energy level, and is looking for a hard demonstration of evidence."

Starr said the nonverbal commu-

nication field is still in its infancy. "Most lawyers know so little about the field, though, that any assistance in this area is a big help to them," she added.

Fast said nonverbal communication can be an aid, but warned lawyers not to rely upon it too heavily. "A good solid case is still the best way to win a favorable verdict," he said.

American Bar Association Journal,
January 1979, p. 38

"Perhaps the witness would care to reconsider his answer to the last question?"

The New Yorker

What do your eyes reveal to others? Various eye movements are associated with emotional expressions: A downward glance suggests modesty; staring suggests coldness; wide eyes suggest wonder, naïveté, honesty, or fright; and excessive blinking suggests nervousness. Researchers have also shown that as we begin to take an interest in something, our blinking rate decreases and our pupils dilate. For example, when people were shown photographs of naked models, their pupils dilated.

The length of time we look at another person or thing also communicates a message. Somehow it is deemed acceptable to stare at animals and inanimate objects such as paintings or sculptures, but it is judged "rude" or inappropriate to stare at people. Julius Fast, author of the popular book *Body Language*, suggests that we stare at individuals we believe to be nonpersons. Who have you stared at lately? Why? Instead of staring at

other persons, we are supposed to demonstrate "civil inattention." Civil inattention is the practice of not establishing sustained eye contact or of letting your eyes rest only momentarily on another person. In other words, we practice "keeping our eyes to ourself." For instance, where do you place your eyes when you enter a crowded elevator? How might people react if someone at the front of the elevator turned around and stared or gazed at each of the other passengers for an extended period of time? Our guess is that

Eye contact, which signals our need for inclusion or affiliation, is more frequent among those who are emotionally close.
(© *Monique Manceau/Photo Researchers*)

the elevator would quickly empty at the next stop! Thus, it is permissible to look at someone we do not know for one to two seconds. After that, however, we are expected to "move our eyes along." Notice your own eye behavior the next time you walk down a street. Your eyes will probably wander from face to face. But if you and someone you do not know are looking at each other while approaching from opposite directions, at least one of you will redirect your gaze before you actually get too close. If we look at someone for a long time, we may make them fidgety and uncomfortable. They may actually believe we are challenging them. Have your eyes "innocently" rested on another person only to have him demand, "What are you staring at? You want to start something?" Despite this, whether it be at a party or a chance meeting, the first thing most people do is "eye each other."

Eye contact gives us certain types of information. First, it gives us feedback on how we are coming across to the other person. Eye contact can indicate that the communication channel is open. It is easier to avoid talking to people if we have not made eye contact with them. According to researchers Michael Argyle and Janet Dean, eye contact almost makes interaction an obligation. The type of eye contact between people also offers clues to the type of relationship being shared. Eye contact signals our need for inclusion or affiliation. Persons who have high affiliative needs will more frequently return the glances of others. There is a high degree of eye contact between people who like each other. We also increase eye contact when communicating with others if the physical distance between us is increased. In this case, eye contact helps to reduce the barrier of physical space. For similar reasons, we decrease the amount of eye contact when we are situated too close to the person with whom we are communicating; reducing eye contact psychologically increases the physical distance between us.

What is communicated if eye contact is missing? Others may feel we are trying to hide something or that we do not like them. A lack of eye contact can also suggest that two people are in competition with each other. Others may interpret it as signifying either boredom or simply a desire to end the conversation. How do you rate your own eye contact? When are you a looker and when are you a nonlooker?

SKILL BUILDER

IT'S EYE TIME

1. Experiment with how the presence or absence of eye contact affects your interactions with others by operating under each of these conditions when talking to others:

 A. Keep your eyes on the floor.
 B. Keep glancing around.
 C. Stare at the other person's face.
 D. Look at the other person's waist.
 E. Maintain comfortable eye contact.

2. Be prepared to report your findings to the class.

Like the eyes, the lower facial area also has much to communicate. Some people smile with just their mouth and lips. For others, such as Bette Midler, the smile appears to consume the entire face.

(© Michael Kagan/Retna Ltd.)

As a child, were you ever told to "wipe that smile off your face"? Why? Besides happiness, what can a smile communicate? How does your face look when you are not smiling? When it is at rest? Some of our faces display neutral expressions. Others seem to display frowns, snarls, or habitual smiles—that is, the corners of our mouths normally turn up. One of your authors had a student in class who constantly grinned. He could have been told that he failed the course, and still he would have appeared to grin.

What about when you choose to smile? How do people react to your smile? People often find that others will respond by returning a smile to those who smile at them but will look away or avoid stopping to speak to the person whose lips are pursed into a frown. To what extent do your experiences confirm this?

THE INVISIBLE SMILE

Brian Weiss

Keeping a straight, inscrutable face depends a lot on who's looking. Just as invisible lip movements accompany reading, it appears that unseen muscle activity previews what our faces are going to say.

Harvard psychologist Gary Schwartz and his colleagues looked behind faces by measuring the electrical output of four muscles, located near the forehead, eyebrows, mouth and jaw. Through his electrodes, he was able to judge what people were feeling even when their faces said nothing.

Schwartz asked people to make faces representing happy, sad and angry expressions. He found that each of these faces was accompanied by a distinctive set of muscular signals, giving him a baseline from which to measure other muscular maneuvers.

Working with a group of women suffering from depression, and a control group of female volunteers, Schwartz asked each simply to think about being happy, sad and angry. Given a chance, he reasoned, people will produce the thoughts that have the strongest impact on them, thus increasing his chances of "seeing" differences in the way the two groups respond.

Schwartz and his associates reported to a meeting of the American Psychosomatic Society that they found changes in muscle activity that were too slight to register on people's faces. The control subjects produced a distinctive muscular reaction for each emotion. When asked to "think about a typical day," they offered a covertly happy expression.

The depressed women produced similar patterns when they thought of sadness and anger, but their faces fell when it came to thinking about a typical day. Not only did they show less reaction when asked to think about happiness, but when they envisioned a typical day, the muscle-measurer registered "sad."

The face is a sensitive tablet on which we record our emotions, and we've learned to become careful readers. The universality of at least some facial expressions suggests an origin far back in our evolutionary past, and the discovery that muscles record what we're feeling before putting on a public display raises the possibility that what's covert to us today may have been visible to our forebears.

Psychology Today,
September 1975, p. 38

You can see that we have many options when expressing our emotions through our facial expressions. As you watch television comics and performers work, examine closely how they use facial expressions to communicate. An awareness of how your facial expressions affect others will help you become a more effective interpersonal communicator. After all, facial cues communicate large portions of the messages you send to others. In fact, researcher Albert Mehrabian has concluded that while verbal and vocal

cues are used to help communicate meaning, the face is relied on to a greater extent than either of these.

Posture. How many times have you heard the following admonitions?

"Hey, stand up straight!"

"Don't slouch!"

"Why are you slumping?"

"Get your feet off the furniture!"

"Keep your shoulders back!"

"Why are you hunched over that desk?"

What conditions cause you to tense up? What conditions allow you to relax? When do you stand erect? When do you slouch? What kinds of nonverbal messages does your posture send to others? The way we hold our physical selves when sitting or standing is also a nonverbal broadcast. It, too, gives others information that they use to assess our thoughts and feelings.

SKILL BUILDER

POSTURE BROADCAST

1. Stop! Do not move a muscle! How are you sitting? How is your back positioned as you read this? Your legs? Shoulders? Hands? Are you slumped over the book? Are you reclining in a chair?

2. What messages would your posture broadcast to others? If necessary, adopt a posture that you believe others would interpret as studious. What aspects of your posture did you have to change?

Although no one bodily position means precisely the same thing to everyone, research has provided us with enough information to reach some general conclusions about how others are likely to interpret our posture.

Nancy Henley in her book *Body Politics* suggests that "The *bearing* with which one presents oneself proclaims one's position in life." Television and film support this premise by frequently contrasting the upright bearing of a wealthy person with the submissive shuffle of a servant or the slumped demeanor of a nobody. In line with this, nonverbal theorist Albert Mehrabian determined that when people are compelled to assume inferior roles, they reflect this move by lowering their heads. In contrast, when assuming superior roles, people often raise their heads.

We each have certain expectations regarding the types of postures we expect others to display. For instance, how would you expect a military general to stand? The general usually adopts an extremely straight and somewhat stiff posture. Henley suggests that "standing tall" in and of itself helps a person achieve dominance. Dame Judith Anderson achieved fame by performing the roles of various dominant women from Shakespeare and Greek tragedies on the stage. Although a very slight person, her posture and bearing was such that she seemed to fill or dominate the stage.

THE HEIGHT REPORT

Jean Strouse (5 feet 2)

Is James Arness taller than John Kenneth Galbraith? How much taller than Howard Cosell is Julia Child? Who said, "Being short never bothered me for three seconds . . . The rest of the time I wanted to commit suicide"? If you answered no, 2 inches and Mel Brooks, chances are you don't need Ralph Keyes's "The Height of Your Life," though you might want to leave it around in the bathroom or on the coffee table for friends. (Galbraith, by the way, is 6 feet 8 and Arness 6 feet 7; Julia Child is 6 feet 2, and—surprising as it seems, for he *acts* smaller—Cosell is 6 feet even.)

Just about everything else you never thought of asking about height is in here, too. For instance, J. Edgar Hoover (5 feet 7) had his employees say that he was "just under 6 feet," and he used specially selected toilets so his feet wouldn't dangle. Asked for the zillionth time about the weather up there, a large basketball player in an elevator simply poured his Coke over the questioner's head and replied, "Raining." A Minnesota woman explained succinctly why she did not want Vietnamese refugees to settle in her town: "I don't want short grandchildren." In 1971, a 4-foot-10½ sophomore at New College in Florida posted a list of Short Demands, including lower library shelves, admission quotas favoring small applicants, required courses on the history of tall oppression and a Mickey Rooney Film Festival.

Is taller really better? Even our language reflects the bias. Keyes (5 feet 7.62) writes: "Americans in particular have always looked up to big men who sit tall in the saddle and

won't stoop to anything so small as short-changing another man, belittling him, or giving him short shrift." He compares *Newsweek's* description of Russian dancer Aleksandr Godunov ("With his tall, powerful build, mane of blond hair and rugged features, the 29-year-old Godunov cuts an overwhelming figure onstage") with *Parade's* description of Dustin Hoffman ("With his short stature, hook nose, beady eyes, unkempt hair, he looks like a loser").

'CUTE GUYS':

Do big guys really get more girls? Comedian David Landsberg (5 feet 2) says he was always called "cute" and "Cute guys do not get laid. That is a rule. A rule of thumb. The tides go out twice a day and cute guys do not get laid. Newton, I think. Newton was one of the people who said that." In fact, though bed serves as a great equalizer, a survey of 6,000 businessmen found that men over 6 feet tall reported a greater frequency of sexual intercourse than shorter men, and in a study of Har-

vard graduates, the tall men had produced more children than the small men had. (Also, men over 6 feet earn on the average 10 per cent more per year than men under 6 feet and women in general.)

What is this thing people have about height? Harvard biologist Stephen Jay Gould (5 feet 8) suggests that height itself matters less than eye level—"whether you're looking up or . . . down. So I wonder if the angle of the sight line may not function as a cue to inferred rank." In animal societies, the biggest male often scares away other males and wins the females just by showing off his stature. And Keyes points out that everybody was once a child, looking up at the big folks who had all the power. Equating power with tallness, people tend to see presidents and psychotherapists as taller than they actually are. Height is a state of mind, concludes Keyes. You're only as tall as you feel. It's all in your head—that is, if it's not in your legs.

Newsweek, May 19, 1980

As a communicator, you will want to develop a posture appropriate to and supportive of your goals and aspirations. While stooped shoulders can indicate that you are heavily burdened or submissive, raised shoulders suggest that you are under a great deal of stress. Square shoulders usually suggest strength to Americans.

SKILL BUILDER

POSTURE POINTERS

1. Walk around the room in a stooped posture. Then develop a list of phrases to describe how carrying yourself in that fashion makes you feel.
2. Walk around the room with your shoulders raised and your head and neck taut.

Our emotions and our physical bearing are closely related. The relationship is expressed through the verbal idioms that have developed through the years. It is said that we "shoulder a burden," have "no backbone," keep our "chin up," or "shrug it off." The way we carry ourselves can affect the way we feel just as much as the way we feel can affect the way we carry ourselves. Bodily expression communicates.

Posture and sex roles are also believed to be related. Men are expected to sit and stand in different positions than women. This next experience gives you a chance to try on the postures associated with the other sex.

SKILL BUILDER

MALE AND FEMALE POSTURES

1. Divide into male/female pairs.
2. If you are a man, sit in a straight chair. Cross your legs at the ankles, and keep both knees pressed together.
3. If you are a woman, sit as if you were wearing football gear. Separate your legs, place your hands on your thighs, and imagine you have on a helmet, bulky shoulder pads, and thick knee pads.
4. While adopting the physical demeanor associated with the other sex, converse with each other about the day's events or other topics of your choice.
5. How did you feel about assuming these postures? Would you behave differently if you "wore" this posture habitually? Would people respond to you differently? To what extent do you favor a "unisex" posture?

The last aspect of posture we will consider is the way we lean, or orient ourselves, when we communicate. If you were speaking to someone and she suddenly turned or leaned away from you, would you consider it a positive sign? Probably not. We usually associate liking and other positive attitudes with leaning forward, not withdrawing. The next time an interesting bit of gossip is discussed in the cafeteria, notice how most if not all people lean forward to insure they do not miss one juicy morsel of the story. When

Again, develop a list of phrases to describe the way carrying yourself in that fashion makes you feel.

3. Walk around the room with squared shoulders. Contrast how you feel while carrying yourself this way with how you felt in the previous exercise phases.

communicating with others interpersonally, a slight forward lean of your upper body may indicate that you are interested in what your cocommunicator has to say. Mehrabian found in his studies that we lean either left or right when communicating with a person who is of lower status than we are. The right or left leaning is a part of our more relaxed demeanor.

Using the posture ideas that have been presented here, try this:

SKILL BUILDER

POSTURE POSES

1. Divide into groups of three. Each of you will assume, in turn, that you are a photographer and the other two group members are your models. You will pose your models to demonstrate a variety of relationships. The models' arms will remain at their sides, but you may position them to sit or stand, slump or be straight, lean forward, backward, or to either side. Position your models to show one of these relationships:

 Servant and manor lord
 Waiter and customer
 Two people with romantic interest
 Two boxers before a fight
 Boss and secretary
 Teacher and student who is failing
 Your choice

2. After each "photographer" sets up the models, remaining class members should attempt to guess the relationship displayed. Discuss cues you used to make your choices.

Remember, body posture talks. The messages sent by your posture vary and reflect whether you are feeling content and confident, angry and belligerent, or worried and discouraged. Your posture helps signal whether you are ready to approach and meet the world or whether you wish to avoid and withdraw from the world. Thus, how you hold yourself helps define the way you feel about those with whom you are communicating.

Gestures. The movements of our hands, arms, and legs constitute another way in which we broadcast nonverbal interpersonal data. We will examine each element separately, beginning with the hands.

As you read this, examine your hands. What do they tell you? Do you need to wash them? Cut your cuticles? Polish your nails? Rub your hands with a dab of lotion? Look at lines, texture, pigmentation, wrinkles, and scars. What do you see in your hands that you had not noticed before? What messages are they communicating? Are you a nervous nail chewer? A cuticle picker? Are your hands weather-beaten? Feminine? Your hands,

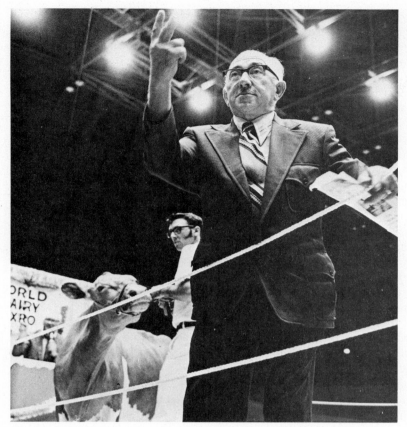

Gestures can have important meanings in some contexts. At an
auction, if you raise your hand absentmindedly to scratch your ear,
you might end up bidding on a dairy cow.
(© Daniel S. Brody/Stock, Boston)

like your face, are nearly always exposed to view. Therefore, they constitute an influential
nonverbal cue.

In order to concentrate on the movements or gestures of the hands, we shall divide
them into four sections: palm, back, tip, and edge. Infants quickly learn that showing
the palm to "Grandma" while moving the fingers is associated with "hello" or "bye-
bye." Gesturing with the palm up is interpreted as a sign of openness or pleading. Rock
musicians wave at fans with the hands extended overhead, palm open. Sometimes, of
course, we expose the palm in order to push something or some idea away. Is the back
of the hand as friendly, more friendly, or less friendly than the front? Is it more aggressive
or more conciliatory? As children we often had the tip of a finger pointed at us or poked
into us when we made errors. During wartime, Uncle Sam has been pictured wanting
"You!" with the tip of his index finger extended toward you, the potential recruit. The

emphatic nature of the pointed finger is exhibited by University of Texas fans when they cheer on their teams with the "hook 'em horns" gesture; in this case, the index and little finger are extended but with the tips pointed forward symbolizing the horn of the longhorn cattle. In all fairness, Texas Tech, the rival school, also has an appropriate gesture that accompanies their school slogan, "Gig 'em Aggies." If you make a karate chop, which portion of the hand is used? The edge of the hand is often used to connote force. In karate, the boards or bricks are broken with the edge, not palm, of the hand. Likewise, the angry politician or business person may pound on the table with a clenched fist and the edge of the hand. What meanings do these four areas of the hand have for you?

The way we position our arms also broadcasts information about our attitudes. Cross your arms in front of you. Do you feel closed off from the world? Stand up and put your hands on your hips. How does this stance make you feel? You may remind yourself of the old army sergeant stereotype. Next, clasp your arms behind your back in a self-assured manner. Then, hold your arms stiffly at your sides as in a nervous speaker or wooden soldier pose. Finally, drop your arms to your sides in a relaxed fashion. Become aware of the habitual arm positions you use. What messages do your arm positions communicate?

Our legs also help express information about us to others. Try standing as a model would stand. Next, sit down and proceed to put your feet up on the desk or table. Then stand with your feet wide apart. Does this stand make you feel more powerful? Why? Return to a more comfortable position. Shift your weight forward toward the front of your feet. Then, rock back so the weight is on your heels. Watch someone else do this. Does the forward position communicate more energy and enthusiasm? The distribution of your body weight and the placement of your legs and feet can broadcast stability, femininity, masculinity, anger, happiness, and so forth. Choose the stance that most accurately reflects your goals for an interpersonal encounter.

Finally, let us put the hands, arms, and legs together and consider their interaction as we walk. Try this.

SKILL BUILDER

HAPPY/SAD WALKS

1. Form a group of five or six class members, and walk from one side of the room to the other as you normally walk. The rest of the class should observe the movements of hands, arms, and legs.

2. Having established a "neutral" walk, each group member should think of something that makes him or her very happy. The group should then walk across the room in a happy mood. How did the walks change? Point out specific movements. Repeat the exercise by portraying sad walks, timid walks, arrogant walks, and sympathetic walks, with class members pointing out how walking behaviors changed in each instance.

3. Once each group in the class has had a chance to display a number of different attitudes through their walks, each group should briefly caucus and choose a

It could be said that gestures are simply motions of your limbs or body that you use to express or accentuate your moods and ideas. Let us now turn to two other nonverbal cues—your physique and your dress style.

Physique and Dress Style

People can generally be divided into one of three body types: endomorphic (heavy), mesomorphic (muscular), and ectomorphic (thin). For some time researchers have tried to establish a relationship between body types and personality. Use the following test, adapted from J. B. Cortes and F. M. Gotti's "Physique and Self-Description of Temperament" (1965), to determine the relationship, if any, between your body type and temperament.

Instructions: Fill in each blank with a word from the suggested list following each statement. You may select any word from the list of twelve immediately below for any of the three blanks in each statement. An exact word to fit you may not be in the list, but select the words that seem to fit *most closely* the way you are.

1. Most of the time I feel _____, _____, and _____.

calm	relaxed	complacent
anxious	confident	reticent
cheerful	tense	energetic
contented	impetuous	self-conscious

2. When I study or work, I seem to be _____, _____, and _____.

efficient	sluggish	precise
enthusiastic	competitive	determined
reflective	leisurely	thoughtful
placid	meticulous	cooperative

character type. Everyone in the group—men and women—will walk as this chosen character. Some possibilities include:

Football coach	Female model
Shy child	Male model
Happy three-year-old	Tired old man
Prostitute	Spry old woman

Do not tell observers your group's chosen character. Group members should walk across the room "in character" while the class attempts to identify the character type portrayed. Analyze how arm, leg, and hand movements led you to make the correct or incorrect identification.

3. Socially, I am _____, _____, and _____.

outgoing	considerate	argumentative
affable	awkward	shy
tolerant	affected	talkative
gentle-tempered	soft-tempered	hot-tempered

4. I am rather _____, _____, and _____.

active	forgiving	sympathetic
warm	courageous	serious
domineering	suspicious	soft-hearted
introspective	cool	enterprising

5. Other people consider me rather _____, _____, and _____.

generous	optimistic	sensitive
adventurous	affectionate	kind
withdrawn	reckless	cautious
dominant	detached	dependent

6. Underline one word out of the three in each of the following lines that most closely describes the way you are.
 a. assertive, relaxed, tense
 b. hot-tempered, cool, warm
 c. withdrawn, sociable, active
 d. confident, tactful, kind
 e. dependent, dominant, detached
 f. enterprising, affable, anxious

Next, add up the number of responses you selected from each of the endomorph, mesomorph, and ectomorph categories listed below:

ENDOMORPHIC	MESOMORPHIC	ECTOMORPHIC
dependent	dominant	detached
calm	cheerful	tense
relaxed	confident	anxious
complacent	energetic	reticent
sluggish	impetuous	self-conscious
placid	enthusiastic	meticulous
leisurely	competitive	reflective
cooperative	determined	precise
affable	outgoing	thoughtful
tolerant	argumentative	considerate
affected	talkative	shy
warm	active	awkward
forgiving	domineering	cool
sympathetic	courageous	suspicious
soft-hearted	enterprising	introspective
generous	adventurous	serious
affectionate	reckless	cautious
kind	assertive	tactful
sociable	optimistic	sensitive
soft-tempered	hot-tempered	withdrawn

If you chose three adjectives from the endomorph category, fifteen from the mesomorph category, and three from the ectomorph category, your temperament score would be 3/15/3. Operating on the basis of your temperament analysis, we would guess that you were a mesomorph. To what extent did the qualities you attributed to yourself match your actual body type? Although these personality traits are not always associated with the body type under which they appear, the accepted physique–temperament stereotype may have much to do with how you are being treated by others or with the traits others expect you to exhibit.

"Sweetie, will you help me with my tie?"

The New Yorker

Since we adorn our bodies with clothes, let us consider this nonverbal cue next. "I can't decide what to wear!" "What should I wear?" "What are you wearing?" Clothing decisions face us every day. Some people choose their clothes very carefully, and others just seem to "throw on" whatever is at hand. Many of us enjoy shopping for clothes, and others of us must be dragged to clothing stores. Even paying attention to dress, however, does not guarantee that we make appropriate choices. Have you ever arrived at a function only to find yourself severely overdressed or underdressed? How did you feel? Were you able to put on or take off some part of your outfit to "fit in" with the prevalent dress style? The manner in which we dress ourselves is extremely important in creating a first impression. John T. Molloy, author of *Dress for Success* and *The Woman's Dress for Success Book*, gathered his research from numerous studies in which people offered their first impressions of the dress of others. What first impressions do people get from your clothes? What impression would you like to create? Let's find out.

SKILL BUILDER

WHAT WOULD YOU WEAR WHEN . . . ?

1. Using the following chart, compile a list of the articles of clothing you have on at this moment.

YOUR POSITION/ LOCATION	GARMENTS	OVERALL IMPRESSION (SOCIOECONOMIC STATUS, ROLE PLAYED, ETC.)

2. Select a partner. Have your partner fill out an "Overall Impression" list. To what extent do your partner's opinions differ or overlap with your own?

3. Next, using another chart, indicate the articles of clothing you would wear and the impression you would try to create if you were to assume these roles:

ROLE	CLOTHING	IMPRESSION
Corporate president		
Army officer		
Secretary		
Mechanic		
Physician		
Carpenter		

Compare your choices with the choices of others in your class. To what degree did selected clothing differ? To what extent did men and women choose the same or similar articles of clothing?

What we wear can send potent messages. Consider what might happen if this young man wore his "punk" attire to a job interview. (© *Hazel Hankin 1980*)

It should be apparent that your dress and your choice of image would change as your roles changed. Mechanics must create the impression that they can repair your car, and corporate presidents must give the impression that they can lead the company through an uncertain future. Artists must convince others that they can transfer their ideas to a canvas. The role we play to some extent dictates the uniform we wear. Some organizations, such as fast food outlets and the military, require their employees to wear specific articles of clothing. Most people, however, are given some latitude of dress choice, although the uniform concept is adhered to, to a certain extent, even in business. John Molloy has identified clothing that he claims should be worn by people who wish to become managers or executives. For men, he suggests dark blue pin-stripe suits to add a feeling of authority. Dark grey is also accepted as an executive "uniform." Molloy also created a "uniform" for women in business. The basic outfit is summed up in this statement, which many of his female seminar attendees adopted:

> I pledge to wear a highly tailored, dark colored, traditionally designed
> skirted suit whenever possible to the office.

What is your reaction to such dress codes? Would such attire be appropriate for you in your present position? In the future? Test the ways in which the clothes you wear affect others:

What you wear causes people to relate to you in particular ways. As a case in point, your authors knew one instructor who wore a black suit and tie to class the first day of each semester just to see how his students would react. His class always believed he was on his way to a funeral. No one spoke a word to him before or after class. Thus, clothes send potent and forceful messages to others. They are one of the nonverbal stimuli that influence the interpersonal responses of others.

Voice

In many ways, you either play your voice or you are a victim of your voice. Researcher Albert Mehrabian estimates that 38 percent of the meaning of a message delivered via face-to-face conversation is transmitted by your voice or vocal cues. Frequently, *how* something is said *is* what is said. Many performers make a living from their voices, such as Mel Blanc, the voice behind Bugs Bunny and many other Warner Brothers cartoon characters. Some stand-up comics have trained themselves to take on the vocal characteristics of famous people. Presidents, politicians, and other well-known figures are fair game for the impressionists. How are you at "playing" a voice?

The vocal cues that accompany spoken language are termed "paralanguage." Among the ingredients of paralanguage are pitch, rate, volume, hesitations, and pauses. Wise interpersonal communicators realize that the spoken word is never neutral, and they have learned how to use the basic elements of paralanguage to transfer both the emotional and intellectual meanings of their messages. In other words, adept communicators know how to use vocal nuances to help their listeners appreciate and understand the content and "mood tones" of their conversations. They have made their voices adaptable. They use their voice; they do not let it use or abuse them. Let us examine these paralinguistic ingredients more closely now.

Pitch is the highness or lowness of the voice on a musical scale. We tend to identify higher pitches with female voices and lower pitches with male voices. We also learn vocal stereotypes. We associate low-pitched voices with strength, sexiness, and maturity and high-pitched voices with helplessness, tenseness, and nervousness. Test your pitch range right now by singing "La" up and down the scale from the lowest note you can hit easily to the highest that you can reach without straining. Of all those pitches, does

one seem to be most comfortable? Do you use one much or most of the time? Although we all have what is termed a habitual pitch, we have also learned to vary our pitch to reflect our mood and generate listener interest. Some individuals, however, overuse one tone to the exclusion of all others. They have monotonous or monotone voices, which are characterized by having too little variety in pitch. Other individuals speak toward the upper end of their pitch scale, producing very fragile, unsupported tones. One way for men and women to discover a pitch that is not overly high is simply for them to yawn. Try it now. Permit yourself to experience a good stretch; extend your arms to shoulder level and let out a nice vocalized yawn. Do it again. Now count to ten out loud. To what extent does the pitch of your voice appear to have changed? Is it more resonant? It should be. If you indulge yourself and yawn once or twice before stressful meetings or occasions, you will be able to pitch your voice at a more pleasing level.

Volume is a second paralinguistic factor that affects perceived meaning. Some people cannot seem to muster enough energy to be heard by others. Others blast their voices through interpersonal encounters. Have you ever sat in a restaurant and heard more of the conversation at a table several feet away than you heard at your own table? Volume frequently reflects emotional intensity. Loud persons are often perceived as aggressive or overbearing. Soft-spoken persons are often perceived as timid or polite. Volume must be varied if it is to be effective. Knowing how to use volume to control meaning is a useful skill. Try your hand at it by participating in this exercise adapted from Ken Cooper's book, *Nonverbal Communication for Business Success* (1979).

SKILL BUILDER

VOLUME DISTORTION

1. Read the following sentence to yourself: "How many animals *of each species* did Moses take aboard the *ark*?" Why is this a riddle? Moses, of course, never had an ark. Noah was the ark builder.

2. Now, tell a friend or acquaintance that you have a riddle. Read the sentence aloud, being careful to increase your volume for each of the italicized words. Keep a tally of the number of people who answer "two."

3. Try it again, this time increasing your volume only on the name *Moses*. How did your vocal change affect the reactions of listeners?

In most instances, varying your volume to emphasize the word "Moses" increases the listeners' accuracy. It is important that the volume you use in interpersonal communication enhance rather than distort the meaning of your messages. Remember, by varying your volume and emphasizing certain words, you can control the meaning attributed to your statements.

The *rate*, or speed, at which we speak is also important in interpersonal communication. Do you, for example, expect high-pressure salespeople to talk rapidly or slowly? Most often, we find that they speak very quickly. Similarly, "pitch" men and women who are

charged with selling all types of gadgets in department stores or on television also speak at a quick clip in order to retain the interest of the crowds that gather or the viewing audience. In contrast, more stately or formal occasions require that communicators use slower speaking rates and planned pauses. Politicians at rallies typically litter their speeches with pauses that function almost like applause signs. These pauses serve a purpose. Researcher Goldman-Eisler has concluded that two-thirds of spoken language comes to us in chunks of less than six words. Therefore, knowing when to pause is an essential skill for the effective communicator to master. Such pauses serve to slow the rate of speech and give both sender and receiver a chance to gather their thoughts. But unfortunately, many, if not most, people intuitively feel that all pauses must be filled. The question then becomes, how do you fill the pauses? All too frequently, we fill them with sounds such as:

er . . . huh . . . uh . . . uh . . .

uh huh

You know? You know?

"Right! Right!" "Okay! Okay!" are used to fill pause time. Such fillers, called "nonfluencies," disrupt the natural flow of speech. Since a pause is a natural part of speech, it makes sense to stop trying to eliminate it. Give the pause a chance to function.

How adept are you at employing the paralinguistic factors we have discussed?

SKILL BUILDER

ALPHABET RECITAL

1. Select a partner. Each of you will choose one of the following emotions for further work. Do not let your partner know which emotion you have chosen. In addition, your partner's eyes should be closed.

happiness	love
sadness	nervousness
anger	pride
jealousy	satisfaction
fear	sympathy

Your task is to communicate the selected emotion to your partner by reciting letters of the alphabet from A to G. As you recite the letters, attempt to make your voice reflect the selected emotion. Your partner's goal is to identify the emotion by listening only to the paralinguistic cues you are sending.

2. To what extent did the various paralinguistic factors (volume, pitch, pause, rate) help your partner guess the emotion? If your partner was unable to determine the emotion you were sending, what could you have done to make the message clearer?

This exercise, a variation of a study conducted by researchers Joel Davitz and Lois Davitz, should prove that you do not always need to see a person to tell whether he or she is happy, sad, angry, fearful, or proud. Many of us can judge emotional state through the voice alone. Of course, some of us encode the emotional messages with our voices better than others, and some of us can decode these messages better than others. Accuracy in sending and judging the nature of emotional messages appears to be related to an individual's sensitivity and familiarity with the vocal characteristics of emotional expression. Besides communicating emotional content, the voice has also been found to be a communicator of personal characteristics. Let us examine this aspect next.

Vocal Stereotypes. Listening to a person's voice can sometimes help you identify that person's key characteristics. For instance, when we answer the telephone, we are frequently able to determine the speaker's sex, age, vocation, and the region of the country where he or she lives, even though we have never met the person. To what extent do the voices of four-year-olds and teen-agers vary? How do the voices of college-aged males and male retirees contrast? Are there differences in the vocal characteristics of corporation executives and plumbers? What differences in the qualities of these voices can be discerned?

We also tend to associate particular voice types with particular body or personality types. For example, what type of appearance would you attribute to a person who possessed a breathy, feminine voice? How would you think a person who had a throaty, raspy, masculine voice would look? The accompanying chart summarizes stereotypes related to vocal cues.

VOCAL CUES AND PERSONALITY STEREOTYPES

Vocal Cues	Speakers	Stereotypes
Breathiness	Males	Young; artistic
	Females	Feminine; pretty; effervescent; high strung; shallow
Thinness	Males	Did not alter listener's image of the speaker
	Females	Social, physical, emotional, and mental immaturity; sense of humor and sensitivity
Flatness	Males	Masculine; sluggish; cold; withdrawn
	Females	Masculine; sluggish; cold; withdrawn
Nasality	Males	A wide array of socially undesirable characteristics
	Females	A wide array of socially undesirable characteristics

VOCAL CUES AND PERSONALITY STEREOTYPES (continued)

Vocal Cues	Speakers	Stereotypes
Tenseness	Males	Old; unyielding; cantankerous
	Females	Young; emotional; feminine; high strung; less intelligent
Throatiness	Males	Old; realistic; mature; sophisticated; well adjusted
	Females	Less intelligent; masculine; lazy; boorish; unemotional; ugly; sickly; careless; inartistic; humble; uninteresting; neurotic; apathetic
Orotundity (fullness/ richness)	Males	Energetic; healthy; artistic; sophisticated; proud; interesting; enthusiastic
	Females	Lively; gregarious; aesthetic sensitivity; proud
Increased Rate	Males	Animated and extroverted
	Females	Animated and extroverted
Increased Pitch Variety	Males	Dynamic; feminine; aesthetic
	Females	Dynamic and extroverted

Adapted from P. Heinberg's *Voice Training for Speaking and Reading Aloud*, 1964

As an interpersonal communicator you should be aware that your vocal quality suggests certain things about you. Whether receivers are interested in identifying your age, occupation, or status, they are likely to make assumptions based on what your voice says to them. Although the picture or stereotype they form may be far from accurate, it could still influence their assessment of you as an individual and affect the way they interact with you.

Double-edged Messages. Just as we have double-edged razor blades, so we have double-edged messages. We send double-edged messages whenever we say one thing but mean another. Albert Mehrabian calls such statements "contradictory messages." We commonly refer to them as sarcasm. Have you ever said to someone, "Oh, you're a winner!" when both of you understood that you meant just the opposite? At this point, select a partner and take turns saying each of the following messages in both a positive and a negative manner.

Isn't this a nice restaurant?

I really enjoyed the evening.

I certainly look forward to meeting with them next week.

Can you tell when your partner is sincere? When he or she is using sarcasm to project a negative feeling? In each case, which message do you believe—the actual words or the underlying tone? If you are perceived as sarcastic, your partner probably paid more attention to the vocal cues you provided than to your verbal cues. When the attitude you communicate through words contradicts the attitude you communicate through tone, the tone carries more meaning. Mehrabian suggests that using sarcasm fulfills certain psychological needs. Otherwise, why would we use it? It is important to note that we do not always intend to be sarcastic; we may try to mask our real feelings. However, sometimes, much to our surprise, our voice gives our real feelings away.

Like our voice, our use of space, distance, time, and color also reveals much about us.

Use of Space and Distance

How much space in this world do you call your own? How much space do you carry around with you? Are there times when people encroach on your space? During his college days one of your authors spent a summer as a soft drink salesman at one of New York's theaters. On the first day of work, he innocently perched himself on the edge of a step. A flurry of activity and shock went through the corps of ushers. It seems that the ticket taker at the theater had rested on that particular step for nearly half a century! The drink seller had usurped his space.

Let us next examine space and distance as it affects interpersonal communication. In his book *The Hidden Dimension*, Edward Hall used the term "proxemics" to mean "man's use of space." Today, "proxemics" refers to the space that exists between us as we talk and relate to each other, as well as the way we organize the space around us in our homes, offices, and communities. Hall identified four different distances that we keep between us and another person, depending on the type of encounter and the nature of our relationship.

Intimate distance: 0 to 18 inches

Personal distance: 18 inches to 4 feet

Social distance: 4 to 12 feet

Public distance: 12 feet to limit of sight

Intimate distance ranges from the point of touch to 18 inches from the other person. Physical contact is natural at this distance. We can wrestle and we can make love. At this distance our senses are in full operation. They are easily stimulated but also easily offended if we find ourselves in an uncomfortable situation. Have you ever had someone come too close to you? Did you want that person to back off? Did you back away? Sometimes we are forced to endure intimate distance with strangers in crowded buses, trains, and elevators. How do you feel and respond during such occasions?

Hall calls from 18 inches to 4 feet "personal distance." When communicating at this distance you can hold hands or shake hands with the other person. We are apt to conduct most of our conversations at this distance. It is the most common distance between people talking informally at parties, in class, or at work. If you reduce this distance to intimate distance, you are likely to make the other person feel uncomfortable. If you increase it, the other person is likely to begin to feel rejection.

Hall's social distance ranges from 4 feet to 12 feet. In contrast to personal distance, at this distance we are not likely to share personal concerns. By using "social distance," we can keep people at more than an arm's length. It is, thus, a "safer" distance, a distance at which we would communicate information and feelings that were neither particularly private nor revealing. Many of our conversations during dinner or at business conferences or meetings occur within this space. In business, the key protector of one's social space is the desk. Of course, the greater the distance between persons, the more formal their encounters. If you go to a social gathering, you can normally tell how well people know each other by examining how closely they stand to each other.

Public distance (12 feet and further) is commonly reserved for strangers with whom we do not wish an interaction. Distances at the further end of public distance are well beyond the personal involvement range and make interpersonal communication very unlikely. People waiting in an uncrowded lobby for an elevator frequently use public distance. It can be assumed that if a person chooses to use public distance when he or she could have done otherwise, the person really does not care to converse.

SKILL BUILDER

DISTANCE DETERMINATIONS

1. Work with a partner of the other sex. Back away from each other and attempt to carry on a conversation from a distance of 12 feet or more. Maintain this distance for thirty seconds.

2. Continue the conversation, but move into the social distance area (up to 4 feet). Again, converse for thirty seconds.

3. Next, move forward into the personal distance sphere (up to 18 inches) and continue talking.

4. Finally, move closer than 18 inches and attempt to continue your conversation.

5. How did your conversation change as the distance between you changed? How did you feel as you moved closer to each other? Did you become aware of the other's presence? Of his or her odor? To what extent did your visual perception of the person change? Did you or your partner feel you were being intruded upon? How did your behavior reflect this?

The concept to remember regarding intimate, personal, social, and public distance is that space speaks.

SUNDAY OBSERVER: HIGH INVISIBILITY

Russell Baker

Some time ago, having noticed that a man's stature in the world is measured by the difficulty of getting in to see him, I decided to call attention to my importance by going into the business of not seeing people.

I took an office with an anteroom, in which I posted a receptionist and waited for customers. In no time at all, business was thriving. The receptionist was turning away people at a rate that soon improved my reputation so remarkably that the tobacconist in the neighborhood began abandoning other customers and rushing to serve me when I favored him with a visit to buy chewing gum.

Each Friday the receptionist gave me the count of callers who had come in to see me and been turned away that week. It rose gratifyingly. Three the first week, seven the next, 18 by the end of the month. After six months, people were being turned away at the rate of 42 per week.

If the work was rewarding to the ego, it also had drawbacks. Sealed privately in my inaccessible office, I was unable to witness the chagrin of callers when they were told they were not of sufficient importance to merit my time. Moreover, I soon tired of sitting there all day solving crossword puzzles and waiting for something entertaining to become visible at the hotel window across the street.

To make the work more enjoyable, I had a peephole placed in the wall. It gave an excellent view of the anteroom. There I could sit for hours, eye glued to the tiny glass cylinder, waiting for someone to come in so that I could savor his discomfiture at being turned away.

As my reputation grew, the people who wanted to see me became more obstreperous, hurling their weight against my locked office door and shrieking about life-or-death necessity.

I retained a heavily muscled man to deal with such cases. To enlarge my worldly standing even more handsomely, I issued instructions to throw out five people bodily each week and toss two down the stairs. Business skyrocketed. My receptionist was never off the telephone, explaining that I was much too vital to be talked to, much less seen.

With such success, it seemed ridiculous to go to the office not to be seen when I could stay at home and not be seen just as easily and without spending money on subway fares. At this stage, a curious development occurred.

My reputation had become so grand that the office began attracting persons I should very much like to have seen. Names like Elizabeth Taylor and Earl Weaver began turning up on the weekly summary of rejects. Valéry Giscard d'Estaing was ejected bodily by my security man, and Norman Mailer was tossed down the stairs, along with an old classics professor of my college days to whom I was still devoted.

Matters came to a crisis one lunch-time when, having amused myself for several consecutive weeks by lounging around the house swatting cockroaches, my wife became exasperated with the mess in the kitchen.

"Why don't you go to the office like all the other important men and not see a few dozen people?" she suggested. I went to the office. My receptionist—she must have had five people holding on her telephone console—did not look up, but simply murmured, "He's not seeing anyone today."

"Do you know who you're talking to?" I said.

By way of reply, the heavily muscled man crunched across the carpeting, seized me and threw me down the stairs. On his behalf, I must concede there was no reason for him to recognize me, since he had been hired by the receptionist with the explanation that I was too important ever to be seen.

Bad temper, a sprained shoulder and feelings of outraged eminence prevailed, however, over good sense. From the safety of a telephone booth, I called the office. The receptionist recognized my voice at once, and I fired the two of them.

Not wishing to shatter my reputation by seeing members of the national labor pool, I had an employment agency hire and instruct substitutes, but the instructions were sloppy and imprecisely given, with the result that upon trying to unlock my office door the following Monday I was severely beaten and left at the bottom of the elevator shaft.

I have not dared go to the office for weeks. With a little imagination, I suppose, a plan could be formed that would get me safely into my place of business, but such complex schemes are beyond me now. I have spent too much of my life concentrating on not seeing people to have any flair for creative management.

Meantime, my reputation has become more awesome than ever. For weeks I have been unable to get through to the office by phone. Always a busy signal. People being turned away by the thousands daily. And if I did get through, would it help? The new receptionist doesn't recognize my voice.

New York Times, September 23, 1979

Thus, becoming aware of how people use space can improve your communication effectiveness. The nature of our environment affects the amount of distance we maintain between ourselves and others. Those who study nonverbal communication divide environmental spaces into classifications: fixed feature, semifixed feature, and informal. These classifications are based on the perceived permanence of the physical space. Thus, informal space is seen as a highly mobile, quickly changing space that ranges from intimate to public (from no space between us and others to 25 or more feet between us and others). In many ways, informal space functions much like a personal bubble or balloon. We can enlarge it and keep people at some distance from us, or we can decrease it and permit people to get closer to us.

In contrast to informal space, semifixed feature space employs objects to create distance. Semifixed features include chairs, benches, sofas, plants, and other items that can be moved. Today, some office walls can be classified as semifixed features since they are designed to be relocated as space needs change. Such movable structures might more appropriately be termed partitions since they rarely meet the ceiling. How are the chairs in your classroom arranged? Are they laid out in neat aisles? Is your instructor partially hidden by a desk or lectern? Does he or she speak from a raised area or platform? Assuming the chairs in your classroom are not bolted to the floor, try this:

SKILL BUILDER

ARRANGE THAT ROOM

1. Divide into groups.
2. Each group is to rearrange the room's furniture in order to make the class space more conducive to interpersonal interaction. Have the class test your design.
3. Next, rearrange the room's furniture in such a way that you inhibit interpersonal interaction. Work to develop a design that promotes self-involvement rather than self–other involvement. Have the class try out this arrangement.

How did your group's two arrangements differ? Were you successful in creating two distinct climates? How did you arrange the semifixed features of the room? How did you work to increase or decrease barriers? Researchers have found that barriers, like desks, can reduce interaction. In a study of doctor–patient relationships, its author determined that patients were more ''at ease'' when they spoke with a physician who was sitting in a chair across from them than when the physician was seated behind a desk. Why do you think this was so? To what extent to you feel the same way about your instructor? Why do you think police interrogators are sometimes advised to eliminate barriers between themselves and the person they are questioning?

Study the spatial arrangements of public places. If interaction between persons is desired, the space will usually contain within it chairs that face each other. Such arrangements are found in bars, restaurants or lounges. In contrast, the chairs in airport or bus terminal waiting rooms are often bolted together in long rows. When confronted with such an arrangement, persons are not able to face others to speak without some discomfort. In fact, one chair manufacturer designed a chair that creates an uncomfortable pressure on the spine after the sitter has spent a few moments on it. The chair is used when it is deemed desirable for people not to spend time interacting. How do semifixed features function in homes? Have you ever been in a living room that was created to be looked at but not lived in? Your authors know of one sofa that simply deteriorated from age rather than from wear. It had been declared ''off limits'' to an entire household for years. Try this exercise to test your awareness of semifixed objects and their uses:

SKILL BUILDER

THE TABLE

1. Imagine that you have entered the school dining room with a plate of food. It is raining. You cannot go outside. Every table is full except one. A bird's-eye view of the table is shown below.

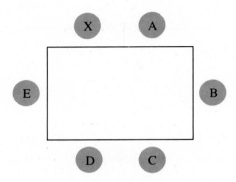

You must sit in chair A, B, C, D, or E. The person who is sitting in the chair marked X is named below. For each instance listed, where would you sit?

PERSON	CHAIR	REASON
1. Your best friend		
2. A stranger who has body odor		
3. An attractive person you would like to meet		
4. A professor who unfairly failed you last term		

2. Compare your choices and reasons with those of your classmates.

Generally, our choice of seating is not accidental or random. For example, when people want to converse, they either choose to sit opposite each other or across the corner of a table. We like to look at people when we speak to them; thus, we work to increase personal visibility. It seems fair to say that we will select different seats depending on whether we want or do not want to interact with another. We will also choose different seats depending on the type of interaction we expect to engage in.

SKILL BUILDER

SEATED SITUATIONS

1. Imagine where you would seat yourself and a friend in order to:

 A. Chat before class. B. Study for the same exam.

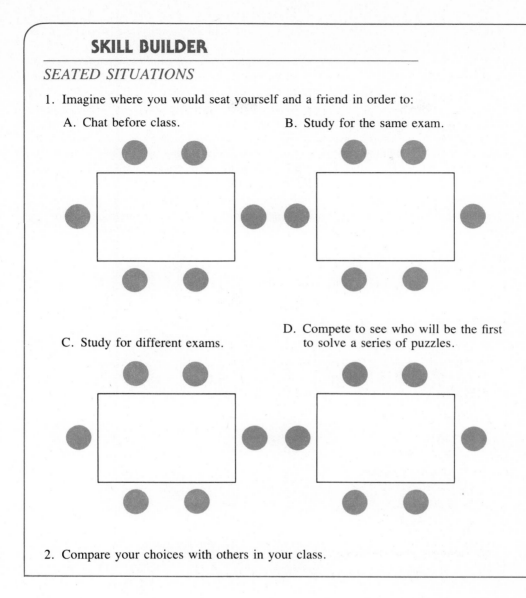

 D. Compete to see who will be the first
 C. Study for different exams. to solve a series of puzzles.

2. Compare your choices with others in your class.

Robert Sommer, a researcher in nonverbal communication, determined that chatting before class and studying for the same exam required closer seating arrangements than studying for separate exams or completing a competitive task. Conversations before class elicited corner or opposite seating choices. Cooperation elicited predominately side-by-side choices. When they were studying for different exams, individuals felt they should be seated at a greater distance—a long diagonal—from each other. Competition, however,

was believed to require an opposite seating arrangement. Apparently, this way individuals could keep an eye on each other.

Unlike the spatial types we have examined thus far, fixed feature space refers to those relatively permanent objects that define the space around us. Included in this category are unmovable walls, doors, trees, sidewalks, roads, and highways. Fixed features help control our actions. For example, most classrooms are rectangular with windows along one side, usually to the students' left. The window location also determines the front of the room. In like fashion, apartments that open onto a common rotunda increase the chances for tenant communication. So do swimming pools and parks. Fences, however, can serve to inhibit communication. Shopping malls and department stores rely on fixed features to help route pedestrian traffic in certain directions that will increase sales. The next time you shop in a carefully designed environment, examine the location of the store's fixed features. Can you walk unencumbered to a desired department or are you carefully directed through the perfumes, lingerie, and knickknacks? Why?

"Your cat is entering my sphere of influence!"

The New Yorker

Territoriality and Personal Space. Also related to proxemics is our need for a defined territory. Animals mark their territory by urinating around its perimeter, and they will protect their area against invaders. We also lay out or stake our space, or territory, and territoriality is an important variable in interpersonal communication. Earlier, we mentioned the story of the step "owned" by the ticket taker at a prominent New York theater. Concerned individuals protected his space. What examples of territoriality have you encountered during your life? Are you familiar with "Dad's chair"? "Mom's bureau"? Your room? How do you feel when someone invades your territory? Is it comfortable to look into your rear view mirror and find you are being tailgated by a tractor-trailer truck? By a Volkswagen? What happens when someone stands too close to you? How are you treated when you enter another's territory? For example, did your sister ever throw you out of her room? Did she ever ask you to keep your hands off of the stereo? Has a friend ever thrown you out of his seat?

We employ markers to establish territory. At the library, for instance, do you spread your things out, over, and across the table so that others will not find it easy to enter your territory? How do you stake your territory claim? In large corporations a person's status is often reflected by the size of his or her space. Thus, the president may be accorded a large territory on the top floor while a clerk is given a desk in a second-floor room amid a number of other desks and copy machines. Regardless of the size, however, we each identify with our location and we will frequently act as if we own it.

Use of Color

Your authors once taught at a college that was in the midst of some summer redecorating and painting. The departmental secretary selected the paint colors. She told this story. The painters arrived the day before her vacation was to start and showed her a color chart. She picked out a variety of colors—pastel blues, greens, and off-whites—that she felt would be appropriate and would give the rooms and offices the lift they needed. Since she had an eye for color, she also chose a few accent colors to provide contrast to the pastels. She left for vacation confident that she would return to a clean, happy-looking environment. On her return two weeks later, however, she was shocked to find that the rooms were each painted one rather sickening shade of grey. She sought out the painters and queried, "Why didn't you use the colors I selected?" "We did," they replied. "We put all the colors into one large bucket and mixed them up. It was faster that way!"

What nonverbal messages do colors send to you? How do various colors make you feel? Colors seem to have more than a passing effect on us. Max Lüscher in his book *The Lüscher Color Test* claims that when people are asked to look at pure red for long periods, their blood pressure, respiration, and heartbeat all speed up. Red tends to excite the nervous system. In contrast, when researchers examined the impact of dark blue, the reverse proved true: blood pressure, respiration, and heartbeat receded, and the person tended to become calmer. Keeping your own reactions in mind, examine the color schemes used in several public areas, including fast food chains, stores, and terminals. What colors are chosen? Do they make you want to move quickly? Do the colors excite you, or are

they designed to help you relax? If you were selected as a color consultant, what colors would you choose for:

	COLOR	REASON
1. A fast-food operation		
2. An airline		
3. Your classroom		

Use of Time

Do you have enough time? Are you usually prepared for exams or assignments? Do you arrive for appointments on time, early, or late? Edward Hall says that "time talks." What does your use or misuse of time say about you? To what extent do others communicate with you through time? Would you feel insulted if you were asked out for a date at the last minute by someone you did not know very well? Many Americans probably would. A last-minute invitation may mean that another date fell through or that the person is asking only as a last resort! Some students have a habit of being consistently fifteen minutes late to class—even when their previous class was just down the hall! What cues does such habitual lateness transmit to an instructor? Should the instructor conclude that the person does not like the class? Does not care about the class? Is unable to organize activities in such a way that he or she can accomplish even the simplest routine task?

The way you use time—or allow it to use you—
communicates messages to others.

Some jobs demand that a person be on time. Would you wait thirty minutes for a bank teller to arrive? To a military officer, the concept of being "on time" really means to arrive five minutes early. Thus, the military has created the "hurry up and wait" syndrome familiar to every basic trainee; everyone rushes to arrive, but once on site everyone stands around for a while with nothing to do.

At times certain activities are appropriate and at other times they are not. It is acceptable to call a friend for a chat at 3 P.M., but not at 3 A.M. Business is traditionally conducted between the hours of 9 A.M. and 5 P.M. We have, however, met an attorney who goes to work at 5:30 A.M., and by 6:30 A.M. has already made phone calls to a number of people. How would you react if you were called by a lawyer at 5:30 in the morning? He reports that he gets great results because people's defenses are down at 5:30 A.M., and they often reveal things that they would be prepared to cover up by 9 or 10.

People are expected to structure their time in certain ways. We are expected to schedule our activities so that our tasks are accomplished. People in business want to get the greatest return on their time investment. In other countries, however, time is treated differently. In some cultures people are accustomed to waiting several hours for a meeting to begin. In others, the meeting begins whenever the second party arrives. Even in the United States we function at different time levels. Your authors come from two different areas of the country. It has taken us years of married life to adjust to one another's internal clocks. One of us can start and nearly complete a task before the other manages to be seated. The term "a long time" meant one thing to one of us and something completely different to the other.

How well do you use your time? In his book *The Time Trap* Alec Mackenzie lists several barriers to effective time usage:

Attempting too much

Unrealistic time estimates

Procrastination

Interruptions

Do any of these apply to you? How might you go about improving your use of time?

Touch

The final nonverbal category we will consider here is touch. We have already mentioned touch in relation to space and distance. Hall suggests that intimate space begins at the point of touch and moves to 18 inches. How important is touch in your communication encounters? As children we are admonished not to touch ourselves or things around us. "Don't pick your nose!" or "Don't play with yourself" are frequent childhood reprimands. Yet we do need to touch and be touched. In the nineteenth century orphaned young children died in hospitals—not because they were ill, but because they were not touched. Now children are picked up and carried when they are in hospitals. We crave to touch and we crave to be touched. Watch a nursery school teacher as he or she reads a story to three-year-olds. They surround the adult, sitting on a knee or clutching at a piece of clothing. Focus on the effect touch has on your communication.

A PAT ON THE BACK

1. Everyone in the class should stand up and move the desks and chairs out of the way.
2. Each person should find a partner. Greet that person by shaking hands. Chat briefly, and after a minute or two, when given a signal by your instructor, say ''goodbye'' and give each other a pat on the back. Move on to another person. Continue until everyone has had the experience several times.

All human beings need to touch others and to be touched, and touch can have a powerful effect on our communication with others.
(© *Leif Skoogfors 1980/Woodfin Camp & Assoc.*)

How did you feel when you were shaking hands? Why did you feel that way? What does a pat on the back communicate? For many of us, the back pat is a sign of recognition or a message of approval.

How accessible are you to touch? Psychologist Sidney Jourard counted the frequency of contact between couples in cafés in various cities. He reports the number of contacts per hour:

San Juan, Puerto Rico	180
Paris, France	110
Gainesville, Florida	2
London, England	0

Thus, it seems that to touch or not to touch is partially a cultural question. Where do you touch your father? Your mother? Your brother? Your sister? A friend of the same sex? A friend of the opposite sex? Men seem to touch their fathers' hands—they shake hands—while women touch their fathers' arms and faces. In general, women seem to be more accessible to touch. Men and women will often kiss women when greeting each other; men who meet usually shake hands. Contact between males is often limited to "contact" sports such as football and soccer.

Touch can also be used to reflect status. Nancy Henley points out that we are unlikely to go up to our boss and pat him or her on the shoulder. Would you, for example, put your arm around your university or college president? Why? Would your behavior change if you met the president at a party? Probably not. That person, however, might well put an arm around you, or another student.

Touch, of course, functions in sexual communication. If people hold hands we assume they have a romantic interest. Are we right? The shaving cream companies have made certain that American males are clean shaven every day in order to avoid any embarrassing "stubble" that would not be touchable. Most women shave legs and underarms and use a variety of lotions to keep their hands "soft" to the touch. When you were growing up, did your parents touch in front of you? Many adults avoid any contact in front of their children. It is almost paradoxical that we spend a great deal of money on creams, blades, and other products designed to make us "touchable" and then work to avoid being touched.

HOW TO ASSESS YOUR COMMUNICATION EFFECTIVENESS: NONVERBALLY SPEAKING

As we have seen, all interpersonal communication takes place in the context of body language, physical characteristics and dress style, vocal tones, spaces and distances, colors, times, and touches that can either support or contradict the meanings of the words we speak. Use each of these variables to help you react to the pictures and the questions on the following page.

© Owen Franken/Stock, Boston

© Clif Garboden/Stock, Boston © Errol Raines

For each picture, answer these questions and identify the cues that influenced your response.

1. Who is more trustworthy?
2. Who is more dynamic?
3. Who is more credible?
4. Who has more status?
5. Who is older?
6. Who is more intelligent?
7. Who is more powerful?

8. Who is more friendly?
9. What is their relationship to each other?
10. What predictions can you make regarding the course their relationship will take?

Compare and contrast your responses with others in your class. The discussion of your observations will be quite valuable since many of our important judgments and decisions are based on nonverbal cues. In order to increase your ability to make valid judgments and decisions, you would do well to follow these guidelines:

Examine the Environment

Ask yourself if any environmental stimuli are apt to affect the interaction. Determine if surrounding people could influence the two communicators. Attempt to assess whether colors and decor will have an impact on the nature and tone of the communication. Analyze the amount of space available to the individuals involved. Evaluate whether architectural factors could alter the outcome. Where are chairs, table, passageways and desks situated? Why have the interactants situated themselves as they did? What type of behavior would we expect to see exhibited in this environment?

Watch the Communicators

Ask yourself if the sex, age, or status of the communicators will exert an influence on their relationship. Assess to what extent, if any, attractiveness, clothing style, or physical appearance should affect the interaction. Determine if, in your own mind, the communicators' dress is appropriate to the environment in which they find themselves. Decide if the communicators appear to like each other. Decide if you think they share similar goals.

Keep an Eye Out for Facial Expressions, Gestures, Posture, and Eye Behavior

What does each communicator's facial expression reveal? Are their facial expressions relatively consistent or fleeting? Do they tend to fluctuate drastically? Assess the extent to which you believe the facial expressions are genuine.

Analyze significant bodily cues. Attempt to decide if hand or foot movements suggest honesty or deception. Decide if any party moves too much or too little. Ask yourself if both individuals are equally involved in the exchange. Is one more eager to continue the communication? Would one rather terminate the communication? How do you know?

Assess the extent to which participants mirror each other's posture. Ask yourself how posture supports or contradicts the status relationship that exists. Do the interactants appear to be relaxed or tense? Why? Determine if the individuals have used their bodies to include or exclude others from their conversation. Analyze when and why the communicators alter their postures.

Watch the eye behavior of participants. Determine if one looks away more than the other. Determine if one stares at the other. To what extent, if any, does excessive blinking occur? When is eye contact most pronounced? How does the eye contact of one individual appear to affect the other individual?

Keep an Ear Open for Vocal Cues

Assess whether in your opinion the communicators are using appropriate volumes and rates, given their particular situation. Determine if and how something that is said supports or contradicts what is being said. Analyze how and when silence is used. Be responsive to signals of nervousness and changes in pitch.

Target In on Touch

Watch to see if participants touch each other at all. Determine, if you can, why they touched. How did touching or being touched affect the interactants? Was the contact appropriate or inappropriate? Why?

These guidelines will help you increase your awareness of and sensitivity to the nonverbal dimension of interpersonal communication.

SUMMARY

We have just explored why we cannot examine the interpersonal communication process without also examining its nonverbal dimension. We have discovered that over 65 percent of the social meaning of messages we send is carried on the nonverbal level, and we have seen that perceiving and analyzing nonverbal cues can help us understand what is really occurring during an interpersonal encounter.

Specifically, we have worked at improving our skill at reading body language, physical characteristics and dress style, voice, space, distance, color, time, and touch. Finally, we identified guidelines to increase our skill at using nonverbal cues to make accurate judgments and decisions during our interactions with others.

SUGGESTIONS FOR FURTHER READING

Birdwhistell, Ray. *Kinesics and Context*. Philadelphia: University of Pennsylvania Press, 1970. An extensive, scholarly treatment of kinesics and the building blocks of body language.

Cooper, Ken. *Nonverbal Communication for Business Success*. New York: Amacom, 1979. An easy-to-read discussion of how the results of research in nonverbal communication can be directly applied to the world of business.

Eisenberg, Abne M., and Ralph R. Smith. *Nonverbal Communication*. New York: Bobbs-Merrill, 1971. A readable overview of the nonverbal communication arena.

Ekman, Paul, and Wallace Friesen. *Unmasking the Face*. Englewood Cliffs, N.J.: Prentice-Hall, 1975. An immensely

understandable work about faces and feelings.

Fast, Julius. *Body Language*. New York: M. Evans and Company, 1970. The work that popularized the field of nonverbal communication. Fun to read and full of examples.

Hall, Edward T. *The Hidden Dimension*. Garden City, N.Y.: Doubleday, 1966. A readable survey of the field of proxemics. Focuses on how the use of space affects our personal and business contacts.

Hall, Edward T. *The Silent Language*. Garden City, N.Y.: Doubleday, 1959. Discusses the cultural implications of nonverbal communication. Combines theory and anecdotes effectively.

Heinberg, P. *Voice Training for Speaking and Reading Aloud*. New York: Ronald Press, 1964. Provides a description of vocal cues and the ways people interpret them.

Henley, Nancy M. *Body Politics: Power, Sex, and Nonverbal Communication*. Englewood Cliffs, N.J.: Prentice-Hall, 1977. Informative and interesting feminist analysis of nonverbal communication.

Knapp, Mark L. *Nonverbal Communication in Human Interaction*. New York: Holt, Rinehart & Winston, 1972. One of the most thorough surveys of the field of nonverbal communication. Contains a wealth of documented information.

Mehrabian, Albert. *Silent Messages*. Belmont, Calif.: Wadsworth, 1971. An overview of how we communicate liking, power, and inconsistency with nonverbal cues.

Molloy, John T. *Dress for Success*. New York: Warner Books, 1977. A reference work for men in business. Discusses what to wear and why to wear it.

Molloy, John T. *The Woman's Dress for Success Book*. New York: Warner Books, 1977. In this volume, Molloy advises women on what to wear to succeed in the business world.

Sommer, R. *Personal Space*. Englewood Cliffs, N.J.: Prentice-Hall, 1969. A description of how we use space to express our feelings and relationships. An analysis of how space controls communication.

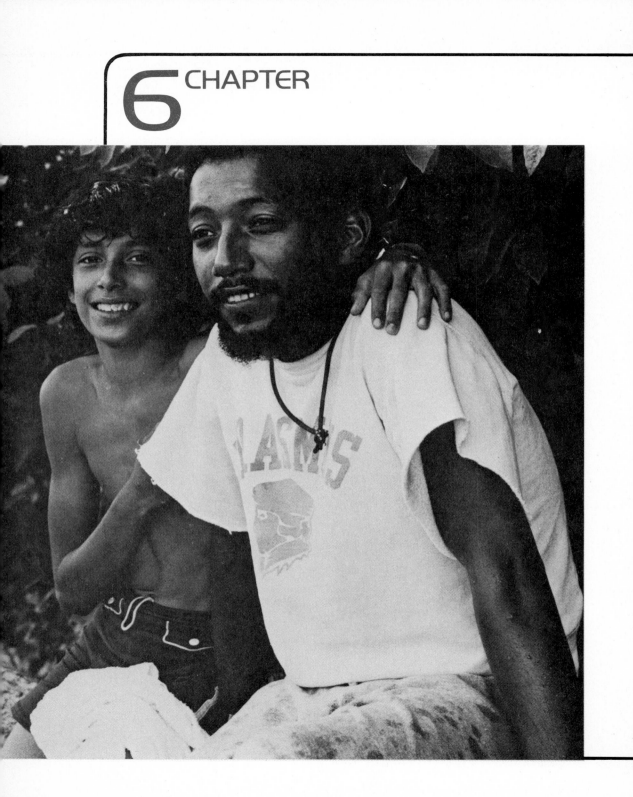

Trust:
Sticking Your Head
in the Lion's Mouth

CHAPTER PREVIEW

After experiencing this chapter, you should be able to:

Explain what it means to depend on another individual

Define "trust"

 Identify character-based sources of truth

 Describe the components of trusting behavior

 Describe the components of trustworthy behavior

 Provide examples of how appropriately or inappropriately trusting another can affect the nature of a relationship

Compare and contrast behaviors present in cooperative and competitive relationships

Identify factors that contribute to the development of supportive and defensive interpersonal climates

Draw and explain the game-theoretical model of the Prisoner's Dilemma

 Explain how you would react when faced with a particular "prisoner dilemma" situation

Define what is meant by the word "lie"

 Provide examples of how lying can affect the nature of the interpersonal relationships you share

Identify behaviors that can foster or impede the development of a relationship based on trust

"I am looking for friends. What does that mean—'tame'?"

"It is an act too often neglected," said the fox, "it means to establish ties."

"'To establish ties'?"

"Just that," said the fox. "To me, you are still nothing more than a little boy who is just like a hundred thousand other little boys. And I have no need of you. And you, on your part, have no need of me. To you, I am nothing more than a fox like a hundred thousand other foxes. But if you tame me [if we establish ties], then we shall need each other. To me, you will be unique in all the world. To you, I shall be unique in all the world."

Antoine de Saint-Exupéry, *The Little Prince*

Do you know what it means to depend on another? Do you know what it means to have another depend on you? In order to assess the extent to which decisions to depend on others are rewarding or disillusioning for you and those with whom you interact, fill in the following charts:

Trust is reciprocal in human relationships. Parents rely on each other in caring for a baby; the baby, in turn, learns from parents to trust and to be trustworthy. *(© R. Lynn Goldberg 1980)*

CAN I DEPEND ON YOU?

Name of persons on whom you relied in the past week	Behavior you expected each person to exhibit	Extent to which your expectation was fulfilled: fully, partially, not at all
1.		
2.		
3.		
4.		
5.		
6.		
7.		
8.		
9.		
10.		

CAN YOU DEPEND ON ME?

Name of persons who relied on you in the past week	Behavior expected of you	Extent to which you fulfilled each expectation: fully, partially, not at all
1.		
2.		
3.		
4.		
5.		
6.		
7.		
8.		
9.		
10.		

Next, answer the following series of questions:

1. How many different people did you rely on in the past week? How many individuals did you rely on only once? More than once? More than twice? Why?
2. How many different people relied on you? How many individuals relied on you only once? More than once? More than twice? Why?

As your charts probably indicate, we rely on each other for a variety of reasons. Frequently, we rely on others because we expect them to perform basic services for us (make breakfast for us, drive us to work). Sometimes, we expect others to give us direction (help us select what to wear for an interview, help us decide what classes to take). Still other times, we expect others to meet our emotional needs (commiserate with us when we are sad, rejoice with us when we are happy). The degree to which our expectations are fulfilled determines whether we will depend on a particular individual again. As the saying goes:

> Fool me once
> Shame on you.
> Fool me twice
> Shame on me.

TRUST AND RISK TAKING: THE ROAD TO SELF-ACTUALIZATION

The first problem any individual who shares a relationship faces is developing an ability and willingness to trust. When we examine the trust dimension of interpersonal relationships, we are interested in analyzing the ways in which individuals judge the intentions of others. After all, it is the nature of their judgments that will influence how they will behave with others. Although each of us uses the word "trust," it is a very difficult concept to explain. Try to internalize what it means to you by completing the following exercise.

For many people, perceiving those with whom they interact as trustworthy poses few problems. They simply believe that people are basically good, and they will trust others

SKILL BUILDER

WHOM DO YOU TRUST?

1. Generate a list of people you trust. Indicate why you believe your trust in each person is justified.

I TRUST: BECAUSE:

A.

B.

C.

D.

E.

until proven wrong. On the other hand, there are individuals whose perceptions tell them that people are basically bad; these people will distrust others until circumstances prove their beliefs to be invalid. As a rule, however, most people develop their attitudes toward trust on the basis of specific interpersonal experiences.

The Bases of Trust

According to communication theorist John G. Gabarro, the degree of trust you place in another individual is to a large extent based on your perception of the individual's character. Character-based sources of trust include trust in the integrity of the person, trust in his or her motives, trust in his or her consistency of behavior, and trust in his or her openness and discretion.

When you trust someone because of his or her integrity, you believe that individual possesses a basic honesty that permeates your relationship. When you trust someone's motives, you trust his or her intentions—that is, you do not believe that that individual would exhibit malevolent behavior toward you. When you trust someone on the basis of his or her consistency of behavior, you feel that you know that individual well enough to be able to predict his or her actions. Finally, when you trust another on the basis of his or her openness and discretion, you conclude that the other person is not afraid to speak up, is honest with you, and will neither violate confidences intentionally, nor disclose to others information that could harm you.

To promote the development of a relationship based on trust, you must work to create an interpersonal climate that will reduce each individual's fear of rejection or betrayal. This is not always easy. Yet, as we have seen, the establishment of trust is essential if the individuals and the relationship are to grow. Let us discuss what trust is, how it develops, and how it can affect the nature of the relationships we share.

2. Next, compile a list of individuals you definitely do not trust. Indicate why you believe your lack of trust in each person is justified.

I DO NOT TRUST: BECACAUSE:

A.

B.

C.

D.

E.

3. Which list was easier for you to generate? On the whole, do you view yourself as a truster or a distruster?

What Is Trust?

Trust comprises two basic components: trusting behavior and trustworthy behavior. Only if both components are present can trust be said to exist.

Trusting and trustworthy behaviors are reciprocal—that is, trusting often precipitates trustworthiness and trustworthiness often precipitates trusting. Trust either grows or weakens over time. *Trusting behavior* involves three basic elements: First, you expect that another person will behave in a way that can have either harmful or beneficial results, and you acknowledge that if the person's actions lead to negative results, these will probably be more damaging to you than the positive results would be rewarding. Second, you are aware that the outcome will depend on the other person's actions. Third, you believe that the other person's behavior will produce beneficial results; you are confident that the positive outcomes are more apt to occur than the negative outcomes. In other words, you believe that the other's behavior has "positive" predictability. Like trusting behavior, *trustworthy behavior* also demands that three conditions be satisfied. First, you are aware of the motivational preferences of another person. Second, you recognize that the other person has confidence in you and is relying on you to confirm his or her expectations. Third, you respond by exhibiting the expected behaviors.

If any one of these ingredients is missing, trust, in the real sense of the word, cannot be said to exist. It is evident that trust is difficult to develop but relatively easy to destroy. Trust necessitates that each party in a relationship be willing to risk something; the element of risk means that either party could be personally harmed or diminished. In other words, trusting others carries with it the possibility that others could use your trusting behavior against you. When this happens, trust is usually shattered.

A good literary example of the negative outcomes of a misplaced trust can be found in Edward Albee's play *Who's Afraid of Virginia Woolf?* During the course of an evening spent at the home of George and Martha, Nick and Honey and their hosts engage in some rather heavy "social" drinking. When the wives are involved elsewhere, George discloses some very personal information about his youth to Nick. Nick reciprocates by telling George that because of Honey's hysterical pregnancy, he was forced to marry her. As the evening progresses, George perceives that Nick has humiliated him; he, therefore, decides to "get the guest." In the presence of Honey and Martha, George reveals what Nick had confided in him about Honey's false pregnancy. Honey, quickly sickened, rushes from the room. The scene ends with Nick vowing to revenge George's behavior.

Unfortunately, not everyone we know can be trusted. Inappropriately trusting another individual can sometimes cause you as many problems as not trusting an individual who merits your trust. Thus, it is wise to avoid trusting another person if that person repeatedly behaves in a way that brings you pain or causes you to feel rejected or betrayed. When you say, "I don't trust George," you probably mean that when you trusted this person in the past, he disappointed you. In effect, you no longer feel you can predict what he will do in a given situation. In contrast, it does make good sense for you to continue trusting those whose behavior you believe you can predict with relatively consistent accuracy. You should acknowledge that while the presence or absence of trust can easily strengthen or weaken a relationship, trust is a gamble and always involves some risk.

NOW YOU TRUST ME, NOW YOU DON'T

1. Describe a relationship you shared that you believe was based on trust. Identify the trusting and trustworthy behaviors exhibited by you and your partner, and attempt to determine the factors in your relationship that permitted a climate of trust to develop.

2. Describe a second relationship you shared that you mistakenly believed was based on trust. Identify the trusting and trustworthy behaviors that were missing, and describe the negative consequences that resulted from the situation. Attempt to determine the factors in your relationship that prevented or inhibited the development of a climate of trust.

According to Abraham Maslow, author of *Motivation and Personality*, people who trust themselves and others tend to make ''growth'' choices as opposed to ''fear'' choices. Maslow believes that people who make ''growth'' choices are self-actualizers; they are close to fulfilling their unique potentials as human beings. The trusting behavior of self-actualizers permits them to experience the world fully and vividly, for they have the ability to be open and honest with others as well as themselves. Since trust can lead you to reveal important information about yourself, it can also help you improve your self-understanding and awareness. Thus, trust, openness, and self-actualization go together.

From CARING ENOUGH TO CONFRONT

David Augsburger

To be trusted, you must trust. To receive trust from others, you risk trusting them by opening yourself to them. These two go together—trust and openness.

A climate of mutual trust develops out of mutual freedom to express real feelings, positive and negative. As each person moves toward a greater acceptance of his total self, more and more of his/her potential for loving, trusting, responsibility and growth are released.

And as the trust level rises be-tween parent and child, the willingness to be open with each other increases too. The two go hand in hand. Trust and openness. Acceptance and honesty. Love and risk.

There are risks involved in all love, acceptance, and trust. If I come to understand another's inner world, if I can sense his confusion or his timidity, or his feeling of being treated unfairly, if I can feel it as if it were my own, then a highly sensitive empathy comes into play between us. A rare kind of trusting-understanding develops.

This is far different from the under-

standing which says: "I know what's wrong with you," or "I can see what makes you act that way."

This trusting-understanding enters the other's world in his or her terms. And that is risky. If I take your world into mine, I run the risk of being changed, of becoming more like you.

Caring Enough to Confront, 1979

THE INFLUENCE OF THE SOCIAL ENVIRONMENT

It is apparent that the nature of the social situation plays an important role in determining whether or not trust will develop. If you and another person view your relationship as primarily competitive, then both of you are likely to attempt to protect yourselves, and the rule of "everyone for himself/herself" applies. If on the other hand, you view your relationship as primarily cooperative, the dog-eat-dog nature of the situation is eliminated, and sharing, interdependent efforts, and trust are likely to appear. Defining a relationship as competitive precipitates defensive and threatening behavior on the part of the com-

Trust requires a spirit of cooperation. In some situations—mobilizing to meet a threat, for example—trust may be more likely to develop. (© *Nick Passmore/Stock, Boston*)

municators, whereas defining a relationship as cooperative precipitates supportive, non-threatening behaviors and honest, open message exchanges. For this reason, labeling an interpersonal situation as cooperative rather than competitive—and acting as if this were true—can help open instead of close communication channels.

Cooperation or Competition

By now you probably realize that each person's goals affect the degree of trust within a relationship. If individuals view their goals as congruent, then an atmosphere of cooperation can be fostered. However, if individuals view their goals as contradictory, then a competitive situation will be engendered. What is at issue here is not whether competition and cooperation exist, but whether they persist where appropriate. Too frequently, we attempt to compete with or defeat another individual when cooperating with that individual would be more beneficial to our relationship. Indeed psychologists Linden L. Nelson and Spencer Kagen believe that when cooperating makes sense, competing is actually irrational and self-defeating. They contend that in a ''dog-eat-dog'' relationship, both interactants may go hungry.

SKILL BUILDER

WHAT'S YOUR STYLE?

1. Generate a list of people with whom you interact on a regular basis.

2. Indicate whether your interactions with each person are predominantly competitive (X) or cooperative (O) in nature by placing the appropriate symbol next to each name. Try to include representatives from both categories on your list.

3. Describe how your feelings about the relationship you share with each of the individuals are reflected in your behavior toward them. In other words, how do you act in situations you define as competitive? In situations you define as cooperative? To what extent does the sex of the other person appear to make a difference? Why?

If both parties in an interpersonal relationship are to cooperate with each other, certain requirements must be met. First, both parties must agree that both of them have an equal right to satisfy their needs. Second, conditions have to enable each person to get what he or she wants at least some of the time. Third, power plays that rely on such techniques as threatening, yelling, or demanding are viewed with disdain. Finally, neither party attempts to manipulate the other by holding back information or dissembling. Consequently, when you cooperate, you do not aim to ''win,'' ''beat,'' or ''outsmart'' another. Unlike competition, cooperation does not require that you gain an edge over another person. For this reason, cooperation, unlike competition, does not promote defensiveness or lying.

Supportiveness or Defensiveness: As the Wheel Turns

Defensive behavior can be said to occur in interpersonal communication when a party to the relationship perceives or anticipates a threat.

SKILL BUILDER

ON THE DEFENSIVE

1. Think of a number of interpersonal encounters where you felt yourself becoming defensive. Use the accompanying table to help you chart your reactions. In the first column, identify the person with whom you were interacting. In the second column, detail the happenings or actions that you believe led to your feeling threatened, anxious, or scared. In the third column, describe feelings you experienced and behaviors you adopted during the encounter.

Name of person with whom I was communicating	Behaviors exhibited by that person which increased my feelings of defensiveness	My reactions
A.		
B.		
C.		
D.		
E.		

Whenever you feel yourself becoming defensive, you might experience one or more physical symptoms: a change in voice tone (as you become nervous, your throat and vocal mechanism tense and your vocal pitch tends to rise), a tightening of your muscles and a degree of rigidity in your body, a rush of adrenalin accompanied either by a desire to fight or an urge to flee. Let us examine the behaviors that precipitate such reactions.

We tend to become defensive when we perceive others attacking our self-concept. In fact, when we behave defensively, we devote much of our energies to defending ourself. We become preoccupied with how we appear to others; we become obsessed with discovering ways to make others see us more favorably. Such behaviors were evidenced in the communication strategies employed by Blanche DuBois in Tennessee Williams' *Streetcar Named Desire*. Blanche held a false picture of herself and a set of values contradicted by actuality. As she put it, "I don't want realism. I want magic. I try to give that to people. I misrepresent things to them. I don't tell the truth. I tell what ought to be truth." Blanche felt the need to act defensively in order to maintain her false image. She could not "stand a naked light bulb" any more than she could stand the truth.

When our self-concept is attacked, we often armor ourselves with defenses.

Blanche's inner feelings and outward acts tended to create equally defensive postures in her brother-in-law Stanley. Their resulting circular response pattern became increasingly destructive. Let us eavesdrop on one "conversation" they shared:

STANLEY: This millionaire from Dallas is not going to interfere with your privacy any?

BLANCHE: It won't be the sort of thing you have in mind. This man is a gentleman and he respects me. *(Improvising feverishly)* What he wants is my companionship. Having great wealth sometimes makes people lonely! A cultivated woman, a woman of intelligence and breeding, can enrich a man's life—immeasurably! I have those things to offer, and this doesn't take them away. Physical beauty is passing. A transitory possession. But beauty of the mind and richness of the spirit and tenderness of the heart—and I have all of those things—aren't taken away, but grow! Increase with the years! How strange that I should be called a destitute woman! When I have all of these treasures locked in my heart. *(A choked sob comes from her)* I think of myself as a very, very rich woman! But I have been foolish—casting my pearls before swine!

STANLEY: Swine, huh?

BLANCHE: Yes, swine! Swine! And I'm thinking not only of you but of your friend, Mr. Mitchell. He came to see me tonight. He dared to come here in his work-clothes! And to repeat slander to me, vicious stories that he had gotten from you! I gave him his walking papers . . .

STANLEY: You did, huh?

BLANCHE: But then he came back. He returned with a box of roses to beg my forgiveness! He implored my forgiveness. But some things are not forgivable. Deliberate cruelty is not forgivable. It is the one unforgivable thing in my opinion and it is the one thing of which I have never, never been guilty. And so I told him, I said to him, "Thank you," but it was foolish of me to think that we could ever adapt ourselves to each other. Our ways of life are too different. Our attitudes and our backgrounds are incompatible. We have to be realistic about such things. So farewell, my friend! And let there be no hard feelings . . .

STANLEY: Was this before or after the telegram came from the Texas oil millionaire?

BLANCHE: What telegram? No! No, after! As a matter of fact, the wire came just as—

STANLEY: As a matter of fact there wasn't no wire at all!

BLANCHE: Oh, oh!

STANLEY: There isn't no millionaire! And Mitch didn't come back with roses 'cause I know where he is—

BLANCHE: Oh!

STANLEY: There isn't a goddamn thing but imagination!

BLANCHE: Oh!

STANLEY: And lies and conceit and tricks!

BLANCHE: Oh!

STANLEY: And look at yourself! Take a look at yourself in that worn-out Mardi Gras outfit, rented for fifty cents from some rag-picker! And with the crazy crown on! What queen do you think you are?

BLANCHE: Oh—God . . .

STANLEY: I've been on to you from the start! Not once did you pull any wool over this boy's eyes! You come in here and sprinkle the place with powder and spray perfume and cover the light-bulb with a paper lantern, and lo and behold the place has turned into Egypt and you are the Queen of the Nile! Sitting on your throne and swilling down my liquor! I say—*Ha!—Ha!* Do you hear me? *Ha—ha—ha! (He walks into the bedroom)*

As can be seen, when either party in an interpersonal relationship is bent on self-protection, either by withdrawing or by attacking the other person, the conditions necessary for maintaining a healthy relationship crumble. In short, defensive behavior gives rise to

defensive listening. Also working to raise the defense levels of the communicators are accompanying postural, facial, and vocal cues. Once the defensiveness of an interpersonal communicator has been aroused, the individual no longer feels free to concentrate on the actual meaning of messages. Instead, a defensive recipient feels compelled to distort the messages. Thus, as individuals become more and more defensive, they experience a corresponding inability to process accurately the emotions, values, and intentions of those with whom they are relating. For this reason, consequences of defensiveness include destroyed or badly damaged relationships, continuing conflicts, and increased personal anxiety, as well as wounded egos and hurt feelings.

Before we can work to minimize or even eliminate the arousal of defensiveness in our own relationships, we must understand the stimuli that can cause us to become defensive in the first place. Jack R. Gibb identified six such defense-causing behaviors, and he also isolated six contrasting behaviors that, when exhibited, help to allay or reduce the level of threat experienced. Let us examine these:

CATEGORIES OF BEHAVIOR CHARACTERISTIC OF DEFENSIVE AND SUPPORTIVE CLIMATES

Defensive Climate	Supportive Climate
1. Evaluation	1. Description
2. Control	2. Problem Orientation
3. Strategy	3. Spontaneity
4. Neutrality—*Distancing*	4. Empathy
5. Superiority	5. Equality
6. Certainty	6. Provisionalism — *tentative less sure*

A relationship can run into trouble if a party to it makes judgmental or evaluative statements. As Gibb notes in his article "Defensive Communication," "If by expression, manner of speech, tone of voice, or verbal content the sender seems to be evaluating or judging the listener, then the receiver goes on guard." Far too often, we are apt to label the actions of others as "stupid," "ridiculous," "absurd," "wonderful," or "extraordinary." We simply are predisposed to use judgmental terms. Although some of the people we communicate with do not mind having their actions praised, the anticipation of judgment can hinder the creation of a positive communication climate.

In contrast to evaluative behaviors, descriptive behaviors recount particular observable actions of a communicator without labeling those behaviors as good or bad, right or wrong. When you are descriptive, you do not advise the receiver to change his or her behavior. Instead, you simply report or question what you saw, heard, or felt.

Communication that receivers see as seeking to control them will also provoke defensiveness rather than trust. In other words, if your intent is to control another, to get that person to do something or change his or her way of believing, you are apt to evoke resistance. The amount of resistance you meet will depend partly on the openness with which you approach the individual and on the degree to which your behavior causes the

individual to question or doubt your motives. When we conclude that someone is trying to control us, we tend to also conclude that this person feels that we are ignorant and unable to make our own decisions. A problem orientation, on the other hand, promotes just the opposite type of response from a receiver. Since the sender communicates that he or she has not already formulated a solution and is not going to attempt to force his or her opinions on us, we feel free to cooperate to solve the problem.

Our level of defensiveness will also be increased if we feel another individual is trying to "put something over on us." No one likes to be conned, and no one likes to be the victim of someone with a hidden plan. We are suspicious of strategies that are concealed or tricky. We do not appreciate having others make decisions for us and then attempting to make us feel we made the decisions ourself. We do not like to feel manipulated. When we perceive this, of necessity, we become defensive and self-protective. In contrast, honest, spontaneous behavior, free of deception, will help reduce defensiveness. Under such conditions, the receiver does not feel a need to question the motivations of the source, and trust is engendered.

Another behavior that can function to increase defensiveness is neutrality. For the most part, we like and need to feel that we are seen as worthwhile, valued, and well-liked. We need to feel that others care about us and will take the time to establish a meaningful relationship with us. If instead of communicating warmth and concern, a person communicates neutrality or indifference, we may well interpret this as worse than rejection. We feel that such an individual is not interested in us; we may even conclude that the individual perceives us as a nonperson.

The fifth set of behaviors related to the development of defensiveness or trust in interpersonal relationships is superiority and equality. Our defensiveness will be aroused if another communicates feelings of superiority about social position, power, wealth, intellectual aptitude, appearance, or other such characteristics. When we receive such a message, we tend to react by attempting to compete with the sender, by feeling frustrated by or jealous of the sender, or by disregarding or forgetting the sender's message altogether. On the other hand, a sender who communicates equality can decrease defensive behavior in us. We perceive such an individual as willing to develop a shared problem-solving relationship with us, as willing to trust us, and as concluding that any differences that do exist between us are unimportant.

The last set of behaviors identified by Gibb is certainty and provisionalism. The expression of absolute certainty (dogmatism) on the part of a communicator will probably succeed in making us defensive. We are simply suspicious of those who believe they have all the answers, view themselves as our "guides" through life rather than as our fellow travelers, and reject all information we attempt to offer them. In contrast, an attitude of provisionalism (openmindedness) encourages the development of trust. Instead of attempting to win arguments, to be right, and to defend their ideas to the bitter end, individuals who communicate a spirit of provisionalism are perceived to be flexible and open rather than rigid and closed.

Whereas Gibb described the behaviors associated with defensive and supportive climates, Linda and Richard Heun in *Developing Skills for Human Interaction* and Anita Taylor in *Communicating* identified the nonverbal cues that usually accompany such behaviors. The following chart is adapted from their work.

NONVERBAL SYMBOLS THAT CAN CONTRIBUTE TO THE DEVELOPMENT OF A SUPPORTIVE OR DEFENSIVE CLIMATE

Behavior Producing Defensiveness	Behavior Producing Supportiveness
1. *Evaluation*	1. *Description*
Maintaining extended eye contact	Maintaining comfortable eye contact
Pointing at the other person	Leaning forward
Placing your hands on your hips	
Shaking your head	
Shaking your index finger	
2. *Control*	2. *Problem Orientation*
Sitting in the focal (central) position	Maintaining comfortable personal distance
Placing hands on hips	Crossing your legs in the direction of the other person
Shaking your head	Leaning forward
Maintaining extended eye contact	Maintaining comfortable eye contact
Invading the personal space of the other person	
3. *Strategy*	3. *Spontaneity*
Maintaining extended eye contact	Leaning forward
Shaking your head	Crossing your legs in the direction of the other person
Using forced gestures	Maintaining comfortable eye contact
	Using animated natural gestures
4. *Neutrality*	4. *Empathy*
Crossing your legs away from the other person	Maintaining close personal distance (20–36 inches)
Using a monotone voice	Maintaining comfortable eye contact
Staring elsewhere	Crossing your legs in the direction of the other person
Leaning back	Nodding your head
Maintaining a large body distance (4½–5 feet)	Leaning toward the other person
5. *Superiority*	5. *Equality*
Maintaining extended eye contact	Maintaining comfortable eye contact
Placing your hands on your hips	Leaning forward
Situating yourself at a higher elevation	Situating yourself at the same elevation
Invading the other person's personal space	Maintaining a comfortable personal distance

Behavior Producing Defensiveness	Behavior Producing Supportiveness
6. *Certainty*	6. *Provisionalism*
Maintaining extended eye contact	Maintaining comfortable eye contact
Crossing your arms	Nodding your head
Placing your hands on your hips	Tilting your head to one side
Using a dogmatic voice	

Take some time and examine the ways in which you elicit defensiveness or give support in your own relationships.

THE PRISONER'S DILEMMA: CAN I TRUST YOU?

The concepts of cooperation, reliance, dependence, and trust can perhaps be better understood if we examine the game-theoretical model of the Prisoner's Dilemma, formulated and named by researcher Albert W. Tucker. Imagine this: A district attorney is holding two men suspected of armed robbery. He does not have enough evidence to

Whom to trust is a problem faced not just by prisoners, but by anyone involved in interpersonal relationships.
(© *Leif Skoogfors/Woodfin Camp & Assoc.*)

convict them if he takes the case to court, so he decides to plea-bargain with them. The district attorney asks that the men, named Charlie and Nick, be brought to his office for a discussion. Once inside, he tells them that in order to convict them of the crime with which they are charged, he must have a confession from them. If both men confess, he promises that he will ask for the minimum sentence for armed robbery—two years. Without their confession, he will only be able to charge them with illegal possession of a deadly weapon—a crime that carries a maximum sentence of six months. Chances are, however, that the charge will not stick and the men will be released.

The men offer no response to either offer, and the district attorney continues discussing other possibilities. If only one of the duo confesses, that individual will be considered a material witness and will be asked to testify against his confederate. In exchange for turning state's evidence, he will be freed, have all expenses paid for five years, and set up in a comfortable hotel. His partner, however, will receive a stiff sentence—five years in a maximum security prison. At this point, without giving the men a chance to discuss his propositions, the district attorney orders them separated and locked in individual cells. He further announces that they will not be permitted to communicate with each other.

The described situation can be presented in the form of a matrix, or game board. The board indicates that Charlie's choices are limited to "Not Confess" (a_1) and "Confess" (a_2), and Nick's choices are limited to "Not Confess" (b_1) and "Confess" (b_2).

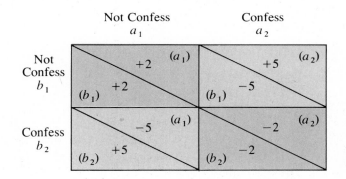

By examining the matrix we see that if Charlie confesses (choice a_2) and his partner Nick also confesses (choice b_2), both will go to jail for a short time (represented by a -2 points on the game board). This is what the district attorney would like them to do. After all, he would receive credit for two convictions. On the other hand, if Charlie confesses (choice a_2) but Nick does *not* confess (choice b_1), then Charlie will be permitted to go free (represented by a $+5$ points on the game board), be set up in a comfortable hotel, and have all of his expenses paid for five years in exchange for testifying against Nick, who will have the book thrown at him (represented by a -5 on the game board). Likewise, if Charlie refuses to confess (choice a_1) while Nick confesses (choice b_2), Nick will go free (represented by a $+5$ points on the game board), be set up in a comfortable hotel, and have all of his expenses paid for five years in exchange for testifying against Charlie, who will receive the stiff penalty (represented by a -5 points on the game board). However, should both men refuse to confess (the a_1b_1 choice), the district attorney

will probably be unable to make any charge stick (represented by a $+2$ points on the game board), and both men could be released. Given these circumstances and alternatives, what do you think the men should do? Why? What would you do? Why?

The situation poses a dilemma because neither prisoner is certain which alternative the other will select. Both prisoners must make their choices at the same time without communicating with each other. The *safest* road is the confess-confess (a_2b_2) possibility; even though it carries with it a potential loss of two years for each party, both are assured the book will not be thrown at them. Of course, a *more reasonable* solution would consist of not confess/not confess (a_1b_1) selections. This decision carries with it the possible freeing of each prisoner. Such a happening will occur, however, only if both men trust each other implicitly and are willing to cooperate with each other for their mutual gain. It is important to recognize that this last decision is risky; it carries with it the real possibility that one person will not trust the other person, secretly confess, and blow the

SKILL BUILDER

THE RELATIONSHIP GAME

1. Once again, compile a list of people you trust implicitly.

 A. D.

 B. E.

 C.

2. Compile another list of people you do not trust.

 A. D.

 B. E.

 C.

3. On the game board on the facing page, you are person *A*. Pick one or two people on each list and arrange to play the following interpersonal dilemma games with them. Each person you select is to act the part of person *B*. Inform your friend that the object of the game is to accumulate points by voting red or blue. Tell your friend that the game board indicates that if you (*A*) vote red and he or she votes red, you each earn five points. However, if you choose blue when your friend chooses red, your friend loses five points and you win eight points. Also note that the converse is true: If your friend chooses blue when you choose red, your friend wins eight points and you lose five points. Finally, show your friend that if you choose blue and he or she chooses blue, you both lose three points. After examining the matrix or game board, answer the questions below. When you have correctly answered all of the questions, the game may begin.

other's hope for freedom to shreds. After all, joint decision a_2b_1 not confess/confess ($+5 -5$), or a_1b_2 confess/not confess ($-5 +5$) gives one player the maximum obtainable gain—freedom, a comfortable hotel room, paid expenses. Playing it safe or trusting, that is the ultimate question. Thus, taking a risk, recognizing that someone could take advantage of you, but still opting to make the cooperative choice (a_1b_1) is a road many are afraid to travel.

We face situations quite similar to the Prisoner's Dilemma in our interpersonal relationships. Many people simply do not trust each other enough to select the alternative most beneficial to both of them. Instead, they either "play it safe" or "go for personal gain" at the possible expense of the other person's loss. What types of choices do you or those with whom you interact make? Do you trust other people to cooperate with you? Can you envision yourself or any of your friends or relatives trying to obtain personal gain at someone else's expense? Let's try to find out.

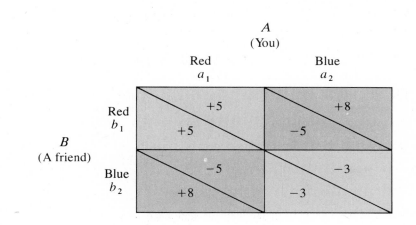

A. If you choose red (a_1) and your friend chooses red (b_1), then you receive _____ points, and your friend receives _____ points.
B. If you choose blue (a_2) and your friend chooses red (b_1), then you receive _____ points, and your friend receives _____ points.
C. If you choose red (a_1) and your friend chooses blue (b_2), then you receive _____ points, and your friend receives _____ points.
D. If you choose blue (a_2) and your friend chooses blue (b_2), then you receive _____ points, and your friend receives _____ points.

4. Once the nature of the game has been made clear to your friend, both of you should secretly indicate your selections by writing either "red" or "blue" on separate slips of paper. Play nine rounds. Record the results on the charts provided.

SKILL BUILDER CONTINUED ON FOLLOWING PAGE

RELATIONSHIP GAME CHART 1

Your Choice	Your Friend's Choice	Your Gain or Loss	Your Friend's Gain or Loss
1.			
2.			
3.			
4.			
5.			
6.			
7.			
8.			
9.			

RELATIONSHIP GAME CHART 2

Your Choice	Your Friend's Choice	Your Gain or Loss	Your Friend's Gain or Loss
1.			
2.			
3.			
4.			
5.			
6.			
7.			
8.			
9.			

Only if you and each partner made the choice that was less advantageous to you personally did the two of you win as a team. If you or your partner were hesitant to cooperate for fear of being deceived, you probably chose not to trust your partner and responded in a manner that reflected your desire to win or, at the least, not lose very

5. Be prepared to report the results of your play with each partner to the class.
6. Respond to these probes:

 A. To what extent were your judgments about the trustworthiness of each individual justified by the outcome of each game? Indicate your impressions of each coplayer during a game by marking the appropriate spaces in the tables below.

Coplayer 1

Fair	——	——	——	——	——	Unfair
Cooperative	——	——	——	——	——	Competitive
Trustworthy	——	——	——	——	——	Untrustworthy
Honest	——	——	——	——	——	Dishonest
Giving	——	——	——	——	——	Stingy
Open	——	——	——	——	——	Suspicious
Warm	——	——	——	——	——	Cold

Coplayer 2

Fair	——	——	——	——	——	Unfair
Cooperative	——	——	——	——	——	Competitive
Trustworthy	——	——	——	——	——	Untrustworthy
Honest	——	——	——	——	——	Dishonest
Giving	——	——	——	——	——	Stingy
Open	——	——	——	——	——	Suspicious
Warm	——	——	——	——	——	Cold

 B. To what extent did each coplayer's behavior please, alarm, or surprise you?
 C. To what extent did your own behavior please, alarm, or surprise you?
 D. Did you or your coplayers ever choose to increase your own immediate gain instead of working to increase the total gain of both of you? Why? Why not?

much. What happens, however, when two players can communicate or bargain with each other during the course of a relationship game? How does this affect the way the game is played? Let us find out.

First, imagine this predicament adapted from a situation suggested by communication

theorist Thomas Steinfatt. A woman named Anne (A) and a man named Ben (B) were recently married. Both are employed (a_1b_1) and happy (+5, +5). Anne has been given a chance to change jobs, but to do so, she must relocate. If she should change jobs (a_2), she would receive a substantial increase in salary, work fewer hours, and gain in status and power (move from +5 to +20). But if she accepts the new position without the approval and backing of her husband, Ben, she could lose him and much of her happiness (move from +5 to −10). Thus, Anne must convince Ben that it is to their mutual advantage to move. In order to accomplish this, she must assure him that the negative effects he sees in the move—his having to look for another job, leaving friends—are far outweighed by the fact that he will not have to work as hard as he does in his present job, nor will he have to work so many hours since the huge increase she will receive will permit him "to take it easy." To be sure, Anne must convince her husband that she will really share the rewards of her new job with him, since after he consents to change from b_1 to b_2 (+5 to −2) he will be vulnerable. In fact, Ben believes that once Anne rises to the top, he only stands to lose, since she may feel that she no longer needs him. On the other hand, he knows that if he opposes her taking the new job, and they stay as they are (+5 +5), she will not be able to achieve her goals.

Next, imagine this. A man named Aaron (A) and a woman named Barbara (B) were recently married. They are quite happy (+5, +5), and both planned to work in order to save money before going to college (a_1b_2). Aaron, however, has just been given an opportunity to attend an Ivy League college (+20). If he accepts (a_2), Barbara will be required to work full time to pay the tuition and living expenses at the prestigious institution. This means she will not be able to pursue her own college education until after Aaron receives his degree. If Aaron decides to enter college without the permission of his wife (b_1a_2), he could lose Barbara, her income and much of his happiness (−10). Thus, it is incumbent upon Aaron to convince Barbara that it is to their mutual advantage that he attend school before she does. Barbara, however, fears that once Aaron graduates, he will no longer want her because she will no longer be his equal. In addition, she has no guarantee that he will pay to permit her to attend college when her time comes.

The situations just described may each be diagramed as follows:

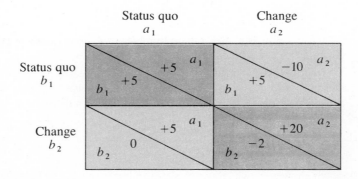

What would you do in each case? Why?

SKILL BUILDER

THE MARRIAGE-GO-ROUND

1. Divide the class into male/female pairs.

2. Each pair should discuss the problems presented.

3. When their discussions are completed, each male and female should secretly indicate his or her decision for each case on a separate slip of paper. If you are a male, your choices are limited to b_1 (status quo) or b_2 (change). If you are a female, your choices are limited to a_1 (status quo) or a_2 (change). Each set of "couple" responses should then be labeled to indicate sex and clipped together, then passed to the instructor for tabulation.

4. The results of each set of deliberations should be entered on the following class charts.

A. CASE OF THE FEMALE SEEKING SELF-IMPROVEMENT

Analysis of Individual Decisions by Sex

Number of males selecting to maintain the status quo (Choice b_1)	Number of males selecting to change (Choice b_2)
Number of females selecting to maintain the status quo (Choice a_1)	Number of females selecting to change (Choice a_2)

Analysis of "Couple" Decisions

Number of couples selecting the a_1b_1 possibility: _____	Number of couples selecting the a_2b_1 possibility: _____
Number of couples selecting the a_1b_2 possibility: _____	Number of couples selecting the a_2b_2 possibility: _____

B. CASE OF THE MALE SEEKING SELF-IMPROVEMENT

Analysis of Individual Decisions by Sex

Number of males selecting to maintain the status quo (Choice b_1)	Number of males selecting to change (Choice b_2)

SKILL BUILDER CONTINUED ON THE FOLLOWING PAGE

Number of females selecting to maintain the status quo (Choice a_1)

Number of females selecting to change (Choice a_2)

Analysis of "Couple" Decisions

Number of couples selecting the a_1b_1 possibility: _____

Number of couples selecting the a_2b_1 possibility: _____

Number of couples selecting the a_1b_2 possibility: _____

Number of couples selecting the a_2b_2 possibility: _____

5. Was there a difference in the number of males and females who were willing to cooperate for the betterment of their spouses? Why?
6. What do the results say about the nature of our society?
7. What do the results say about trust?

Until each of the individuals described in our illustrations learns to trust the other, their relationship will not grow. In addition, as our experiences show, for real trust to develop in a relationship, both partners need to be supportive and honest with each other. However, this is not as easy as it seems. Let us examine why.

ETHICAL CONSIDERATIONS: "WHAT? ME LIE?"

An old Moroccan proverb includes this line: "Why are you lying to me who are my friend?" How do you define the word "lie"? To whom would you lie? What types of conditions do you believe call for a lie? How many times in the past week have you lied? How many times have you been caught? Write your responses to these questions in the space provided.

1. A lie is _____.
2. I would lie to _____.
3. I would lie if _____.
4. In the past week I lied _____ times.
5. In the past week I was caught lying _____ times.

Let us now examine what we mean by the word "lie," how we feel about lies, and how lies affect the development of our relationships.

What Is a Lie?

LIES

Yevgeni Yevtushenko

Telling lies to the young is wrong.
Proving to them that lies are true is wrong.
Proving to them that God's in his heaven
and all's well with the world is wrong.
The young know what you mean.
 The young are people.
Tell them the difficulties can't be counted,
and let them see not only what will be
but see with clarity these present times.
Say obstacles exist they must encounter,
sorrow happens, hardship happens.
The hell with it. Who never knew
the price of happiness will not be happy.
Forgive no error you recognize,
it will repeat itself, increase,
and afterwards our pupils
will not forgive in us what we forgave.

When we lie to someone we are not merely delivering wrong information; rather, we are intentionally seeking to deceive that individual. As described by Sissela Bok, author of *Lying,* when we lie it is our hope and probably our expectation that we will succeed in misleading an individual to believe something that we ourselves do not believe. Thus, lying involves a sender and a receiver—a liar and someone who is lied to. What the liar does is simply invite the receiver to believe a statement the liar knows to be false. In a very real sense, the liar exploits the receiver.

Few people who lie are able to limit their lying to a single episode. One theorist observed, ''It is easy to tell a lie, but hard to tell only one.'' As an insightful thinker put it, the initial lie ''must be thatched with another or it will rain through.'' Thus, when telling a lie, individuals would be wise to recognize that to sustain the lie, they might find it necessary to tell more lies. As Sissela Bok writes, ''The liar always has more mending to do.'' Keeping untruths straight requires a great deal of energy. The liar has to remember who was told what and why. In many ways, liars are like counterfeiters, who rarely if ever print only one false bill. At the same time, liars appeal to the maxim: ''Let the Buyer Beware.'' In their mind it is a ''seller's market.'' The philosophy of the habitual liar is to try to get away with as much as possible as often as possible. Yet, all lying, like all communication, has serious consequences—sometimes for one person, sometimes for a nation. What consequences does lying hold for you?

Imagine sharing a relationship, no matter how ideal in other aspects, in which you

could never rely on the words or gestures of your partner. Information exchanged in that relationship would be virtually meaningless, and feeling expressed would be practically worthless. Unless some trust and truthfulness are present between persons, a relationship is doomed from the outset.

Many people think that lying, whatever the reason, is a serious offense. Others believe that it is the individual's motives that really matter; they ask, is harm intended? Still others believe that it is the lie's outcome that merits consideration. What do you believe?

The Liar and the Deceived

How do lies affect us? Lies misinform those they deceive. They may serve to convince an individual that something he or she wanted is no longer obtainable or desirable, or they may help to make an individual believe that more possibilities are open to him or her than actually exist.

How do you feel when you are deceived? The most common feelings are suspicion, resentfulness, and disappointment. No one likes to be duped. No one likes to appear stupid, gullible, or weak. No one likes to play the fool and have others put something over on him or her. Yet, we all know what it means to lie to an individual with whom we share an interpersonal relationship. We also know what it means to be told lies, and what it means to be suspected of telling lies. Let us now explore some of these aspects.

SKILL BUILDER

STORY TIME

1. Your instructor will divide you into groups of As and Bs. Partners will also be assigned.

2. Each A and each B will be asked to think of a story to tell to his or her partner. As and Bs will be secretly informed by the instructor to make their story either predominantly true or predominantly false. Thus, the stories that an A and a B share with each other may be something that really happened to them or outright lies.

3. After listening to each other's stories, partners are to respond to these questions:

 A. Do you believe your partner's story was true or false?
 B. What about your partner's behavior or method of delivery led you to this conclusion? For example, was it something your partner said, did, or a combination? Be specific.

4. Partners are to share reactions with each other.

5. Have each individual reveal to his or her partner whether the partner's perceptions were correct—that is, whether, in fact, the story was true or false.

6. Finally, ask participants to reveal how they felt about lying and how they felt about being lied to.

THE LIE DETECTOR

1. Report on an experience of being lied to. Indicate who lied to you, the nature of the lie, the reason for the lie, and your reactions when you found out you had been lied to. Also, describe how the lie affected your relationship with the liar.

2. Report on a "lying to" experience. Indicate who you lied to, the nature of the lie, your reason for lying, and the other person's reaction when the lie was found out. How did the lie affect the relationship you shared?

3. Report on a "falsely suspected of lying" experience. Indicate why you were suspected, who suspected you, and how you reacted to being doubted.

THE WIZARD OF ID by Brant parker and Johnny hart

Liars, like those they deceive, share a desire not to be misled. For this reason, liars are apt to hope that the individuals with whom they interact are honest and straightforward in their dealings. Most liars want to gain the benefits that lying could bring without having to experience the risks that being lied to could carry. It is acknowledged that the lying individual frequently feels guilt, shame about having lied, anxiety about being found out, and even resentment because the "victim" was not strong enough or astute enough to detect the deceit. In a way, this makes sense; we each bear a responsibility to try to learn how to distinguish truth from falsehood. Unfortunately, molding the truth to meet personal needs is quite a common way of exerting influence in interpersonal relationships.

Lying and Interpersonal Relationships

As we have seen, lying sometimes is a result of the competitive nature of the interactional situation; it has been attributed to a lack of confidence or trust in one partner by the other partner in the relationship. In addition, lying frequently results because individuals are afraid that if they do not lie, they will not be accorded respect and they will not be accepted. Thus, persons seek to hide their imperfections by attempting to present instead what they perceive to be a socially desirable facade. Consequently, the more intense the degree of interpersonal friction between communicators, the larger the threats to one's

ego, the more likely individuals are to use diversionary tactics and communicate lies in order to attain their personal goals or maintain their feelings of self-worth. Thus, instead of revealing how they feel and what they want from a relationship, individuals sometimes feel compelled to dissemble and lie. To the extent that trust is undermined, cooperative undertakings between the involved persons break down. After all, there is really no logical reason for you to ask another individual for an opinion on some point if you do not believe that the answer will actually express his or her opinion.

We have all experienced the harm that such lying can do to interpersonal trust. If individuals feel a need to lie, a good healthy relationship cannot be said to exist. This is not to say, however, that lying is always wrong or always unjustified. Consider this.

SKILL BUILDER

THE WHITE LIE

1. Define what the term ''white lie'' means to you.
2. Describe the last white lie you told. Indicate your motivations for telling it and the effect it had.
3. Describe an interpersonal situation where you could have told a white lie but did not. What were your motivations in this case? What were the effects of your telling the truth?
4. Explain why you feel white lies are justified or unjustified.
5. Finally, do you mind being told white lies? Why?

A white lie is commonly understood to be a falsehood that is not meant to harm or injure anyone. In interpersonal relationships, white lies are used to help provide moral support, cheer, and sometimes to maintain the ''humanness'' of the social relationship itself. Consider this.

POSITIVE DENIAL: THE CASE FOR NOT FACING REALITY

Richard S. Lazarus

When I started out as a psychologist, the prevailing view was that accurate reality testing was the hallmark of mental health. A healthy person, we assumed, was an accurate reflector of what is real in the world. To live life successfully meant to face the truth, however painful. This ide-ology is around today; the latest form of this doctrine is that to have an ''authentic'' relationship with another person, you have to be absolutely honest with that person, and with yourself, about how you feel.

Clinicians assumed self-deception is pathological, I think, because they saw only people who had trouble facing the truth about the sources of

their problems. So the clinical view has become that denial leads to pathology. Paradoxically, poets, playwrights, and novelists have been saying just the opposite: we need our illusions. As Don Quixote puts it in *Man of LaMancha*, "Facts are the enemy of truth."

Ibsen's *The Wild Duck* takes up the theme of necessary illusions. So does O'Neill's *The Iceman Cometh*. In that play, there are a number of derelicts in a bar who are filled with self-deception. One of their occasional cronies comes by and zealously tells them to stop believing these lies about themselves and face the truth. He succeeds in destroying one man, who commits suicide. Finally, they all give up and go back to their illusions. O'Neill was telling us that life cannot be lived without illusions. . . .

My own research on how people actually deal with life crises has brought me around to the view that illusion and self-deception can have positive value in a person's psychological economy. Indeed, the fabric of our lives is woven in part from illusions and unexamined beliefs. There is, for example, the collective illusion that our society is free, moral, and just, which, of course, isn't always true. Then there are the countless idiosyncratic beliefs people hold about themselves and the world in which they live—for example, that we are better than average, or doomed to fail, or that the world is a benign conspiracy, or that it is rigged against us. Many such beliefs are passed down from parent to child and never challenged.

Despite the fixity with which people hold such beliefs, they have little or no basis in reality. One person's beliefs are another's delusions. In effect, we pilot our lives in part by illusions and by self-deceptions that give meaning and substance to life.

Psychology Today, November 1979, p. 47

As we see, people do not just lie to others; they also lie to themselves. Individuals use a number of defensive strategies to protect themselves from facing reality. Three commonly employed defense mechanisms are displacement, repression, and rationalization. Displacement occurs when we release our anger or frustration by communicating our feelings to persons or objects who are perceived to be more accessible and less dangerous than the individuals who precipitated our feelings in the first place. For example, if you were to yell at a younger brother or sister or a child when you really wanted to yell at your boss, that would be displacement.

We use the self-protective strategy of repression when situations are too painful or unpleasant for us to face. What we do is "forget" the stimulus that disturbs us by denying its very existence. If, for example, a man and a woman who were of different faiths married and could not agree on what religion to raise their child in, they might "solve" the problem by pretending they did not care what religion the child adopted. While the facade they erected would say "nothing was wrong," in reality, feelings of anger and aggression would be building, and in a matter of time resentment in the form of slips of tongue, sarcastic comments, or disgusted looks might surface and affect their relationship.

Rationalization is also a frequently employed self-protection strategy. When we engage in rationalization, we simply give ourselves a logical or reasonable explanation for the

unrealistic pictures, thoughts, or feelings we hold. For instance, the worker who received a poor assessment from a manager might tell himself that "everyone gets poor assessments." Similarly, the individual who interviewed for a position only to be turned down might convince herself that she did not really want the job.

What is unfortunate is that we often fail to realize that under some circumstances a truth that hurts someone can be just as harmful as a lie that maims. A person is not an ashtray; every individual needs to be treated with respect and concern. There are individuals who view themselves as truth seekers. Sometimes, these persons succeed in removing false beliefs from those who really need them to survive. Unwittingly or wittingly, these individuals do as much damage as callous liars. Some people need their illusions. They simply are unable to confront certain aspects of themselves without losing their sense of balance or equilibrium. If you analyze your own interpersonal situation it will probably become clear that some of your friendships and some of your family relationships rely on the silent agreement made between parties that certain illusions will be sustained and certain memories will be suppressed. This, too, is a form of trust.

Thus, the issue is not just whether you lie in an interpersonal relationship but the reason why you lie, the nature of the lie you tell, and the effects of the lie. Whether to lie, be silent, or tell the truth is often a difficult decision to make.

HOW TO DEVELOP TRUST IN YOUR RELATIONSHIPS

As our examination of trust has shown, being trustworthy means working to build a real relationship, not working to get to know the other person so that you can take advantage of his or her vulnerability. When you use your knowledge to harm a partner in a relationship, you destroy your partner's trust in you. By now, it should be apparent that fear, distrust, and other defensive feelings are common blocks to the functioning and self-actualizing abilities of an individual, as well as barriers to the development or maintenance of a good relationship. Thus, the key to building trust in a relationship is to behave in a trustworthy manner. How is this accomplished?

SKILL BUILDER

TRUST BUILDERS IN ACTION

1. Working individually, compile a list of behaviors you believe will help build trust in a relationship.
2. Form groups of four to five individuals. Pool your ideas so that a group list is developed.
3. Appoint a person to read your group's list aloud.
4. Finally, pool responses with the other groups to create one major class list of trust-producing behaviors.

Examine your list to see if you have included the key ideas listed below:

Be Willing to Disclose Yourself to the Other Person

Trust, like self-disclosure, is a reciprocal process. Trusting behavior on your part can often precipitate trusting behavior in the person you are communicating with. Thus, disclosing yourself to another can work to help the other come to know you, understand you, and realize that he or she must also take a risk if a relationship based on mutual trust is to develop.

Let the Other Person Know You Accept and Support Him or Her

When you reduce threats to the ego of another individual, you increase the level of trust between you. If the other individual feels accepted by you and feels that you perceive him or her as a significant human being who is worthy of your time and attention, then

Trust cannot develop unless we are willing to disclose personal information to another. This kind of risk taking is essential to the development of human relationships.
(© Susan Meiselas/Magnum)

he or she will be less likely to experience anxiety and fears about being placed in a vulnerable position. Such feelings of acceptance will also deter others from attempting to defend themselves by lying or dissembling. They will simply have no reason to do so. Thus, warmth and acceptance encourage trust and honesty.

Develop a Cooperative Rather than a Competitive Orientation

Working to "win" in a relationship can destroy the relationship. How a relationship is defined affects how easily trust may be built and whether it will be built at all. If you aim only to increase your own immediate gain, even though it means sacrificing the well-being of a partner, the degree of trust your partner is willing to place in you will diminish rapidly. You will be perceived as a manipulator. In contrast, healthy relationships depend on the problem-solving abilities of the individuals involved. Problem solving presupposes a nonmanipulative orientation. If individuals choose to compete with each other instead of cooperating with each other, trust simply will not develop.

Trust Another Individual When It Is Appropriate

Taking inappropriate risks can cause as many problems as never being willing to take a risk. In other words, always trusting people who do not merit your trust is as dysfunctional as never trusting anyone. People who consistently trust exploitative people find themselves taken advantage of, and behaving in this way will not help build a relationship based on a foundation of trust. Instead, you must be willing to question the other person's motivations and behaviors openly. The other person may learn to respect you for feeling strong enough or capable enough to call a halt to the duplicity. Remember, trust is sustained only if both parties to a relationship behave in trustworthy ways.

SUMMARY

In this chapter we have explored a number of interpersonal dilemmas; the nature of trust; cooperative, competitive, supportive, and defensive interpersonal climates; and the issue of lying. We have examined how we act in our own interpersonal encounters, and we have investigated our motivations for displaying such behaviors. Recognizing that trust is essential for the development of effective relationships, we have identified the bases of trust, the components of trust, and ways in which we can help build trust.

By participating in a number of exercises, you have been given an opportunity to experience how the presence or absence of lying, a supportive climate, and competition or trust can help to maintain or destroy a relationship. Use your new insights to facilitate your personal growth as well as to help develop healthy interpersonal relationships.

Bok, Sissela. *Lying: Moral Choice in Public and Private Life*. New York: Pantheon Books, 1978. A discussion of ethical theory and the perplexities of moral decision making. An examination of the causes and consequences of lying.

Fried, Charles. *Right and Wrong*. Cambridge, Mass.: Harvard University Press, 1978. A scholarly analysis of the forces that help us distinguish right from wrong.

Gabarro, John G. "The Development of Trust, Influence, and Expectations," in Anthony G. Athos and John G. Gabarro, *Interpersonal Behavior: Communication and Understanding Relationships*. Englewood Cliffs, N.J.: Prentice-Hall, 1978. A discussion of the bases of trust. Contains a clarification of the conditions that contribute to or detract from a trusting relationship.

Gibb, Jack R. "Defensive Communication," *Journal of Communication*, Vol. 2 (1961), 141–148. This article identifies behaviors that help elicit defensive or supportive reactions from others.

Heun, Linda R., and Richard E. Heun. *Developing Skills for Human Interaction*, 2nd ed. Columbus, Ohio: Charles E. Merrill, 1978. Offers a clear discussion of the nonverbal cues that contribute to the establishment of a defensive or supportive climate.

Johnson, David W. *Reaching Out: Interpersonal Effectiveness and Self-Actualization*. Englewood Cliffs, N.J.: Prentice-Hall, 1972. A very readable analysis of the characteristics of a relationship based on trust.

Steinfatt, Thomas M. *Human Communication: An Interpersonal Introduction*. Indianapolis: Bobbs-Merrill Educational Publishers, 1977. Provides a good explanation of the nature of the Prisoner's Dilemma.

Taylor, Anita, Teresa Rosengrant, Arthur Meyer, and Thomas B. Samples. *Communicating*. Englewood Cliffs, N.J.: Prentice-Hall, 1977. Like Huen and Huen, provides a clear description of the nonverbal cues that characterize supportive and defensive interactions.

Watzlawick, Paul. *How Real Is Real?* New York: Vintage Books, 1977. Offers a clear analysis of the Prisoner's Dilemma and its relationship to trust.

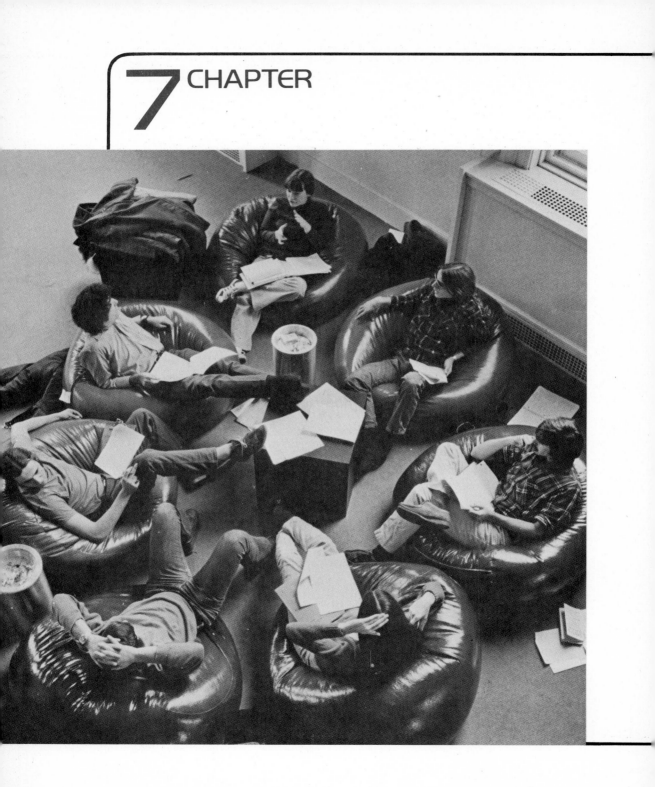

Language
and Meaning:
Helping Minds Meet

CHAPTER PREVIEW

After experiencing this chapter, you should be able to:

Define ''language''

Describe and explain the triangle of meaning

 Identify what is meant by a word barrier

Discuss how words mean

 Explain the relationship that exists between meaning and time, meaning and place, and meaning and experience

 Identify the differences between connotative and denotative meaning

 Provide examples of bypassing

 Distinguish between intensional and extensional orientation

Identify when the use of a sublanguage is appropriate and inappropriate

Provide examples of the ways in which word shading can modify meaning

Identify factors that contribute to your own effective or ineffective use of language

*Whatever we call a thing, whatever
we say it is, it is not. For whatever
we say is words, and words are words
and not things. The words are maps,
and the map is not the territory.*

Harry L. Weinberg,
"Some Limitations of Language"

Have you ever considered the type of person you would be if you were unable to use words to express yourself? Going even further, have you ever considered the kind of person you would be if you were unable to make a sound? To give you an idea of how it would feel, try this exercise:

SKILL BUILDER

SOME TIME AGO

The purpose of this exercise is to enable you to experience the desire and the need to communicate as well as the frustration of having to do it under certain restrictions.

1. Select one of the following topics to discuss with another person.

 Television Beauty
 Education Politics
 Cruelty to animals Life styles

2. After choosing a topic, begin to communicate your ideas to your partner, using only bodily action. You may not use sounds or words, but you are allowed to draw pictures and other sketches or point to objects. You will have approximately ten minutes to attempt to communicate your ideas in this manner.

3. Next, you may add sounds such as whining, growling, or laughing to aid you in your communication efforts. Devote about ten minutes to this attempt.

4. Finally, you may use all means of communication: nonverbal, vocal, and verbal. Take another ten minutes to express your ideas free of any restrictions.

5. After completing the exercise, describe how you felt during each of the three stages. To what extent were you and your partner able to share meaning and understand each other during each phase of the experience? Do you consider language an important aspect of your ability to communicate with other people? Why?

As you probably discovered, expressing yourself clearly on any of the subjects suggested in this exercise is difficult enough *with* words, but it is almost impossible *without* words. Even when you were permitted to use sounds as well as body language and pictures, you probably still found communicating clearly exceedingly difficult. In fact, we imagine that intelligent, understandable communication began only when you were allowed to use words.

You should now have a better understanding of how it feels to have certain ideas and not to be able to communicate them. For perhaps the first time, you may realize how much you take your speaking abilities for granted. Like so many other things of importance, the value of speaking is frequently only appreciated when it is threatened, lost, or taken away. We depend on language to help us communicate meaning to others, and meaning is what communication is all about. If we understand how language works, we will be able to use words to help us share meaning with others.

LANGUAGE: WHAT'S THAT?

Language is a symbol system. A symbol is something that stands for something else. Words are symbols. We use words to represent things. Notice that we have used the words "represent" and "stand for" rather than the word "are." This is a very important distinction. Words *stand for* or *represent* things. Words are *not* things. Words are spoken

Meaning resides in people, not in words. The sense the speaker attributes to words must overlap with that of listeners for communication to be effective.
(© Michael Weisbrot & Family)

sounds or their written representation that we have agreed will stand for something else. We can, by mutual consent, make anything stand for anything.

The meaning of a verbal message is not stamped on the face of the words we use. Meanings are in people, not in words. The process of communication involves using words to help create meanings and expectations. What is important to realize is that you have your meaning, and the other person has his or her meaning. Even a common word such as "cat" can bring to mind meanings ranging from a fluffy angora to a sleek leopard. Your goal is to have your meanings overlap so that you can each make sense out of the other's messages and understand each other. Thus, to communicate, you translate the meaning you have in your head into language so that another person will respond to it by forming a meaning in his or her head that is similar to the one in yours. If language is used carefully, the meanings overlap, aiding effective interpersonal communication. Far too often, however, language serves as an obstacle to interpersonal communication. Let us begin to examine why.

THE TRIANGLE OF MEANING: WORDS, THINGS, AND THOUGHTS

Language only fulfills its potential if we use it correctly. To use it correctly, we have to understand a number of things about it. Unfortunately, we have many mistaken ideas regarding how language works. This triangle, developed by theorists C. K. Ogden and I. A. Richards, will help explain what we mean.

The dotted line connecting the word (symbol) and the thing (referent) indicates that the word is not the thing and that there is no direct relationship or connection between the word and the thing. When you use words, you must constantly remind yourself that the only relationship between the words you use and the things they represent are those that exist in people's minds. Frequently, even the existence of an image does not establish meaning. A few years back, a public service commercial depicting a rat and a child living in a ghetto tenement was shown on television. The child was seen beckoning to the rat as she repeated, "Here kitty, kitty. Here kitty, kitty." It is quite possible for two of us to look at the same object but give it different meanings. The meaning of anything is inside the person who has experienced it. Although the example above may appear somewhat exaggerated to you, its meaning is really quite clear. No one else will respond to a stimulus (word or thing) exactly as you do. Thus, if you are to be a successful interpersonal communicator, you should understand the relationship that exists between words, people's thoughts, and people's reactions.

Word Barriers

When we talk to people we often assume too quickly that they understand us. There are, however, many reasons why we may not be understood as we want to be and why the words we use can create barriers. In Lewis Carroll's *Alice in Wonderland,* Humpty Dumpty and Alice have the following conversation:

> "I don't know what you mean by 'glory,' " Alice said.
> Humpty Dumpty smiled contemptuously. "Of course you don't—till I tell you. I meant, 'There's a nice knock-down argument for you!' "
> "But 'glory' doesn't mean 'A nice knock-down argument,' " Alice objected.
> "When I use a word," Humpty Dumpty said in a rather scornful tone, "it means just what I choose it to mean—neither more nor less."

Do you think this is true? Can we make words mean whatever we want them to mean? Nothing stops us—except our desire to share meaning with others.

Language that impedes communication constructs word walls.

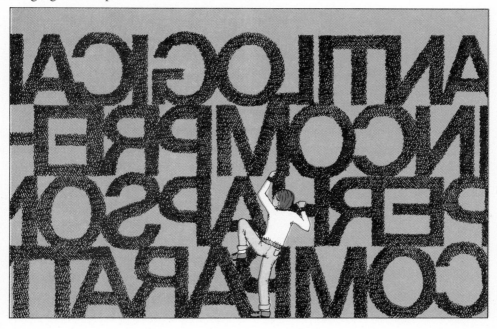

MEASURING DENOTATIVE AND CONNOTATIVE MEANING

Sometimes we forget that we may experience a problem in communication if we consider only our own meaning for a word. *We* know what *we* mean. The crucial question is what does our word bring to mind for those with whom we are communicating?

STRONG STUFF

William Safire

Order "regular coffee" and what do you get?

"In the United States," reports Phil Shea, public-relations director of Sheraton hotels, "with only one exception, an order for 'regular coffee' would produce plain coffee with sugar and cream on the side.

"The exception is Boston. An order for 'regular coffee' in the coffee shop would produce coffee with cream already added, and sugar on the side. In the hotel restaurant, the waiter would question the guest to clarify the order."

Since Americans drink about 460 million cups of java on a winter's day, it may be helpful to examine other regional language distinctions in the ordering of coffee. I put the question to the president of the National Coffee Association, who started talking about a study of "preferences for creaming agents." I could tell he was not my man; to me, a "creaming agent" is a hit man.

Vann E. Hettinger, a reader from Redding, Conn., supplied a useful variation: "coffee, light," in the North, is coffee that is light-colored because of the great amount of cream, half-and-half, milk, nondairy creamer, or other, uh, creaming agent, it contains. However, in the Southeast, "coffee, light" means coffee with a small amount of white stuff—the "light" refers to going lightly on the cream, or not pouring with a heavy hand.

Perhaps because of this confusion about "light," or perhaps a spillover from British usage about tea, the word "white" is sometimes used to differentiate an order from "black" coffee. When used in the United States, "coffee, white" means "not black" and leaves to the pourer's discretion the amount of cream to agent.

The man from DARE—Prof. F. G. Cassidy, editor of the Dictionary of American Regional English—saw this query as a perfect example of our language's variety.

"Get down into Tennessee and such parts," reports Cassidy, "and they'll know what *egg coffee* is— you throw eggshells in the pot so the last of the egg white will *settle* the grounds and *clear* the coffee. Coffee is serious stuff, but jocular types may call it *barefoot* (black) and *with socks on* (white). Get down to New Orleans and a different distinction comes up: coffee will be either *chicory* or *pure* (no chicory). Get out West and you may be lucky enough to find *range* or *cowboy* coffee, which when properly made is *boilt*. The wagon cook's recipe, or *receipt*, for making cowboy coffee went something like this: 'Take two pounds of Arbuckle's, put in 'nough water to wet it down, boil for two hours, and then throw in a hoss shoe. If the hoss shoe sinks, she ain't ready.' "

How is weak coffee characterized? Americans are united on *dishwater*, though *bilgewater* is heard up North, *stump water* down South, and *scared water* out West. In Virginia, it's *driddle water*.

Strong coffee is equated in the American language with good cof-

fee: words of praise include *Norwegian, creek-bank, sawmill, shanty* and *sheepherder's* coffee. However, Professor Cassidy reports that, on occasion, strength and viscosity go too far, and in rural Wisconsin farmers complain: "It's too thick to drink, and too wet to plow."

The best put-down is "If this is coffee, bring me tea, and if it's tea, bring me coffee." At my local greasy spoon, after the confusion of "coffee, light" and arguments over what constitutes "regular," I always sing out, "Coffee, with a side of soybean creamer and a packet of saccharin," which gets me coffee, regular, along with a black look.

New York Times Magazine,
January 27, 1980, p. 9

Meaning and Time

In order to explore how words continually change meaning, try the following activity:

SKILL BUILDER

THE WORD–TIME CAPSULE

1. Write the following words on a sheet of paper:

pot	pad
gay	grass
high	speed
freak	gross
trip	hip
swing	dust
straight	joint
rock	stoned

2. On a separate sheet of paper, write your definition of each of the words.
3. Show the list, without definitions, to your parents, older relatives, or older friends, and ask them to write their definitions for the words. Compare your meaning for each term with the meaning given by others you questioned. Why do you suppose their meanings differed?
4. Pretend it is now the year 2020. Create new meanings for each of the words listed.

A definition is not attached to a word forever. Words evolve new meanings through the years. When we use a word that referred to a particular object at one point in time, we should attempt to determine if it still means the same thing now. "Old" words often

acquire vivid new meanings each decade or so. Remember this when speaking with others who are older or younger than you.

Meaning and Place

Not only do words change meaning with the times, they also change as we move from one region of the country to another. For example, what would you envision having if you were to stop for a "soda"? For an "egg cream"? For a "Danish"? For some "pop"? The "thing" each word brings to mind probably depends on the region of the country where you were raised. In some parts of the United States, a "soda" refers to a soft drink; in others, it refers to a concoction of ice cream plus soft drink plus water. In some sections of the country, an "egg cream" refers to a seltzer, syrup, and milk mixture. In others, it would conjure up images of an egg mixed with cream. To people in some parts of the United States, a Danish means any kind of breakfast pastry. In other regions, when you order a Danish, you expect to be served a particular kind of breakfast pastry. In still

SKILL BUILDER

MEET MY MEANING

Below are a number of semantic differential scales developed by Charles Osgood, George Suci, and Percy Tannenbaum. After reading the instructions for completing them, use them to indicate what the words "college," "marriage," and "parent" mean to you.

Instructions for Completing Semantic Differential Scales

Taking the good–bad scale as an example, the seven positions should be interpreted as follows: If you feel that the word being measured gives you an extremely good feeling or extremely bad one, place your X as follows:

If you feel the word makes you feel quite good or quite bad, place the X as follows:

If you feel the word is only slightly good or slightly bad (but not really neutral), place your X as follows:

other sections, the waitress or waiter might have no idea you were asking for food and might think that you were ordering a foreign specialty or even a foreigner.

Meaning and Experience

The meanings we assign to words are based on our past experiences with the words and with the things they represent. Take the word "cancer," for example. If you were dealing with three different people in a hospital—a surgeon, a patient, and a statistician—how do you imagine each would react to this word? What thoughts would come to the mind of each individual? The surgeon might think about operating procedures or techniques, or how to tell a patient with cancer that he has the disease. The patient might think about the possibility of death and might well experience fear. The statistician might see "cancer" as another factor in the life-expectancy tables. See how your own experience influences the meanings you assign to words by completing the activity that begins at the bottom of the previous page:

good ____ ____ X ____ ____ ____ ____ bad

or

good ____ ____ ____ ____ X ____ ____ bad

The direction in which you check the scale will, of course, depend upon which of the two ends of the scale you feel is more descriptive of the word being studied. On the other hand, if you feel the word is neutral in regard to good–bad, place your X in the middle space:

good ____ ____ ____ X ____ ____ ____ bad

COLLEGE

good	___	___	___	___	___	___	___	bad
happy	___	___	___	___	___	___	___	sad
strong	___	___	___	___	___	___	___	weak
honest	___	___	___	___	___	___	___	dishonest
hot	___	___	___	___	___	___	___	cold
active	___	___	___	___	___	___	___	passive
valuable	___	___	___	___	___	___	___	worthless
sweet	___	___	___	___	___	___	___	bitter
fast	___	___	___	___	___	___	___	slow

SKILL BUILDER CONTINUED ON THE FOLLOWING PAGE

MARRIAGE

good	——	——	——	——	——	——	——	bad
happy	——	——	——	——	——	——	——	sad
strong	——	——	——	——	——	——	——	weak
honest	——	——	——	——	——	——	——	dishonest
hot	——	——	——	——	——	——	——	cold
active	——	——	——	——	——	——	——	passive
valuable	——	——	——	——	——	——	——	worthless
sweet	——	——	——	——	——	——	——	bitter
fast	——	——	——	——	——	——	——	slow

PARENT

good	——	——	——	——	——	——	——	bad
happy	——	——	——	——	——	——	——	sad
strong	——	——	——	——	——	——	——	weak
honest	——	——	——	——	——	——	——	dishonest
hot	——	——	——	——	——	——	——	cold
active	——	——	——	——	——	——	——	passive
valuable	——	——	——	——	——	——	——	worthless
sweet	——	——	——	——	——	——	——	bitter
fast	——	——	——	——	——	——	——	slow

You have just indicated your connotative meanings for these words. Unlike denotative (dictionary) meanings, which are objective, abstract, and general in nature, connotative meanings are personal, subjective, and emotional in nature. Unlike dictionaries, which give definitions with particular references omitted, your connotative meanings for a word vary according to your personal feelings for the concept or object you are considering. Now, let us numerically analyze your connotative meanings.

You can compute a class average for each concept studied and, if desired, you can also code results according to male/female responses, as shown on the chart above. Use the following questions to improve your ability to discuss the nature of meaning.

How did your meanings for each word compare with the meanings of other students? Was there a discernible difference that could be attributed to the sex of the respondent? What do you think accounts for the differences among the students' word scales?

Did anyone else in your class fill out the scales exactly as you did? Words will have

Analysis

For each scale number the positions 1 through 7 from left to right, as follows:

	1	2	3	4	5	6	7	
good	____	____	____	____	____	____	____	bad

Determine your scores and enter them on the Word Analysis Form provided below. Total the scores for each word.

WORD ANALYSIS FORM

Scale	College	Marriage	Parent	Class Average	M	F
good/bad						
happy/sad						
strong/weak						
honest/ dishonest						
hot/cold						
active/ passive						
valuable/ worthless						
sweet/ bitter						
fast/slow						
TOTAL						

the same connotative meaning for people only to the degree that people have had the same experiences. Since you and others in your class probably have not shared the identical experiences with the idea of college, marriage, or parent, it is likely that you also will not share the identical connotative meanings for these terms.

As we mentioned earlier, if we do not make an attempt to analyze how someone's background may influence them to assign meaning, we may have trouble communicating with them.

For most of us, words have more than a single meaning. In fact, commonly used words frequently have more than twenty different definitions. We know that a "strike" in bowling is different from a "strike" in baseball. We know that "to strike" a match does not have the same meaning as "to strike" an employer. "Striking up" a conversation is not the same as "striking up" the band. For this reason, we must pay careful attention to the context of a message. Unfortunately, we frequently forget that words are rarely used in one and only one sense, and we assume when we speak to others that words are used in only the way we intend them to be understood. Just like us, our receivers may mistakenly assume that we intended our words the way they happen to interpret them. When this happens, we say that we have bypassed each other in communication. Let us explore this aspect further.

BYPASSING AND BYPASSING THE BYPASS

As we mentioned, we can experience communication problems if different people attribute different meanings to the same words. Sometimes people assume they understand each other but in fact are really missing each other's meaning. This pattern of miscommunication is termed "bypassing": meanings simply pass by one another.

We can identify two main kinds of bypassing. The first occurs when people use different words to represent the same thing but are unaware that they are talking about the same thing. For example, two politicians once argued vehemently over welfare policies. One stated that the city's welfare program should be overhauled. The other believed that the city's welfare program concept should be kept intact, but that minor changes should be made. Far too much time passed before one politician realized that what he termed an "overhaul" was equivalent to what the second politician called "minor changes." How many times have you argued unnecessarily because you were unaware that the other person was using a different word or words to mean the same thing?

The more frequent type of bypassing occurs when people use the same word or phrase but give it different meanings. In such cases, people appear to be in agreement when they substantially disagree. They are simply unaware that they each give different meanings to the same words. Sometimes this bypass is harmless: A young man from England was astonished that he got slapped when he told an American acquaintance that he would "knock her up" before he returned to Britain. It was only after he explained that to him "knock her up" meant "come and see her" that the young woman apologized.

At other times bypassing can be less innocuous. Semanticists tell a story about a motorist who was driving on a parkway outside New York City when his engine stalled. The motorist lifted up his car's hood and determined that his battery was dead. He managed to flag down another driver, who listened to the motorist's story, and consented to push his car to get it started. "My car has an automatic transmission," he explained, "so you'll have to get up to thirty or thirty-five miles an hour to get me started." The other driver nodded understanding. The stalled motorist climbed into his own car and waited for the other car to line up behind his. He waited and waited. Finally, he turned around to see what was wrong and saw the other driver coming at him at thirty miles per hour. Considerable damage was done to both automobiles.

Unfortunately, the results of bypassing can be tragic. During World War II it was thought the Japanese had decided to ignore the Potsdam Declaration because they had announced that they were adhering to a policy of "mokusatsu." It was only after the atomic bomb was dropped on Hiroshima that it was realized that the Japanese word "mokusatsu" could also have been translated as "make no comment at the moment" rather than as "reject." The cost of this possible mistake of interpretation is incalculable. The activity below will give you an opportunity to demonstrate your understanding of bypassing.

SKILL BUILDER

BYPASS THE BYPASS

Select a partner and together create a brief skit or improvisation that illustrates a communication problem caused by bypassing. The improvisation may illustrate either how different words can mean the same thing or how the same word can have different meanings.

After each presentation, the class should discuss the bypassing problem that was presented and identify ways it could have been avoided.

Developing an awareness that bypassing can occur when you communicate is really a first step in preventing it from interfering with or complicating your interpersonal relationships. If you believe it is possible for your listeners to misunderstand you, you will willingly take the time needed to insure that your meanings for words overlap. Try never to be caught saying, "It never occurred to me that you would think I meant . . ." or, "I was certain you'd understand." To avoid bypassing, you must be person-minded instead of word-minded. You must remind yourself that your words may generate unpredictable or unexpected reactions in others. Trying to anticipate these reactions will help you forestall communication problems.

WORD–THING CONFUSIONS: LABEL MADNESS

Each of us has learned to see
the world not as it is, but through the
distorting glass of our words. It is
through words that we are made
human, and it is through words
that we are dehumanized.

Ashley Montagu,
"The Language of Self-Deception"

Sometimes we forget that it is people and not words that make meanings. When this happens, we pay far too much attention to names and far too little attention to realities. Let us approach this phase of our study of meaning by considering this problem: What type of behavior would you exhibit around vats labeled "Gasoline Drums"? You would probably be careful not to light any matches, and you would be certain not to toss away any cigarette butts. Would you change your behavior if the label on the containers were altered to read "Empty Gasoline Drums"? Chances are you might relax a bit and give little thought to the possibility of starting a fire. Despite the label, however, empty drums are actually more dangerous because they contain explosive gasoline vapor.

After studying such incidents, a linguistic researcher named Benjamin Lee Whorf suggested that the way people defined or labeled a situation had a dramatic impact on their behavior. According to Whorf, coformulator of the Sapir–Whorf hypothesis, the words we use help mold our perception of reality and the world around us. In other words, Whorf believes that our words determine the reality we are able to perceive. Thus, a person from Florida who rarely if ever experienced snow, and who simply called snow "snow," probably sees only one thing—"snow"—when confronted with different samples of frozen moisture falling from the sky. In contrast, skiers who depend on snow, seek out snow, and follow snow report that they are able to label and distinguish between approximately six different types of "snow."

How important are labels in our culture? The following exercise may help answer this question.

SKILL BUILDER

STICKS AND STONES

Pretend that you are a district court judge. You are faced with the following case. Simon Maynard Kigler would like to change his name to 1048. Simon would like to be called "One Zero Four Eight," or "One Zero" for short. It is your task to decide whether you would grant Simon the requested name change. Justify your decision with specific reasons.

When faced with a similar case, a judge ruled that the individual could not change his name because a number was totalitarian and an offense to human dignity. What does a number signify? Would we change if our names were changed? Shakespeare offered some thoughts on the significance of names when he had Juliet, a member of the Capulet family, say these words to Romeo, a member of the Montagues:

> 'Tis but thy name that is my enemy;
> Thou art thyself, though not a Montague.
> What's Montague? It is nor hand, nor foot,
> Nor arm, nor face, nor any other part
> Belonging to a man. O! be some other name;

What's in a name? that which we call a rose
By any other name would smell as sweet;
So Romeo would, were he not Romeo call'd . . .

Are most people blinded by labels? A curious storekeeper attempted to answer this question by conducting a test. The storekeeper had just received an order of identical handkerchiefs. He arbitrarily divided the order in half and placed one half of the order on a table and labeled it "Genuine Irish Linen Handkerchiefs—two for $3.00." He placed the other half of the order on another counter and labeled it "Noserags—two for 25¢." What do you think happened? Why? Right! His customers displayed an intensional orientation. Instead of being extensionally oriented and inspecting the territory, they reacted to the labels. It seems nobody likes to buy "noserags"—even if they are "Genuine Irish Linen." Would you?

Far too frequently, our reactions to the same event are totally changed by words—or even a single word. We simply confuse words and things. If we are not aware of our responses to language, we can very easily be manipulated and conned by language.

SKILL BUILDER

WORDCON

Analyze how your reactions are changed as the labels in each of the following word sets are changed.

1. coffin	casket	slumber chamber
2. girl	woman	broad
3. backward	developing	underdeveloped
4. the corpse	the deceased	the loved one
5. cheat	evade	find loopholes
6. janitor	custodian	sanitary engineer
7. kill	waste	annihilate
8. war	police action	defensive maneuvers
9. toilet	bathroom	restroom
10. senior citizens	aged	old people
11. air strike	bombing raid	protective reaction
12. broke	poor	disadvantaged
13. bill collector	debt chaser	adjuster
14. love child	illegitimate child	bastard
15. an illegal	an alien	an undocumented resident

Words can help alter our perception of events, objects, people, and our world. Once our perception is altered, our behavior may also change. Thus, language can shape our attitudes and the attitudes of those around us.

IMPROVING ORAL LANGUAGE ABILITIES: A CALL FOR COMMON SENSE AND CLARITY

When we communicate interpersonally we consciously or unconsciously select the level of language we will use. Normally, the words we select depend on whom we are communicating with and where we are communicating. The purpose of the exercise below is to enable you to recognize that different styles of behavior are required in different circumstances.

SKILL BUILDER

DESCRIBE YOUR BEHAVIOR

1. On a chart similar to the one below, describe in a word or two the language, style of dress, posture, and attitude you would use when placed in each of the listed situations.

	LANGUAGE	DRESS	POSTURE	ATTITUDE
At home				
At work				
At school				
On vacation				
At a party				
In a courtroom				

2. Compare and contrast your responses with other members of your class.

A Call for Common Sense

It should be apparent that just as particular styles of apparel and behavior are appropriate for certain situations, so certain styles of language are appropriate for certain occasions. You have the capability to adapt the language you use as you move from one interpersonal situation to another. You need to be aware of the conditions and circumstances that could affect your language usage. Jonathan Swift said it long ago when he noted that style is simply "proper words in proper places." Thus, it all boils down to deciding what is meant by "proper."

What we think is proper and what someone else thinks is proper may not always coincide.

SKILL BUILDER

WHAT'S TABOO TO YOU?

1. Would you feel comfortable using obscenities with any of the following people? Why or why not?

Your grandparents	A maitre d'
Your best friend	Your team coach
The president of your school	Your instructor
Your state senator	Your physician
Your employer	

2. How would your answer to the preceding question change when you were placed in each of the following environments?

A fancy restaurant	A department store
A truck-stop diner	The school cafeteria
Your living room	A sports stadium
Your den	An auditorium
A classroom	

3. How would your answers change if each of the listed individuals was a man? A woman?
 To what extent, if any, did your responses vary? Why?

A Call for Clarity

THE GOBBLEDEGOOK

Eugene J. McCarthy
and James J. Kilpatrick

Of all the creatures catalogued in this Bestiary, none is more familiar, none more widely distributed in North America, than the Gobbledegook.

This lamentable beast has some of the characteristics of the common garden toad: He sits there, stolidly blinking, warts and all. He has some of the characteristics of the polecat and the inky squid, whose properties are to spread a foul diffusion. He has the gaudy tail of a peacock, the impenetrable hide of the armadillo, the windy inflatability of the blow-fish.

It is commonly thought that the Gobbledegook resides only at seats of government, chiefly at the seat of

national government, but this is not true. The Gobbledegook is equally at home in academic groves and in corporate mazes. He is often observed on military reservations, in doctors' offices, and in judicial chambers. He feeds on polysyllables, dangling participles, and ambivalent antecedents. He sleeps in subordinate clauses. The Gobbledegook is composed mostly of fatty tissues, watery mucus, and pale yellow blubber. The creature is practically boneless. Owing to cloudy vision, once he has launched into a sentence, he cannot see his way clear to the end.

In the foggy world of the Gobbledegook, a janitor becomes a material waste disposal engineer and a school bus in Texas a motorized attendance module. Here meaningful events impact; when they do not impact, they interact; sometimes they interface horizontally in structural implementation.

For all its clumsiness, the Gobbledegook is amazingly adept at avoiding capture. President Carter pursued his quarry through ten thousand pages of the *Federal Register* and emerged with no more than a couple of tail feathers plucked on the trail. The beast can survive for months on a jar of library paste; when startled by an angry editor, the Gobbledegook fakes a retreat, spouting syntactical effluvium as it goes, but once the editor's back is turned, the beast appears anew. It cannot be killed; it cannot even be gravely wounded. It dwells in thickets, in swamps, in heavy brush, in polluted waters, in the miasmic mists of intentional obfuscation.

A Political Bestiary, 1978

As a communicator, you want to be sure to use words your receivers will understand. What language problem is illustrated in this example adapted from Stewart Chase's *The Power of Words?*

A plumber with a limited command of English was aware that hydrochloric acid opened clogged drain pipes quickly and effectively. However, he thought he had better check with the National Bureau of Standards in Washington, D.C., to determine if hydrochloric acid was safe to use in pipes, so he wrote the bureau a letter. A scientist at the bureau wrote back, stating: "The efficacy of hydrochloric acid is indisputable, but the corrosive residue is incompatible with metallic surfaces."

The plumber wrote a second letter, thanking the bureau for the quick reply and for giving him the okay to use hydrochloric acid.

The plumber's second letter bothered the scientist and he showed it to his boss. The boss decided to write another letter to the plumber. The boss's letter read: "We cannot assume responsibility for the production of toxic and noxious residue which hydrochloric acid can produce; we suggest that you use an alternative procedure."

This left the plumber somewhat confused. He dashed off a letter to the bureau telling them that he was glad they agreed with him. "The acid was working just fine."

When this letter arrived, the boss sent it to the "top administrator" at the bureau. The top administrator solved the problem by writing a short note to the plumber: "Don't use hydrochloric acid. It eats the hell out of pipes!"

Far too often, we use language that our receivers cannot easily decipher. It doesn't matter how accurately a selected word or phrase expresses our ideas if, when the receiver hears it, he or she cannot comprehend it. If you want to be understood, you must make every attempt to match your language to the educational level of your listeners. If you select words with meaning for your listeners, you will have taken a giant step toward achieving understanding.

Would you use the same language when speaking to a two- or three-year-old that you would use when speaking to an adult? How does your word level change? Would you modify your normal word choice for a sixth grader? A high school student? A good rule to follow if you hope to achieve clarity is to keep jargon usage to a minimum unless your receiver is schooled in the jargon. In other words, to speak the same language as your listener.

Most of us who live in the United States share a common language, but many of us also use one or more sublanguages. A sublanguage is simply a special language used by members of a particular subculture. We all belong to several subcultures—an occupational group, a national group, an educational group, perhaps a religious group. Having a common sublanguage helps members of the group attain a sense of identity. When some blacks address their acquaintances as "brother" or "sister" when greeting each other in the street, they are affirming their subcultural membership. All sublanguages enable members of the subcultures to communicate clearly and specifically with each other in

As infants we learn not only a language, but a sublanguage—the speech of our own particular subculture.
(© Linda Ferrer 1980/Woodfin Camp & Assoc.)

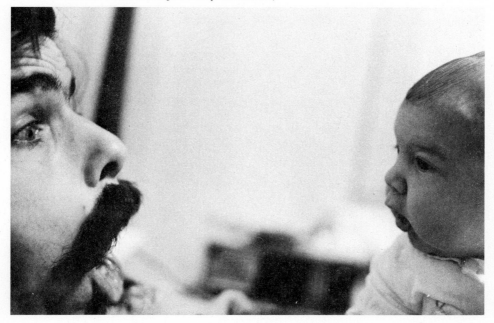

a language that is not readily understood by those outside of the subculture. Consequently, according to Edgar Dale, the language of a subculture is clear only if known. Would you worry if your doctor told you that you were suffering from "cephalalgia" or "agrypnia"? Your guesses would probably be far worse than the doctor's actual diagnosis. What is the doctor actually telling you? "Cephalalgia" is the medical term for headache, and "agrypnia" refers to insomnia. To be sure, jargon can help specialists communicate accurately and concisely with each other, but trouble will certainly arise if the specialist expects the uninitiated to understand the same jargon. The following article illustrates this point.

PLAIN ENGLISH

Richard Haitch

The New York State Attorney General was puzzled by this sentence:

"The liability of the bank is expressly limited to the exercise of ordinary diligence and care to prevent the opening of the within-mentioned safe deposit box during the within-mentioned term, or any extension or renewal thereof, by any person other than the lessee or his duly authorized representative and failure to exercise such diligence or care shall not be inferable from any alleged loss, absence or disappearance of any of its contents, nor shall the bank be liable for permitting a co-lessee or an attorney in fact of the lessee to have access to and remove the contents of said safe deposit box after the lessee's death or disability and before the bank has written knowledge of such death or disability."

Saying, "I defy anyone, lawyer or lay person, to understand or explain what that means," Attorney General Robert Abrams sued the Lincoln Savings Bank in New York City two months ago, demanding that it simplify a customer agreement on safe-deposit boxes. It was the first suit to enforce the state's new Plain English Law on contracts.

The case is settled. The bank has rewritten its lease contract in "much more readable English," says Stephen Mindell, assistant attorney general.

The former 121-word sentence now says: "Our liability with respect to property deposited in the box is limited to ordinary care by our employees in the performance of their duties in preventing the opening of the box during the term of the lease by anyone other than you, persons authorized by you or persons authorized by the law."

New York Times, August 31, 1980, p. 35

People schooled in the technical language of a particular group should constantly guard against what may be termed an innate temptation to impress others rather than to communicate. In short, we must always ask ourselves "Who am I talking to?" if we want our receiver to understand us. Consider the brief dialogue below. The italicized

"My life was as nothing, Ann, until you impacted on it."

The New Yorker

words may make sense to a group of prisoners, but they would probably be incomprehensible to those who know nothing about the criminal subculture.

JOHN: I saw the *scratcher* carefully examine the scrip.

MARY: He told me that the *buttons* wouldn't get him if he could help it.

What do you think the italicized words mean? Attempt to translate the dialogue into commonly understood language. Did you decipher the actual meaning:

JOHN: I saw the forger carefully examine the forged check.

MARY: He told me that the police wouldn't get him if he could help it.

Using readily understandable language need not keep you from aiming for accuracy. Never abandon your efforts to find the exact words that represent the ideas you want to communicate. Remember that a clear interpersonal message is neither ambiguous nor confusing. Your precise meaning will be shared with another person only if your words tell him or her precisely what you mean. Thus, attempt to be concrete rather than vague in the words you select to represent your thoughts. For example, if you were trying to

convey how someone sounded when he spoke, you could state: "He said," "he yelled," "he cried," "he purred," "he chuckled," "he growled," "he boomed," or "he sang." Each description would leave your listener with a somewhat different impression and feeling. Your words would shape the meaning you convey to others. As you increase your sensitivity to language, your awareness of the subtle shades in meaning that can be achieved with words will grow.

The exercise that follows will give you an opportunity to try your hand at word shading.

SKILL BUILDER

WORD COLOR

Before the exercise begins, the following sentences will be written on cards and placed in a container at the front of the room.

She is *thin*.	She is *good looking*.
She is *fat*.	She is *rich*.
He is *smart*.	He is *old*.
He is *firm*.	She is *tired*.

1. Divide into teams of three to four individuals. A member of one team selects a sentence from the container and writes it on the board.

2. All teams then have sixty seconds to generate a list of as many substitutes as possible for the italicized word. Word substitutes should represent shadings, colorations, or nuances that modify the sentence's meaning. For example, the sentence, "He was *cheap*," could be rewritten by group members to read: "He was *thrifty*," "He was *stingy*," or "He was *a miser*." Results should be reported to the class.

If your words do not mean what you intend them to mean, your listener may receive a meaning quite different from the one you intended to communicate. On the other hand, clear and precise language usage will facilitate your communication efforts.

HOW TO MAKE WORDS WORK FOR YOU: A GUIDE TO FURTHER SKILL DEVELOPMENT

Throughout this chapter, we have stressed that the mastery of certain language skills will improve your ability to communicate effectively with others. The following guidelines may be used to help insure that the words you use work for you rather than against you.

Politicians understand the importance of using language. If skillful, they can be "perfectly clear" or fuzzy and evasive, as the occasion demands.
(© Rose Skytta/Jeroboam)

Identify the Ways in Which Word Labels Affect Your Behavior

We can state one of the most fundamental precepts of language usage simply and directly: words are not things. Always remember that words are nothing more than symbols. No necessary connection exists between the symbol and what people have agreed the symbol represents. In other words, symbols and their representations are independent of each other. Despite the fact that we know this, at times each of us probably responds as if words and things were intimately connected. This feeling is exhibited whenever we make statements resembling the following: "A bathroom is a bathroom; it's certainly not a watercloset." "Pigs are called pigs because they wallow in mud and grime." Think of how many times you buy products such as Intimate, Brute, Bold, Caress, Secret, or Gleem simply because of what the label seems to promise. Think of how many times you are turned against a person because he or she is called liberal, conservative, feminist, chauvinist, intellectual, or brainless. Examine your behavior as a consumer. Be product-minded, not label-minded. Examine your relationships with others. Make certain you react to people, not to the categories within which you or others have placed them.

Far too frequently, we let words trigger our responses, shape our ideas, affect our attitudes, and direct our behavior. We believe that words have magical or mystical powers, and they do not. We foolishly transfer qualities implied by labels to the things that labels represent. Becoming conscious of how labels affect you is the first step in changing your attitudes toward them. Do not permit labels to blind you, mislead you, fool you, or imprison you.

Identify How the Words You Use Reflect Your Feelings and Attitudes

It is important to recognize that few of the words you select to describe things are neutral. S. I. Hayakawa, author of *Language in Thought and Action,* notes this when he writes:

> We are a little too dignified, perhaps, to growl like dogs, but we do the next best thing and substitute series of words, such as "You dirty double crosser!" "The filthy scum!" Similarly, if we are pleasurably agitated, we may, instead of purring or wagging the tail, say things like "She's the sweetest girl in all the world!"

We all use "snarl" words and "purr" words. These words do not describe the persons or things we are talking about; rather, they describe our personal feelings for and attitudes toward the objects of our orientation. When we make statements like "He's a great American," "She's a dirty politician," "He's a bore," "She's a radical," "He's a Wall Street Slicky," "She's a greedy conservative," "He's a male chauvinist pig," "She's a crazy feminist," we should not delude ourselves into thinking that we are talking about anything but our own preferences. In effect, we are neither making reports nor describing conditions that necessarily exist. We are expressing attitudes, not information. If others are to determine what we mean by our descriptions, they are compelled to follow up and ask, "Why?" Count the number of times you use purr words or snarl words each day. What do they reveal about your likes and dislikes? How do your words give you away?

It is also important to realize that a word that does not function as a "snarl" word or "purr" word for you may function as a "snarl" word or "purr" word for someone else. It does not matter that you did not intend your words to be interpreted in this way. What does matter is the response of the person with whom you are interacting. Become conscious of the ways others react to the words you use. Listen to people around you and attempt to read their responses to your words. What words that incite them would not incite you? What words do they find unacceptable or offensive? Why?

We all have our own meanings for words. When engaging in interpersonal communication, however, we have to be concerned with how others will react to the words we use. We have to consider the possible meaning they may have for our words. In order to accomplish this, you must make an honest effort to get to know the people with whom you interact. Become familiar with how their background could cause them to respond to certain words with hostility, anger, approval, or joy. Remember, your ability to have an effective relationship with someone else can be positively or adversely affected by the words you use.

Identify the Ways in Which Experience Can Affect Meaning

Since we give meaning based on our experience, and since no two people have had exactly the same set of experiences, it follows that no two people will have exactly the same meanings for the same word. This aspect of language should neither be lauded nor cursed; it should simply be remembered.

It is important to understand that word meanings can change as the people who use words change. The fact that you would wear a sports jacket and slacks or a skirt and sweater if invited to a "casual" party does not mean that everyone else who was invited to the party would interpret the word "casual" in the same way. One person might decide to wear jeans and a sport shirt; another might wear shorts and a T-shirt. Likewise, because you feel that the word "freak" has only positive connotations does not exclude the possibility that another person might believe it has only negative connotations. The meanings that people attribute to symbols are affected by their backgrounds, ages, educational levels, and professions. Forgetting this can cause misunderstandings and lead to communication difficulties.

Be guided by the fact that words in themselves have no meaning; remember that meaning resides in the minds of the communicators. Try to identify how the life experiences of people with whom you communicate could cause them to respond to words in ways that you would not respond. Remember, the responses of the people are not wrong; they are only different. Do not take your language for granted. Do not conclude that everyone thinks as you do and means what you mean. You know what a word means from your own frame of reference, but do you know what it means to someone who has a different frame of reference? Have the patience required to find out.

Check to Be Sure Meaning Is Shared

Since intended meanings are not necessarily the same as perceived meanings, it may be necessary for you to ask the individuals with whom you are speaking such questions as "What do you think about what I've just said?" or "What do my words mean to you?" Their answers serve two important purposes: they help you determine if you have been understood as you had hoped you would be; and they permit the other person to become involved in the encounter by expressing his or her interpretations of your message. If differences in the assignment of meaning surface during this feedback process, you will be immediately able to clarify your meanings by substituting different symbols, or by relating your thoughts to the background, state of knowledge, and experiences of your receiver.

Keeping each of these guidelines in mind while interacting should help to improve your interpersonal communication skills. If you recognize that every time you communicate with another person you run the risk of being misunderstood, then you will be more likely to become sensitive to the ways in which your words affect those with whom you relate. As John Condon, author of *Semantics and Communication,* advises: "Learning to use language intelligently begins by learning not to be used by language."

SUMMARY

Language is a sharing of meaning. Language allows minds to meet, merge, and mesh. When we make sense out of people's messages, we make sense out of people. When we meet an individual's message, we meet the individual. If used properly, language can help initiate and maintain an effective interpersonal relationship.

In this chapter we have examined how language works and how meaning is communicated. We have investigated the relationship that exists between words, things, thoughts, and behavior. Recognizing the fact that language is constantly on the move, we explored meaning and time, meaning and place, and meaning and experience. We identified a number of reasons why people sometimes fail to understand each other, and we began to chip away at word barriers that we unnecessarily create.

We now recognize that meanings exist in people, and if we want to improve our interpersonal language skills and not bypass each other, we must attempt to find out how people use and react to words.

SUGGESTIONS FOR FURTHER READING

Chase, Stuart. *The Power of Words*. New York: Harcourt Brace Jovanovich, 1953. A very readable description of some of the semantic problems that plague us.

Condon, John C. *Semantics and Communication,* 2nd ed. New York: Macmillan, 1975. Contains a good discussion of barriers to verbal interaction.

Haney, William V. *Communication and Organizational Behavior*. Homewood, Ill.: Richard Irwin, 1973. A clear discussion of the misevaluations that impede communication effectiveness.

Hayakawa, S.I. *Language in Thought and Action*. New York: Harcourt Brace Jovanovich, 1964. A comprehensive study of general semantics. Contains useful exercises.

Hayakawa, S.I. *The Use and Misuse of Language*. Greenwich, Conn.: Fawcett Books, 1962. A collection of essays that treat common language problems.

Newman, Edwin. *A Civil Tongue*. Indianapolis: Bobbs-Merrill, 1976. Contains wonderful examples of semantic atrocities.

Osgood, Charles, George Suci, and Percy Tannenbaum. *The Measurement of Meaning*. Urbana: University of Illinois Press, 1957. A scholarly discussion of how words mean.

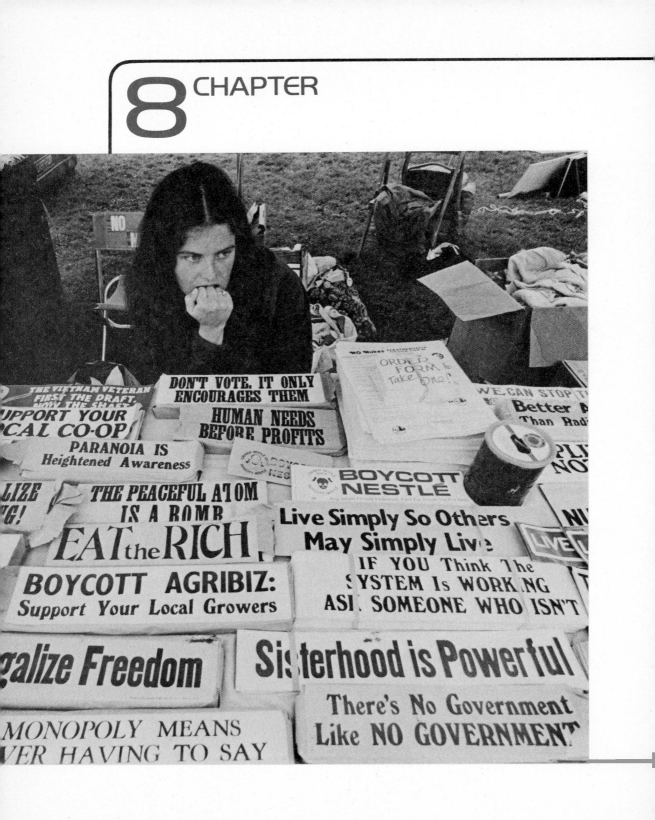

Beliefs, Values, and Attitudes: Persuade Me If You Can

CHAPTER PREVIEW

After experiencing this chapter, you should be able to:

Define and distinguish between attitudes, beliefs, and values

Identify ways in which attitudes affect interpersonal communication

 Identify how attitudes are measured

 Identify the sources of your attitudes

 Distinguish the functions served by attitudes

Identify ways in which beliefs affect interpersonal communication

 Identify how beliefs are measured

 Explain your reasons for believing and disbelieving people and information

Identify ways in which values affect interpersonal communication

 Provide examples of the types of values that guide your life

 Identify ways in which your values can be measured

 Distinguish between terminal and instrumental values

Explain what is meant by ''balance''

 Compare and contrast balanced and unbalanced systems

 Provide examples of balanced and unbalanced systems

 Identify ways to restore balance to a relationship

Identify factors that contribute to successful interpersonal persuasive efforts

Assess your own persuasive abilities

To be nobody-but-yourself in a world which
is doing its best, night and day, to make
you everybody else—means to fight
the hardest battle which any human
being can fight; and never stop fighting.

e.e. cummings

Each day we become involved in situations that call for decisions and actions. Every decision we make, every action we take, is related to or determined by our consciously or unconsciously held attitudes, beliefs, and values. In fact, we do or say few things during the course of a day that do not reflect our attitudes, beliefs, and values: They are at work when we are thinking about ourselves, our friends, and our environment; they are at work when people try to influence us and when we try to influence others. How frequently do you succeed in convincing others to see things your way? How frequently do you give in and do things their way? If you understand how and why you are able to influence others and how and why they are able to influence you, your effectiveness as an interpersonal communicator will be markedly improved.

What are you doing when you attempt to influence other people? You are usually trying to modify thoughts, feelings, and actions. You hope certain individuals will eliminate behaviors you do not approve of and adopt behaviors compatible with your interests and consonant with the way you see the world. Today, more than ever, we are concerned about being able to influence others. We are so preoccupied with this that a main aim of many of our interpersonal communication encounters is to create similarity of thought, feeling, and behavior between ourselves and those with whom we interact. Let us now examine how attitudes, beliefs, and values are internalized, maintained, and changed during and through the interpersonal communication process. Understanding this will also enable us to understand the life choices we make. If we do not attempt to understand our life choices, we could find ourselves turning into the type of person described in this passage from *Some People* by Maurice Nicoll.

> Some people stay very much in the same places all their lives, in their vast, inner, unmanifested, psychological country. It is as if one lived internally in a small village and always took the same walk. Every day the same thoughts and feelings repeat themselves, every day the same attitudes are at work, the same mechanical prejudices, the same buffers, the same automatic sentences. As we take time to become aware of the attitudes, beliefs, and values we prize, those we would be willing to stand up for in and out of the classroom, we are also taking time to change for the better and become more effective interpersonal communicators.

YOUR ATTITUDES ARE SHOWING

Although you cannot see, hear, or touch your attitudes, you can see, hear, or touch the behavior that is attributable to the influence of attitudes. You communicate your attitudes through your verbal and nonverbal behavior. Your facial expressions, posture, and gestures reveal your attitudes. Each time you socialize, attend class, or go to a meeting,

Our families are our first instructors in values. If this mother believes that dissent is patriotic, her son is likely to hold a similar view. (© *Jeffrey Blankfort/Jeroboam*)

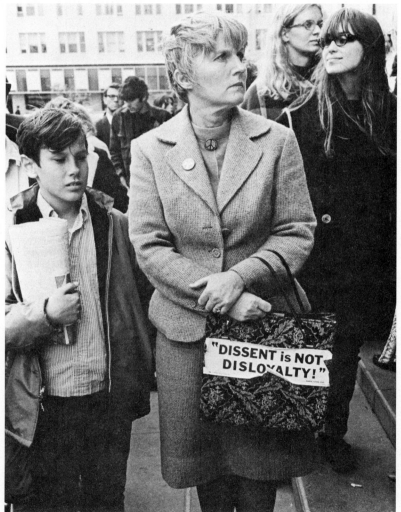

your attitudes are displayed. They affect who you are and how you interact with others. Let us now take a closer look at what attitudes are and how they work.

What Are Attitudes? How Are They Measured?

Most psychologists define an attitude as a mental set that causes you to respond in a particular way to a given stimulus. It is a predisposition or readiness to react positively

SKILL BUILDER

ATTITUDE ASSESSMENT

1. Use the following scales to indicate your positive and negative evaluations of each of the following terms:

MERCY KILLING

Positive Scale	0	10	20	30	40	50	60	70	80	90	100
Negative Scale	0	10	20	30	40	50	60	70	80	90	100

CAPITAL PUNISHMENT

Positive Scale	0	10	20	30	40	50	60	70	80	90	100
Negative Scale	0	10	20	30	40	50	60	70	80	90	100

NATIONAL HEALTH INSURANCE

Positive Scale	0	10	20	30	40	50	60	70	80	90	100
Negative Scale	0	10	20	30	40	50	60	70	80	90	100

MONEY

Positive Scale	0	10	20	30	40	50	60	70	80	90	100
Negative Scale	0	10	20	30	40	50	60	70	80	90	100

MARRIAGE

Positive Scale	0	10	20	30	40	50	60	70	80	90	100
Negative Scale	0	10	20	30	40	50	60	70	80	90	100

2. Next, indicate your evaluation of these same terms using a single continuum set of scales:

or negatively toward certain things, people, ideas, or situations. In other words, attitudes represent your evaluations of things, people, ideas, or situations. Our attitudes help us sort our perceptions into extremely favorable, fairly favorable, neutral, fairly unfavorable, and extremely unfavorable categories.

Thomas Scheidel has asserted that attitudes can more accurately be viewed as points along two different scales: 0 to 100 on the positive scale, and 0 to 100 on the negative one.

MERCY KILLING

Extremely Favorable	Fairly Favorable	Neutral	Fairly Unfavorable	Extremely Unfavorable

CAPITAL PUNISHMENT

Extremely Favorable	Fairly Favorable	Neutral	Fairly Unfavorable	Extremely Unfavorable

NATIONAL HEALTH INSURANCE

Extremely Favorable	Fairly Favorable	Neutral	Fairly Unfavorable	Extremely Unfavorable

MONEY

Extremely Favorable	Fairly Favorable	Neutral	Fairly Unfavorable	Extremely Unfavorable

MARRIAGE

Extremely Favorable	Fairly Favorable	Neutral	Fairly Unfavorable	Extremely Unfavorable

3. Which type of attitude scale did you find easier to use—the single or the double version? Why? Which scale helped you clarify the nature of your feelings to a greater extent? Why?

4. To what extent did your attitudes show absolute conviction (0 on one measure, 100 on the other measure)? To what extent were they mixed or ambivalent?

5. Compare and contrast your evaluations with those of your peers.

There is nothing good or bad, but
thinking makes it so.

Shakespeare

To a great extent our behavior and communication preferences are determined by
the attitudes that we possess. Thus, attitudes lead you and others to behave in certain
ways, and attitudes influence the likelihood of certain kinds of behavior occurring.

We may view attitudes as points along a continuum, positioning each of our attitudes
along a scale or scales. We can also analyze our attitudes by examining the following
attitudinal dimensions: direction, strength, and salience. When we speak of the direction
of an attitude, we are simply noting whether we like something (render a positive
evaluation), dislike something (render an unfavorable evaluation), or do not care (render
a neutral evaluation). The strength of our attitude reveals the intensity of our evaluation.
As we saw in the scales we filled out, we can feel moderately or extremely disposed or
undisposed toward a concept. We can dislike certain people, or we can hate them. We
can like a job, or we can love it. In other words, while the direction of the attitudes we
and another person hold may be similar, the comparative strength of our attitudes may
be different. Not all people who favor a concept favor it equally. We hold attitudes with
various degrees of intensity. Finally, the salience of an attitude indicates how important
the attitude is to us or any individual who holds it. Some attitudes are more important
to us than they are to others. To find out which of your attitudes are most salient for you,
try this.

SKILL BUILDER

SALIENCE SIDETRIP

1. Compile a list of attitudes you hold that could cause you to behave in the following ways:

 A. Display little if any emotion when someone speaks against it:

 B. Become mildly annoyed when someone speaks against it:

 C. Argue strongly in favor of it:

 D. Fight physically for it:

2. Compare and contrast your list with the lists compiled by others in your class. What kinds of attitudes did the class feel were most important? Least important? What attitude meant more to you than it did to anyone else? Why?

Where Do Your Attitudes Come From? Roots Revisited

We act according to pictures we carry in our heads, pictures that do not necessarily correspond with reality. To understand why we hold the attitudes we do, we can try to "dig out" the roots of our pictures. What forces helped us create our attitudes? What forces help us sustain them?

SKILL BUILDER

THE ATTITUDE DIG

1. In the space provided below, make a list of factors you believe helped to influence the development of your attitudes.

SOURCE TYPE OF INFLUENCE

A.

B.

C.

D.

E.

2. Compare and contrast your list with the lists developed by other students. How were the lists similar? How were they different?

The roots of your attitudes extend in all directions. How many of the following possible roots did you identify?

Your Family. Few people escape the strong influences exerted by their families. Many of our parents' attitudes are communicated to us and eventually acquired by us. As communication theorists Scott Cutlip and Alan Center write, "It is the family that bends the tender twig in the direction it is likely to grow."

Your Religion. Believers and nonbelievers alike are affected by religion. In fact, the impact of religion is becoming ever more widespread as churches strive to generate and guide attitudes on such social issues as abortion, civil rights, child abuse, and divorce.

Schools. More children than ever are attending school; they start young (sometimes before the age of five) and many attend until they are in their twenties or older. Moreover, the traditional role of the school has expanded as adults return to complete their educations. The courses taught, the people who teach them, the books that are assigned, and the films shown all help shape attitudes.

Economic and Social Class. Your economic or social status also shapes your attitudes. In fact, your economic status helps determine the social arena you frequent. Your view of the world will likewise be affected by the company you keep and the money you have.

Your Culture. As John Donne wrote, "No man is an island entire of itself . . ." From the crib to the casket we are influenced by others—in person or through the media. The groups we belong to, the friends we have, and the fabric of the society within which we find ourselves in part form and mold us. In our social environment we discover the ingredients that help determine our mental sets and, in turn, determine our attitudes. We may shape our institutions only to then be shaped by them.

John Berryman expressed his attitude about life in this poem from his collection, *77 Dream Songs*.

Life, friends, is boring. We must not say so.
After all, the sky flashes, the great sea yearns,
we ourselves flash and yearn,
and moreover my mother told me as a boy
(repeatedly) 'Ever to confess you're bored
means you have no

Inner Resources.' I conclude now I have no
inner resources, because I am heavy bored.
Peoples bore me,
literature bores me, especially great literature,
Henry bores me, with his plights & gripes
as bad as achilles,

who loves people and valiant art, which bores me.
And the tranquil hills, & gin, look like a drag
and somehow a dog
has taken itself & its tail considerably away
into mountains or sea or sky, leaving
behind: me, wag.

Germaine Greer's attitude about being a woman is the subject of this excerpt from "The Stereotype."

> I'm sick of pretending eternal youth. I'm sick of belying my own intelligence, my own will, my own sex. I'm sick of peering at the world through false eyelashes, so everything I see is mixed with a shadow of bought hairs; I'm sick of weighting my head with a dead mane, unable to move my neck freely, terrified of rain, of wind, of dancing too vigorously in case I sweat into my lacquered curls. I'm sick of the Powder Room. I'm sick of pretending that some male's self-important pronouncements are the objects of my undivided attention. I'm sick of going to films and plays when someone else wants to, and sick of having no opinions of my own about either. I'm sick of being a transvestite. I refuse to be a female impersonator. I am a woman. . . .

SKILL BUILDER

WHAT'S YOUR ATTITUDE?

Write a short paper delineating an attitude you hold. Discuss what led you to form the attitude, and describe the attitude's direction, strength, and salience.

What Functions Do Attitudes Serve?

In "The Functional Approach to the Study of Attitudes," Daniel Katz identified four functions of attitudes, which we should consider if we want to understand how and why attitudes operate as they do. According to Katz, first, attitudes serve an adjustive, instrumental, or utilitarian function. By this Katz means that attitudes help us reach desirable goals and avoid undesirable goals—that is, we form and adhere to certain attitudes because they are reinforcing. Such attitudes are developed on the basis of the rewards and punishments we receive. We like those things we judge to be good for us, and we dislike those things we judge to be harmful. Thus, we hold some of our attitudes just because we believe they will help us achieve what we would like to achieve. We hold some attitudes simply because we perceive them to be useful. For example, common attitudes useful to college students might include favorable attitudes toward athletic ability, high grades, popularity with fellow students, and good wages. In contrast, unfavorable attitudes might be directed toward poor grades, unpopularity, irrelevant courses, and low wages. Each of these attitudes is utilitarian because each, in its own way, can help or impede the student's goal attainment.

Second, Katz notes that attitudes can serve ego-defensive functions—that is, they can help us protect our self-concepts, and they can aid us in working through our own internal conflicts. Sometimes such attitudes enable us to avoid real or imagined dangers; at other times they help keep us from discovering basic truths about ourselves that could damage our ego. For example, if we discovered that our supervisor was about to fire us, we might well develop negative attitudes toward her, the company, and our job in an effort to cover up our disappointment and protect our ego from accepting the judgment that we were not a valued employee. Likewise, if we were unpopular with one particular group of people, we might create attitudes that would protect and sustain our egos: We might develop unfavorable attitudes toward those in the group and convince ourselves that the group's members were inferior, dull, and worthy of neither our time nor attention. Labeling others as inferior permits us to feel superior. Unfortunately, such defensive attitudes frequently keep us from revealing our true feelings to others.

The third function of attitudes identified by Katz is value-expressive. Some attitudes express the values we hold, and by so doing, clarify for us and others the type of person we conceive ourselves to be or the kind of person we would like to be. In this way, value-expressive attitudes also help us communicate our self-image. For example, if you considered yourself to be an enlightened liberal, you would probably hold attitudes that you consider the appropriate expressions of the "enlightened liberal" values.

It is apparent that we each think of ourselves in somewhat different terms. However, regardless of how or what we think of ourselves, we maintain attitudes that help us express those values we believe in. We hold attitudes that indicate our central values. Thus, if we valued free speech, we would probably have unfavorable attitudes toward censorship and laws that limited freedom of expression. At the same time, we would probably have favorable attitudes toward whatever supported our "free speech" value. In like fashion, if we valued humane treatment for animals, we would probably have negative attitudes toward hunting and toward wearing fur coats, and we would probably

have favorable attitudes toward groups that opposed using animals for experimental purposes or that supported our feelings in other ways.

The last function of attitudes identified by Katz is the knowledge function. According to Katz, some attitudes help us understand our world by serving as standards against which new information can be evaluated or judged. Your attitude toward human rights, for example, can provide you with a frame of reference for interpreting your feelings about racial conflict.

Check your understanding of each of these attitude functions by completing this exercise:

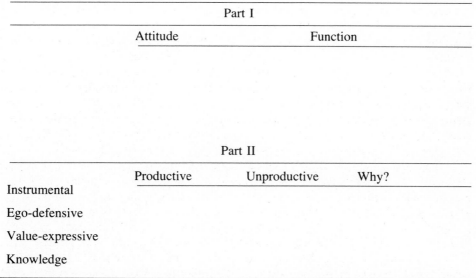

SKILL BUILDER

ATTITUDE SURVEY

1. Use the diagram below to develop a personal attitude function chart. First, compile a list of attitudes you hold.
2. Next, indicate whether each attitude serves an instrumental, ego-defensive, value-expressive, and/or knowledge function by placing an *I, E, V,* and/or *K* in the function column.
3. Then, enter each attitude in its appropriate position(s).
4. Finally, indicate whether you believe the attitude is productive or unproductive. Give your reasons for your evaluations.

ATTITUDE SURVEY CHART

Part I

Attitude	Function

Part II

	Productive	Unproductive	Why?
Instrumental			
Ego-defensive			
Value-expressive			
Knowledge			

Realize that attitudes may fulfill any or all of the functions we have examined. Thus, a single attitude may serve one function, two functions, three functions, or all four functions simultaneously. Some of the attitudes we hold are productive and help us maintain a sense of worth as we strive to reach our goals. Others, however, are unproductive and perhaps even destructive, presenting us with questionable standards and false self-images. In what kind of shape are your attitudes?

YOUR BELIEFS ARE SHOWING

The term "attitude" is sometimes used interchangeably with the term "belief." However, they are distinguishable. Although you have internalized many attitudes, you have formed an even greater number of beliefs. In fact, you have already developed thousands of them. Let us now examine what beliefs are and how they are measured.

What Are Beliefs? How Are They Measured?

Beliefs and attitudes are related to one another as buildings are related to the bricks that are used to construct them. In many ways, beliefs are the building blocks of attitudes; they form the basis, or foundation, of attitudes. Whereas attitudes are measured on a favorable–unfavorable or good–bad continuum, beliefs are measured on a true–false or probable–unprobable continuum. Thus, if you say that you think something is true, you are really saying you believe it. Beliefs help describe the way you view your environment

Attitudes can be measured on a favorable-unfavorable continuum;
beliefs, on the other hand, can be measured on a true-false continuum.
(© Joyce McKinney 1980/Jeroboam)

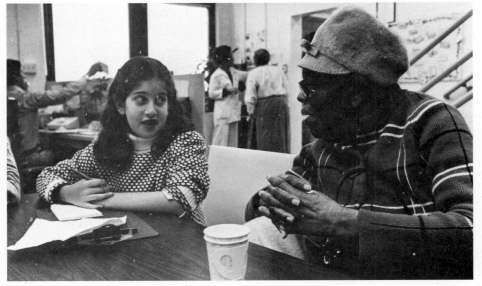

and reality. Now, why do you believe the things you do? Why do you believe what your friends tell you? Why do you believe your doctor? Your mechanic? The newspaper?

We believe things for a variety of reasons. Sometimes we believe information because we read it somewhere, and we have "blind faith" in what we read, never recognizing that the author may be wrong or biased. At other times we believe things because "statistics say it is true." We forget too readily that it is quite possible to mislead with statistics. We even believe things because "an authority says it is so," because "everyone believes it," or simply because "that's the way it really is." It is important for you to realize that your beliefs are not necessarily logical. Rather, they are largely determined by what you want or need to believe, what you are able to believe, and what you have been taught to believe. For these reasons, we do not require positive proof to believe the things we do. Instead, our beliefs influence our interpretation and permit us to distort or manipulate what we see and hear. We simply act in a way that is consistent with what we think is true. Thus, to an extent, what we believe restricts what we perceive.

According to psychologist Milton Rokeach, your belief system is made up of everything with which you agree. It includes all the information and biases you have accumulated since you were born. Forming along with this belief system is your disbelief system. It is composed of all the things you disagree with. Together, the two systems affect the way you process information. To better understand this concept, try this:

SKILL BUILDER

THE BELIEVER AND THE DISBELIEVER

1. Compile ten different responses to this sentence:

 "I believe _____."

2. Next, compile ten different responses to this sentence:

 "I do not believe _____."

3. Attempt to identify how what you believe and what you do not believe influence you by describing how each belief listed above affected what you did or said in a particular situation.

4. Finally, attempt to describe how your behavior would change if you did not believe what you said you believed and believed what you said you did not believe.

Beliefs have the same three dimensions as attitudes: direction, intensity, and salience. When we spoke of the direction of an attitude, we were referring to the location of our attitude on a good–bad continuum. When we speak of the direction of a belief, we are referring to where the belief is located on a true–false continuum. Our beliefs can lie in any of three directions: We can believe something is true; we can believe it is false; or we can decide we don't know whether it is true or false. For example, you can believe you are going to fail a test, your friend can believe you are going to pass a test, and your teacher can be undecided.

Place a *T* next to each of the following statements that you believe are true, an *F* next to those you believe are false, and a *U* next to those of which you are unsure.

1. Hitler is still alive.
2. Abortion is a crime.
3. God exists.
4. The harder you work, the more money you make.
5. Grades are necessary.
6. The sun will rise tomorrow.
7. It is going to rain today.
8. Being prepared for war prevents war.
9. Lee Harvey Oswald killed John F. Kennedy.
10. Democracy is the best form of government.

We can also distinguish beliefs by intensity. The strength or intensity of each of our beliefs runs on a probability scale that ranges from zero to 100 percent. The percentage you select indicates how certain you are that your conclusion is correct.

SKILL BUILDER

INTENSITY INQUEST

Use the scales below to measure how strongly you adhere to each of the beliefs you listed.

1.	0	10	20	30	40	50	60	70	80	90	100
2.	0	10	20	30	40	50	60	70	80	90	100
3.	0	10	20	30	40	50	60	70	80	90	100
4.	0	10	20	30	40	50	60	70	80	90	100
5.	0	10	20	30	40	50	60	70	80	90	100
6.	0	10	20	30	40	50	60	70	80	90	100
7.	0	10	20	30	40	50	60	70	80	90	100
8.	0	10	20	30	40	50	60	70	80	90	100
9.	0	10	20	30	40	50	60	70	80	90	100
10.	0	10	20	30	40	50	60	70	80	90	100

Just as salience of attitude indicates how relevant an attitude is for you, so salience of belief indicates how relevant you perceive that belief to be. Thus, although you may believe that furniture you make yourself is more sturdy than mass-produced furniture, the belief may not be salient because you do not intend to make furniture.

SKILL BUILDER

THE BELIEF CHALLENGE

1. Select a belief you hold strongly—one you would defend if challenged by others.

2. Prepare a two- or three-minute presentation to explain your belief to the entire class or to a segment of it.

3. After listening to your explanation, members of the class or group will be asked to challenge your belief. They might question the nature of your belief, the belief's validity, or even your right to hold the belief. Respond to each challenge as you deem appropriate.

4. After participating in the exercise, answer these probes:

 A. What feelings did you experience as other persons tried to shake a belief you firmly held?

 B. What type of challenge did you find most threatening?

 C. To what extent, if any, was your belief altered as a result of this exercise?

Some of our beliefs are more central or important to us than others. The more central a belief is, the less willing we are to change it.

YOUR VALUES ARE SHOWING

Like attitudes and beliefs, the values we internalize and the values internalized by others influence the nature of the communication interaction we share. Let us examine values to determine how they affect us, our lives, and our relationships.

What Are Values? How Are They Characterized?

Values may be defined as your ideas about what is important in life. Values represent your feelings about the worth of things. To begin understanding the values that guide your life, try this:

SKILL BUILDER

VALUE GRAPH

1. Six different types of people are described in the box below. Read each description and then rank them from 1 to 6. Place the number 6 next to the description that most closely resembles you, the number 5 next to the one that quite closely resembles you, and so forth down to number 1—the description that least fits you.

	A.	You value the pursuit and discovery of truth—the intellectual life.
	B.	You value that which is useful and practical.
	C.	You value form, harmony, and beauty.
	D.	You value love, sympathy, warmth, and sensitivity in relationships with people.
	E.	You value competition, influence, and personal power.
	F.	You value unity, wholeness, a sense of purpose above human beings.

2. Now, look at the graph below.

Take the numbers you entered in the boxes in part one of this exercise and plot them in the appropriate place on the graph. Connect the dots and what you have

is your personal value profile—a visual representation of six dimensions of your personal system of values.

3. Compare and contrast the rankings of males and females in the class. Use the accompanying charts to aid you in answering this phase of the experiment. Simply enter the number of males and females who made each choice in the appropriate column.

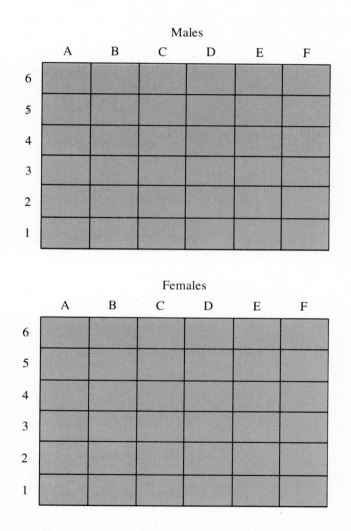

Males

	A	B	C	D	E	F
6						
5						
4						
3						
2						
1						

Females

	A	B	C	D	E	F
6						
5						
4						
3						
2						
1						

To what extent, if any, was there a difference in ranking by sex? Why?

The value graph you have completed is based on the work of Edward Spranger, a German scholar. In his book *Types of Men*, he argues that we each have one predominant value system drawn from the following six major value types:

Theoretical: Values the pursuit and discovery of truth, the "intellectual life"

Economic: Values that which is useful, practical

Aesthetic: Values form, harmony, and beauty

Social: Values love, sympathy, warmth, and sensitivity in relationships with people

Political: Values competition, influence, personal power

Religious: Values unity, wholeness, a sense of purpose above human beings

With which value type do your preferences lie? Why?

Your values provide you with a relatively persistent framework for deciding what you think is right or wrong, what to aim for, and how to live. They provide you with criteria for evaluating persons, ideas, and actions. Your values indicate what you think is desirable, to what extent you find it desirable, and, consequently, what you are willing to strive for. A clearer understanding of the nature of your values can help you better understand why you communicate as you do.

From DIARY OF A YOUNG GIRL
Saturday, 15 July, 1944

Anne Frank

"For in its innermost depths youth is lonelier than old age." I read this saying in some book and I've always remembered it, and found it to be true. Is it true then that grown-ups have a more difficult time here than we do? No. I know it isn't. Older people have formed their opinions about everything, and don't waver before they act. It's twice as hard for us young ones to hold our ground, and maintain our opinions, in a time when all ideals are being shattered and destroyed, when people are showing their worst side, and do not know whether to believe in truth and right and God.

Anyone who claims that the older ones have a more difficult time here certainly doesn't realize to what extent our problems weigh down on us, problems for which we are probably much too young, but which thrust themselves upon us continually, until, after a long time, we think we've found a solution, but the solution doesn't seem able to resist the facts which reduce it to nothing again. That's the difficulty in these times: ideals, dreams, and cherished hopes rise within us, only to meet the horrible truth and be shattered.

It's really a wonder that I haven't dropped all my ideals, because they seem so absurd and impossible to carry out. Yet I keep them, because in spite of everything I still believe that people are really good at heart. I simply can't build up my hopes on a foundation consisting of confusion, misery, and death. I see

the world gradually being turned into a wilderness, I hear the ever approaching thunder, which will destroy us too, I can feel the sufferings of millions and yet, if I look up into the heavens, I think that it will all come right, that this cruelty too will end, and that peace and tranquillity will return again.

In the meantime, I must uphold my ideals, for perhaps the time will come when I shall be able to carry them out.

Yours, Anne

Measure My Values

We could say that your values form the basis for your beliefs and attitudes. Like attitudes and beliefs, your values are multidimensional, and they may be analyzed according to

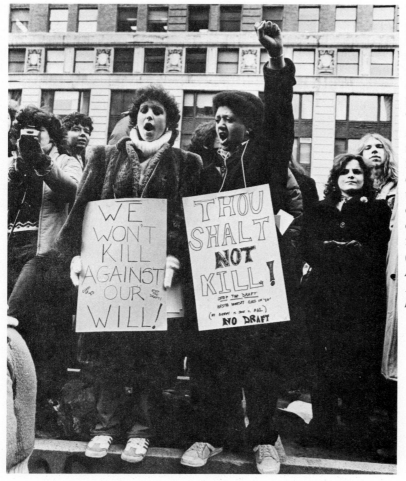

Whether people act on their values reflects the intensity with which they hold them. Those who are only mildly in favor of a cause are unlikely to come out and demonstrate for it. (© *Jim Anderson 1980/Stock, Boston*)

direction, intensity, and salience. The direction of a value, like the direction of an attitude, ranges from good to undecided to bad. But whereas an attitude is focused on a particular thing or situation, a value guides our behavior across situations. You might, for example, have negative attitudes toward both war and capital punishment because in your mind they both cause unnecessary death. These two attitudes are related to the high value you place on human life. Some individuals hold this value more intensely than others: Some will march and join organizations, others will announce their views if asked, and still others will do nothing. The difference in behavior is due to the difference in value intensity. As with attitudes and beliefs, salience is a measure of how relevant a value is to you. You have a value hierarchy. Do you know which are your most salient values? The salience of a value makes itself known when you have to choose between alternative values. In fact, were there no alternatives, there would be no values.

Values may also be classified according to whether they are terminal or instrumental in nature. According to Milton Rokeach, author of *The Nature of Human Values*, our

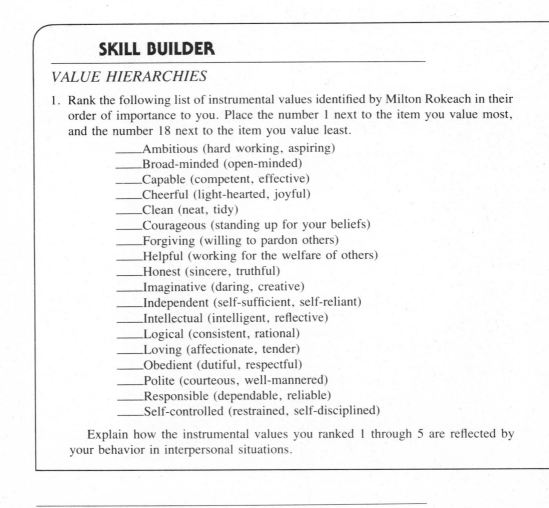

SKILL BUILDER

VALUE HIERARCHIES

1. Rank the following list of instrumental values identified by Milton Rokeach in their order of importance to you. Place the number 1 next to the item you value most, and the number 18 next to the item you value least.

____Ambitious (hard working, aspiring)
____Broad-minded (open-minded)
____Capable (competent, effective)
____Cheerful (light-hearted, joyful)
____Clean (neat, tidy)
____Courageous (standing up for your beliefs)
____Forgiving (willing to pardon others)
____Helpful (working for the welfare of others)
____Honest (sincere, truthful)
____Imaginative (daring, creative)
____Independent (self-sufficient, self-reliant)
____Intellectual (intelligent, reflective)
____Logical (consistent, rational)
____Loving (affectionate, tender)
____Obedient (dutiful, respectful)
____Polite (courteous, well-mannered)
____Responsible (dependable, reliable)
____Self-controlled (restrained, self-disciplined)

Explain how the instrumental values you ranked 1 through 5 are reflected by your behavior in interpersonal situations.

terminal values express ideal states for which we strive during our lifetime: a comfortable life, a world at peace, a world of beauty. We hold relatively few terminal values—perhaps only half a dozen. In contrast, we probably hold several dozen instrumental values. Instrumental values express what we believe to be desirable ways of behaving: being happy, being helpful, being independent. In order to determine your own terminal and instrumental values, try the exercise below.

Your Values and Interpersonal Communication

As we have seen, we seek out interpersonal situations that help us sustain or reinforce our values. We attempt to avoid communicative encounters that threaten or challenge our values. Consequently, we are often attracted to persons who share our values or who hold values similar to the ones we hold.

2. Next, using the numbers 1 through 18, rank the following terminal values identified by Rokeach in order of their importance to you. As before, place the number 1 next to the item you perceive to be most important and the number 18 next to the item you believe to be least important.

 _____A comfortable life (a prosperous life)
 _____An exciting life (a stimulating, active life)
 _____A sense of accomplishment (lasting contributions)
 _____A world at peace (free of war and conflict)
 _____A world of beauty (beauty of nature and the arts)
 _____Equality (brotherhood, equal opportunity)
 _____Family security (taking care of loved ones)
 _____Freedom (independence, free choice)
 _____Happiness (contentedness)
 _____Inner harmony (freedom from inner conflict)
 _____Mature love (sexual and spiritual intimacy)
 _____National security (protection from attack)
 _____Pleasure (an enjoyable, leisurely life)
 _____Salvation (eternal life, exaltation)
 _____Self-respect (self-esteem)
 _____Social recognition (respect, admiration)
 _____True friendship (close companionship)
 _____Wisdom (a mature understanding of life)

Once again, explain how the terminal values you ranked as the top five are reflected in the interpersonal relationships you share.

SKILL BUILDER

VALUE VIEWS

1. Complete each of the following statements.

 A. I feel best when I am with a person or persons who _____

 _____.

 Explain.

 B. I feel worst when I am with a person or persons who _____

 Explain.

2. Next, use "personal coat-of-arms" emblems to compare and contrast your values with the values of someone you enjoy being with and the values of someone you abhor being with.

My Coat-of-Arms

For you:

 A. In area 1, draw a symbol or design to represent something about which you believe you would never budge.

B. In area 2, place a personal motto.

C. In area 3, indicate one thing people do that makes you content.

D. In area 4, describe what you are striving to become.

E. In area 5, describe one thing you hope to accomplish by age seventy.

F. In area 6, list three things you believe would be said about you if you died today.

_____'s Coat-of-Arms
(a person you enjoy being with)

For the person you enjoy being with:

A. In area 1, draw a symbol or design to represent your perception of something about which you believe _____will not budge.

B. In area 2 create a personal motto for _____.

C. In area 3, indicate the one thing people do that makes _____content.

D. In area 4, describe your perception of what _____ is striving to become.

E. In area 5, describe one thing you think _____hopes to accomplish by age seventy.

F. In area 6, list three things you believe would be said about _____if he or she were to die today.

SKILL BUILDER CONTINUED ON THE FOLLOWING PAGE

SKILL BUILDER CONTINUED

_____'s Coat-of-Arms
(a person you abhor being with)

Now design a coat-of-arms for someone you abhor being with, completing the same statements as those on the previous page.

To what extent is your desire to be with the one person or your lack of desire to be with the other due to a congruence or conflict in values? Many of our interpersonal problems with others are value conflicts. In fact, many relationship difficulties can be explained by the fact that the interactants see things and life differently. What one very much likes or wants, the other does not like or want very much or at all. Unfortunately, often we simply have trouble communicating with individuals whose values differ from our own. Yet, can we say whose values are ''best''? This is a difficult, if not impossible, question to answer. Our value preferences are subjective; they help define us and guide us— nothing more. No two individuals will ever have precisely the same set of values. Values, like attitudes and beliefs, are a product of our life experiences; like attitudes and beliefs, they are learned and acquired. Since values, attitudes, and beliefs are learned, they can also be unlearned. Just as we may change when we encounter new experiences, so may our values, attitudes, and beliefs.

PROMOTING ATTITUDE AND BEHAVIORAL CHANGE: BALANCE AND IMBALANCE

Because we are always encountering new experiences (meeting new people, interacting in new situations) we should realize that we may be required to change or adjust our attitudes. We will encounter individuals whose actions conflict with our beliefs. When this occurs, we will try to take steps to reduce or eliminate the conflict. We work hard to maintain internal consistency, or balance, among our actions, feelings, and beliefs.

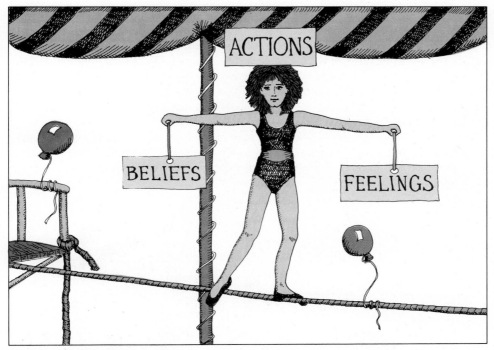

We struggle to balance our feelings, actions, and beliefs.

Balance is a state of psychological health or comfort in which our actions, feelings, and beliefs are related to each other as we would like them to be. When we are in a balanced state, we are content and satisfied. When our actions, feelings, and beliefs are not related to each other in a way we would psychologically want them to be, instead of experiencing satisfaction, we experience discomfort and tension. If given a choice between interacting while feeling relatively secure and free from anxiety or interacting when feeling distraught and tense, most people would prefer the former.

We can illustrate consistency theory by referring to a model of attitude change called Heider's Balance Theory, developed by communication researcher Fritz Heider. In

Heider's model, P refers to one person, O stands for another person, and X represents the topic being discussed or considered.

Imagine yourself as person P. Your relationship with O and X can be symbolized by plus and minus signs. A plus sign signifies a positive feeling or attitude; minus signifies a negative feeling or attitude. According to Heider, we expect people we like to like what we like and we expect people we dislike to dislike what we like. In other words, Heider asserts that you feel comfortable when people toward whom you feel positively hold the same attitudes you do, and when people toward whom you feel negatively hold different attitudes than you do. Thus, whenever the model contains three pluses or one plus and two minuses, the interpersonal relationship will be balanced.

When our relationships are balanced, we exist in a state of equilibrium; people we like think the same way we do. When our relationships are not balanced, however, we exist in a state of disequilibrium. Things do not fit together as we expected they would or as we desired they should. How do we handle this?

"*It would work with us, Francine. We share the same narrow personal interests and concerns.*"

The New Yorker

SKILL BUILDER

YOU BALANCE ME, YOU BALANCE ME NOT

1. The following triangles represent balanced states.

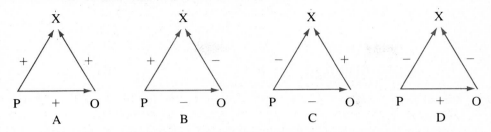

Assume you are person *P*. Describe four different encounters you shared with another person, *O*, when talking about *X*, making each encounter match the relationship depicted in each model. Also describe the tone of each interaction.

A.

B.

C.

D.

2. The following triangles represent imbalanced states.

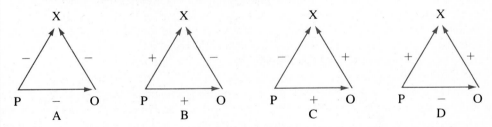

Again, assume you are person *P*. This time describe four encounters you shared with a different person, again *O*, when talking about *X*, matching each encounter to the relationships depicted in each of the models. Also, describe the tone of each interaction and indicate how you attempted to handle the situation.

A.

B.

C.

D.

Balance the See-Saw

When elements in our world do not fit together as we would like, we may try to make them do so. We can do this in a number of ways. Sometimes we simply choose to involve ourselves in situations where we believe our attitudes will be reinforced, and we attempt to avoid dealing with individuals whom we believe will not be reinforcing. This explains in part why we like to communicate with some people but not others.

SKILL BUILDER

WHAT DO I SEEK?
WHAT DO I AVOID?

1. For the next two days keep a record of all messages you deliberately seek out and all messages you deliberately avoid.
2. To what extent does your "diary" reveal a natural kind of "interpersonal censorship"?

At times each of us purposefully avoids interacting with individuals if we fear we will dislike or disapprove of what they will say to us. This is one way we attempt to maintain a state of consistency or balance. At other times, however, we cannot easily avoid situations that threaten our balance. This is especially true if we really like another individual and our relationship with that person is important to us. When a valued relationship is endangered by inconsistencies that discomfort us, we can attempt to restore balance in a number of ways. First, we can change our attitude toward *X* (the object of communication). We can say we have reassessed our stand and decided that our original judgment was in error. Second, we can try to change *O* (the other person) by going out and finding information that supports our point of view in order to convince *O* that his or her assessment is wrong. Third, we can withdraw from considering this issue with *O*. We can simply decide that whether we agree on the issue is not of vital importance to our relationship. By doing this, we have in effect redefined the salience of *X*. Fourth, we can misinterpret *O*'s position, convincing ourselves that *O* does not really mean what he or she said. We would convince ourselves that *O* really agreed with us. In this instance the person who is the liar and the person who is lied to are one and the same. Finally, we can choose to view the imbalance as an asset, telling ourselves that it demonstrates the maturity of the relationship we share with *O*. We could then disagree without feeling excessive discomfort.

It should now be evident that consistency theory operates under the assumption that when a situation is balanced, changes in beliefs or attitudes are not needed. However, when an unbalanced situation surfaces, consistency theory asserts that attitude change might well occur.

SKILL BUILDER

ATTITUDE ALTERATIONS

1. Identify three attitudes you would like various friends to change. Explain how changing these attitudes would help restore balance to the relationship you share.

2. Discuss the various ways that balance could be restored to each of the relationships you described above.

3. Using the continuum provided, indicate your willingness to use the strategies you identified. Which strategy do you favor most? Which are you most opposed to?

STRATEGY ONE:_____

Extremely Unfavorable	Quite Unfavorable	Neutral	Fairly Favorable	Extremely Favorable

STRATEGY TWO:_____

Extremely Unfavorable	Quite Unfavorable	Neutral	Fairly Favorable	Extremely Favorable

STRATEGY THREE:_____

Extremely Unfavorable	Quite Unfavorable	Neutral	Fairly Favorable	Extremely Favorable

STRATEGY FOUR:_____

Extremely Unfavorable	Quite Unfavorable	Neutral	Fairly Favorable	Extremely Favorable

STRATEGY FIVE:_____

Extremely Unfavorable	Quite Unfavorable	Neutral	Fairly Favorable	Extremely Favorable

HOW TO BECOME MORE EFFECTIVE AT INTERPERSONAL PERSUASION

Whenever we try to influence another to change his or her beliefs, attitudes, or behavior or whenever another tries to influence us, we are participating in the persuasive process. We are constantly using persuasive strategies, often without realizing it.

Although it is unlikely that a single persuasive encounter with another individual will alter either of your lives, you should realize that continuing encounters probably would affect attitudes and behavior. An analysis of your experiences with persuasion should help you identify your weaknesses and suggest more effective means for attaining your persuasive goals. Let us now examine a number of the procedures you can use to increase your persuasiveness.

Identify Your Persuasive Goal

To be successful at interpersonal persuasion, you must have a clearly defined purpose in mind. You must be able to answer these questions: What response do I want from the other person? Would I like this person to think differently, act differently, or both? Which of this person's beliefs or attitudes or behaviors am I trying to alter? Why? Unless you know what you want the other person to think, feel, or do, you will not be able to realize your objective.

Know Who You Are Trying to Reach

The nature of your persuasive task is partly related to the extent and type of change you hope to see in an individual. Your task would be simplified if you had some idea of

To succeed at persuasion, you need a clearly defined goal: exactly
what attitude or belief am I trying to alter in another?
(© Rose Skytta/Jeroboam)

whether the other person realized you were trying to change him or her and of how the
other person felt about your proposed change. For example, to what extent does the
individual favor this change? How important is it to him or her to change or not to change?
What is at stake? Realize that the more ego-involved individuals are, the more committed
they are to their current positions, the harder it will be for you to affect them. Thus, your
answers to the preceding questions will tell you how difficult your task will be.

Know What the Person You Are Trying to Persuade Thinks of You

In part, your success as a persuader will be determined by what the target of your efforts
thinks of you—in other words, by your credibility. When we talk about credibility, we
are talking about how a receiver perceives you; we are not talking about what you
"really" are like. If your receiver accepts you as a credible source, if he or she believes
you are a person of good character, knowledgeable and personable, your ideas are more
likely to get a fair hearing. On the other hand, if your receiver believes you are a liar,
incompetent, and unfriendly, he or she is less apt to respond as you desire.

SKILL BUILDER

THE PERSUASIVE TOUCH

1. Identify several people you believe possess high persuasive credibility. Explain your reasons for your choices.

 A.

 B.

 C.

 D.

 E.

2. Identify people you believe possess low persuasive credibility. Explain your reasons for your decisions.

 A.

 B.

 C.

 D.

 E.

3. Identify people you think would find you to be a highly credible source. Explain your reasons for your choices.

 A.

 B.

 C.

 D.

 E.

4. Identify people you think would not find you highly credible. Explain your reasons for your choices.

 A.

 B.

 C.

 D.

 E.

Gain the Attention of Your Receiver

Before you can hope to persuade other persons to believe or behave as you would like them to, you must first get their attention. In his book *The Art of Persuasion*, Wayne Minnick relates how a nine-year-old girl succeeded in getting the undivided attention of a male guest. It seems that during the course of the girl's party, the boys gathered at one area of the room, talking to each other and ignoring the girls. ''But I got one of them to pay attention to me, all right,'' the little girl assured her mother. ''How?'' inquired her mother. ''I knocked him down,'' replied the daughter.

Needless to say, we are not suggesting that you ''knock out'' the individual with whom you hope to relate. We are suggesting that you find a way to encourage that person to want to listen and speak to you. It is your responsibility to put the person in a receptive frame of mind. You can do this in different ways: You can compliment people; you can question them; you can relate what you have to say directly to their interests; or you can surprise them—that is, you can relate to people in a way they would not expect. Once you get your receiver's attention, you must then work to hold it.

Arouse Needs and Issues Relevant to Your Purpose

Human behavior is motivated. If you are to convince your receivers to believe and do what you would like them to do, you must make your interpersonal messages appeal to their needs and goals.

A popular device used to analyze human motivation is Abraham Maslow's *Needs Hierarchy*. Maslow saw motivation as the pyramid below, with our most basic needs at the base and our most sophisticated needs at the apex.

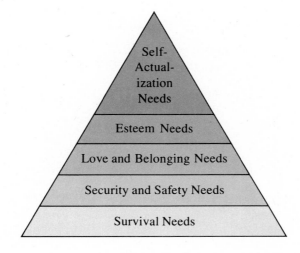

According to Maslow, our survival needs are the basic necessities of life—shelter, food, water, and procreation. Our safety needs include the need for security and the need to know that our survival needs will be satisfied. Under the third level, love and belonging, are our needs for love and for fulfilling interpersonal relationships. It is Maslow's belief that once love and belonging needs are met, our needs for esteem can be addressed. Our esteem needs include the need for self-respect and for others to respect us and what we

SKILL BUILDER

CLIMBING THE MOTIVATION PYRAMID

1. For each of the following situations identify the types of appeals you could use to persuade a friend to believe or behave as you would like. First, fill in a friend's name for each example listed. Second, fill in each level of the pyramid. Third, star the level and appeal you believe would be most effective. Fourth, explain your choices.

 A. You want to convince your friend _____ to stop smoking.

 B. You want to convince your friend _____ to travel cross country with you.

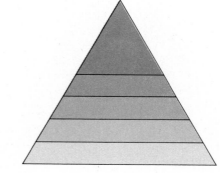

represent. Our efforts to obtain particular goals are often attempts at satisfying our esteem needs because success gains us respect and attention. Finally, at the peak of Maslow's hierarchy is the need for self-actualization. When we satisfy this need, we realize our potential; that is, we become everything we are capable of becoming.

How does Maslow's hierarchy relate to you as an interpersonal communicator? Let's try to find out.

C. You want to convince your friend _____ to change jobs.

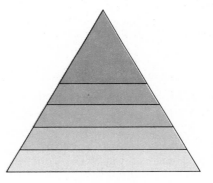

D. You want to convince your friend _____ to join your political group.

2. As you consider the types of appeals that can be used to persuade other persons, you should realize that the Maslow hierarchy applies to most people in most situations. Effective interpersonal communicators are adept at identifying the motivations they can use to achieve their particular goals.

Salient needs make salient motives. Your goal is to make your receiver identify his or her needs with your proposal. To do this, you will probably have to zero in on feelings.

Promise a Reward

Demonstrate how personal needs can be satisfied by your proposal. You should stress how your ideas can personally benefit the person you are trying to persuade. Make that person believe that your proposal will supply a reward. Different people value different types of rewards. To demonstrate your understanding of this concept, try this:

SKILL BUILDER

INTERPERSONAL SALES

1. List the names of three friends below.

 A. B. C.

2. Identify the most important needs of each.

3. Imagine that you are a salesperson trying to convince each individual listed above to purchase one of the following items: a guitar, a plant, a dog, a hat, an attaché case.

4. Describe the strategies you would use to persuade each person to make the purchase. What types of adaptations did you make? To what extent did you display your awareness of their individual differences?

5. List your own most important needs. How might someone use this information to capture your attention and convince you to buy one or more of the items listed above?

It is important to remember that people are usually preoccupied with how something will personally benefit them. They want something in return for behaving as you would like them to behave.

You should now realize that interpersonal persuasion involves more than simply communicating with others. It is also your responsibility to familiarize yourself with the beliefs, attitudes, and values of those you hope to persuade. Only by doing so will you be in a good position to influence others and understand how they try to influence you.

SUMMARY

We have examined how beliefs, values, and attitudes affect our interpersonal interactions. We have seen that beliefs, values, and attitudes are communicated through our behavior, and we have identified ways to measure them and determine the functions they are serving.

In addition, we explored the interpersonal influence process, and we examined ways to bring about desired behavior change. By doing this, we were able to determine how attitudes, beliefs, and values are internalized, maintained, and changed during and through the interpersonal communication process.

SUGGESTIONS FOR FURTHER READING

Cutlip, Scott M., and Allen H. Center. *Effective Public Relations,* 5th ed. Englewood Cliffs, N.J.: Prentice Hall, 1978. A survey of research and theory in the field. Contains a good section on attitude development.

Heider, Fritz. *The Psychology of Interpersonal Relations.* New York: Wiley, 1958. Contains a description of Heider's theory of attitudes and cognitive organization.

Katz, David. ''The Functional Approach to the Study of Attitudes,'' *Public Opinion Quarterly,* Vol. 24 (1960), 163–204. Offers a discussion of the dimensions and functions of attitudes.

McCroskey, James C., Carl E. Larson, and Mark L. Knapp. *An Introduction to Interpersonal Communication.* Englewood Cliffs, N.J.: Prentice Hall, 1971. Contains a good chapter on the influence and persistence of attitudes, beliefs, and values.

Rokeach, Milton. *Beliefs, Attitudes and Values.* San Francisco, Calif.: Jossey-Bass, 1970. Sets attitude and value formation within a scientific and philosophic framework; an in-depth study.

Rokeach, Milton. *The Open and Closed Mind.* New York: Basic Books, 1960. A classic work. Provides complete descriptions of open and closed belief–disbelief systems.

Simon, Sidney B., Leland W. Howe, and Howard Kirschenbaum. *Values Clarification.* New York: Hart Publishing Company, 1978. A practical manual; contains many useful exercises.

Triandes, Harry C. *Attitude and Attitude Change.* New York: Wiley, 1971. Scholarly discussion of attitudes and beliefs.

Zimbardo, Philip G., Ebbe B. Ebbesen, and Christina Maslach. *Influencing Attitudes and Changing Behavior,* 2nd ed. Reading, Mass.: Addison-Wesley, 1977. A good overview of research and theory.

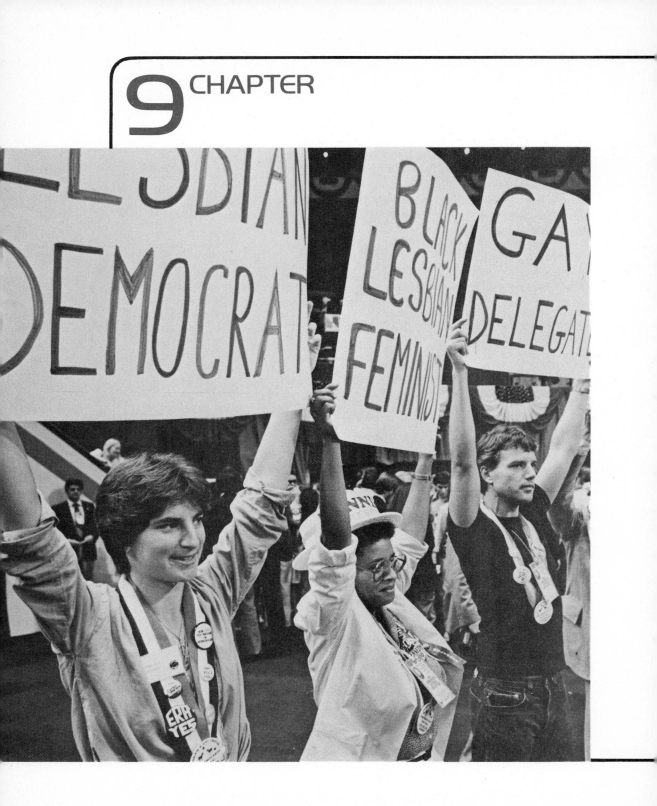

Enter Conflict: Disagreeing Without Being Disagreeable

CHAPTER PREVIEW

After experiencing this chapter, you should be able to:

Define "conflict"

 Distinguish between intrapersonal and interpersonal conflict

Explain how you feel when involved in a conflict

Identify conflict causes

Identify the benefits that can be derived from handling interpersonal conflict effectively

 Provide examples of what can happen if interpersonal conflicts are handled poorly

Distinguish between healthy and unhealthy conflict management styles or strategies

 Demonstrate an ability to use constructive strategies to resolve interpersonal conflicts

Discuss how conflict can be categorized

 Differentiate between low-intensity, medium-intensity, and high-intensity conflicts

 Distinguish between pseudoconflict, content conflict, value conflict, and ego conflict

Explain the difference between a competitive and a cooperative conflict orientation

 Demonstrate an ability to use the technique of role-reversal

 Draw, explain, and use the Blake and Mouton Conflict Grid

Identify behaviors that can be used to help resolve conflicts effectively

Assess the extent to which you are able to manage conflict successfully

I was angry with my friend:
I told my wrath, my wrath did end.
I was angry with my foe:
I told it not, my wrath did grow.

William Blake, "A Poison Tree"

The test of a man or woman's breeding
is how they behave in a quarrel.

George Bernard Shaw

Conflict is an inevitable part of life, and sooner or later touches us all. A conflict can be started by anyone, and a conflict can occur in any place. Forces within us that oppose each other can build conflicts, or we can find ourselves in tension as external forces build and create conflicts. Thus, a conflict can originate within a person, or between two or more people. A conflict exists whenever a person's thought or act limits, prevents, or interferes with other thoughts or acts of that person or another. If you will think about your experiences for this past week, you will probably discover that you were involved in conflict situations: Some involved only you; some involved you and another. Some were mild and subtle; others were intense and hostile. In any case, all were probably interesting.

Our goal in this chapter is to explore what conflict is, how it arises, how it affects us, and how we can handle it productively. In doing so, we will develop skills to help us deal more effectively with intrapersonal tensions and interpersonal turmoils.

HOW DO YOU VIEW CONFLICT?

In order to find out what "conflict" means to you, complete the exercise on the opposite page.

The dictionary defines "conflict" as "disagreement . . . war, battle, collision . . ." Thus, the definition suggests that conflict is a negative force that of necessity leads to undesirable consequences. To what extent does your score support this premise? To what extent do you believe that conflict is undesirable, that it should be avoided at all times and at all costs? Do you believe that conflict is taboo? Why? Unfortunately, many of us have been led to believe that conflict is "evil," one of the prime causes of divorce, disorder, or violence, and that to disagree, argue, or fight with another person will either dissolve whatever relationship exists or prevent one from forming.

Somehow, many people grow up thinking that nice people do not fight, do not "make waves." They believe that if they do not smile and act cheerful people will not like them. Thus, they have learned to feel angry or hurt whenever they do not get along with someone. We contend, however, that when everyone thinks alike, no one thinks very much. In our opinion, conflict in and of itself is neither a positive nor a negative

SKILL BUILDER

CONFLICT: A PERSONAL DEFINITION

1. In the space provided, give your personal definition of the word "conflict" and indicate how you feel when involved in a conflict situation.

 opposition of views

2. Next, use the following scale to measure how you feel about conflict.

 CONFLICT

good	1	2	③	4	5	bad
rewarding	1	②	3	4	5	threatening
normal	①	2	3	4	5	abnormal
constructive	①	2	3	4	5	destructive
necessary	①	2	3	4	5	unnecessary
challenging	①	2	3	4	5	overwhelming
desirable	1	②	3	4	5	undesirable
inevitable	1	②	3	4	5	avoidable
healthy	1	②	3	4	5	unhealthy
clean	1	②	3	4	5	dirty

 A. Add your circled numbers together. If you scored between:

 10–14 You believe conflict is definitely a positive experience.
 15–20 You believe that conflict can be helpful. _17 →_
 21–30 You do not like to think about conflict; you have very ambivalent feelings.
 31–40 You believe conflict is something to try to avoid.
 41–50 You believe conflict is definitely a negative experience.

 B. Determine the average male and female scores in the class. How do they compare? If they are different, what do you believe caused the difference? How does your score compare to the average score for your sex?

 C. Compare the average score for your class. Where do you stand as a group?

3. Finally, complete these sentence starters:

 A. The time I felt worst about dealing with conflict was when
 B. The time I felt best about dealing with conflict was when
 C. I think the most important outcome of conflict is
 D. My greatest difficulty in handling conflict is
 E. My greatest strength in handling conflict is

phenomenon. For this reason, we will not show you how to avoid it. We do believe, however, that how you view conflict and how you handle it determine, in part, the nature of your person-to-person relationships and your satisfaction with them. Conflict can be productive if you meet its challenge, but counterproductive if you deal with it poorly. In other words, whether a conflict is helpful or harmful, destructive or facilitative, depends on how constructively you cope with it.

One of our main objectives in this chapter is to investigate conflict with an eye to discerning how we can learn to handle it better. This makes sense when you consider you have been and will be faced with conflicts all of your life. Consequently, we think that observing our conflicts and giving more thought to them can be a positive learning experience.

We can say that conflict develops for a multitude of reasons and takes a variety of forms. It can arise because of different needs, attitudes, or beliefs. We can say that conflict tests each relationship we share with another individual. It helps measure each relationship's health or effectiveness. If handled well, a conflict can help each party develop a clearer picture of the other party, and it can strengthen and cement relationship bonds. If handled poorly, however, conflict can create schisms, cause psychological scars, fan burning hostilities, and cause lasting resentments. Thus, conflicts have the ability to produce highly constructive and highly destructive relational consequences.

MY PERSONAL CONFLICT INVENTORY

1. For the next week, keep a record of how you handle your interpersonal conflicts. Use the following chart to record your observations.

DAY	THE CONFLICT	HOW IT WAS HANDLED	THE OUTCOMES
	(Who was involved? What was the conflict about?)	(What I did. What the other person did.)	(How I felt. How I think the other person felt.)

2. Use your chart to help you answer these questions:

 A. How often were you involved in conflict situations? Over what issues did you argue?
 B. How many times were you involved in a conflict situation with the same person?
 C. What strategies did you use to handle the conflicts? Do you think they were effective? Why? How did the other person (or people) react to them?
 D. What strategies did the other person use to handle the conflicts? Do you think they were effective? Why?
 E. To what extent do you think the conflicts were resolved satisfactorily? Why?
 F. What did you learn about yourself in this experience? What did you learn about the people with whom you share relationships?

Every relationship that is worth maintaining, every relationship that is worth working at, will experience moments of conflict. In fact, as David Johnson, author of *Reaching Out,* notes, "A conflict-free relationship is a sign that you really have no relationship at all, not that you have a good relationship." To say we should never experience conflict is akin to saying we should have no relationships. If a relationship is healthy, conflict will occur regularly and will be handled effectively.

An article in the June 1976 issue of *Redbook* magazine pointed out that how people express themselves in conflict situations is frequently more important than what they disagree about. *Redbook* asked readers how they were most likely to behave when displeased with their husbands and how their husbands were most likely to behave when displeased with them. Readers were asked whether they were most apt to "say nothing, brood about it, hint they were unhappy, express their feelings, or start an argument." They were also questioned about how they handled themselves when they did argue. Were they most likely to "leave the room, sulk, sit in silence, swear, shout, hit out, cry or break things"?

Survey results indicated that the most happily married wives responded that both they and their husbands were able to reveal when they were displeased with each other, discuss it, and try to resolve the problem in a calm and rational manner. These women also noted that they rarely, if ever, felt compelled to resort to active-aggressive fighting (swearing, shouting, hitting, crying, or breaking things) or to passive-aggressive fighting (leaving the room, sulking, or keeping silent).

Conflict is inevitable in relationships. Depending on how it is handled, it can either strengthen or weaken the bonds between people.
(© Michael Weisbrot & Family)

It appears that avoiding conflicts, trying to settle them prematurely, or prohibiting the discussion of differences can lead to serious relationship problems. At this point, reexamine your personal conflict inventory to determine your style of managing conflict. Do you or your partner use any of the ineffective or pseudo methods of dealing with conflict that we mentioned? Do you feel a need to deny that a conflict exists, to withdraw, surrender, placate, or distract by introducing irrelevancies? Do you intellectualize, blame or find fault, or force another to accept your ideas by physically or emotionally overpowering the other person? Why? What elements of the relationship you share elicit these kinds of responses instead of a rational discussion of the pros and cons of the issues in conflict?

SKILL BUILDER

CONFLICT COMBINATIONS

1. Find a partner.
2. With your partner, role-play two people trying to plan something while adopting these strategies during ensuing rounds:

	Person 1	Person 2
Round 1:	Blame	Blame
Round 2:	Blame	Placate
Round 3:	Placate	Placate
Round 4:	Blame	Withdraw
Round 5:	Intellectualize	Force
Round 6:	Discuss	Blame
Round 7:	Discuss	Placate
Round 8:	Force	Discuss
Round 9:	Distract	Discuss
Round 10:	Discuss	Discuss

3. Which combinations did you find most difficult to handle? Why?
4. Which combinations facilitated the conflict-resolving process? Why?

Of these strategies, only discussion, or leveling, can break interpersonal impasses and solve interpersonal difficulties. Thus, the fate of any conflict is related to the communication strategies employed. Conflict, of necessity, forces an individual to choose, to select from available response patterns. An individual can choose a disruptive or a constructive response. Try using constructive strategies as you participate in this experience on the next page:

We see that relationship problems can develop if we fail to deal with conflict appropriately. We also see that there are interpersonal benefits or values to be derived from handling conflict appropriately. Alan Filley, in the book *Interpersonal Conflict Resolution,* identifies four major values. First, many conflict situations can function to eliminate the probability of more serious conflicts in the future. Second, experiencing conflict can increase our innovativeness by helping us acquire new ways of looking at things, new ways of thinking, and new ways of behaving. Third, conflict can develop our sense of cohesiveness and togetherness by increasing our closeness and trust. Fourth, conflict can provide us with an invaluable opportunity to measure the strength or viability of our relationships.

In effect, if conflict is handled properly, we can learn from it how our past behavior has affected others with whom we share relationships. Only if we discover this can we learn the ways we could change to improve our relationships. Conflict can lead to self-growth and growth of our relationships. Conflict, after all, is a natural result of diversity.

HOW CONFLICT ARISES: THE TUG OF WAR

We have examined what conflict is and how we feel about it. Let us now explore how and why it arises.

We could start by saying that conflict is apt to occur wherever human differences meet. As we have seen, conflict is the clash of opposing beliefs, opinions, values, needs, assumptions, or goals. Conflict can result from honest differences, from misunderstandings, from anger, from expecting too much, or from expecting too little. Conflicts can be handled rationally or irrationally. Also, it does not take two to argue; we can sometimes be in conflict with ourselves. Intrapersonal conflict occurs when we find ourselves having to choose between two or more mutually exclusive options—two cars, two classes, two

potential spouses, two activities. In choosing one we must reject the other. The internal struggle we experience while deciding is intrapersonal conflict. In contrast, interpersonal conflict occurs when the same type of opposition process takes place between two or more individuals. Such encounters can be prompted by differences in perceptions and interests; a scarcity of resources such as money, time, or position; or rivalries where we find ourselves competing with someone else. Those involved in either an intrapersonal or interpersonal conflict situation usually feel pulled in different directions at the same time.

SKILL BUILDER

TIED IN KNOTS

This exercise was suggested by an experience included in *Peoplemaking,* by Virginia Satir.

1. Think of an idea, belief, value, need, or goal that has involved you in a conflict situation. Summarize it in the space provided.

2. Identify the aspects of yourself and of the other individual involved in the conflict situation. Briefly summarize each position.

3. Select class members to play the part of those you perceive yourself to be in conflict with.

4. Cut heavy twine or rope into 10-foot lengths, one for each player. Also cut a number of 3-foot lengths to tie around each individual's waist, including your own. Next, tie your 10-foot rope to the rope around your waist. Then, hand your rope to the person with whom you perceive yourself to be in conflict, who will also hand his or her rope to you.

5. While tied to each other, begin to talk about the issue under conflict.

Having to choose between two mutually exclusive options can create
an internal tug-of-war.

How did it feel? Of course, when engaged in conflict you do not really have ropes tugging
at you, but we are certain you sometimes feel as if you do. Sometimes you are able to
handle the conflict, and the ropes do not get in the way. At other times, however, the
conflict escalates out of your control. Before you know it, you are "tied up in knots"
and unable to extricate yourself. In any case, the exercise probably demonstrated that
those who see themselves as in conflict with each other are interdependent and have the
power to reward or punish each other. Thus, whenever two or more people get together,
conflicts serious enough to damage the relationship may develop.

We can categorize conflict in different ways: First, we can identify the type of goal
or objective about which the conflict revolves. Goals or objectives can be nonshareable—
for example, both parties cannot win a basketball game. They can be shareable—you win
some and the other party wins some. Or they can be fully claimed and possessed by each
party to the conflict—you can both win everything.

Second, conflicts can be categorized according to their level of intensity. In low-
intensity conflicts, the interactants do not want to destroy each other; they devise an
acceptable procedure to help control their communications and permit them to discover
a solution beneficial to both. In medium-intensity conflicts, each party feels committed
to win, and winning is seen as sufficient. Neither feels that the opposition must be
destroyed. In high-intensity conflicts, one individual intends to destroy or seriously hurt
the other individual. In such conflicts, winning is but part of the game; to mean anything,
victory must be total.

THE CONFLICT THERMOMETER

1. Describe and give an example (real or hypothetical) of a low-, medium-, and high-intensity conflict.
2. At which temperature do you prefer to keep your conflict thermometer? Why?

A conflict can also be categorized by classifying it as a pseudoconflict, a content conflict, a value conflict, or an ego conflict. Though not really a conflict, a pseudoconflict gives the appearance of a conflict. It occurs when a person mistakenly believes that two goals cannot be simultaneously achieved. Pseudoconflicts frequently revolve around false either–or judgments (either I win or you win), or simple misunderstandings (failing to realize that you are really in agreement). A pseudoconflict is resolved when the person is shown that no "real" conflict exists. A content conflict occurs when individuals disagree over the accuracy of a fact, the implications of a fact or the inferences based on it, a definition, or solutions to a problem.

CONTENT CONFLICT QUERY

1. Identify a real or hypothetical conflict over:

 A. The accuracy of a fact
 B. Inferences based on a fact
 C. A definition
 D. Solutions to a problem

2. Indicate how each conflict could be resolved:

 A.

 B.

 C.

 D.

If you noted that facts could be verified, inferences could be tested, definitions could be checked, and solutions could be evaluated by measuring them against criteria, you realize that content conflict can be settled rationally.

In contrast to pseudoconflict or content conflict, a value conflict arises when people

with different views focus on a particular issue, such as welfare. A person who values individual independence and self-assertiveness will have very different opinions about the welfare system than a person who believes that we are responsible for the well-being of others. The realistic outcome of such an encounter is that the parties to the conflict will disagree without becoming disagreeable—that is, they will agree that it is acceptable to disagree.

SKILL BUILDER

DOOMSDAY DIARY

1. Divide into pairs.

2. You and your partner are the owners of the only "failsafe" fallout shelter in your town. Suddenly World War III breaks out and a nuclear holocaust begins. Cities around the world are being devastated. People are clamoring to get into available fallout shelters. Your shelter contains only enough room, food, and supplies for you, your partner, and five others. Ten people are competing for these spaces. Because fallout is spreading quickly, time is of the essence. You must decide which persons may enter your shelter on the basis of superficial descriptions. You have only thirty minutes to make your decision. Here is what you know about the ten people:

 A tax collector, thirty-three years old
 His pregnant wife, twenty-nine years old
 A female college student, physical education major
 A law enforcement officer with a gun
 A judge, fifty-seven years old
 A rabbi, forty-six years old
 A physician known to be a racist
 A homosexual biochemist
 An eighteen-year-old female, genius IQ
 A twenty-four-year-old male rock star

3. What did your five choices say to you about your values? To what extent did you think your answers were right and your partner's wrong? Did you at any time believe that your ability to persuade your partner to see things your way was a reflection of your "self-worth"? Why?

In contrast to pseudoconflicts, content conflicts, and value conflicts, ego conflicts have the greatest potential to destroy a relationship. Ego conflict occurs when the parties to a conflict believe that "winning" or "losing" the conflict is a reflection of their own self-worth, prestige, or competence. When this happens, the issue itself is no longer central to the conflict; rather, the person perceives himself or herself to be on the line. This development makes it almost impossible to deal with the situation rationally.

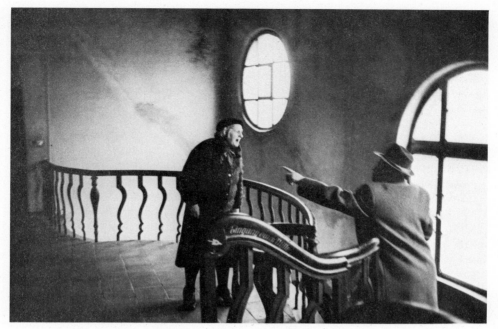

An ego conflict—one in which the parties believe that "winning"
or "losing" is crucial to their self-worth, prestige, or competence—is
almost impossible to resolve rationally.
(© *Leonard Freed/Magnum*)

At this point you should understand that conflict can develop for a number of reasons. We are all aware of the types of disagreements and problems that can arise during intrapersonal and interpersonal encounters. We should also realize that particular conflict-generating behaviors affect each of us differently. We see this in the following excerpt from Neil Simon's *The Odd Couple*.

THE ODD COUPLE

Neil Simon

(*FELIX comes out of the kitchen carrying a tray with steaming dish of spaghetti. As he crosses behind OSCAR to the table, he smells it "deliciously" and passes it close to OSCAR to make sure OSCAR smells the fantastic dish he's missing. As FELIX sits and begins to eat, OSCAR takes can* of aerosol spray from the bar, and circling the table sprays all about FELIX, puts can down next to him and goes back to his newspaper.*)
FELIX. (*Pushing spaghetti away.*) All right, how much longer is this gonna go on?
OSCAR. (*Reading his paper.*)

Are you talking to me?

FELIX. That's right, I'm talking to you.

OSCAR. What do you want to know?

FELIX. I want to know if you're going to spend the rest of your life not talking to me. Because if you are, I'm going to buy a radio. (*No reply.*) Well? (*No reply.*) I see. You're not going to talk to me. (*No reply.*) All right. Two can play at this game. (*Pause.*) If you're not going to talk to me, I'm not going to talk to you. (*No reply.*) I can act childlish too, you know. (*No reply.*) I can go on without talking just as long as you can.

OSCAR. Then why the hell don't you shut up?

FELIX. Are you talking to me?

OSCAR. You had your chance to talk last night. I begged you to come upstairs with me. From now on I never want to hear a word from that shampooed head as long as you live. That's a warning, Felix.

FELIX. (*Stares at him.*) I stand warned. . . . Over and out!

OSCAR. (*Gets up taking key out of his pocket and slams it on the table.*) There's a key to the back door. If you stick to the hallway and your room, you won't get hurt. (*Sits back down on couch.*)

FELIX. I don't think I gather the entire meaning of that remark.

OSCAR. Then I'll explain it to you. Stay out of my way.

FELIX. (*Picks up key and moves to couch.*) I think you're serious. I think you're really serious. . . . Are you serious?

OSCAR. This is my apartment. Everything in my apartment is mine. The only thing here that's yours is you. Just stay in your room and speak softly.

FELIX. Yeah, you're serious. . . . Well, let me remind you that I pay half the rent and I'll go into any room I want. (*He gets up angrily and starts toward hallway.*)

OSCAR. Where are you going?

FELIX. I'm going to walk around your bedroom.

OSCAR. (*Slams down newspaper.*) You stay out of there.

FELIX. (*Steaming.*) Don't tell me where to go. I pay a hundred and twenty dollars a month.

OSCAR. That was off-season. Starting tomorrow the rates are twelve dollars a day.

FELIX. All right. (*He takes some bills out of his pocket and slams them down on table.*) There you are. I'm paid up for today. Now I'm going to walk in your bedroom. (*He starts to storm off.*)

OSCAR. Stay out of there! Stay out of my room! (*He chases after him. FELIX dodges around the table as OSCAR blocks the hallway.*)

FELIX. (*Backing away, keeping table between them.*) Watch yourself! Just watch yourself, Oscar!

OSCAR. (*With a pointing finger.*) I'm warning you. You want to live here, I don't want to see you, I don't want to hear you and I don't want to smell your cooking. Now get this spaghetti off my poker table.

FELIX. Ha! Haha!

OSCAR. What the hell's so funny?

FELIX. It's not spaghetti. It's linguini! (*OSCAR picks up the plate of linguini, crosses to the doorway, and hurls it into the kitchen.*)

OSCAR. Now it's garbage! (*Paces above the couch.*)

FELIX. (*Looks at OSCAR unbeliev-*

ingly.) What an insane thing to do You are crazy! . . . I'm a neurotic nut but *you are crazy!*

OSCAR. I'm crazy, heh? That's really funny coming from a fruitcake like you.

FELIX. (*Goes to kitchen door and looks in at the mess. Turns back to OSCAR.*) I'm not cleaning that up.

OSCAR. Is that a promise?

FELIX. Did you hear what I said? I'm not cleaning it up. It's your mess. (*Looking into kitchen again.*) Look at it. Hanging all over the walls.

OSCAR. (*Crosses up on landing and looks at kitchen door.*) I like it. (*Closes door and paces Right.*)

FELIX. (*Fumes.*) You'd just let it lie there, wouldn't you? Until it turns hard and brown and . . . yich. . . . It's disgusting. . . . I'm cleaning it up. (*He goes into the kitchen. OSCAR chases after him. There is the sound of a struggle and falling pots.*)

OSCAR. (*Off.*) Leave it alone! . . . You touch one strand of that linguini—and I'm gonna punch you right in your sinuses.

FELIX. (*Dashes out of kitchen with OSCAR in pursuit. Stops and tries to calm OSCAR down.*) Oscar . . . I'd like you to take a couple of pheno-barbital.

OSCAR. (*Points.*) Go to your room! . . . Did you hear what I said? Go *to your room!*

The Odd Couple, 1966

Felix and Oscar function as almost a prototype of roommate relationships. Through them, the human contrasts that precipitate interpersonal conflict are exposed. Are you a Felix or an Oscar? Both? Neither?

Some of us perceive ourselves to be involved in a conflict if we are deprived of a need; others do not. Some of us perceive ourselves as involved in a conflict if someone impinges on our territory or disagrees with us regarding the way we define a particular role; others do not. Take some time to discover your own personal sources of conflict before proceeding.

SKILL BUILDER

WHAT SETS ME OFF

1. Compile a list of conflict-generating behaviors.

2. Rank order your list from most disturbing to least disturbing.

3. Next time you find yourself in conflict with another person, try to observe and listen to the nonverbal and verbal cues sent and received. Then ask yourself:

 A. What did we disagree about?

 B. Why did we disagree? How did we relate to each other during the conflict? How did we affect the atmosphere in which the conflict was being waged?

 C. Create a simile to represent your behavior and a simile to represent your partner's behavior. For instance, you may have come across ''like a locomotive'' while your partner came across ''like a wilting daisy.''

Compiling this list and making these observations will help you understand the types of issues that draw you into a conflict with yourself or others. It will also let you see the types of things you and others tend to disagree about and how you tend to respond when faced with a conflict situation. Let us now examine constructive and destructive ways of handling conflict in more detail.

COMBATING THE WIN–LOSE SYNDROME: CONSTRUCTIVE VERSUS DESTRUCTIVE CONFLICT

A lion used to prowl about a field where four oxen dwelled. Many a time he tried to attack them, but whenever he came near, they turned their tails to one another, so that whichever way he approached them, he was met by the horns of one of them. At last, however, they fell a-quarreling among themselves, and each went off to the pasture alone in a separate corner of the field. Then the lion attacked them one-by-one and soon made an end to all four.

Aesop's Fables, 600 B.C.

Why did this happen? Let's try to find out.

SKILL BUILDER

BROWN PAPER

1. Divide into groups of three to five individuals.
2. Distribute a 3-foot by 5-foot length of brown wrapping paper to each group.
3. At a given signal, each individual will take hold of a section of the brown wrapping paper.
4. Upon receiving a second signal, group members will pull the brown paper toward themselves and away from their group members. Each member's personal goal is to get as much brown paper as he or she can.

What happened? The paper was probably ripped to shreds. Like the oxen, instead of cooperating, you pulled in separate directions. Unlike oxen, however, you can learn to handle your conflicts constructively, and you can learn to disagree without becoming disagreeable. To do this, you must view conflict as a mutual, noncompetitive endeavor. Unfortunately, sometimes this is easier said than done. In many conflict situations, we are too quick to view our own position as correct or true, while we condemn and misperceive the other person's position.

SKILL BUILDER

WHAT DO YOU SEE?

1. Look at the picture below.

2. In the space provided, describe what you see. Include such items as sex, clothing, and age of the person depicted.

3. Pair yourself up with a person whose description differed from yours. Together, answer the questions listed below and then formulate a "new" description of the person in the picture. Each question should have one and only one answer.

 A. What sex is the person in the picture?
 B. What type of clothing is the person wearing?
 C. How is the person's hair styled?
 D. How old is the person?

4. What types of problems did you experience while attempting to create a "common" description?

If you were firmly convinced that your perception was right and your partner's was wrong, you had an oversimplified view of the conflict that existed between you, which made it difficult to find a constructive way to settle your differences. Yet, once we see something one way, it is very difficult for us to see it another way. Our frame of reference and our previous experience with the person/object/item/idea under discussion play an active role in the way we respond to a conflict that involves it. Selective perception affects how we view our own beliefs and behaviors as well as how we view the beliefs and behaviors of our partner.

Somehow we find it difficult to open our eyes to concrete evidence that contradicts our way of thinking. Instead, we have a tendency to evaluate opposing statements as "stupid," reiterate that we are "right," and attempt to manipulate the other person until he or she sees things our way. Such behavior only serves to increase the other person's defensiveness, cementing his or her position and possibly terminating communication between us.

From COMPETING

Harvey L. Rubin, M.D.

Everybody likes to win.

There is something about coming in first, about achieving a victory over a rival, which seems to fulfill a deep need of the human psyche. Accomplishments of many different kinds give human beings satisfaction, but the ones which are most cherished are often those which are carried through in the face of competitive resistance from others.

The medal we honor most is not the one given for a job well done, but the one given for a job done better than some other job. The immense popularity of competitive sports, the attraction of political contests, and the pervasiveness of social "gamesmanship" . . . all bear witness to the importance of competition as a means of enhancing position, pride, and prestige.

Competition can function in many different ways, at times acting as a kind of social glue, at other times severing the most intimate of bonds. It can be blatant or subtle, aggressive or ingratiating, conscious or unconscious. The ways in which we strive to win are almost as varied as human personalities themselves.

Yet we all do strive to win, in one way or another, and that is of central importance. In almost every culture and at every stage of individual development, people seem to have an urge to achieve victory over others. So omnipresent is this condition that we might be justified in relabeling *homo sapiens*; perhaps *homo contendens* would be a better name for us all.

Competing, 1980

Besides prompting us to defend our own position and condemn someone else's, conflicts can also cause us to compete when we should cooperate. In fact, when a conflict first develops, one of the key variables affecting the outcome is the cooperative or

competitive nature of the participants' attitudes. (Will one person achieve victory while the other's position is destroyed? Will they argue to a draw? Or will they share the goal?) If both individuals bring a competitive orientation to the conflict, then each will tend to be ego-involved and view winning the conflict as a test of personal worth and competence. In contrast, if both individuals bring a cooperative orientation to the conflict, then each will tend to look for a mutually beneficial way to resolve the disagreement. The next exercise explores how situations become defined as cooperative or competitive.

SKILL BUILDER

THE GOLD RUSH

1. Divide the class into groups of six to eight persons. Designate one person as group auctioneer. The auctioneer is given an unlimited supply of gold bars (represented by rectangular pieces of yellow posterboard) to auction off to group members.

2. The group members sit in a row. The auctioneer puts a gold bar up for sale, and each of the persons in the group offers a bid in turn. Bidding is done in pennies, and each group member has a "bank" of one hundred pennies. The gold bar is considered sold when all group members but one have passed on it in turn.

3. Whenever a new gold bar is placed on the auction block, the first chance to bid is passed down the line of group members. Keep a record of how much each member ends up paying for each gold block. At the end of play, those who have purchased the most gold bars are the winners. Note: A group can contain no winners, one winner, two winners . . . or all winners. Members may meet to discuss their strategy after each round of play—that is, after each member has had a turn to bid or pass.

4. Once ten complete rounds have been played or twenty minutes have elapsed, the group should discuss what has just occurred. Members should attempt to answer these questions:

 A. Who behaved cooperatively? How do you know?
 B. Who behaved competitively? How do you know?
 C. What factors affected the way your group defined the situation?

Your group defined the situation as competitive if at any time you bid against each other or raised the bidding level. You defined it as cooperative if you permitted each volunteer to buy an equal number of gold blocks at the minimum price of one cent each.

If a conflict is to be defined as cooperative in nature, each party to it must demonstrate a willingness to resolve it in a mutually satisfactory way. In other words, each party must avoid behaving in a way that could make someone else defensive or combative, which would escalate the conflict. On the other hand, if each party to a conflict is treated with respect by all the others, if he or she is neither demeaned nor provoked, and if com-

munication is free and open instead of underhanded and closed, the conflict may be settled amicably.

Unfortunately, competing with or defeating another person with whom we are interacting is a characteristic of interpersonal encounters in our society. The phrases we use reflect this orientation: We speak of ''outsmarting'' one person and putting another ''in his or her place,'' of getting ourselves ''one up'' and someone else ''one down.'' We can define a conflict as a win–lose situation, or we can define it as a win–win situation. If we define it as win–lose, we will tend to pursue our own goals, misrepresent our needs, attempt to avoid empathizing with or understanding the feelings of others, and use threats or promises to get others to go along with us. If we define it as win–win, we will tend to view the conflict as a mutual problem, try to pursue common goals, honestly reveal our needs to others, work to understand the position and frame of reference of others, and make every attempt to avoid using threats so that we reduce defensiveness levels rather than increase them. In general, we can say that individuals come to a conflict situation with one of two orientations or perspectives: competition or cooperation. A person who has a competitive set perceives a conflict situation in win–lose terms and believes that, to attain victory, he or she must defeat the other party. A person who has a cooperative set believes that a way to share the rewards of the situation can be discovered. We believe conflicts do not require winners and losers. We believe conflicts can be turned into win–win or no-lose encounters. To accomplish this, you must use effective communication techniques. One of our goals is to help you discover workable strategies and give you an opportunity to practice them until you can use them on your own. You should aim to become a conflict processor, and develop the ability to view a conflict situation through the other party's eyes.

SKILL BUILDER

CONFLICT CORNER: CAN YOU SEE IT MY WAY?

1. Recall a time when you observed a conflict between two other parties, one of whom was your friend. Or watch two other parties (one of whom is your friend) attempt to settle a personal conflict. Be prepared to discuss your answers to these questions:

 A. What was the conflict about?
 B. How did the parties attempt to resolve it?
 C. Were they successful? Why or why not?
 D. Which person did you side with? Why?
 E. Recall our discussion of selective perception in a previous chapter. To what extent did selective perception affect your view of the conflict situation?

2. Rewrite a fairy tale from the point of view of one of the characters in it. For example, you might tell ''Little Red Riding Hood'' as the wolf would tell it. Consider these questions:

```
        I remember well my sensation as we first entered
     the house. I knew instantly that something was
     very wrong. I realized that my father's chair had
     been sat in, as well as my mother's and my own.
     The porridge we had left on the table to cool had
     been partially eaten. None of this, however, pre-
     pared me for what we were about to discover up-
     stairs. . . .
```
The New Yorker

 A. How did things look to the character?

 B. How did the change in frame of reference affect the story?

3. Finally, select a current topic of interest that is controversial—for example, abortion, the draft, capital punishment, nuclear energy. You will be assigned to defend or oppose the issue under consideration. Defenders and opposers will have a chance to meet separately in order to prepare their cases. Each defender (*A*) will be paired with an opposer (*B*). Person *A* will have five minutes to present the defense's position of the controversy to person *B*. Person *B* then has five minutes to present the opposition's perceptions to person *A*. Players then switch roles, and *B* presents *A*'s case and *A* presents *B*'s case.

 A. To what extent did reversing roles permit you to understand and appreciate another point of view?

 B. How could utilizing such a procedure help turn an individual with a win–lose orientation into one with a win–win orientation?

The role-reversal technique can help parties to a conflict understand each other, find creative ways to integrate their interests and concerns, and work toward a common goal. Reversing roles helps you avoid judging the other party by helping you see things from his or her perspective. Once you are able to replace statements like ''You're wrong,'' or ''You're stupid,'' with a statement like ''What you believe is not what I believe,'' you are on your way to developing a cooperative orientation.

A number of different paradigms representing the ways in which we try to resolve conflicts have been proposed. Among these are Blake and Mouton's Conflict Grid (below). The grid has two scales. The horizontal scale represents the extent to which an individual wishes to realize his or her personal goals. The vertical scale represents the extent to

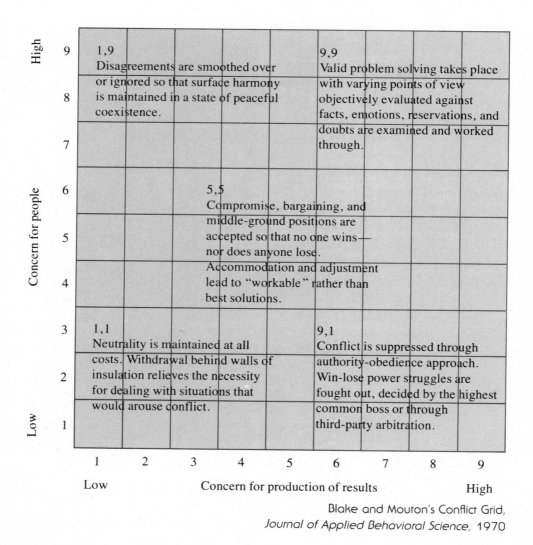

Blake and Mouton's Conflict Grid,
Journal of Applied Behavioral Science, 1970

which an individual is concerned for people. The interface between the measures indicates how strongly an individual feels about these concerns—that is, how concern is apportioned.

As we can see, concern for production of results is scaled from 1 (low concern) to 9 (high concern), representing the increasing degree of importance in the mind of the individual. Likewise, concern for people is scaled from 1 (low concern) to 9 (high concern). Given this scaling, Blake and Mouton are able to identify five main conflict styles. As you explore the grid, try to identify where your style would fall. If you are a 1,1 style, your goal is to maintain neutrality at all costs. As a 1,1 (lose and walk away; an avoider) person, you probably view conflict as a useless and punishing experience, one that you would preferably do without. Thus, rather than tolerate the frustrations that sometimes accompany conflict, you simply, physically or mentally, remove yourself from the conflict situation.

If you are a 1,9 (give in and lose; an accommodator) person, your behavior demonstrates that you overvalue the maintenance of relationships and undervalue the achievement of your own goals. Your main concern is to insure that others accept you, like you, and "coexist in peace" with you. You are afraid to make others angry and you will do anything not to be perceived as a troublemaker. While conflicts may exist in your world,

Determined to dominate and destroy the McCoy family, the feuding Hatfields had a win-lose approach to conflict.
(© *Culver Pictures*)

you refuse to deal with them. You feel a need to maintain the appearance of harmony at all costs. This discrepancy leads to the creation of an uneasy, tension-filled state characterized by a great deal of smiling and nervous laughter.

If you are a 5,5 (middle ground; a compromiser) your guiding principle is compromise. Thus, you work to find a way to permit each party to the conflict to gain something. While compromise is a valid strategy to use in some cases, it can become a problem if you always try to find workable solutions because you are afraid that the conflict may escalate if you try to find the best solution. Although you adhere to the maxim that half a loaf is better than none, such an approach, besides leaving participants half-satisfied, can also be said to leave them half-dissatisfied. Thus it is sometimes referred to as the lose–lose method.

If you use a 9,1 (win–lose, compete; a forcer) style, attaining your own personal goals is far more important to you than concern for people. You have an overwhelming need to win and dominate others, and you defend your position and battle others whatever the cost or harm to them. In contrast, if you are a 9,9 (win–win; a problem solver–collaborator), you actively seek to satisfy your own goals (result-oriented) as well as the goals of others (person-oriented). This, of course, is the optimum style to use when seeking to reduce

SKILL BUILDER

TRUE GRID

1. Answer the following questions, then use the Blake and Mouton grid and three different colored pencils to graph the conflict style you employed when involved in each of three conflict situations.

2. Questions about conflict 1:

 A. Whom were you in conflict with?
 B. What was the conflict about?
 C. How concerned were you with "results," with getting what you wanted?
 Low 1 2 3 4 5 6 7 8 9 High
 D. How concerned were you for "people," for maintaining the relationship?
 Low 1 2 3 4 5 6 7 8 9 High
 E. Enter the results on the grid.
 F. To what extent were you satisfied with the outcomes? To what extent was the other party satisfied?

3. Questions about conflict 2:

 A. Whom were you in conflict with?
 B. What was the conflict about?
 C. How concerned were you for "results," that is, for getting what you wanted?
 Low 1 2 3 4 5 6 7 8 9 High

conflict. As a problem solver, you know that conflicts are normal and can be helpful; you realize that each party to a conflict holds legitimate opinions that deserve to be aired and considered. You are able to discuss differences without issuing personally insulting statements or making personal attacks. According to Alan C. Filley, effective conflict resolvers rely to a large extent on problem solving (9,9) and smoothing (1,9); ineffective conflict resolvers rely extensively on forcing (9,1) and withdrawal (1,1). Which strategies do you use?

If we are to develop and sustain meaningful relationships, we must learn to handle conflicts constructively. According to Morton Deutsch, a conflict has had a productive outcome if all parties to it are satisfied with the outcomes and believe they have gained as a result of the conflict. In other words, no one loses, everyone wins. In contrast, a conflict has had a destructive outcome if all parties to it are dissatisfied with the outcomes and believe they have lost as a result of the conflict. Perhaps one of the most important questions facing each of us today is whether we can turn our conflicts into productive rather than destructive interactions.

When individuals or groups fail to achieve cherished goals, they may feel a need to strike out. Consider this poem by Langston Hughes on the next page:

 D. How concerned were you for "people," that is, for maintaining the relationship?
 Low 1 2 3 4 5 6 7 8 9 High
 E. Enter the results on your grid.
 F. To what extent were you satisfied with the outcomes? To what extent was the other party satisfied?

4. Questions about conflict 3:

 A. Whom were you in conflict with?
 B. What was the conflict about?
 C. How concerned were you for "results," that is, for getting what you wanted?
 Low 1 2 3 4 5 6 7 8 9 High
 D. How concerned were you for "people," that is, for maintaining the relationship?
 Low 1 2 3 4 5 6 7 8 9 High
 E. Enter the results on the grid.
 F. To what extent were you satisfied with the outcomes? To what extent was the other party satisfied?

5. To what extent did the conflict style you employed differ from situation to situation? Why?

DREAM DEFERRED

Langston Hughes

What happens to a dream deferred?
 Does it dry up
 like a raisin in the sun?
 Or fester like a sore—
 And then run?
 Does it stink like rotten meat?
 Or crust and sugar over—
 like a syrupy sweet?

 Maybe it just sags
 like a heavy load.

 Or does it explode?

We will be most likely to succeed in creating constructive rather than destructive interactions if our conflicts are characterized by cooperative problem-solving methods, attempts at mutual understanding, accurate and complete communication, and a demonstrated willingness by each party to trust the other. We will be most likely to fail, however, if our conflicts become win–lose encounters characterized by misconceptions and misperceptions; inaccurate, sketchy, and disruptive communication; and a demonstrated hesitancy by each party to trust the other. It is apparent that in a conflict situation, the best way to insure a constructive resolution is to find a cooperative solution to the conflict.

HOW TO MANAGE CONFLICT SUCCESSFULLY: SKILLS AND STRATEGIES

Conflict can be resolved productively by applying principles of effective communication. When you use effective communication techniques, you reduce the likelihood that your comments will escalate the conflict by causing angry, defensive, or belligerent reactions in others. Learning to handle conflict successfully is an easily obtainable goal that can lead to increased self-confidence, improved relationships, and a greater ability to handle stressful situations. All that is required is a commitment to practice and apply the necessary skills. Anyone who is willing can learn creative and effective ways of managing conflict— ways that increase the likelihood of future harmony and cooperation. Let us examine the behaviors that can turn our conflict situations into problem-solving situations. The following suggestions can function as a basic guide to conflict resolution.

Recognize That Conflicts Can Be Settled Rationally

A conflict stands a better chance of being settled rationally if you do not:

Pretend it does not exist (act like an ostrich)

Withdraw from discussing it (act like a turtle)

Surrender to the individual with whom you are in conflict (act like a sheep)

Try to create distractions so that the conflict will not be dealt with (act like a cuckoo)

Overintellectualize or rationalize about the conflict (act like an owl)

Blame or find fault with the other party to the conflict (act like a screeching parrot)

Attempt to force the other party to accept your views (act like a gorilla)

Conflicts can be settled rationally if you act like a capable, competent problem solver.

SKILL BUILDER

*TO BE RATIONAL OR IRRATIONAL:
THAT IS THE QUESTION*

1. Identify two interpersonal conflict situations that you attempted to settle through nonrational and/or rational means. Use the questions and graphs below to help you identify the behaviors you and the other parties to the conflicts employed. For example, did any of you begin the interaction by acting like a screeching parrot or an overly intellectual owl? Did you switch strategies during the interaction? Why? What was your behavior like at the conclusion of the interaction?

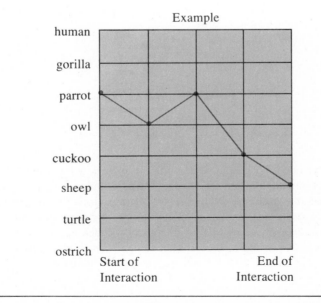

SKILL BUILDER CONTINUED ON THE FOLLOWING PAGE

SKILL BUILDER CONTINUED

CONFLICT INTERACTION: 1

Issue in Conflict: _____.

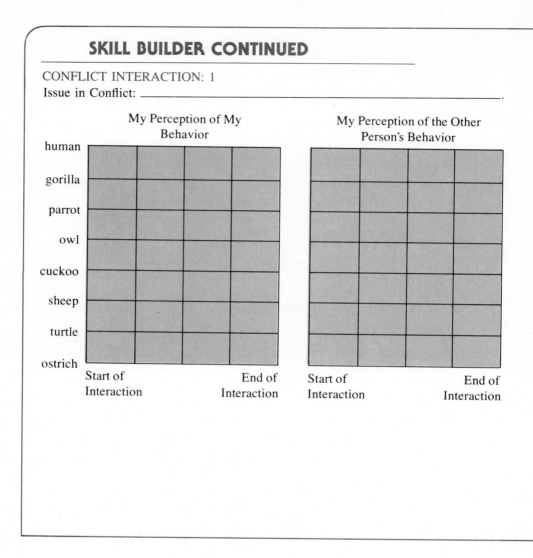

My Perception of My Behavior

My Perception of the Other Person's Behavior

human
gorilla
parrot
owl
cuckoo
sheep
turtle
ostrich

Start of Interaction End of Interaction Start of Interaction End of Interaction

Recognizing the unproductive behaviors identified above is a first step in learning to handle your conflict situations more effectively. Being willing to express your feelings openly, directly, and constructively without resorting to irrational techniques that destroy mutual trust and respect is a prerequisite to becoming a productive conflict manager. Thus, instead of insulting, physically or psychologically attacking, or withdrawing from a conflict, you should be willing to describe the action, behavior, or situation you find upsetting, and you should do this without negatively evaluating the other person or prompting him or her to become defensive. This means that you would be wise to focus on the issues, not the personalities. It also means you should be willing to listen to and react to what the other person is saying. Communication channels must be kept open.

CONFLICT INTERACTION: 2
Issue in Conflict: _____.

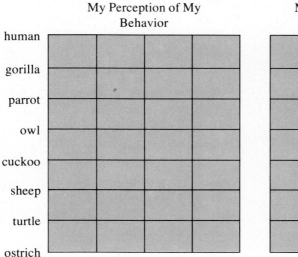

| | My Perception of My Behavior | My Perception of the Other Person's Behavior |

human

gorilla

parrot

owl

cuckoo

sheep

turtle

ostrich

If possible ask the other individuals involved in the conflict to fill out similar graphs. Then compare and contrast your perceptions.

2. For each situation, answer the following questions:

 A. Which ineffective behaviors did you find yourself using during the course of the interaction?
 B. What consequences did these behaviors have on your relationship?
 C. What factors or occurrences do you believe kept you from functioning in a human-to-human manner?

Define the Conflict

Once you recognize that a conflict situation can be handled rationally, you are ready to ask: Why are we in conflict? What is the nature of our conflict? Which of us feels more strongly about the issue? What can we do about it? Here again, it is crucial to send "I messages" ("I think it is unfair for me to do all the work around here." "I don't like going out when I'm tired.") and to avoid sending blame messages to the other person ("You do everything wrong." "You are a spoiled brat." "You will kill me yet."). Be very clear that you would like to join with the other person to discover a solution that will be acceptable to and beneficial for both of you—a solution where neither of you will lose, but both will win.

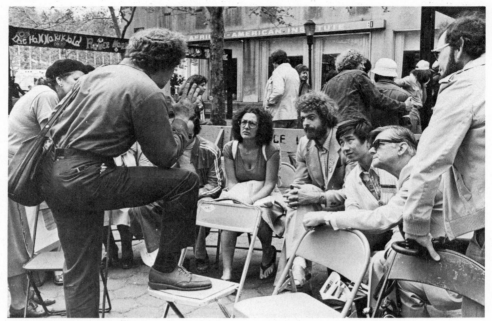

Conflicts about political issues can be constructive and rewarding if they are dealt with rationally, without name calling, coercion, or violence.
(© *Christina Thomson 1978/Woodfin Camp & Assoc.*)

Check Your Perceptions

A conflict is a conflict when it is perceived to be one. Conflict-ripe situations, however, frequently give rise to perceptual distortions of the other party's behavior, position, or motivations. We prefer to attribute one set of motivations rather than another to an individual because it meets our own need to see the situation a certain way. When we do this, we deny the legitimacy of the other person's position. Thus, it is not uncommon for each party to believe, mistakenly, the other is committing underhanded and vicious acts; not out of the ordinary for each party to make certain erroneous assumptions regarding the other's feelings; not unusual for individuals to think they disagree with each other simply because they have been unable to communicate their agreement. For these reasons, it is important that each party take some time to explain his or her assumptions and frames of reference to the other. It is also important that each of the parties feel that their contributions are listened to and taken seriously.

After each of you has identified how you feel, it is time to determine whether you understand each other. This calls for active empathic listening techniques. Each of you should be able to paraphrase what the other party has just said, in a way the other party finds satisfactory. Doing this before you respond to those feelings can help to avert conflict escalations. Along with active listening, the role-reversal techniques we spoke

of earlier in the chapter are also effective in helping individuals in conflict understand each other. Like active listening, role reversal permits you to see things as your partner sees them. Remember, if you are willing to listen to and experience the other person's point of view, the other person will be more likely to listen to and experience yours.

Suggest Possible Solutions

The goal during this phase is to put your heads together and come up with a variety of solutions. Most important, neither you nor your partner should evaluate, condemn, or make fun of any of the solutions suggested. You must suspend judgment and honestly believe the conflict can be resolved in many different ways. Let's try this:

SKILL BUILDER

SOLUTION ROUNDUP

1. Select a partner.
2. You and your partner are to play the roles of the parties to each of the following situations. It is your task to generate as many solutions to each conflict as you can.

> Roles: Teacher, Student
> Situation: You disagree about the fairness of a grade.
>
> Roles: Two friends
> Situation: You disagree about how to spend free time.
>
> Roles: Parent, Child
> Situation: You disagree about what should be eaten for dinner.
>
> Roles: Husband and Wife or Roommates
> Situation: You disagree about how to split housekeeping responsibilities.

Again, be certain you understand the meaning and intention behind each of the solutions. In other words, you should understand what you must do and what the other must do to resolve the problem between you.

Assess the Alternative Solutions and Pick the Best One

After the solutions have been generated, it is time to see what each person thinks of the suggested solutions. It is legitimate to seek to determine which solutions will let one party ''win'' at the other's expense, which solutions make both parties lose, and which solutions let both parties win. What you are seeking to discover is which solutions are totally unacceptable to either party and which are mutually acceptable. It is important to

be honest during this stage. Once all solutions have been assessed, you are in a position to determine if one of the mutually acceptable solutions is clearly superior to the others—that is, if it has the greatest number of advantages and the fewest number of disadvantages. Also, be sure to explore whether it is the most constructive solution.

Try Out the Solution and Evaluate It

During this stage we see to what extent the chosen solution is or is not working. We seek to answer *who* is doing *what, when, where,* and *under what conditions,* and we ask *how* this is affecting the relationship. We want to know if the parties were able to carry out the job as planned, whether the selected solution solved the problem that existed, and if the outcomes have been mutually rewarding. If they have not, we know it is time to begin the conflict-resolution process again.

Remember, conflict situations can be learning experiences; if handled properly they can help us discover ways we can change to improve our interpersonal relationships and enhance our interpersonal contacts. Thus, your goal should not necessarily be to have fewer conflicts; rather, it should be to make those conflicts you do have constructive. Instead of eliminating conflict from our interpersonal relationships, we simply need to learn how to use it.

SUMMARY

We have just explored the ways in which conflict can affect the interpersonal relationships we share. We have examined how conflict arises, how we react to it, and how we can cope with it more effectively. We have seen that conflict need not be a negative force that leads to undesirable consequences. Indeed, if handled constructively, we understand that conflict is a positive force that facilitates the development and maintenance of healthy interpersonal contacts.

To effectively handle conflict, we suggested you examine your own attitudes toward it, become aware of the strategies you use when involved in a conflict, analyze your strong and weak behaviors, and try to master conflict-resolution techniques.

SUGGESTIONS FOR FURTHER READING

Bach, George R., and Peter Wyden. *The Intimate Enemy.* New York: Avon Books, 1970. A popular, well-written book that identifies ways in which conflict is mismanaged in marriage. The authors contrast "fair fighting" and constructive conflict with destructive styles of conflict handling. Contains good examples and illustrations.

Blake, Robert, and Jane Mouton. "The Fifth Achievement," *Journal of Applied Behavioral Sciences,* Vol. 6 (1970), 413–426. Contains an explanation of the conflict grid.

Deutsch, Morton. "Conflicts: Productive and Destructive," *Journal of Social Issues,* Vol. 25 (1969), 7–43. Compares and contrasts constructive and destructive conflicts.

Filley, Alan C. *Interpersonal Conflict Resolution.* Glenview, Ill.: Scott Foresman,

1975. The author describes how to handle conflict in the organizational setting.

Gordon, Thomas. *Parent Effectiveness Training*. New York: Peter H. Wyden, 1970. A well-written account of how parents and children can develop no-lose styles of handling conflict.

Jandt, Fred E. *Conflict Resolution Through Communication*. New York: Harper & Row, 1973. Ten articles, theoretical in nature.

Johnson, David W. *Reaching Out: Interpersonal Effectiveness and Self-Actualization*. Englewood Cliffs, N.J.: Prentice-Hall, 1972. Demonstrates that conflict is necessary to the development of a healthy relationship.

Ruben, Harvey L. *Competing*. New York: Lippincott & Crowell, 1980. A popular, insightful account of the role competition plays in our lives.

Rubin, Theodore Isaac. *The Angry Book*. New York: Macmillan, 1969. Describes how to use anger; demonstrates that anger need not be abusive.

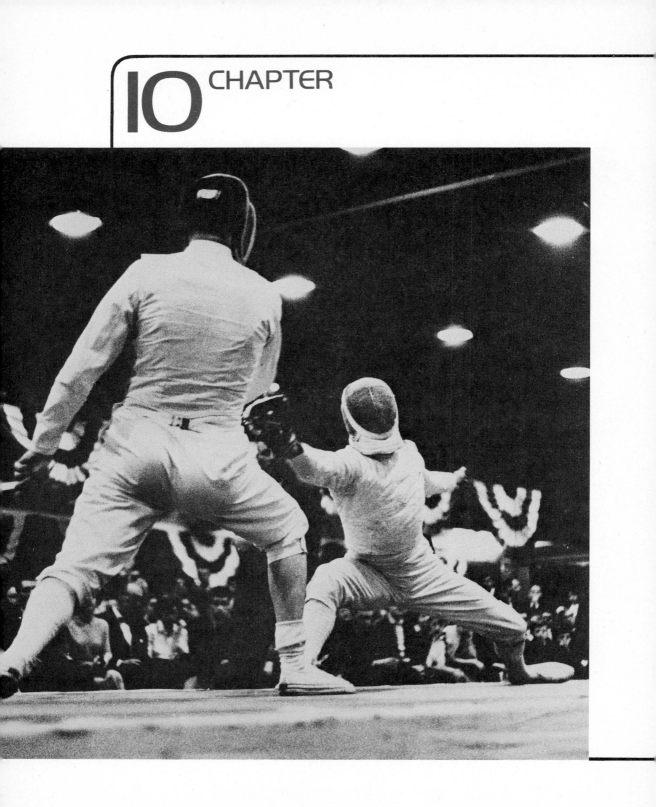

The Cat and the Mouse: Assertion, Nonassertion, and Aggression

CHAPTER PREVIEW

After experiencing this chapter, you should be able to:

Explain what an interpersonal trap is

Define "assertiveness," "nonassertiveness," and "aggressiveness"

 Measure your "victim" potential

 Distinguish between assertive, nonassertive, and aggressive verbal and nonverbal behavior

Identify interpersonal problems that could result from nonassertion

 Define "shyness"

 Identify factors that contribute to shyness

Identify factors that contribute to aggressive behavior

Provide examples of assertive, nonassertive, and aggressive behavior

 Explain the rewards of assertion

Draw and explain a "relationship window"

Create and explain a DESC script

Identify behaviors that foster and behaviors that impede the development of a relationship based on assertiveness

*"I think one must finally take
one's life in one's arms."*

Arthur Miller, *After the Fall*

Have you ever felt: Hesitant to express your opinions to others? Edgy about making small talk or polite conversation? Intimidated by a salesperson, waiter, or repairperson? Reluctant to speak up when you believed someone was treating you unfairly?

If you have, then you know what it feels like to get caught in an interpersonal trap. An interpersonal trap can be set anywhere—at school, at home, at work, in a store, in a restaurant, or at a party. We are vulnerable to traps because no matter how self-assured we think we are, at some time we may have been afraid to claim our rights, felt unable to state our feelings, or believed we had to suppress our desires to avoid rejection; thus, we became overly passive. Likewise, no matter how self-confident we think we are, at some time we may have felt it necessary to scream, hit, or threaten someone to make a point, to put down a friend to protect ourself, or simply to hurt someone else to feel that we were still important; in other words, we became unnecessarily aggressive. It is not surprising that people often feel that they are either too passive or too aggressive when communicating with others. These are common experiences. Such beliefs, however, could serve to reinforce your feelings of personal insignificance or diminish your chances to exert legitimate interpersonal power. Learning how to free yourself from such inter-personal traps is necessary—even essential.

In this chapter, we will explore various forms of interpersonal entrapment, and we will suggest strategies you can use to help insure that you neither take advantage of others nor are taken advantage of by others. In order to do this, we will focus on who you think you are now, and what you would like out of your relationships. Specifically, we will identify skills you can practice to help you relate to others more effectively—more assertively.

BEHAVING ASSERTIVELY: WATCHING OUT FOR YOURSELF

It is important to realize that there are ways to insure fair treatment and respect. You are not required to throw a tomato, have a tantrum, stomp on someone's foot, or sneak away and sulk to assert yourself. You do not have to be mean and nasty, neither do you have to be a shrinking violet. You do have to believe in *you*. If you do not, you will permit yourself to be victimized, or you will feel it necessary to become a manipulator of others—that is, an interpersonal conqueror—in order to attain the stature you feel you deserve.

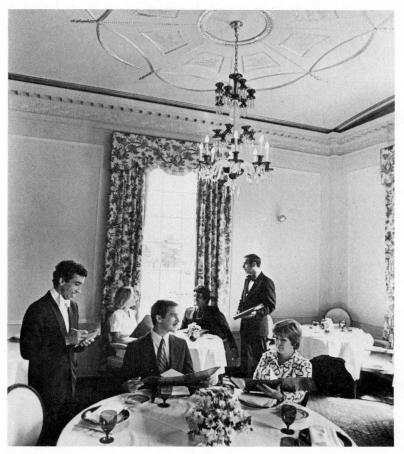

Some people are reluctant even to ask what the soup of the day is, let alone ask for a dish that is not on the menu. Difficulty in self-assertion can make people easy victims: for example, what would you do if you discovered that the restaurant had made an error in your check and charged you a dollar too much?
(© James R. Holland/Stock, Boston)

The phenomenon of victimization is widespread. Newspapers and television news shows recognize this when they offer action lines, hot lines, and complaint corners to help those who feel they are being mistreated get help. Victimization is not limited to consumers, however. It permeates all phases of our existence. A recent classified ad in a local Bergen County, New Jersey, newspaper supports this. It reads:

> For a fee of $10 plus the cost of delivering your message, I will make any phone call (except obscene) that you do not wish to make yourself. Let me assert myself for you.

333 Assertion, Nonassertion, and Aggression

Such an advertisement is reminiscent of the following excerpt from an article that appeared in the January 23, 1977, issue of the *Chicago Tribune* (note how inflation has hit the ''assertion'' business).

> If you are reticent about asking for a raise or telling neighbors that their stereo music is shaking the pictures on your walls, bite your tongue no longer. . . .
>
> There is someone who will ask for that raise for you, will tell your best friend that it would be an asset to him if he started using deodorant, and will even tell your loved one that you're in love with someone else.
>
> This someone, with all the gusto and assertiveness that many of us lack, is a thirty-year-old Western Springs housewife and mother of two who, for $5 and the cost of making a long-distance phone call, will deliver your message.
>
> Marti Hough began operating her ''Speak Up Service'' from her home in November after taking an eight-week assertiveness training course.
>
> ''Many people in the course would say, 'I can't do it. Why don't you do it for me,' and out of this I saw there was a need for someone to speak for others,'' she said.
>
> ''I've been averaging about six calls per day and have received calls from all over the Chicago area and even calls from as far away as Connecticut and Virginia.''

A victim is manipulated by outside forces; a victor is self-assertive.

Are there any messages you would like either of these individuals to deliver for you?

SKILL BUILDER

ASSERT-A-SERVICE

Write down ten messages you would like someone else to deliver for you. Identify the target of each message, the price you are willing to pay to the deliverer, and the reasons why you would not like to deliver the message yourself.

	Message	Target	Price	Reason
1.				
2.				
3.				
4.				
5.				
6.				
7.				
8.				
9.				
10.				

Are there moments in your life when you are still reluctant to claim your rights? Are there times when you feel powerless? Are you afraid to let others know when you are angry? Are you afraid to let others know how you feel? If you answer "yes" to any of these questions, you have "victim potential." Take some time and begin to assess how much of a victim you are in danger of becoming. The following "test" is adapted from Dr. Wayne W. Dyer's book, *Pulling Your Own Strings*. The test contains brief descriptions of common victimization situations followed by two alternative ways of reacting. One alternative represents a victim response, the other a nonvictim response. As you proceed through the test, indicate which response best describes the way you would handle the situation.

SKILL BUILDER

TO THE VICTIM BELONGS THE . . .

1. A friend asks you to go for coffee when you are busy and would rather not stop working.

 Victim Response:

 ____You go with your friend and feel upset, guilty, and tense.

 Nonvictim Response:

 ____You tell your friend you are really too busy and do not have time to go for coffee.

2. You ate dinner in a restaurant and felt that the food was inadequate and the service poor.

 Victim Response:

 ____You tip the waiter between 15 and 20 percent and tell yourself you will not return.

 Nonvictim Response:

 ____You do not leave a tip; you do inform the management why you were dissatisfied.

3. Your doctor tells you that you have arthritis and need to take the drug cortisone; you are wary.

 Victim Response:

 ____You fill the prescription and take the drug three times a day as instructed.

 Nonvictim Response:

 ____You ask the doctor to explain to you what the drug is used for and to describe its possible side effects. You then seek a second opinion.

4. You are requested to plan a relative's surprise party—something you would rather not be burdened with.

 Victim Response:

 ____You go ahead and do it, all the while feeling upset and irritated.

 Nonvictim Response:

 ____You say you would rather not be so actively involved and refuse to do it.

These are but nine situations that, if not handled properly, could lead to your becoming a victim. Award yourself one point for every nonvictim response. If you scored low on this test, it is time to take steps to reduce your victim quotient. If you scored high, it is time to find out what you are doing right.

We start with the belief that each of us should acknowledge that we help to determine the quality of our relationships. Thus, we should be able to identify and accept our personal rights as well as the rights of others. We work from the premise that all

5. Your boss asks you to do something that you do not care to do and that your job does not require you to do.

> Victim Response:
> _____You proceed to do what you were requested to do, but you feel used and abused.
> Nonvictim Response:
> _____You refuse to do it.

6. A friend is smoking next to you; the smoke is beginning to bother you.

> Victim Response:
> _____You sit there without showing your displeasure.
> Nonvictim Response:
> _____You politely ask your friend not to smoke.

7. You are standing among a group of people at a reception and one of the guests makes a derogatory remark about the ethnic group you belong to.

> Victim Response:
> _____You say nothing because you do not want to make a scene.
> Nonvictim Response:
> _____You object to the comment and explain why.

8. You are attending a party at which you know no one.

> Victim Response:
> _____You stand alone and hope that someone will approach you.
> Nonvictim Response:
> _____You walk up to someone and introduce yourself.

9. You receive a grade you believe is unjust.

> Victim Response:
> _____You do nothing, but feel enraged at the instructor.
> Nonvictim Response:
> _____You make an appointment and explain your feelings to your instructor.

individuals have the same fundamental rights in interpersonal relationships, regardless of their roles and titles. It is important that we learn to exercise our rights without feeling guilty and without infringing on the rights of others.

> There is no such thing as a
> well-adjusted slave.
>
> Wayne W. Dyer

SKILL BUILDER

ASSESSMENT TIME

To determine the extent to which you characteristically assert yourself during inter-personal situations, answer the questions below. The accompanying scale can guide you in measuring the extent to which each statement typifies a characteristic behavior. Score:

- 5 if you almost always display the behavior (90 to 100 percent predictability)
- 4 if the behavior occurs about three-quarters of the time (75 percent predictability)
- 3 if you have a fifty-fifty chance of displaying the behavior (50 percent predictability)
- 2 if you sometimes, but not frequently, behave in this manner (25 percent predictability)
- 1 if you almost never display the behavior (0 to 10 percent predictability)

When a friend and I have experienced interpersonal communication problems, I have:

____not tried to make my friend feel guilty
____calmly let my friend know why I was upset
____not blamed my friend for the interpersonal breakdown
____looked directly at my friend when speaking to him or her
____not made assumptions about my friend's feelings
____questioned my friend to avoid a misunderstanding
____not used sarcasm to belittle my friend
____not experienced excessive anxiety about speaking up and said what I thought
____used an appropriately forceful voice tone, body language, facial expressions, and gestures to support my feelings
____neither cursed nor used obscenities to make my point
____presented my thoughts in an organized fashion
____considered the impact of my actions
____TOTAL

When a close relative and I have experienced interpersonal communication problems, I have:

____not tried to make the other person feel guilty
____calmly let the other person know why I was upset
____not blamed the other person for the interpersonal breakdown
____looked directly at the other person when speaking to him or her
____not made assumptions about the other person's feelings
____questioned the other person to avoid a misunderstanding
____not used sarcasm to belittle the other person

_____not experienced excessive anxiety about speaking up and said what I
 thought
_____used an appropriately forceful voice tone, body language, facial expres-
 sions, and gestures to support my feelings
_____neither cursed nor used obscenities to make my point
_____presented my thoughts in an organized fashion
_____considered the impact of my actions
_____TOTAL

When a professor and I have experienced interpersonal communication problems, I
have:

_____not tried to make the professor feel guilty
_____calmly let the professor know why I was upset
_____not blamed the professor for the interpersonal breakdown
_____looked directly at the professor when speaking to him or her
_____not made assumptions about the professor's feelings
_____questioned the professor to avoid a misunderstanding
_____not used sarcasm to belittle the professor
_____not experienced excessive anxiety about speaking up and said what I
 thought
_____used an appropriately forceful voice tone, body language, facial expres-
 sions, and gestures to support my feelings
_____neither cursed nor used obscenities to make my point
_____presented my thoughts in an organized fashion
_____considered the impact of my actions
_____TOTAL

When my boss and I have experienced interpersonal communication problems, I have:

_____not tried to make my boss feel guilty
_____calmly let my boss know why I was upset
_____not blamed him or her for the interpersonal breakdown
_____looked directly at my boss when speaking to him or her
_____not made assumptions about my boss's feelings
_____questioned my boss to avoid a misunderstanding
_____not used sarcasm to belittle my boss
_____not experienced excessive anxiety about speaking up and said what I
 thought
_____used an appropriately forceful voice tone, body language, facial expres-
 sions, and gestures to support my feelings
_____neither cursed nor used obscenities to make my point
_____presented my thoughts in an organized fashion
_____considered the impact of my actions
_____TOTAL

If you consistently scored near 60, you can consider yourself in control of interpersonal conflicts. If you consistently scored near 12, you are rarely in control of conflict situations. Reexamine each set of responses. With which people were you most effective? Why? Which caused you to feel personally inadequate? Why? Note the questions you responded to by filling in 1, 2, or 3. These are your weaker interpersonal behaviors. You may want to try to strengthen them.

> All men are born free and equal, and have
> certain natural, essential and
> unalienable rights
>
> Constitution of Massachusetts 1778

Once we understand that every individual is equal in terms of interpersonal rights, once we understand that roles and titles do not alter this fact, we may find it easier to stand up for what we believe and for what we want. At this point, we need to define more explicitly what we mean by nonassertive, aggressive, and assertive behaviors. Once the differences between the classifications become clear, you will be in a better position to develop your assertive skills.

Nonassertiveness: The Timid Trap

How would you respond if faced with these situations?

Your friend wants to use the same speech you delivered in a public speaking course in her class.

You are in line waiting to buy concert tickets and someone pushes in front of you.

Your grade on a term project is much lower than anticipated.

You are not given the promotion you believe you deserved.

You purchase a record only to discover it is scratched.

You have been chosen to represent your school at a national conference but you have neither the time nor the desire to do it.

Your friend suffers from onion breath.

THE WIZARD OF ID by Brant parker and Johnny hart

For each case, what would be wrong with doing nothing? First, by behaving nonassertively you force yourself to keep your real feelings inside. Second, you do not take the steps needed to improve a relationship that is causing you problems. Third, you could change colors like the chameleon described in the Wizard of Id cartoon. Fourth, you can end up with something you really do not want. And fifth, important interpersonal issues are not aired. With so much at stake, why do people refrain from asserting themselves?

SKILL BUILDER

ASSERTIVENESS HOLDBACKS

In the space provided, identify reasons why you might be hesitant to protect your rights—that is, why you would be reluctant to assert yourself.

1.

2.

3.

4.

5.

Unfortunately, when we are nonassertive we attempt to avoid interpersonal conflict altogether. This usually means that we permit ourselves to become the victim we discussed earlier. The wishes of others become more important than our own needs. To put it

bluntly, we simply have difficulty saying no. We hesitate to assert ourselves for a number of different reasons. Sometimes inertia or laziness intervenes, and the easy response for us to adopt is no response. After all, assertion can be hard work. Other times apathy and lack of interest lead us to exhibit nonassertive responses; we simply do not care enough to become actively involved. Frequently, interpersonal fears also exert an influence. We feel inadequate, and we fear the rejection we believe could result from our self-assertion. We become convinced that our speaking up will make someone angry. Thus, we are afraid to be honest, and we have difficulty expressing our hurt. We do not feel that we are equipped with needed interpersonal skills. For these reasons, we convince ourselves it is better to keep quiet.

If it is any comfort, each of us experiences feelings of personal inadequacy at some

SKILL BUILDER

STANFORD SHYNESS SURVEY

Take a few minutes to quickly fill out this shyness survey.

_____ 1. Do you consider yourself to be a shy person?
1 = yes 2 = no

_____ 2. If yes, have you always been shy (were shy previously and still are)?
1 = yes 2 = no

_____ 3. If no to question 1, was there *ever* a prior time in your life when you were shy?
1 = yes 2 = no

If no, then you are finished with this survey. Thanks.
If yes to any of the above, please continue.

_____ 4. *How shy* are you when you feel shy?
1 = extremely shy
2 = very shy
3 = quite shy
4 = moderately shy
5 = somewhat shy
6 = only slightly shy

_____ 5. How *often* do you experience (have you experienced) these feelings of shyness?
1 = every day
2 = almost every day
3 = often, nearly every other day
4 = one or two times a week

time. We might feel exploited. We might feel stifled. We might feel imposed on. These feelings manifest themselves in a variety of ways—as depression, as weakness, as loneliness, but most of all, according to psychologist Philip G. Zimbardo, as shyness. In fact, in one survey, reported in the May 1975 issue of *Psychology Today,* more than 80 percent of the American college and high school students interviewed responded that they had been disturbingly shy for a great portion of their lives. What effect does this have? As Zimbardo states in his work *Shyness,* "The shy person shrinks from self-assertion."

At the bottom of these two pages is a condensed version of the Stanford Shyness Survey that Zimbardo gave to more than five thousand people around the world. Fill it out to assess the extent to which shyness affects your relationships.

 5 = occasionally, less than once a week
 6 = rarely, once a month or less

_____ 6. Compared to your *peers* (of similar age, sex, and background), how shy are you?

 1 = much more shy
 2 = more shy
 3 = about as shy
 4 = less shy
 5 = much less shy

_____ 7. Is (or was) your shyness ever a personal *problem* for you?

 1 = yes, often
 2 = yes, sometimes
 3 = yes, occasionally
 4 = rarely
 5 = never

(8–16) WHICH OF THE FOLLOWING DO YOU BELIEVE MAY BE AMONG THE *CAUSES* OF YOUR SHYNESS? CHECK ALL THAT ARE APPLICABLE TO YOU.

_____ 8. Concern for negative evaluation

_____ 9. Fear of being rejected

_____ 10. Lack of self-confidence

_____ 11. Lack of specific skills (specify):

SKILL BUILDER CONTINUED ON THE FOLLOWING PAGE

_____ 12. Fear of being intimate with others

_____ 13. Preference for being alone

_____ 14. Value placed on nonsocial interests, hobbies, etc.

_____ 15. Personal inadequacy, handicap (specify):

_____ 16. Others: (specify):

(17–22) PERCEPTIONS OF YOUR SHYNESS

Do the following people consider _you_ to be shy? How shy do you think they judge you to be? Answer using this scale.

1 = extremely shy
2 = very shy
3 = quite shy
4 = moderately shy
5 = somewhat shy
6 = only slightly shy
7 = not shy
8 = don't know
9 = not applicable

_____ 17. your mother

_____ 18. your father

_____ 19. your siblings (brothers and/or sisters)

_____ 20. close friends

_____ 21. your steady boy/girl friend/spouse

_____ 22. teachers or employers, fellow workers who know you well

_____ 23. Have people ever misinterpreted your shyness as a different trait, e.g., ''indifference,'' ''aloofness,'' ''poise''?

Specify: _____

_____ 24. Do you ever feel shy when you are *alone?*

 1 = yes 2 = no

_____ 25. Do you ever feel *embarrassed* when you are alone?

 1 = yes 2 = no

_____ 26. If yes, please describe when, how, or why:

WHAT MAKES YOU SHY?

_____ 27. If you now experience, or have ever experienced feelings of shyness, please indicate which of the following situations, activities, and types of people make you feel shy. (Place a check mark next to *all* of the appropriate choices.)
Situations and activities that make me feel shy:

_____ social situations in general

_____ large groups

_____ small, task-oriented groups (e.g., seminars at school, work groups on the job)

_____ small, social groups (e.g., at parties, dances)

_____ one-to-one interactions with a person of the same sex

_____ one-to-one interactions with a person of the opposite sex

_____ situations where I am vulnerable (e.g., when asking for help)

_____ situations where I am of lower status than others (e.g., when speaking to superiors, authorities)

_____ situations requiring assertiveness (e.g., when complaining about faulty service in a restaurant or the poor quality of a product)

_____ situations where I am the focus of attention, before a large group (e.g., when giving a speech)

_____ situations where I am the focus of attention, before a small group (e.g., when being introduced, when being asked directly for my opinion)

_____ situations where I am being evaluated or compared with others (e.g., when being interviewed, when being criticized)

SKILL BUILDER CONTINUED ON THE FOLLOWING PAGE

_____ new interpersonal situations in general

_____ where sexual intimacy is possible

(28–30) SHYNESS REACTIONS

_____ 28. How do you know you are shy, i.e., what *cues* do you use?

 1 = my internal feelings, thoughts, symptoms only (private)

 2 = my overt behavior in a given situation only (public)

 3 = I use a mix of internal responses and overt behavior

Physical reactions

29. If you do experience, or have ever experienced feelings of shyness, which of the following *physical reactions* are associated with such feelings? Put 0 next to those that are not relevant, then order the rest from 1 (most typical, usual, severe) to 2 (next most), and so on.

_____ blushing

_____ increased pulse

_____ butterflies in stomach

_____ tingling sensations

_____ heart pounding

_____ dry mouth

_____ tremors

_____ perspiration

_____ fatigue

_____ others (specify below)

Actions

30. If you do experience, or have ever experienced, feelings of shyness, what are the *obvious behaviors* which might indicate to others that you are feeling shy? Put 0 next to those that are not relevant, then rank order the rest from 1 (most typical, usual, severe) to 2 (next most), and so on. (More than one item can be given the same rank.)

_____ low speaking voice

_____ avoidance of other people

_____ inability to make eye contact

_____ silence (a reluctance to talk)

_____ stuttering

_____ rambling, incoherent talk

_____ posture

_____ avoidance of taking action

_____ escape from the situation

_____ others (specify):

(31–32) SHYNESS CONSEQUENCES

31. What are the *negative* consequences of being shy? (Check all those that apply to you.)

 _____ none, no negative consequences

 _____ creates social problems; makes it difficult to meet new people, make new friends, enjoy potentially good experiences

 _____ has negative emotional consequences; creates feelings of loneliness, isolation, depression

 _____ prevents positive evaluations by others (e.g., my personal assets never become apparent because of my shyness)

 _____ makes it difficult to be appropriately assertive, to express opinions, to take advantage of opportunities

 _____ allows incorrect negative evaluations by others (e.g., I may unjustly be seen as unfriendly or snobbish or weak)

 _____ creates cognitive and expressive difficulties; inhibits the capacity to think clearly while with others and to communicate effectively with them

 _____ encourages excessive self-consciousness, preoccupation with myself

SKILL BUILDER CONTINUED ON THE FOLLOWING PAGE

32. What are the *positive* consequences of being shy? (Check all those that apply to you.)

_____ none, no positive consequences

_____ creates a modest, appealing impression; makes one appear discreet, introspective

_____ helps avoid interpersonal conflicts

_____ provides a convenient form of anonymity and protection

_____ provides an opportunity to stand back, observe others, act carefully and intelligently

_____ avoids negative evaluations by others (e.g., a shy person is not considered obnoxious, overaggressive, or pretentious)

_____ provides a way to be selective about the people with whom one interacts

_____ enhances personal privacy and the pleasure that solitude offers

_____ creates positive interpersonal consequences by not putting others off, intimidating them, or hurting them

_____ 33. Do you think your shyness can be overcome?
1 = yes
2 = no
3 = uncertain

_____ 34. Are you willing to seriously work at overcoming it?
1 = yes, definitely
2 = yes, perhaps
3 = not sure yet
4 = no

We learned to be shy or nonassertive in a multitude of ways. We may have had a negative self-assertion experience, or we may have observed someone else get hurt by being assertive. We may have prophesied failure for ourselves and fulfilled the prophecy. Or we may have learned to question our own capabilities, and we may never have mastered a number of needed social skills. Zimbardo also notes that the passive, nonassertive nature of the shy person may, in part, be due to a learned pattern of responding to a televised world. Why act when you can simply let your favorite characters act for you?

Suppose a shy, nonassertive individual wanted to get another person to cooperate with him in planning a party for a friend. Their conversation might proceed as follows:

A: Uh, pardon me. This really isn't important, uh, you know I was wondering if you would be willing to take a few minutes and help me plan Tim's party.

B: (Head buried in a book) Can't do it now. I'm reading.

A: Oh, sure. Sorry.

Nonassertive people tend to suppress honest feelings and emotions and permit themselves to be victimized by others. At the same time, nonassertive people display a need to apologize or seek forgiveness even when they have done nothing wrong. In effect, the message communicated by the nonassertive person is "I don't count; only you count." Various nonverbal and verbal behaviors support this belief. Nonassertive nonverbal behaviors include downcast eyes or evasive eye contact, excessive head nodding, body gestures such as hand wringing, a slouched posture, and a low, whining, hesitant or giggly voice. The amount of distance maintained between interactants is also a factor.

MEASURING SHYNESS— THE 12-INCH DIFFERENCE

Jack C. Horn

Shyness can be measured in inches as well as blushes. Or so psychologists Bernardo Carducci and Arthur Webber concluded when they had 73 California college students (42 men and 31 women) approach other people in a recent study.

Carducci and Webber employed a standard psychological method of measuring the distance people like to keep between themselves and others. As each volunteer entered the room where the experiment took place, he or she was met by an experimenter and asked to stand on a certain spot while the experimenter moved 18 feet away. The student was then asked either to walk toward the other person until the student reached a point that felt comfortable, or to stand still while the experimenter approached, saying "Stop" when the experimenter reached a comfortable distance.

After the experimenter measured this distance, the process was reversed—students who had walked, stood still, and those who had stood still, walked—and the preferred distance was measured again. Students then filled out the Stanford Survey on Shyness, a measure developed by psychologist Philip Zimbardo. . . . Based on the shyness scores, Carducci and Webber split the students into very-shy and less-shy groups, and compared the interpersonal distances chosen by each.

They found that when the experimenter was doing the walking, shy people did not say "Stop" at a farther distance than less shy people did, apparently because they were just too shy to say it when they wanted to. But when Carducci and Webber averaged the two distances to get a single measure for each student, they found that shyer people preferred a distance 8 inches farther apart, on the average, than did the less shy—33.4 inches rather than 25. The difference grew to a foot (36.3 inches rather than 24.4) when the shy student and the experimenter were of opposite sexes.

Psychology Today, December 1979

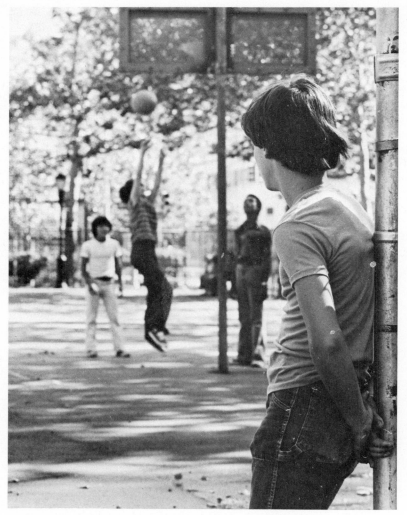

When we feel that our interpersonal skills are inadequate, we may stay
on the sidelines of life, too shy to join in activities with others.
(© *Ed Lettau/Photo Researchers*)

Nonassertive verbal behaviors include fillers like "uh, um" and "you know"; negators
like "This really isn't important but . . . ," and "You'll probably think I'm stupid";
qualifiers like "just," "I guess," and "only"; an overuse of apologetic words; and a
speech pattern that could be characterized as disconnected. In general, nonassertive
behaviors reduce the impact of what is being said, which is one reason why individuals
who fear self-assertion use them. Remember, the nonassertive individual aims to appease
others. Let us now examine individual motivations for nonassertion.

According to Lynn Z. Bloom, Karen Coburn, and Joan Pearlman, authors of *The New Assertive Woman,* in our society nonassertive behavior is often perceived to be an asset for women but a liability for men. To what extent did your results support this? Do you think women gain more from being nonassertive than men lose? Why? Drs. Arthur J. Lange and Patricia Jakubowski, authors of *Responsible Assertive Behavior,* believe people use nonassertive behavior for a number of reasons. First, they may not understand the differences between assertion and aggression. Second, they may mistakenly believe that nonassertion and politeness are synonymous. Third, they may believe they are helping other persons by not asserting themselves. Fourth, they may fear rejection, loss of affection, or otherwise have anxiety about the negative consequences of assertion. Fifth, they simply may not know how to act otherwise. In any case, nonassertive people have given up their rights to emotional and behavioral control. They permit themselves to be vicitimized. They operate from positions of weakness rather than positions of strength. Let us next examine the polar opposite of the nonassertive individual—the aggressor.

Aggressiveness: The Tantrum Trap

Unlike nonassertive people, who often permit others to victimize them and who are reluctant to reveal or express their own feelings, aggressive people are insistent on standing up for their own rights while ignoring and violating the rights of others. Thus, aggressive individuals get more of their needs met than nonassertive individuals, but they

accomplish this at someone else's expense. The aggressor aims to dominate and win in a relationship; breaking even is not enough. The message of aggressive persons is selfish: "This is the way I feel. . . . You're dumb for feeling differently." "This is what I want; what you want does not count and is of no consequence to me." Now suppose an arrogant, aggressive individual was attempting to persuade another person to help her plan a party for a friend. The other person is busy and not excited by the prospect. Their conversation might proceed as follows:

A: I'm fed up with you. I'm sick of listening to you tell me you don't have time to plan this party. You'd better help me plan this party now!

B: (Head buried in book) Can't do it now. I'm reading.

A: You're wrong. You can do it now. You're just selfish. You don't give a darn about anyone but yourself.

B: Not so. I care.

A: That's an outright lie. Who always does everything? I do. All you ever do is read, drink, and watch television. You're just a fat, lazy slob. I'm sick and tired of looking at you.

B: Oh, just shut up.

Aggression involves both verbal and nonverbal cues. What is likely to be the next step in this dispute?
(© Don Ivers/Jeroboam)

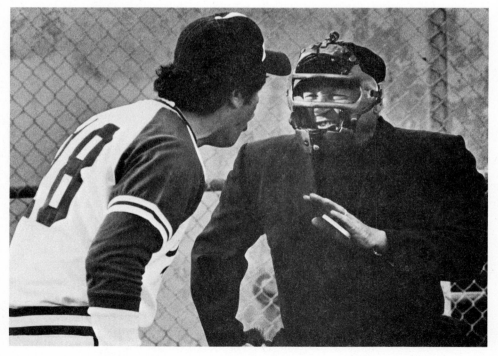

In contrast to the nonassertive person, who starts hesitantly, the aggressive person begins by attacking. Nonverbal and verbal behaviors support the effort being made. Nonverbal cues frequently include "stare down" messages; a raised, harsh, strident voice; a cold, sarcastic, or demeaning tone; excessive finger pointing, fist pounding, and a willingness to invade the personal space of other individuals. Characteristically, the verbal messages of aggressive persons also spell p-u-t d-o-w-n. Aggressors frequently answer before you finish speaking, use threats like "You'd better . . . ," "If you don't stop . . . ," or "I'm warning you." Also peppering the conversations of aggressive persons are evaluative judgments and accusative statements like "that's bad," "you're wrong," "your approach is clearly inferior," as well as degrading comments like "you can't be serious," "you're joking," and "shut up." It is not surprising that scenes often escalate out of control because the target of the aggressor frequently feels a need to retaliate. In such situations, no one really wins; what we end up with is a stalemate. Let us now examine how you feel about aggression.

SKILL BUILDER

READY—AIM—FIRE

1. Draw two pictures (abstract or literal): One should portray or symbolize the way you feel (or imagine you would feel) when being nonassertive; the other should portray or symbolize the way you feel when being aggressive. Compare and contrast both images.

2. Next, describe the last time you displayed aggression during an interpersonal encounter. Explain what prompted your aggression, how you treated the other person, how the other person responded, and the results of your aggressive behavior.

People act aggressively for different reasons. According to assertiveness counselors Arthur J. Lange and Patricia Jakubowski, we tend to lash out when we feel ourselves becoming vulnerable to another; we attempt to protect ourselves from the perceived threat of powerlessness. Second, unresolved, emotionally volatile experiences may cause us to overreact when faced with a relationship difficulty. Lange and Jakubowski offer this example in their book *Responsible Assertive Behavior:*

> Sitting with her husband and woman friend, a wife was trying to explain the need for the Equal Rights Amendment. Her husband casually asked why it was needed since the issues were already covered by the other amendments in the Constitution. The wife overreacted and started to berate the husband for his ridiculous position. After the tirade, her woman friend calmly asked the husband whether the wife always reacted so strongly. He responded, "Yeah, when we start talking about issues like this, Kathy gets pretty uptight." The calm way in which both her friend and husband reacted caused Kathy to realize that she had acted as thoug' she had been personally attacked; in reality her husband had only as'

for additional information. In thinking about her own overreaction, she realized that the feelings of powerlessness and personal attack she experienced were the same that she had felt as an adolescent, arguing to no avail with her unyielding father about religion and other issues. Discussing an emotionally charged issue produced feelings of powerlessness and thus triggered aggression, even though her husband did not respond like her father. In subsequent disputes she deliberately reminded herself that the other person was not her father, that she was no longer a child, etc. This self-talk helped her to maintain her perspective, composure, and assertion when presenting her opinions to potentially rejecting individuals.

Third, we may firmly believe that the only way for us to get our ideas and feelings across to the other person is through aggression. For some reason, we may believe that people will neither listen nor react to what we say if we are merely mild-mannered. Fourth, we may never have learned how to channel or handle our aggressive impulses. Finally, our aggression may be related to repeated nonassertion in our past. The hurt, the disappointment, the bewilderment, and the sense of personal violation that accompany nonassertive responses may have built to a boiling point. No longer able to keep these feelings inside, we abruptly vent them. Needless to say, at times the consequences of aggression are damaged or destroyed relationships.

SKILL BUILDER

TALLY SHEET

1. What can or what have you gained by being aggressive?

 A. C.

 B. D.

2. What can or what has aggressiveness cost you?

 A. C.

 B. D.

3. Describe two interpersonal experiences to verify your beliefs.

Interpersonal Situation	Action You Took	Benefit You Gained	Consequence You Suffered

The aggressor manipulates others and by so doing uses and abuses friendships. Thus, neither the nonassertive nor the aggressive person has many meaningful relationships. Both patterns of behaving leave something to be desired. For this reason, we need to find the middle ground or golden mean between the extremes of nonassertion and aggression.

PULL YOUR OWN STRINGS

Gayle Spanier Rawlings

We are connected
in invisible ways
to our fears
we are the puppet
& the puppeteer,
the victims of our
expectation.

Silken threads pull,
arms & legs
flop & jangle.
We dance to the music
of our fears
bodies crouched inside
children hiding, pretending,
under that rock
behind that tree
someplace, everywhere
not what we control.

Pull your own strings
move into your body
& to the beat of life
cut your strings
hold out your hand to
the unknown,
walk in the dark
open your arms
to the embrace of air,
make them wings
that soar.

Assertiveness: Avoiding the Trap

We have seen that the intent of nonassertive behavior is to avoid any kind of even if it means sacrificing your wants and needs, and the intent of aggressi

is to dominate in a relationship, even if this domination means that someone else will be hurt. In contrast, the intent of assertive behavior is to communicate honestly, clearly, and directly, to stand up for what you believe without harming others or being harmed yourself. If we can assume that both nonassertion and aggression are due, in part, to learning inappropriate ways of reacting during interpersonal encounters, then we should be able to improve the nature of our interpersonal relationships by internalizing appropriate ways of behaving. Understanding the meaning of assertiveness will help us accomplish this goal.

When you assert yourself, you protect yourself from being made a "victim," you meet more of your interpersonal needs, you make more of your own decisions, you think and say what you believe, and you establish close interpersonal relationships without infringing on the rights of others and without violating their dignity. To be assertive is to recognize that all individuals have the same fundamental rights. Neither titles nor roles alter this fact. We all have a right to influence the way others behave toward us. We all have a right to protect ourselves against interpersonal mistreatment, and we have a right to do this without guilt. We believe that there is no such thing as an interpersonal situation in which one person has a right to make another person the victim or underdog. Do you agree?

SKILL BUILDER

UNDERDOG

1. Describe an interpersonal situation where you took advantage of someone who allowed you to do it. What motivated you? Why do you believe the other person permitted the victimization to occur?
2. Describe an interpersonal situation where someone took advantage of you and you permitted it. What do you believe motivated the person to act in this fashion? What motivated you to respond as you did?

If you—either as aggressor or victim—failed to express your thoughts and beliefs honestly, you contributed to the self-violation process. If you feel you don't count, others will take advantage of you. Such behavior promotes an unhealthy interpersonal climate— one where people feel one way but act in other ways; where behaviors, beliefs, and personal needs conflict with each other; and where people act as victims or victimizers. In contrast, assertive individuals announce what they think and feel; they reveal how they see the situation. They do so without apologizing and without dominating. Neither the self nor the other is demeaned; both are respected. Such behavior promotes a healthy interpersonal climate.

Thus, being assertive means being a nonvictim as well as a nonvictimizer. Being assertive means you neither set nor get caught in interpersonal traps. This involves learning to say no, yes, I like, and I think. In other words, assertive people have learned

Speaking in public is one form of self-assertion. The assertive person
knows how to get his or her message across without apology or
aggression.
(© A. Hagman/Sygma)

how to stop themselves from sending nonassertive or aggressive messages when they
believe such behavior would not be appropriate. Instead, they attend to feelings and use
specific verbal and nonverbal skills to help solve interpersonal problems. Whereas
aggressive people often hurt others and nonassertive people often hurt themselves, assertive
people protect themselves as well as those with whom they interact. Assertive people

focus on negotiation. Unlike nonassertive people, who create a power imbalance by giving everyone more rights than they get for themselves, and unlike aggressive people, who create an imbalance by giving themselves more rights than they give others, assertive people try to balance social power and try to equalize the nature of the relationships they share. We see this trait in the following illustration: Imagine that an assertive person is attempting to convince another person to help him plan a party for a friend. Their conversation might sound like this:

A: It's March and that means it's time to begin planning Tim's party.

B: (Head buried in book.) Oh, not yet! It's only March first.

A: I think the party will have a better chance of succeeding if we give ourselves plenty of time to get organized.

B: It's going to be impossible for me to give it much thought.

A: I've already jotted down some preliminary ideas. I hope you'll look at them when you finish the chapter you're reading?

B: Must I do it today?

A: Is there another day that would be better for you?

B: Oh, I can't say.

A: Well, let's talk about it when you complete the chapter. Are we agreed?

B: All right.

A: Fine! It shouldn't take more than half an hour, and I'll feel so much better when our preliminary planning is done.

Being assertive tends to be self-rewarding. We feel good when we begin to accomplish our goals in a relationship. We feel good when we can act in our own best interests without harming or depreciating others. We feel good when others respond to us positively. We feel good when we can openly express our personal feelings and thoughts.

Assertion, like nonassertion and aggression, is also characterized by particular non-verbal and verbal cues. Good eye contact is an essential ingredient of assertive behavior. As we have seen, avoiding eye contact sends the message that you are nervous, anxious, uncomfortable, or perhaps even incompetent, while staring suggests that you hold the other person in contempt. However, looking at others with interest and focusing on them when you speak communicates that you are serious and concerned. Likewise, a strong, well-modulated, steady voice signals that you are in control of yourself and sincere. Assertive people do not shrink from shaking hands. They offer others neither a limp-fish nor a bone-crushing grip, but instead, shake hands firmly and directly. Assertive people also know how to use space and distance to communicate. They stand neither too far away nor too close to others; instead they use the comfort zone. Their posture and gestures also support their efforts. In other words, their nonverbal messages help buttress the intent of their verbal messages.

The verbal characteristics of assertive people include an ability and willingness to send "I" messages and "we" messages. Assertive people let us know what they think and feel ("I want . . ." "I don't like . . .") and are willing to cooperate with others for the

betterment of a relationship ("Let's . . ." "We can . . ."). Assertive people also employ empathic statements of interest such as "What do you think?" or "How do you see this?" Usually missing from the conversations of assertive individuals are wishy-washy statements like "I guess," fillers like "um," and self-demeaners like "I know this sounds dumb, but . . ." They rarely make blame statements or send "you" messages. Thus, assertive people have mastered the ability to express themselves in ways that are personally fulfilling and interpersonally effective.

Remember, to be assertive does not mean you must be insensitive or selfish; neither does it mean that you must be stubborn or pushy. It does mean that you are willing to defend your rights, to communicate your needs, and to attempt to find mutually satisfactory solutions to interpersonal problems or dilemmas that arise. It is time to decide whether you would like to redefine the ways you relate to others. It is time to determine whether you would like to shake off your nonassertive and aggressive ways of behaving in favor of assertiveness.

RELATIONSHIPS AND STRUGGLES

In this section, we will examine some of the difficulties that may arise as we attempt to promote more successful and open communication with others. According to Sherwin B. Cotler and Julio J. Guerra, authors of *Assertion Training,* most assertion situations fall into at least one of the following four categories: (1) an interaction with a stranger where you are requesting something; (2) an interaction with a friend/intimate where you are requesting something; (3) an interaction with a stranger where you are refusing something; and (4) an interaction with a friend/intimate where you are refusing something. These situations may be represented in a "relationship window" (2 X 2 matrix) as follows:

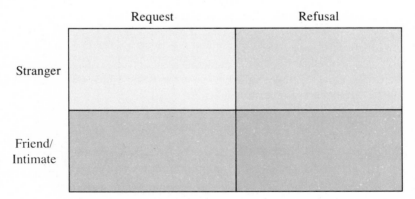

Most persons experience the majority of their assertion difficulties in one or more of the above quadrants. In other words, some people find it easy to refuse a stranger's request but difficult to deny a friend's request. For others, refusing close friends or strangers may pose few problems; instead, these individuals may experience great anxiety when making requests of others. Where do you experience the most difficulty?

SKILL BUILDER

LOVERS, FRIENDS, AND STRANGERS

1. Redraw the relationship window, giving dominance to the quadrant that poses the most problems for you. For example, if refusing the requests of close friends is most difficult for you, your window might look like this:

2. Identify three different interpersonal experiences (personal vignettes) that illustrate the types of problems you have when interacting under the conditions depicted above.

 A.

 B.

 C.

3. During the week, keep a record of situations where you act assertively, nonassertively, and aggressively when interacting with another. Note which quadrant contains the most examples of assertive, aggressive, and nonassertive communication. Bring three examples to class.

It is important to realize that at times we all have some difficulty in at least one of the quadrants. Now that you have identified your problem areas, however, you can begin to examine your behavior more closely. You can begin to assess when you feel a need to fight, when you feel a need to flee, and when you feel you can assert yourself. Although fighting or fleeing makes sense for animals, it does not necessarily make sense for human beings. Yet, people do flee and fight. Sometimes we display these behaviors because we want to, sometimes because we feel we have to, and sometimes because we do not know what else to do or believe we lack the social skills to do anything else. What we can do, however, is use our problem-solving ability to develop assertive means of handling our interpersonal relationship difficulties.

SKILL BUILDER

THE RELATIONSHIP THERMOMETER

1. The emotional response index of nonassertive persons is usually too low—"below normal": they do not permit themselves to react. The emotional response index of the aggressive person is usually too high—"above normal"—that is, they overreact. The emotional response index of the assertive person is "normal." Examine your relationship "temperature" now. Do this by trying to send the following messages in each style of behavior discussed.

 A. You would like a stranger seated near you to stop smoking.

 1. Nonassertive:

 2. Aggressive:

 3. Assertive:

 B. You do not wish to drive a friend to the airport.

 1. Nonassertive:

 2. Aggressive:

 3. Assertive:

 C. You do not want to move your seat on an airplane so that two people whom you do not know can sit together.

 1. Nonassertive:

 2. Aggressive:

 3. Assertive:

 D. You would like a friend to help you plan a club function.

 1. Nonassertive:

 2. Aggressive:

 3. Assertive:

 E. You want to ask a classmate you find attractive out to dinner.

 1. Nonassertive:

 2. Aggressive:

 3. Assertive:

2. At which temperature setting did you find it easiest to operate? Why? Which type of answer was hardest for you to formulate? Why?

By now, it should be apparent that the ability to communicate assertively could put you at an advantage in countless interpersonal situations. It is evident that how you view your role in a relationship affects the nature of the relationship.

SKILL BUILDER

LOOKING AT RELATIONSHIPS

1. In the spaces below, write the names of three people with whom you share an interpersonal relationship in a professional setting, a social setting, and an educational setting.

_____ _____ _____

2. Attempt to symbolize the type of relationship you share with each of these persons by following these rules.

 A. If you view the person as more important than you, use a star to represent him or her and a circle to represent you. If you view yourself as more important than the other person, use a star to represent yourself and a circle to represent him or her. If you view yourselves as equals, use two stars.

 B. If you view the other person as dominant, place his or her symbol above your own. If you view the other person as subordinate to you, place his or her symbol beneath yours. If you view yourselves as equals, place both symbols on the same plane.

 C. If you view the other person as friendly, place his or her symbol close to yours. If you view the other person as distant, place his or her symbol far from yours. If you view the other as intimate, have his or her symbol overlap yours.

3. To what extent do you handle yourself differently in different contexts? Why?

Each of the responses to the following examples indicates either a nonassertive, assertive, or aggressive response to the given situation. Which response do you believe you would have offered if faced with the interpersonal dilemma described?

You and Tom work for the same company. Tom asks you to pick him up and drop him off at the train station every day. You feel this will cause you unnecessary delays. You respond:.

1. "Um, well, I guess it's possible . . . Oh (pause), all right." (Nonassertive)
2. "You're kidding! You have some darn nerve! Why should I do that for you?" (Aggressive)

3. "I know it takes you a while to walk to the station, but I really don't want to be delayed by taking you there." (Assertive)
4. "I would really be happy to do this for you if I didn't have to stop at Mom's on the way home." (Nonassertive)
5. "You need a ride, huh? What's the problem? Your legs won't support the weight you've put on?" (Aggressive)
6. "I understand you get tired of having to walk to the station every day, but still, I'd rather not commit myself to picking you up and driving you there every day. I'd be glad to help you out once or twice a week." (Assertive)

You are attending a school meeting on possible curriculum changes. One of your professors speaks up and urges the committee not to change the existing program. She gives inaccurate data in an attempt to convince committee members that her position is correct. You disagree with her. You:

1. Shout, "You're a liar! You've distorted everything on purpose!" (Aggressive)
2. Keep silent. (Nonassertive)
3. Secretly inform the person sitting next to you that the speaker is presenting an inaccurate picture. (Nonassertive)
4. Quietly say, "Well, uh, I know I'm just a student, and I really don't know anything about the curriculum, but . . ." (Nonassertive)
5. State, "I've listened to what you've said, and I disagree. Now I would like you to listen to my position." (Assertive)
6. "Wait a minute! You can't take advantage of students any longer. We've had it with your fuddy-duddy conservatism." (Aggressive)
7. "I see why you're worried about changing the total curriculum, but I believe we can preserve the integrity of our program and still develop innovative approaches to learning." (Assertive)

Your physician makes a sexist remark while examining you. You:

1. Say, "Who the hell do you think you are?" (Aggressive)
2. Say nothing. (Nonassertive)
3. Laugh and say, "Oh, now really, doctor!" (Nonassertive)
4. Storm out of the office, slamming the door behind you. (Aggressive)
5. Say, "I think that remark is sexist. I can't believe you meant it." (Assertive)

As these examples show, you can be assertive, nonassertive, or aggressive in many different ways. When you interact with another, you can communicate nonassertiveness by demeaning yourself, by keeping silent, or by hesitating to state your position. You can communicate aggressiveness by being openly hostile, sarcastic, or rude. In contrast, you can communicate assertiveness by standing up for your rights, expressing your wishes, and attempting to compromise. In each case, you respond in an honest, direct, and open fashion.

In order for any interpersonal relationship to grow, both individuals need to demonstrate at least a minimal level of assertiveness in their communication with each other. The

important point is to try not to let your actions be dictated by circumstances or people. Although there is no one way you must act in every interpersonal encounter, the choice of how you act should be your own. We can all increase our feelings of self-worth by learning to be more assertive.

SKILL BUILDER

CHANGES

1. If you could change two things about the way you relate to others in interpersonal situations, what would they be?
2. What would this change do for you?
3. What would it do for your relationship?
4. How do you plan to let others know you want to change?

HOW TO MAKE ASSERTIVENESS WORK FOR YOU

The key to becoming assertive is to learn to exercise your rights without violating the rights of others. Remember, there really are not any people who are naturally assertive. There are only people who have practiced assertive behaviors and learned to behave assertively. You can use the following pointers to help you change your behavior in a positive way. If you take them seriously, they will enable you to relate to others more effectively and gain the confidence you need to stand up for your rights and enrich the quality of your interpersonal relationships.

Develop an Assertive Belief System

Those who sacrifice their rights teach others to take advantage of them. Those who demand rights that are not legitimately theirs take advantage of others. We believe that not revealing our feelings and thoughts to others can be just as damaging as not paying attention or reacting to the feelings and thoughts of others. Here is what we consider every person's Bill of Rights:

1. The right to be treated with respect
2. The right to make your own choices or decisions
3. The right to make mistakes and change your mind
4. The right to have needs and to have these needs viewed as being as important as the needs of others
5. The right to express your feelings and opinions
6. The right to judge your own behavior
7. The right to set your own priorities

8. The right to say no without feeling guilty
9. The right not to make choices for others
10. The right not to assert yourself

These rights provide the structure on which you can build effective relationships. Internalizing them will enable you to learn new habits and expectations. Accepting your personal rights and the personal rights of others is an important first step.

Describe, Express, Specify, and Note the Consequences of Behavior

> All the world's a stage
> And all the men and women merely players.
> They have their exits and their entrances;
> Each man in his time plays many parts.
>
> <div align="right">Shakespeare</div>

In their book, *Asserting Yourself*, Sharon and Gordon Bower present a technique that you can use to help you handle interpersonal dilemmas effectively. Their approach is called "DESC Scripts." DESC is an acronym for Describe, Express, Specify, and Consequences. A script contains characters (you and the person with whom you are relating), a plot (a happening that has left you dissatisfied), a setting (the time and place that the interaction occurred), and a message (the words and nonverbal cues of the actors). To begin a DESC script, you *describe* as specifically and as objectively as possible the behavior of another that troubles you and makes you feel inadequate. By describing the bothersome occurrence you give yourself a chance to examine the situation and define your personal needs and goals. Once you have identified what you believe is undesirable about the behavior, you are in a better position to handle it. Use simple, concrete, specific, and unbiased terms to describe the other's actions. For example, instead of saying, "You're always overcharging me, you dirty cheat!" try responding, "You told me the repairs would cost $50 and now you're charging me $110." Instead of saying, "You're ignoring me, you don't care about me," respond, "You never look at me when we speak." Instead of guessing at motives and saying, "You resent me and are attracted to Lisa," observe, "The last two times we've gone out with Jack and Lisa you've criticized me."

In the space provided write a direct description of a particular behavior that bothers you. At this time, also identify the characters, the plot, and the setting.

Characters:

Plot:

Setting:

Description:

The next step is to *express* how you feel and think about the behavior. To do this, get in touch with your emotions and use personal statements. By using personal statements you make it clear you are referring to what *you* are feeling and what *you* are thinking. The cue to a personal statement is a pronoun like "I," "me," or "my"—for example,

"I feel . . ." "I believe . . ." "My feelings are . . ." "It appears to me . . ." Thus, when hurt by the behavior of an unthinking friend, you might say, "I feel humiliated and demeaned when you make fun of me." Recognize that feelings can be described in any number of ways. You can name a feeling: "I feel disappointed; I feel angry." You can use comparisons: "I feel like mashed potatoes without salt," "I feel like a rose whose petals were ripped off one by one." Or you can indicate the type of action your feelings are prompting you to exhibit: "I feel like leaving the room;" "I feel like putting cotton in my ears." By disclosing your feelings tactfully you can make your position known without alienating the other person. On a separate sheet of paper, express your feelings regarding the situation you described earlier.

Once you have described the bothersome behavior and expressed your feelings or thoughts about it, your next step is to ask for a different, specific behavior. Thus, you *specify* the behavior you would like substituted. In effect, you are requesting that the other person stop doing one thing and start doing something else. As before, you need to make your request concrete and particular. It would be more effective to say, "Please stop playing the drums after 11 P.M.," than it would be to yell, "Stop being so damn noisy!" On a sheet of paper compose specific lines relevant to your situation.

Remember, we are not talking about a one-way process. The other person may also find aspects of your behavior irksome and would like to see you change. Thus, you should be willing to compromise. Assertion can involve some give and take. Be ready.

Behavioral changes have *consequences* (punishments and rewards). In the last phase of DESC, you spell out the consequences for the other person. If at all possible, try to emphasize the positive outcomes—you might say, for example, "If you stop criticizing me in front of Jack and Lisa, I will feel better and we will both have a more enjoyable evening." If that does not work, it may be necessary to note the potential negative outcomes: "If you continue to criticize me, I'll simply have to start reminding you of your behavior by leaving the room. I do not want to be demeaned any longer." On a sheet of paper compose consequence lines for the troublesome situations that you are trying to resolve. Review your script and rehearse it until you feel your verbal and nonverbal cues support your goal.

Practice These Basic Assertive Behaviors

First, stop automatically asking permission to speak, think, or behave. Instead of saying, "Do you mind if I ask to have this point clarified," say, "I'd like to know if . . ." In other words, substitute declarative statements for permission requests.

Second, establish eye contact when interacting with people. Instead of looking down and to the side (cues that signal uncertainty and insecurity), look into the eyes of the other person. This lets the person know you have the confidence to communicate honestly and directly.

Third, eliminate hesitations and fillers ("uhs," "you knows," and "hmms") from your speech. It is better to talk more slowly and deliberately than to broadcast lack of preparedness or lack of self-assurance.

Fourth, say no calmly, firmly, and quietly; say yes sincerely and honestly; and say "I want" without fear or guilt.

Practice These Conversational Skills

The skills described in this section will help you initiate, maintain, and terminate conversations. They are adapted from Sherwin B. Cotler and Julio J. Guerra's *Assertion Training*. Cotler and Guerra note that people who are skilled conversationalists are perceived to be more friendly, more sociable, and more assertive than people who have difficulty establishing or carrying on conversations. Being able to talk comfortably with others is a key that can keep you from being isolated. It gives you the opportunity to express and probe for feelings and thoughts, and it can enhance your performance in a variety of social situations.

First, to begin and keep a conversation going, you must be willing to ask open-ended questions. Asking questions that can be answered with a one-word grunt will not sustain a conversation. For example, the close-ended question, ''Do you like Professor Smith?'' will elicit a simple yes or no in response. However, an open-ended question such as, ''What is it that you like or dislike about Professor Smith?'' will elicit a more detailed

Developing effective conversational skills can help us overcome shyness and isolation. Often a few skillful questions can open up a conversation in which we feel comfortable.
(© Fredrik D. Bodin/Stock, Boston)

response and give the other person a chance to tell you about himself or herself in the process.

Second, be alert for free information. We obtain free information when the person we are talking to answers our question and also supplies unrequested information at the same time. If, for instance, you asked someone, "How do you like all the snow we're having?" and she replied, "I'd enjoy the snow more if I could go to my ski lodge in the mountains instead of having to paint my apartment," you would get quite a bit of free information. You now know that she likes to ski, has a vacation home in the mountains, and is in the process of painting her apartment. Whether you follow up on this free information depends on whether you are interested in knowing more about her. Do not forget, getting free information means you will probably have to give some, too. Do not be reluctant to give information about yourself during the course of a conversation.

Third, know how to end a conversation gracefully. We have all experienced an interpersonal situation when we felt trapped, or "nailed to the wall," by someone who was "talking our ears off." Cotler and Guerra suggest a number of "canned" responses that work to end conversations. "I really have enjoyed talking with you," or "I see someone here I haven't spoken with in a long time." As you utter the words you can support the statement by decreasing your eye contact and increasing your physical distance from the person. Just as you need to be adept at beginning and sustaining conversations, so you need to know how and when to end them. Make each of these skills a part of your repertoire of assertive behavior.

Embark on an Assertiveness Program

Use the following sequence of activities to improve your assertive skills.

Step One: Observe your own behavior. What pleases you? What displeases you? How do you feel about the relationships you share with others? Are there some relationships you would like to improve? Why?

Step Two: Keep an assertiveness record. Enter each of your interpersonal interactions in a log. Indicate those situations in which you were able to act assertively, those in which you became aggressive, and those in which you displayed nonassertive traits.

Step Three: Focus on one specific experience at a time. First, use your imagination to visualize how you handled a particular interpersonal incident. Recall the details of the situation, including your feelings before, during, and after the encounter.

Step Four: Formalize your responses. Commit the behavior you "observed" during Step Three to paper. Describe the words you used, the nature of your voice, eye contact, body language, posture, and facial expressions. Place plus signs next to those behaviors that suggest assertiveness and minus signs next to those that suggest aggressiveness or nonassertiveness.

Step Five: Examine alternative ways of responding. How else do you believe the incident could be handled effectively? If possible, discuss possible approaches and their consequences with friends who are assertive, or watch an assertive person in action.

Step Six: Visualize yourself handling the situation again. This time make an effort to be assertive. Repeat this step until responding assertively feels natural.

Step Seven: Do it. Now you are ready to begin experimenting with new ways of reacting to interpersonal situations that pose problems for you.

We are all nonassertive at times, we are all aggressive at times, we are all assertive at times. That is not a problem. The problem develops when we are aggressive or nonassertive too frequently and when we hurt ourselves or others in the process. The problem arises when we lose control. By protecting and projecting your assertive rights, however, you build a framework that will support healthy interpersonal relationships.

SUMMARY

In this chapter, we explored different forms of interpersonal entrapment, and we contrasted these with a method of insuring we get treated fairly. Specifically, we contrasted shyness (nonassertion) and aggression with assertion. We measured the extent to which we characteristically assert ourselves, we listed the verbal and nonverbal components of each behavioral style, and we examined the intrapersonal and interpersonal costs and rewards of behaving assertively, nonassertively, and aggressively.

We have seen that being assertive means being neither a victim nor a victimizer. We discovered that being assertive means we are willing to defend our rights, communicate our needs, and work with others to find mutually satisfactory solutions to interpersonal problems or dilemmas. Finally, we identified pointers we can use to make assertiveness work for us to enrich our interpersonal relationships.

SUGGESTIONS FOR FURTHER READING

Alberti, Robert E., and Michael L. Emmons. *Stand Up, Speak Out, Talk Back!* New York: Pocket Books, 1970. How to become an assertive person; contains good examples and illustrations.

Bloom, Lynn Z., Karen Coburn, and Joan Pearlman. *The New Assertive Woman*. New York: Dell, 1975. A highly readable and in-depth description of assertion.

Bower, Sharon Anthony, and Gordon H. Bower. *Asserting Yourself*. Reading, Mass.: Addison-Wesley, 1976. An easy-to-follow assertiveness training program; explains DESC scripts.

Cotler, Sherwin B., and Julio J. Guerra. *Asssertion Training*. Champaign, Ill.: Research Press, 1976. Strategies for developing assertiveness and successful assertion training approaches.

Dyer, Wayne. *Pulling Your Own Strings*.

New York: Avon Books, 1978. A best seller; identifies effective ways of dealing with people and strategies for eliminating self-defeating behaviors.

Lange, Arthur J., and Patricia Jakubowski. *Responsible Assertive Behavior*. Champaign, Ill.: Research Press, 1976. A guide for trainers; contains useful, structured exercises.

Rubin, Theodore Isaac. *The Angry Book*. New York: Macmillan, 1969. Describes how to use anger to build a stronger and happier personality. Discusses the problems that could result from "unreleased" anger.

Smith, Manuel J. *When I Say No, I Feel Guilty*. New York: Bantam Books, 1975. A well-done "how-to" book.

Zimbardo, Philip G. *Shyness*. New York: Jove Books, 1977. A highly readable work. Discusses what we can do about the social disease that is reaching epidemic proportions.

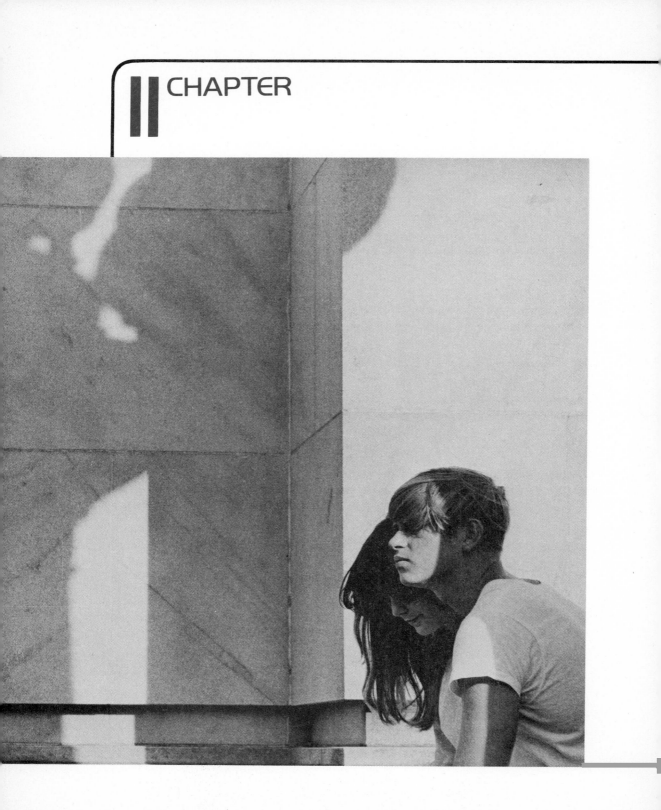

Where Do You Go from Here? A Lifelong Perspective

CHAPTER PREVIEW

After experiencing this chapter, you should be able to:

Explain why developing your interpersonal communication skills is a lifelong task

Demonstrate an ability to use a number of strategies to help make your present and future interpersonal contacts more effective

Explain why we need to acknowledge change

> Provide examples of important life passages you have made or expect to make
>
> Explain what is meant by ''changing communication chairs''
>
> Define and discuss the dangers inherent in frozen evaluations
>
> Identify typical nonchange excuses

Assess your ability to apply principles discussed in this and previous chapters to the arenas of your life

Use ''checkbacks'' to help maintain and improve your interpersonal skills

Continue your interpersonal skill development on your own

They told me to write about life,
To discover new insights,
To probe my inner soul,
To meditate on my faith,
To reflect on ideals,
And to have it in by Friday.

Anonymous

As we mentioned at the start, we wrote this book for you. What we said at the outset is even more relevant now: The topics you have studied should serve you well as you enter into personal and professional relationships. The skills you have mastered should help you fulfill your needs, reach your goals, and improve the quality of your life. But, as we indicated in Chapter 1, your assignment to develop your interpersonal communication abilities has no due date; it is a lifelong process. You have completed this term's work, but your lifelong learning program has just begun. As Aldous Huxley wrote, "There's only one corner of the universe you can be certain of improving and that's your own self." Let us examine a number of strategies you can use to help make your present and future interpersonal contacts as rewarding as you would like them to be. Remember, you can surpass yourself!

HOW TO KEEP IMPROVING YOUR INTERPERSONAL COMMUNICATION EFFECTIVENESS

Today is not exactly like yesterday, the day before yesterday, or the day before that day. Thus, if there is one thing you can count on, it is change. To put it directly, we change with time, the people with whom we relate change with time, and the situations in which we are involved change with time. To deal with this change, we must acknowledge it. Only then can we keep our communicating selves fresh and effective. In her book *Passages*, Gail Sheehy put it this way:

> We are not unlike a particularly hardy crustacean. The lobster grows by developing and shedding a series of hard, protective shells. Each time it expands from within, the confining shell must be sloughed off. It is left exposed and vulnerable until, in time, a new covering grows to replace the old.

It could be said that we too develop from within. As we move through the various stages or passages of our lives, we too shed the protections in which we have encased ourselves. Let us explore the types of shells you have shed in your own life.

SHEDDING SHELLS

1. Identify stages in your own life when your entire existence appeared to undergo a great change. List them below.

 A.

 B.

 C.

 D.

2. Describe the alterations or adaptations you had to make as a result of each change. What new roles did you assume? What roles did you give up? What happened to your sense of status? Your sense of power? Did you adapt new language patterns or dress styles?

3. Explain how you felt after each change. For instance, did you feel exposed or threatened when you entered the college environment? A job environment?

Major life experiences like marriage can make us feel vulnerable as we are called on to adapt and change. Change, however, is an important part of self-development.
(© *Martha Rudenstein*)

Experiences such as graduation, an engagement, moving away, marriage, childbirth, death, a broken relationship, divorce, entering the job market, or being fired can cause us to feel vulnerable because they require adaptation and change. However, as Sheehy writes, ". . . we must be willing to change chairs if we want to grow. There is no permanent compatability between a chair and a person. And there is no one right chair. What is right at one stage may be restricting at another, or too soft."

The message for us is that we must be prepared to change "communication chairs" also. The communication strategies we employed successfully at one point in our lives may be inadequate or inappropriate when we consider the situations and people we interact with today. Just as the physician's practice of medicine changes as new medications are discovered and marketed, and the attorney's practice of law changes as laws are added to or removed from the books, so your practice of communication should change as you leave one life experience and enter another. As this happens, you may notice subtle or dramatic alterations in your sense of self, your feelings about others, or your values and attitudes. This is normal because each change asks you to develop and react in some way. Thus, everyone is expected to play the change game, but only those who take the time to understand it have an advantage.

Watch Frozen Evaluations

Whenever you unconsciously or knowingly apply your evaluation of a person (yourself or another), situation, or idea to the future and the past, ignoring the changes in the objects of your assessment, you are making what William Haney calls a "frozen evaluation." He notes that some of our most frozen evaluations are those we make about ourselves, although evaluations we make about others can be just as harmful.

SKILL BUILDER

CARVED IN STONE

1. Describe an experience in which someone's frozen evaluation of you created difficulties.
2. Describe an experience in which your frozen evaluation of someone else created difficulties.
3. For each situation, answer these questions:

 A. Why do you think the frozen evaluation caused the problem(s)?
 B. What do you believe could have helped prevent the problem(s)?

Worn-out evaluations can do ourselves and others a great disservice. People, situations, and ideas are all in constant flux. Try to prevent your judgments from becoming set in concrete. Effective communicators have the courage to acknowledge past and future changes in the people, the situations, or the objects they evaluate. Effective communicators can substitute the premise of change for the assumption of nonchange.

SKILL BUILDER

CHANGES

1. Compile a list of self-evaluations that have remained relatively unchanged over the years—for example, "I am shy."
2. Identify specific examples that could be used to invalidate each of these self-evaluations.
3. Compile a list of evaluations you have made about others that have remained relatively unchanged over a period of time—for example, "Haynes is a poor teacher."
4. As before, identify data that could be used to expose the fallacies in these evaluations.

Since change is inevitable, remember to take it into consideration when rendering evaluations. People, situations, and things do change with time, and if you refuse to deal with the change, you are actually refusing to deal with the person, situation, or thing.

Avoid Nonchange Excuses

You can also do damage to yourself and your relationship to others if you convince yourself you are unable to change. Such an excuse prevents you from trying out new behaviors, assuming new roles, or interacting successfully in new situations. Change may be difficult, but it is possible.

SKILL BUILDER

EXCUSES, EXCUSES

1. Compile a list of excuses that either you or others you know use to avoid dealing with change. For example, "I can't unlearn poverty," or "I was spoiled as a child, so I always have to get my way," or "I was taught that men don't do dishes and that women belong in the home."
2. Explain why the concept of change makes the validity of each of these excuses doubtful.

To be sure, at times our environment constricts and limits the possibilities open to us. However, at other times our environment stretches, and we find ourselves operating in a somewhat different context. The environment we were born into is not the same environment we are interacting in today. Although your past certainly influences who you are today, how you plan and prepare for your future can also influence you. You will

When we move from school to the larger world, our environment
"stretches." Our attitudes and values are likely to change with our
changing environment—if we are open to growth.
(© Richard Kalvar/Magnum)

permit yourself to grow if you recognize that you are constantly reorganizing and constantly changing. For this reason, the attitudes and values you carry with you from the past may not apply to the present you or the present situation. Remember what Alice answered when the caterpillar asked: "Who are you?"

> —I hardly know, sir, just at present—at least I know who I was when
> I got up this morning, but I think I must have changed several times
> since then.

Openness, curiosity, and the willingness to take a risk and experiment can be assets. You will be wise not to let habits, rigid attitudes, or unyielding opinions hinder your growth by reducing your receptiveness to alternative ways of thinking and acting.

A LOOK AT THE MAJOR ARENAS OF YOUR LIFE—FAMILY, FRIENDS, EDUCATION, AND WORK

The extent to which you develop the skills to help you communicate with others will influence whether you will be able to make your way through your "people environment"

successfully. Your people environment is composed of at least four different arenas: family, friends, education, and work. One of our goals in this book was to equip you with the interpersonal competencies that would enable you to relate effectively in any of these contexts—that is, wherever you happened to find yourself. It is now time for you to assess your ability to function in each of these different interpersonal environments. Doing so will permit you to identify your needs and the demands placed on you when you communicate interpersonally in the vital areas of your life.

Your reactions should indicate to you how communication influences your relationships with others in each of these sectors. After all, as Virginia Satir notes in *Peoplemaking*, "... communication is a huge umbrella that covers and affects all that goes on between human beings." Let us be certain to examine the umbrella's spokes. Use the following exercises to recognize, reaffirm, and set interpersonal skill priorities. Once you understand your priorities in each of your major arenas, you will be in a position to act more consistently to achieve them.

SKILL BUILDER

WHERE AM I NOW?

1. For each arena, identify specific behaviors that you would like to avoid exhibiting during communication contacts with particular individuals.

FAMILY BEHAVIOR TO BE AVOIDED

Person$_1$

Person$_2$

FRIENDS BEHAVIOR TO BE AVOIDED

Person$_1$

Person$_2$

EDUCATION BEHAVIOR TO BE AVOIDED

Person$_1$

Person$_2$

WORK BEHAVIOR TO BE AVOIDED

Person$_1$

Person$_2$

SKILL BUILDER CONTINUED ON THE FOLLOWING PAGE

SKILL BUILDER CONTINUED ON THE FOLLOWING PAGE

2. For each arena, identify specific behaviors you would prefer to exhibit during communication contacts with particular individuals.

FAMILY _____ BEHAVIOR TO BE USED _____

Person$_1$

Person$_2$

FRIENDS _____ BEHAVIOR TO BE USED _____

Person$_1$

Person$_2$

EDUCATION _____ BEHAVIOR TO BE USED _____

Person$_1$

Person$_2$

WORK _____ BEHAVIOR TO BE USED _____

Person$_1$

Person$_2$

Regardless of our arena, we sometimes communicate in ways that hurt ourselves or others. Being able to identify the behaviors that impede our functioning and being able to recognize the behaviors that could be substituted is an important step in improving our interpersonal communication abilities. What happens to us in one arena may be quite different from what happens to us in another; how we perceive ourselves can also change from one arena to another. Accounting for those differences is part of the growth process. By now it should be apparent that one key to communication effectiveness is behavioral flexibility. The people in each arena can present unique communication problems for you; thus, certain behaviors may be more effective in one type of context than in another type.

The goal of the next exercise is to identify the ways in which your evaluation of your communication assets and liabilities affects your ability to function in each communication arena.

SKILL BUILDER

WHERE ARE YOU NOW?

1. Use the following set of scales to measure your ability to apply the skills discussed in this book to each of the indicated communication arenas. The number 1 on the scale represents little or no confidence in your ability, the number 5, total confidence in your ability. Circle the number that best reflects your assessment.

	FAMILY	FRIENDS	EDUCATION	WORK
Your self-concept	1 2 3 4 5	1 2 3 4 5	1 2 3 4 5	1 2 3 4 5
Your perceptual skills	1 2 3 4 5	1 2 3 4 5	1 2 3 4 5	1 2 3 4 5
Your listening skills	1 2 3 4 5	1 2 3 4 5	1 2 3 4 5	1 2 3 4 5
Your ability to send and receive nonverbal cues	1 2 3 4 5	1 2 3 4 5	1 2 3 4 5	1 2 3 4 5
Your ability to trust	1 2 3 4 5	1 2 3 4 5	1 2 3 4 5	1 2 3 4 5
Your ability to communicate through words	1 2 3 4 5	1 2 3 4 5	1 2 3 4 5	1 2 3 4 5
Your persuasive skills	1 2 3 4 5	1 2 3 4 5	1 2 3 4 5	1 2 3 4 5
Your ability to handle conflict	1 2 3 4 5	1 2 3 4 5	1 2 3 4 5	1 2 3 4 5
Your ability to be assertive	1 2 3 4 5	1 2 3 4 5	1 2 3 4 5	1 2 3 4 5

2. What do your ratings tell you about your level of skill mastery? Which skills pose problems for you consistently? Which pose problems for you in only one context? In which arena do you experience the most problems? The fewest problems? Why?

Realize that you can choose to ignore your weaker behaviors and drift through an encounter, or you can choose to deal with your problem behaviors and face your communication challenges. In order to fully develop a skill, however, you must want to improve yourself. You must be willing to work, and you must be personally committed.

You must feel the goal is desirable—a target worth striving for. You probably want to enhance your abilities to communicate interpersonally in all arenas. Your chances of succeeding will be increased if you contract to practice all of the interpersonal skills we have considered. After all, these skills are vital to your success in each area of your life.

CHECKBACKS: EXERCISES YOU CAN USE AGAIN AND AGAIN

MOTHER TO SON

Langston Hughes

Well, Son, I'll tell you
Life for me ain't been no crystal stair
It's had tacks in it,
And splinters,
And boards torn up,
And places with no carpets on the floor,

Bare.
But all the time
I'se been climbin' on
And reachin' landin's
And turning corners
And sometimes goin' on in the dark
Where there ain't been no light.
So, Boy, don't you turn back.
Don't you set down on the steps
'Cause you find it's kinder hard.
Don't you fall now—
For I'se still goin', Honey,
I'se still climbin'
And life for me ain't been
 no crystal stair.

We wrote this text hoping that you would find it a practical interpersonal skill development manual—one you could use again and again. Thus, each of the skill-builder experiences can be repeated at various points throughout your life. Your responses will trace your growth and development as an interpersonal communicator. We have also included a number of key "checkback" exercises, exercises you can repeat through the years to help insure that you continually work to maintain, nourish, and improve your interpersonal skills.

CHECKBACK 1

UP TO DATE

1. Describe yourself ten years ago, five years ago, and today in terms of physical appearance, personality characteristics, intellectual ability, and communication skills. Use the following chart to record your observations:

TEN YEARS AGO

A. Physical Appearance:

C. Intellectual Ability:

B. Personality Characteristics:

D. Communication Skills:

FIVE YEARS AGO

A. Physical Appearance:

C. Intellectual Ability:

B. Personality Characteristics:

D. Communication Skills:

TODAY

A. Physical Appearance:

C. Intellectual Ability:

B. Personality Characteristics:

D. Communication Skills:

2. Which aspects of yourself have undergone the most revision? Why?
3. Be sure to repeat this exercise every few years.

CHECKBACK 2

LIFE–TIME

1. Describe your self-concept. In your analysis, include a description of the roles you believe you performed effectively this year, the roles you feel you need to work on, and new discoveries you made about yourself since the exercise was last performed.

2. Discuss the types of relationships you shared with significant others during the year. Include a description of relationships that have ended, relationships that have been maintained, and relationships that have just been started.

3. Discuss your ability to communicate on the job. What are your strengths? Your problem areas?

4. Identify your communication goals for the coming year.

5. Repeat this exercise annually.

CHECKBACK 3

SAME TIME NEXT YEAR

1. This exercise should be conducted on the same day every year. It gives you an opportunity to plot your communication skill development in your main life arenas.

2. On the chart on the opposite page, use a pen or pencil of one color to plot your personal communication abilities and another color to plot your professional communication abilities. Label each line with this year's date. Redraw the lines each year as necessary, or reproduce the graph for each year's self-examination.

3. What do your "life lines" reveal about your ability to communicate effectively in each of these arenas?

4. Identify factors that can account for the stability and/or the change in the nature of arena life lines.

We hope that we have provided you with the impetus to continue to develop your interpersonal skills. You now have a body of knowledge and a series of exercises you can use to gain understanding of yourself, others, and the relationships you share. Certainly we have not covered everything there is to say about interpersonal communication. However, we think the materials in the text will help make each of you a more effective communicator. Since interpersonal communication occupies most of your time, it makes sense to try to do it well!

SAME TIME NEXT YEAR EVALUATION CHART

YEAR: _____

COLOR CODE: _____

PROFESSIONAL LIFE: _____

PERSONAL LIFE: _____

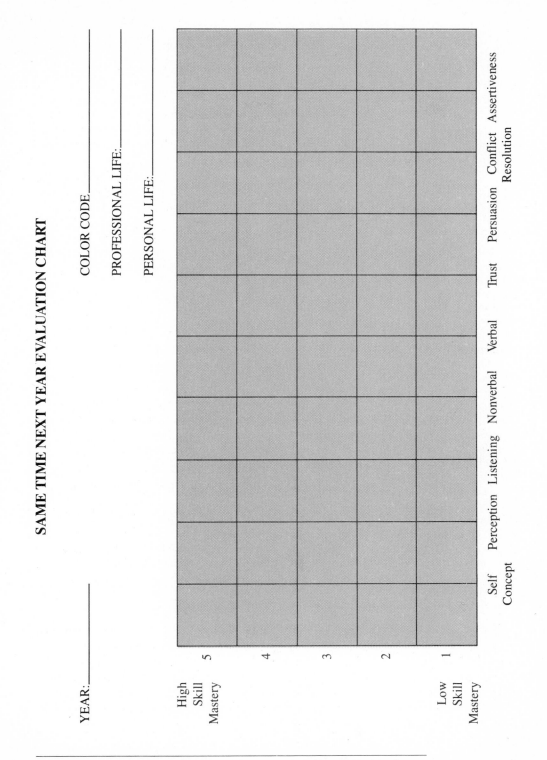

High Skill Mastery — 5, 4, 3, 2, 1 — Low Skill Mastery

Self Concept | Perception | Listening | Nonverbal | Verbal | Trust | Persuasion | Conflict Resolution | Assertiveness

SUMMARY

In this chapter we have explored why developing your ability to communicate interpersonally is a lifelong task. We have explained why mastering interpersonal skills can help improve your chances for success in each arena of your life, and we have stressed the importance of continuing the lifelong learning program you have begun.

To aid you in fulfilling this goal, we suggested strategies you can use to enhance your communication effectiveness, and we provided you with a series of checkback experiences, exercises we hope you will return to again and again.

SUGGESTIONS FOR FURTHER READING

Bolles, Richard Nelson. *The Three Boxes of Life*. Berkeley, Calif.: Ten Speed Press, 1979. A valuable resource for job hunters and job changers.

Bolles, Richard Nelson. *What Color Is Your Parachute?* Berkeley, Calif.: Ten Speed Press, 1978. A best-selling, career/self-development guide.

Gillies, Jerry. *Friends: The Power and Potential of the Company You Keep*. New York: Barnes and Noble Books, 1976. A thorough discussion of the various aspects of friendship; contains useful suggestions on how to assess the nature of your own friendships and relationships.

Heller, Robert. *Super Self: The Art and Science of Self-Management*. New York: Atheneum/SMI, 1979. A practical guide to self-control and self-development.

Moore, Charles Guy. *The Career Game*. New York: Ballantine Books, 1976. A career development handbook. Describes strategies that can be used to analyze career alternatives and market yourself.

O'Neill, Nena, and George O'Neill. *Open Marriage: A New Life Style for Couples*. New York: Avon Books, 1972. A provocative, insightful discussion about how couples communicate.

O'Neill, Nena, and George O'Neill. *Shifting Gears*. New York: Avon Books, 1974. Describes strategies for achieving personal potential.

Satir, Virginia. *Peoplemaking*. Palo Alto, Calif.: Science and Behavior Books, 1972. How to develop a healthy, supportive family communication system; contains good exercises.

Sheehy, Gail. *Passages: Predictable Crises of Adult Life*. New York: Dutton, 1976. A best seller; identifies changes and strains in person-to-person relationships that occur during life stages.

Viscott, David. *How to Live with Another Person*. New York: Arbor House, 1974. A useful, practical work.

Wahlroos, Sven. *Family Communication: A Guide to Emotional Health*. New York: New American Library, 1974. A useful guide. Emphasizes the role communication plays in relationships; offers twenty rules to help improve the quality of interpersonal contacts.

Blindering Problem

The Detective

1. ? 7. ?
2. ? 8. ?
3. F 9. ?
4. ? 10. ?
5. ? 11. ?
6. T

Index

Affect blend, 153
Aggression, 351–355, 359–364
Allness, 90–92
Are You Listening? 106, 127
Argyle, Michael, 159
Art of Persuasion, The, 291
Asserting Yourself, 365
Assertion Training, 359, 367–368
Assertiveness, 332–340, 355–359, 365–369
Attention, getting people's, 291
Attention span, 126
Attitudes
 balancing, 283–287
 functions of, 268–270
 measurement of, 262–265
 source of, 265–267
 see also Beliefs; Values
Augsburger, David, 203–204

Baker, Russell, 75, 181
Balance theory, 283–284
Bartlett, Dorothy, 78
Beavin, Janet, 25–26
Behavior
 aggressive, 351–355
 assertive, 332–340, 355–359, 364–368
 defensive, 206–212
 nonassertive, 340–351
 supportive, 210–212
Belief dimensions, 271–273
Beliefs
 measurement of, 270–273
 persuasion and, interpersonal, 288–294
 see also Attitudes; Values
Berne, Eric, 57

Beuf, Ann, 54
Birdwhistell, Ray, 145
Blanc, Mel, 174
Blindering, 92
Bloom, Lynn Z., 351
Body language, 151–169
Body Language, 156–157
Body Politics, 163
Bok, Sissela, 221
Bower, Sharon and Gordon, 365
Bypassing, 242–243

Caring Enough to Confront, 203–204
Carter, Richard, 78
Center, Alan, 266
Chase, Steward, 248
"Clever Hans," 145
Closure, 80
Coburn, Karen, 351
Communication
 axioms, 25–26
 chain of command transmissions in, 107
 chairs, 374
 serial, 107
 see also Interpersonal communication;
 Nonverbal communication
Communication and Organizational Behavior,
 69
Communicator, interpersonal
 description of, 5–8
 effectiveness of, improving, 29–30, 372–376
Competition, 314
Condon, John, 255
Conflict, 298–328
Contact, axioms of interpersonal, 24–29

Cooperation vs. competition, 314–316
Cotler, Sherwin B., 359, 367–368
Cutlip, Scott, 266

Dance, Frank, 19
"Dangling Conversation, The," 140
Dean, Janet, 159
Defensiveness, 206–212
 categories of behavior characteristics of, 209
 nonverbal symbols of behavior producing, 211
Dependence on others, 198–199
"DESC Scripts," 365
Deutsch, Morton, 321
Diary of a Young Girl, 276–277
"Distortion in Communication," 108
"Don't Cry Out Loud," 59
Doyle, Arthur Conan, 144
Dream Deferred, 322
Dream Songs, 267
Dress for Success, 171
Dyer, Wayne W., 335, 337

Ekman, Paul, 153
Ellison, Ralph, 86
Epstein, Edward Jay, 84
Evaluations, frozen, 374–376
Excuses, nonchange, 375
Expression of Emotions in Man and Animals, The, 151
Expression, facial, 153
Eye contact, 159

Fast, Julius, 156–157
Feedback, 114–125
Figure-ground principle, 72–73
Filley, Alan, 304, 321
Freud, Sigmund, 144
Freund, John R., 108
Friesen, Wallace, 153

Gabarro, John G., 201
"Gobbledegook, The," 247–248
Goldhaber, Gerald, 109
Gordon, Thomas, 122
Guerra, Julio J., 359, 367–368

Haitch, Richard, 250
Hall, Edward T., 155, 178–180, 188
Haney, William, 374
Hayakawa, S. I., 98, 254
Hearing vs. listening, 111–112
Hearth and Home, 53
Height Report, The, 163–164

Henley, Nancy, 191
Heun, Linda and Richard, 210–212
Hidden Dimension, The, 179
Horn, Jack C., 349
Human Listening, 126
Hyperbole, 254

Identity, personal, 36–38
"I" messages, 122–123
Impressions, first, 81–84
Inferences, 98
Influence, interpersonal, 40
Ingham, Harrington, 58
"Interaction: The Goal of Interpersonal Communication," 137–138
Interpersonal communication
 channels of, 11–12
 characteristics of, 21–24
 checkback exercises for, 380–383
 components of, 9–16
 context of, 12–13
 education and, 376–380
 effect of, 16
 family and, 376–380
 feedback and, 14–15
 friends and, 376–380
 functions of, 23–24
 messages, 10–11
 models of, 16–20
 noise, 12, 19
 people and, 9–10
 work and, 376–380
Interpersonal Conflict Resolution, 304
Invisible Man, The, 86
"Invisible Smile, The," 161

Jackson, Don, 25–26
Jakubowski, Patricia, 351, 353–354
Jaws II, 95
Johari window, 58
Johnson, David, 302
Jourard, Sidney, 191

Kagen, Spencer, 205
Katz, Daniel, 268–269
Kinesics, 151–189
Knapp, Mark, 145
Korzybski, Alfred, 90

Lange, Arthur J., 351, 353–354
Language
 abilities, improving oral, 246–255
 bypassing and, 242–243
 denotative and connotative, 235–242

Language (*cont.*)
 word barriers and, 234–235
 word-thing confusions and, 243–245
 see also Meaning
Language in Thought and Action, 254
Leader Effectiveness Training, 122
Leavitt, Harold, 124
Lee, Irving J., 89
"Lies," 221
"Listen Here: Possible Motto for a Man Who
 Is All Ears," 138
Listening, 103–141
Listening Level Energy Involvement Scale, 113
"Locked In," 56
Luft, Joseph, 58
Luscher Color Test, The, 187
Lying, 220–226
 and interpersonal relationships, 223–226

McCarthy, Eugene J., 247–248
MacKenzie, Alex, 189
MacNeice, Louis, 36–38
Maslow, Abraham, 203, 291–293
Meaning
 definition, 233–234
 denotative and connotative, measuring,
 235–242
 experience and, 239–242
 place and, 238–239
 time and, 237–238
 see also Language
"Measuring Shyness—The 12-inch Differ-
 ence," 349
Mehrabian, Albert, 145, 161, 174
Miller, Gerald R., 16–17
Minnick, Wayne, 291
Molloy, John T., 171, 173
Montgomery, Robert, 131
"Mother to Son," 380
Mueller, Ronald, 124

Nature of Human Values, The, 278
Needs, hierarchy of, 291–293
Nelson, Arnold, 108
Nelson, Linden L., 205
New Assertive Woman, The, 351
News from Nowhere, 84
Nichols, Ralph, 106, 127
Nicoll, Maurice, 260
Nonassertion, 340–351
 relationships, 359–364
"Nonverbal Clues Help Lawyers Learn the
 Truth," 156–157

Nonverbal communication, 144–194
 assessing your effectiveness in, 191–194
 body language, 151–169
 color and, 187–188
 cues and contexts of, 148–191
 physique and dress style, 169–174
 space, distance and, 179–187
 territoriality, personal space, and, 187
 time and, 188–189
 touch and, 189–191
 voice and, 174–179
 see also Body language; Voice
*Nonverbal Communication for Business Suc-
 cess*, 175

Ogden, C. K., 234
"Opinion: An Analysis of Miss Muffet," 75–76

"Parable of the Blind Men and the Elephant,
 The," 90–91
Paralanguage, 174
Paraphrasing, 132–133
Passages, 372
Pearlman, Joan, 351
Peoplemaking, 305, 377
People Yes, The, 52
Perception, 65–101
Perceptual set, 74–77
"Permutation Personified," 107
Persuasion, improving interpersonal, 288–294
"Physique and Self-Description of Tempera-
 ment," 169
Pitch, 174–175
"Plain English," 250
Poe, Edgar Allan, 87
"Positive Denial: The Case for Not Facing Real-
 ity," 224–225
Powell, John, 58
*Pragmatics of Human Communication: A Study
 of Interaction Patterns, Pathologics and
 Paradoxes*, 25, 26, 28, 149
"Prayer Before Birth," 36–38
Primacy effect, 82
"Prisoner's Dilemma" and trust, 212–220
Prophecy, self-fulfilling, 52–54
"Proxemics," 179
Pulling Your Own Strings, 335
"Pull Your Own Strings," 355
Pygmalion in the Classroom, 53

Rawlings, Gayle Spanier, 355
Reaching Out, 302
Relationship window, 359

Repetition, 132–133
Responses
 ectomorphic, 170
 endomorphic, 170
 mesomorphic, 170
Responsible Assertive Behavior, 351, 353
Richards, I. A., 234
Rogers, Carl, 135
Rokeach, Milton, 271, 278–279
"Roles We Play, The," 46
Role-taking and self-exploration, 46–48
Rosenthal, Robert, 53
Rubin, Harvey L., 314

Satir, Virginia, 305, 377
Scheidel, Thomas, 263
Schramm, Wilbur, 18, 78
Science and Sanity, 90
Self-actualization and risk-taking, 200–204
Self-concept, 35–62
Self-disclosure, Johari window and, 56–60
Self-exploration, and risk-taking, 46–48
Semantics and Communication, 255
Shyness, 349. *See also* Nonassertion
Shyness, 343
"Some Effects of Feedback on Communication," 124
Some People, 260
Sommer, Robert, 185
"Song of Myself," 54
Spranger, Edward, 276
"Stanford Shyness Survey," 342–348
Steinfatt, Thomas, 218
Stereotyping, 84–89
Stevens, Leonard, 106
Streetcar Named Desire, 206–208
"Strong Stuff," 236–237
Sublanguages, 249
"Sunday Observer: High Invisibility," 181–182
Supportive behavior, 206–210

Taylor, Anita, 210–212
"There was a Child Went Forth," 40, 42

Time and nonverbal communication, 188–189
Time Trap, The, 189
Tosti, Don, 119–120
Trust, 198–228
 bases of, 201
 components of, 202
 developing, 226–228
 lying and, 220–226
 risk-taking and, 200–204
 social environment, influence on, 204–212
Tucker, Albert W., 212
Tuckman, Gaye, 53–54
"Two Friends," 137
Types of Men, 276

Values
 defined, 273
 interpersonal communication and, 279–282
 measurement of, 277–279
 types of, 276
 see also Attitudes; Beliefs
Victimization, 333–337
Voice
 double-edged messages and, 178–179
 nonverbal communication and, 174–179
 rate of speed of, 176–177
 vocal cues of, 177–178
 vocal stereotypes of, 177–178
 volume of, 175
Voice Training for Speaking and Reading Aloud, 177–178

Watzlawick, Paul, 24–26
Weaver, Carl, 126
Whitman, Walt, 40
Whorf, Benjamin Lee, 244
Why Am I Afraid To Tell You Who I Am? 58
Win-lose syndrome, combating the, 312–322
Woman's Dress for Success Book, The, 171
Women, television image of, 53–54
Word-thing relationship, 244

Zimbardo, Philip, 343, 348

About the Authors

Both Teri and Michael Gamble received Ph.D. degrees in communication arts from New York University. Currently, Michael is a professor at New York Institute of Technology and Teri is a professor at the College of New Rochelle. They have had articles published in a number of journals including *Communication Education,* the *Western Speech Communication Journal,* and *Contemporary Psychology.* Award winning teachers, the Gambles have delivered papers and conducted seminars and short courses for numerous business and professional organizations across the United States. They are members of the Speech Communications Association, the International Communication Association, the American Society for Training and Development, and the Eastern Communication Association, and they are currently Co-Executive Secretaries of the New York State Speech Communication Association. Recently, Michael and Teri wrote, produced, and served as on-the-air instructors for *Communication Workshop*, a new program offered by Cablevision. Cofounders of Interact Training Systems, a consulting firm specializing in communication, Teri and Michael live in New Jersey with their favorite communicator, their five-year-old son Matthew.